THE LIFE AND LETTERS
OF
J. ALDEN WEIR

Library of American Art

THE
LIFE AND LETTERS
OF
J. ALDEN WEIR

By Dorothy Weir Young

Edited with an Introduction by Lawrence W. Chisolm

Kennedy Graphics, Inc. • *Da Capo Press*
New York • 1971

This edition of
The Life and Letters of J. Alden Weir
is an unabridged republication of the first
edition published in New Haven, Connecticut,
in 1960. It is reprinted by special arrangement
with Yale University Press.

Library of Congress Catalog Card Number 76-146157

SBN 306-70097-2

© 1960 by Yale University Press, Inc.

Published by Da Capo Press
A Division of Plenum Publishing Corporation
227 West 17th Street, New York, N.Y. 10011

THE LIFE AND LETTERS
OF
J. ALDEN WEIR

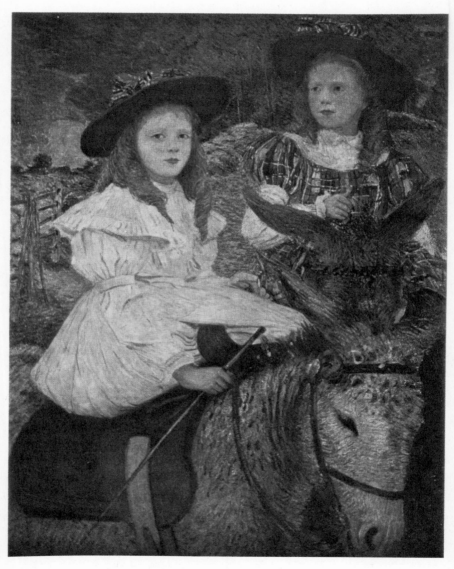

THE DONKEY RIDE. 1899

THE LIFE & LETTERS

OF

J. ALDEN WEIR

BY

DOROTHY WEIR YOUNG

EDITED WITH AN INTRODUCTION
BY *LAWRENCE W. CHISOLM*

NEW HAVEN : YALE UNIVERSITY PRESS, 1960

© 1960 by Yale University Press, Inc.

Set in Linotype Baskerville and printed in the United
States of America by Connecticut Printers, Incor-
porated.

Library of Congress catalog card number: 60-13128

To Mr. and Mrs. Carl P. Rollins
and to Nelson C. White
for their devoted help

FOREWORD

Whom do we need more, or who should be more profoundly honored than a man of complete integrity!

Julian Alden Weir was a man who throughout his life felt the impelling and great responsibility of conveying, through his medium of expression, the forever endless beauties of life which he saw about him, who had the courage always to seek these beauties whether human or in nature and through his sensitive, analytical, and distinguished painting to give us what he found.

The sense of composition and color is inborn. Knowledge of form can be achieved and once learned there follows the capacity to suggest adequately. The mechanics of painting can be learned, and through subtle and masterly technique the artist expresses his thought. These letters show that early in life Weir sensed that to paint freely a complete knowledge of all form must be had. This he achieved through a capacity for searching, beautiful drawing, whether with the etcher's point or the brush, and it continued throughout his life from the work of a student to that of a master.

His dedicated attitude is revealed to us in his correspondence. We are all greatly indebted to his daughter, Dorothy, for this collection, chosen from many sources, and through years of work, to give us a vivid picture of the spirit and mind of a great man and painter. *The Life and Letters of J. Alden Weir* appears at a moment when we need guidance in this period of confusion in the art world, where again integrity in work must be found.

In conclusion, may I express my own indebtedness for a lifetime of inspiration and guidance from this man, who was friend and godfather.

JOHN ALDEN TWACHTMAN

ACKNOWLEDGMENTS

The work of editing owes much to the help, first of all, of Mrs. G. Page Ely and Mrs. Charles Burlingham, sisters of the author, who have supported the project patiently and have provided useful suggestions at every stage. Special thanks are due also to Mr. and Mrs. Carl P. Rollins for their careful readings and criticisms; and to Miss Roberta Yerkes for her judicious direction. Of great help in the details of manuscript preparation were Elizabeth R. Chisolm and Ruth A. Chisolm.

The introduction has benefited from the comments of a number of kind readers: Mrs. G. Page Ely, Mrs. Charles Burlingham, Mr. and Mrs. Carl P. Rollins, Professor Charles Seymour Jr., Professor George A. Kubler, Professor Norman Holmes Pearson, and Mr. William A. Chisolm. They are of course not responsible for possible errors of interpretation.

Acknowledgment is made to the following for the photographs appearing in this book: the Boston Museum of Fine Arts; Bruno Studios; the Cincinnati Museum Association; Gordon W. Haynes; Peter Juley & Son; Pirie MacDonald; the Metropolitan Museum of Art; the National Academy of Design; the National Gallery of Art, Washington; the Phillips Gallery; the Princeton Museum of Historic Art; George Yater.

CONTENTS

ILLUSTRATIONS

Frontispiece
The Donkey Ride. 1899. 52 x 42. Mrs. Charles Burlingham

INTRODUCTION

JULIAN Alden Weir's life has style; his paintings have style; and the integrity of each partakes of a particular historical moment in ways that make biography especially appropriate. This biography invites us to enter a personal dialogue with a portion of the American past as yet scantily understood. Weir's career recalls a more confident era when progress seemed assured and the world's fundamental orderliness could be assumed. Questions of international war and social revolution were not raised in Weir's milieu with any urgency; evidence of disorder could be ignored and kept outside a round of life whose focus on family and friends and work needed no justification. A life of quiet harmony represented not a retreat but an ideal.

This basic harmony is what makes Weir's style of life and art somewhat difficult to appreciate today. The figure of the artist as a man alienated from his society has so dominated modern thinking that an unalienated artist is immediately suspect. If he has not sold himself outright in the market place he is presumably insensitive or untalented, or both, certainly not a true artist. Furthermore, if he is not Bohemian in his personal habits he is likely conventional in his art as well. Western industrial society is hostile to art, we are told by many theorists, because it is too rational, too secular, too mechanized, or again, not rational enough. How can any sensitive artist feel at ease in a society which has at its base neither theology, nor craftsmanship, nor social ownership? Or, the larger society apart, how can anyone's ego develop without building up reservoirs of aggression and a basic hostility to authorities and traditions of all sorts? A man like Weir, at ease with his time and place, seems even more "inartistic" alongside another persistent image, the Romantic genius, a tormented creator driven beyond the timid moralities of middling men, his miseries and ecstasies a sign and measure of his greatness. Taken all together the images of the artist in revolt focus the frustrations and hopes of those sensitive individuals who feel the pressures of their culture all the more keenly for their sense of freedom and the doubts and uncertainties which go with freedom. Consequently the artist has come to stand

for individuality, for protest against the bonds of society and culture—a rebel by proxy for us all.

Weir stands counter to nearly every aspect of the image. He feels thoroughly at home in his native America. He is a gentleman who moves easily in whatever company he chooses, a man who savors life with great gusto but is never coarsened. He enjoys his own private land without social misgivings; he does not deplore secularization; nor does he regret that the factory has displaced the guild. In fact he paints the factory, as well as city streets, with a gentle respect not matching his feeling for the countryside, to be sure, but without hint of malice. His relations with his family are mutually tender and respectful. And despite his strong opinions on art he appears to have made few enemies and many friends. He has his share of distress, but work, family, and the Connecticut woods restore him.

Weir's paintings at their best restore us too, not in the spirit of nostalgia or of escape to a pastoral refuge, but as celebrations of a modest ideal of life. In trying to render "the mystery that it all is" Weir conveys a sense of place, an acceptance of a rooted life seldom flamboyant or dramatic, a life aptly embodied in the particular Connecticut countryside he loved. His landscape is often wild, but moderate, rarely overwhelming, a landscape on a human scale suited to the pleasures of walking, fishing, and hunting; spare rather than abundant, but worthy of respect and care; domestic in the special sense defined by Weir in his paintings: a good place to raise a family and to work each man according to his own lights.

The sense of family so important in shaping and sustaining Weir's style of life and art is heightened by this biography written by his daughter, Dorothy Weir Young. Her own attitude reflects the Weir family's special regard for painting as an activity that is professional and dignified. Her narrative is responsible and honest; her filial piety seldom intrudes, but it is never concealed. Her personal warmth is in a dialogue, as it were, with the impersonal narrative. The large measure of objectivity attained suggests the force of her desire to do justice to an important task.

Robert Walter Weir (1803–89), the family patriarch—Julian Alden was the youngest boy of sixteen children—was a professional painter of broad artistic education who taught drawing at the United States Military Academy, West Point, for forty years. He belonged to a generation of American painters trained in the eighteen twenties and thirties, when the bright future of the arts in a free republic was asserted vigorously and often. Several of Alden's brothers and sisters painted, notably

John Ferguson Weir (1841–1926), who taught at Yale's School of Fine Arts from 1869 to 1913. Family life included professional encouragement and criticism and a concern for significant work. The work, in turn, left time for children and friends who were naturally both models and companions.

Alden Weir grew up in a house full of children, and his own three daughters were always a special delight. Writing from Chicago, where he was working on murals for the World's Fair, he confessed that where his own small children were was "the only place on earth where I long to be." In some of Weir's finest paintings his children pause for a moment on the family place in Connecticut, their figures perfectly matched in stillness with the sunny greens of summer. Both the intimacy and the reticence of Weir's paintings are implied in the tone of his daughter's biographical narrative, affectionate but not sentimental. Her occasional nostalgia is gentle, as much for the passing of a way of life as for the man, her father, who stood for that way of life and for a smaller, more intimate world, insulated perhaps, but deeply felt.

This sense of quiet confidence which Weir's paintings share with their maker defines a moment in the history of the relations of American artists with Europe. Weir's mature work holds a firm balance between European artistic traditions and American particularities. There is little sign of the strain which has swung American painters and writers between the poles of expatriation and nativism. It was perhaps because of his deep local roots that Weir's Americanism did not need to be strident; Europe could be savored with an enthusiasm which neither confused training with a career nor thought to transplant Europe direct to America. During a period when American artists were easily swept off their feet in the currents of European fashions the Weir family held steady.

Robert W. Weir taught drawing to the army men who explored and mapped the western states, their eyes trained to observe detail accurately while preserving a sense of the whole and, inevitably, a sense of the grandeur and mystery of a continental America. Despite his training in Italy and his admiration for European traditions, the patriarch could never have filled the role of expatriate. He escaped the fate of those "improvised Europeans" whose lifeless legacy is symbolized by Hiram Powers' *Greek Slave*, "so undressed, yet so refined, even so pensive," as Henry James put it, "in sugar-white alabaster, exposed under little domed glass covers in such American homes as could bring themselves to think such things right." The Weirs had no trace of this hothouse quality in their lives or in

their work. They were concerned with the provincialism of the arts in America, and Alden Weir worked all his life to strengthen American ties with European art, but the Weirs rarely mistook form for substance. Alden was sure that European art would serve to "fertilize the art soil of America"; America would then see its own new growths. If he was not as sure as his father's generation that a republican America promised a free and glorious flowering of the arts, he was skeptical of rootless artists, men in his own day like G. P. A. Healy; and he would have found a later generation's expatriation unnatural. What Weir sought in Europe were the highest principles of art. He wanted to learn from the touch of a great artist's brush not merely how to make pleasing likenesses or photographic landscapes but how to render "the mystery that it all is."

A moral seriousness which helps account for Alden Weir's search for principles lies at the heart of his personal development and his artistic maturity. His religious faith seems to have been closer to his brother John's devotion to a benevolent God immanent in nature than to his father's rigorous Calvinism, but the stern voice of duty called him to work. Even discounting an understandable filial piety in the student letters to his family from Paris, his dedication to long study and hard work is striking. He cherished "the just and severe criticism" of his master, Gérôme, at the École des Beaux-Arts. He enjoyed the spirited student life of Paris in the seventies, but he ate and drank frugally and seems to have been a notably proper Bohemian. "Parties turning night into day over nonsense," he wrote home in May of 1877, "is the reason that there are not more great persons today." "Art, as I understand it," he wrote again, "is one of the most serious of professions and one above all that necessitates sound and severe surroundings." As a boy of eighteen in New York Weir had concluded "that happiness depends mostly on knowledge and that can only be gotten by study." Five years later in Paris he concentrated on making "intellectual progress" in his work, by which he meant gaining knowledge of the precise nature of the subject to be painted and a grasp of the execution of all details. He assured his mother "that if I once thought I was working at it for the mere sake of painting a picture, regardless of study, I would recover the canvas." What he most admired in his close friend Jules Bastien-Lepage, the plein-airist, was his basic attitude toward life and work. "He is earnest and sincere," wrote Weir, "in all that he does and never tries to show his skill with his brush or in drawings but tries to get in the sentiment of the nature before him." Modesty and integrity applied to art and men alike. "I feel confident,"

wrote Weir from Madrid in 1876, "that for a nation to become strong and great in the art of painting, it must have its examples of sincerity and devotion, by which only is art led to its height." In the Louvre he was filled with wonder at the drawings of Raphael, Michelangelo, Andrea del Sarto, but what struck him especially about study of the old masters was that "they were certainly noble, hard workers and no humbug."

Robert W. Weir's letters to his son recall the strong tone of Scotch theology and propriety in the West Point household. (The elder Weir was customarily addressed by his wife as "Mister Weir.") "Try to keep yourself pure and avoid all Godlessness," wrote father to son. "I am glad that you adhere to keeping Sunday holy; sin comes on little by little, so that you must always be watchful." Not until late in life did Alden Weir permit himself to sketch on Sunday.

Linked to these moralistic and professional attitudes was a strong historical sense. Alden Weir and his brothers had spent long hours with their father in the studio on the bluffs over the Hudson analyzing hundreds of engravings and considering the rise and fall of styles in relation to general historical conditions and to the lives of the great artists. The Beaux-Arts curriculum strengthened this perspective. In the long view, flashes of current fashion seemed less brilliant and compelling. John Ferguson Weir spoke from a family viewpoint when he praised "a few quiet modest things in a wilderness of debaucheries" at the Paris Salon of 1902, highly skeptical of "this banner-flying, crowd-chattering crush." Not fashions but principles were the signs of greatness.

Yet it would be a mistake to conclude that the Weirs were independent of doctrinaire currents. Their historical sense helped offset the pulls of partisan judgments, but they subscribed vigorously to the critical theory of their day which proclaimed that drawing was absolutely prior to composition and color. Robert Weir wrote to Gérôme that a natural intuition of color relates to the great language of drawing much as sound to sense, adding force and beauty, but clearly secondary. Julian agreed, asserting that "the decadence of art begins when too much freedom is taken and drawing is neglected for color." "As for composing a picture," he confided in a letter to his brother John, "for the present I want to be as bête as an enfant of ten"; technique might destroy naiveté.

Although the indifferent compositions and the restricted palette of Weir's early paintings can be traced to these limiting theories, the most important principle of all, nature, which proved a liberating force later, was crucial for Weir's development from the very beginning. In the same

letter to John in which he dismissed composition he stated the root principle of all his best work: "To me there are no rules except those which your own feelings suggest, and he who renders nature to make one feel the sentiment of such, to me is the greatest man." His study of the masters, especially his enthusiasm for Franz Hals, confirmed his resolution to search in his painting "for the character and individuality of the thing that is before me," as he wrote from Haarlem on an early trip away from Paris. "Nature is the great man in my case," he asserted proudly, and again and again he declared that "nature and art are founded on the same principles." In Brittany and especially in Barbizon it was nature which seemed "richer than ever"; in Spain he was impatient "to get to work at nature." As a student his impatience reflected a distaste for modeling antique casts and for endless copying; nature meant any painting from life. But nature soon was identified with Weir's own countryside. To the mature artist a landscape seemed like the soul of a human being. Like all of life, nature was not to be taken in at a glance but allowed to disclose itself gradually to a knowledgeable eye.

For all Weir's delight in European scenes he remained a patriot. He enjoyed summer sketching at Dordrecht, and the English rivers held a fascination preserved in his Itchen River water colors, but he was always aware of himself as an American and judged his experience abroad from a national point of view. On his first visit to England in 1873 he reported that he had shouted on a town street "as only an American free born citizen would dare do." As a student in Paris he was quick to remark on "the good Republican ideas" of his Finnish friend, Albert Edelfelt; and he championed the Emperor of Brazil's plain style of dress and manner. The Fourth of July was always cause for special celebration; and he did not hesitate to comment on the fripperies of the French, the unpoetic solidity of the English, and the drab weight of Berlin. With his brother John, Dean of Yale's School of Fine Arts, he discussed at length the problems of American artistic development. He had many doubts but concluded enthusiastically as he left the Beaux-Arts, "We are bound to be a great art nation and hurrah! for America."

After his student days Weir's trips to Europe, generally in the summer, grew less frequent. He returned in 1878 "a better American than ever." In the eighties he shortened a three year stay to six months. And in a 1901 letter to his friend Wood he admitted, "No one was more happy to return to a place than I was to America. Europe palls on me. For some there is no place like home."

Home meant first of all family and Connecticut. Home meant also a

pleasant social milieu supported by adequate funds. Weir's Paris train-
ing had been financed by a family friend, Mrs. Bradford R. Alden (his
professional signature of J. Alden Weir marked his obligation), but his
income from painting and teaching, once established, kept pace with his
needs. If his bachelor's prosperity seemed less elastic after his marriage
to Anna Baker in 1883, combined family resources were at hand for
emergencies. He lived comfortably enough, welcoming his friends at
his New York house or more informally at the farm in Branchville (near
Ridgefield, Connecticut). Winters in town were brightened by gather-
ings at the Century Club, The Players, and with artists' groups of all
sorts. His close friends were mainly painters, men of talent and character
whose underlying seriousness is preserved in Weir's portraits of them:
Olin Warner, Wyatt Eaton, John Twachtman, Albert Pinkham Ryder.
They returned the compliment. Warner's bust of Weir was a favorite,
and John Sargent's portrait captured Weir's gentleness.

Weir committed himself to a broad professional career, working with
societies of artists, with museums and collectors and art schools to create
the conditions in which great art might flourish. Though not drawn
temperamentally to organizational life, he participated actively in the
Society of American Artists during its formative years from 1877 to 1890;
served the National Academy of Design, eventually as President; inaugu-
rated exhibitions of "The Ten" in 1898; and lent his steadily rising pres-
tige to whatever new groupings of artists tended to stimulate good work.

As a critic and connoisseur Weir's purchases for collectors and mu-
seums challenged Americans to aim high. A few superlative paintings
would set an example for all the rest. The old masters came first, of
course, and Weir was especially proud of the Rembrandt he found for
H. G. Marquand; the Manet paintings he acquired in 1881 pointed
toward a broadening of appreciation for contemporary work as well. As
a student of Gérôme Weir had naturally been skeptical of the first Im-
pressionist canvases he encountered. The Impressionist exhibition of
1877 seemed a "Chamber of Horrors" intentionally sensational. The
legs were boneless and the colors obtrusive. Weir remained critical of
the new movement's disregard for drawing until his own painting moved
in a similar direction in the nineties, but he became convinced that
Manet's paintings spoke the language of principles, not merely fashion,
a feeling confirmed by a visit to Manet in the summer of 1881. Weir felt
that sincere work deserved the support of fellow artists; the public was
inevitably timid.

American painters faced special difficulties. During the eighties and

nineties European paintings flooded United States markets, virtually destroying the patronage which American artists had enjoyed earlier. Even portrait painters were passed over in deference to fashionable Europeans. To Weir the reigning condescension toward American work indicated a provincialism as misleading as its nativist counterpart. On one occasion he publicly censured the Metropolitan Museum for its willingness "to accept any third or fourth rate painting so long as it comes from a European painter," while refusing a canvas (by Theodore Robinson) selected by "professional artists and representatives of American art."

As an art teacher for twenty years from the time of his return to New York until the success of "Ten American Painters," Weir held classes at his studio, at Cooper Union, and for several summers in Connecticut. Characteristically, he encouraged each student to develop his personal style at his own pace, offering criticism and the example of his own earnest and sincere work. Mary Cassatt commented that Weir's pupils "always are more open to advice than any others I see." In teaching as in a wide round of work in the service of American art Weir was seldom doctrinaire.

II

Today, forty years after Weir's death, his work is little known outside professional circles, his diminished reputation due in part to his modesty in life and in paint and to the shifting standards of critics and historians. The whole frame of reference which is brought to bear in any estimate of a work of art has been so enormously extended since Weir's day by the sweep of world art and through the photographs of Malraux's museum without walls that it is both difficult to frame standards and tempting to pass over individual differences in a search for schools and movements. Some four hundred fifty of Weir's oil paintings are in collections across the country, and he is represented in the holdings of nearly every major American museum, yet his personal style has been blurred under the rubric of American Impressionism when it has not been dismissed as academic or genteel. To a degree it is the familiar story of the struggle between generations, a quarrel of sons with their fathers over the values of the culture of post-Civil War America. Now that these scornful sons have become fathers themselves it may be possible to recover a part of that older America evoked by Weir's life and art.

The historiography of American art reflects a continuing rediscovery

of the American past. Weir's place in history, or better lack of place, is linked to reactions against the brownstone culture of the Gilded Age and inflated estimates of American painting by such Edwardian critics as Samuel Isham and his successor Royal Cortissoz. These reactions have been aggravated by the rise of avant garde art and by a theory of cultural organicism which excoriated the Age of Plunder and searched its garish ruins for true talent, finding it (deductively, it might seem) among "outcasts, recluses, exiles," to quote Lewis Mumford. A prime target during the nineteen twenties was the gentility of the prewar generation indicated in art on the one hand by academicism servile to European conventions, and on the other by a sugary sentimentality that confused ideals with experience. The artists and writers of the genteel tradition were accused of shying away from the realities of materialism and assenting to the sham pieties of their day. In *America's Coming of Age* (1915) and *Letters and Leadership* (1918) Van Wyck Brooks spoke for many intellectuals when he condemned the split in American culture between artists and a commercial society. Lewis Mumford derided the earlier generation for their "pragmatic acquiescence" in the spoiling of a continent, for their political corruption, their religious anesthesia, their crude pillage of the European past for loot that would be proof of "culture" but which proved only that consumption, if sufficiently conspicuous, would pass for cultivation.

Mumford's interpretation of American culture in *The Golden Day* (1926) and *The Brown Decades* (1931) pictured the artist of the post-Civil War period as generally succumbing to external pressures, betrayed by commitment to a success which demanded "submissive tutelage" in Europe and catering to a sentimental public. In a 1956 preface to *The Golden Day* Mumford renewed his thesis "that the creative minds of the Brown Decades were necessarily recluses" and that the survival of a painter like Albert Pinkham Ryder "during this period of the flashy and the sordid was a more remarkable feat, morally speaking, than the development of a Thoreau or an Alcott in the earlier New England community." In these terms success and creativity exclude each other, and the mark of integrity becomes alienation.

By way of partial revision of his earlier broadside attack Mumford proposed in his 1956 preface an appreciation of the period's "intense absorption in the local and the regional," suggesting that there may have been some smaller worlds, not all of them sold out to the flashy and the sordid. This rediscovery of the American Scene proceeds apace, and

recognition of Weir might be expected along these lines. But here his work is not sufficiently native, or better, nativist. He never parades his Americanism in the fashion of Thomas Hart Benton or Grant Wood; nor does he celebrate the American folk past or patriotic themes. The kind of implicit chauvinism which led Mumford in 1931 to dismiss Sargent and Whistler as deserters and to speak of European tutelage as servile and timid continues to obscure Weir's particular position in America's artistic dialogue with the Old World. Weir regarded such tutelage as natural. To think of any of Weir's mature work as submissive is again to subordinate his individual style to general theory, in this case to the twin myths of necessary alienation and self-tutored Americanism.

Stated this way the myths are at least suspect, but to intellectuals of the twenties Puritanism, Babbitry, and gentility seemed joined in the Opposition. For the sons to blame their fathers categorically was not surprising. Nor did the Age of the Robber Barons fare better when examined by the social conscience of the thirties. But in the years since the last war, now that the Victorians have become our grandfathers, they merit reappraisal. The Captains of Industry have been substantially rehabilitated; the political boss appears to have had unnoticed virtues; family discipline and the three R's are being revived as though they had disappeared. In many fields our ceremonious, often aloof and solemn grandparents are being reconsidered. The painters of their period deserve no less.

However, the task of historians and critics who would assay American painting before the first World War is complicated further by the rise of avant garde modernism and accompanying shifts in critics' criteria and public taste. The modern movement, most noticeably in its early stages, protested not only against academic conventions but against an entire society whose timid tastes feared freedom as anarchy. In the United States experimental work, exhibited at Stieglitz's "291" gallery and at the Armory Show of 1913, opened a sustained attack. Distorted forms and expressionistic colors challenged the prewar taste for a charm and graciousness that seemed in postwar retrospect often complacent and weak. If *The Orchid* by Weir is contrasted with Marcel Duchamp's *Nude Descending the Staircase* and Matisse's *Nasturtiums and the Dance*—all three exhibited at the Armory Show—the conflict is clear. Duchamp's fragmented, stroboscopic figure and Matisse's elongated nudes assaulted a public ideal of the American gentlewoman as sharply as their techniques exploded the academic palette and satirized academic drawing.

Like so many of the portraits of his generation Weir's girl with orchid has a quality of reverie that recalls a still life. To Weir life had moments of stillness, moments sustained by faith in a general national progress evident in American painting as well. So it seemed to Weir's contemporary, Samuel Isham, a painter trained in Paris ateliers and author of a pioneer work, *The History of American Painting*, published in 1906. Surveying the last quarter of the century Isham saw "a marvelous development of the nation in the direction of culture," most evident in the successful introduction of "higher foreign workmanship." Isham's generous treatment of scores of painters largely unknown today reflected his conviction that American painting was European painting "transplanted" and that the condition of American painting in 1906 was "sound and satisfactory," with public appreciation rising steadily. Weir came in for praise on the ease of his mature work and for landscapes which worked "roughness and unkemptness into patterns of delicate, decorative quality."

This faith in the progress of a transplanted tradition was reaffirmed by Royal Cortissoz in a 1927 supplement to a new edition of Isham's history. Concerning Weir, Cortissoz remarked "an indefinably subtle refinement" in his figures and a "wholly personal impressionism." In general Cortissoz found the "progressive movement" of American landscape painting "axiomatic," criticizing the "purely modernistic hypothesis" for its inchoate thought, crude negation, and ill-equipped self-expression. His conclusion that "the bulk of American painting is untouched by modernism" identifies a point of view that was even then under sweeping and successful attack.

In *The American Spirit in Art*, an illustrated compendium published that same year, 1927, Frank Jewett Mather, Jr. discussed the "luminism" of Robinson, Hassam, and Twachtman with only incidental reference to Weir's "idyllic" work. He did point, however, to the "irradiation" of Weir's portraits, and he speculated cryptically that after meeting Manet, Weir had tried to impart "the same quality" to his own paintings. Otherwise Mather added little to an understanding of Weir, merely repeating an older view of Weir as "a devout student of the moods of American landscape and an even more intimate interpreter of the delicacy and moral fastidiousness of American womanhood of the old stock."

Cortissoz and, to a lesser extent, Mather were engaged in rear guard actions. In 1921, two years after Weir's death, the Century Club published a volume on his life and art. In 1923 Agnes Zimmerman for the

Metropolitan Museum of Art published *An Essay Towards a Catalogue Raisonné of the Etchings, Dry-Points, and Lithographs of Julian Alden Weir,* and the following spring the Metropolitan held a memorial exhibition of Weir's work. But over the last thirty years Weir's paintings have moved from gallery walls to storerooms. Where international modernism has not dominated, only the most insistently American work has won acclaim. A 1952 Weir Centennial Exhibition at the American Academy of Arts and Letters broke a long silence but drew scant critical response. When Weir has been mentioned at all he has been labeled an American Impressionist. In 1937 the Brooklyn Museum's show, "Leaders of American Impressionism," focused on Cassatt, Hassam, Twachtman, and Weir; and John I. H. Baur's introduction to the catalogue sought to reconstruct the chronology of the movement. Relations among the four leaders remained unresolved, however, and Baur emphasized aims held in common and a "thorough affiliation with French-born impressionism."

To call Weir an impressionist is to indicate an important visual vocabulary he often used, but it is also to mislead somewhat as to the special quality of his style, a style grounded in his own life rather than in the Paris art world of the eighteen sixties and seventies. Weir is not concerned with a chromatic analysis of light; nor does he make war on academicism or aristocracy. He shares the French Impressionists' delight in the given natural world but without the pure sensationalism which Monet, for example, pushed to an extreme. If Weir's painting lacks the sense of exhilarated discovery conveyed by the Frenchmen's rainbow palette, he avoids the worship of surface which often acted to obliterate lines and objects. Weir's paintings retain the solidity of fact and a concern for what lies behind surfaces. Yet his way of seeing seems to question its own adequacy. It is as though an obligation to consider the moral condition of man in nature never quite allows Weir the sweep of pure sensuous delight given to those painters who can leave ultimate considerations to "le bon Dieu."

Nevertheless, French Impressionism has set the context for estimates of Weir in the general histories and special studies of American art which have multiplied in the last ten years. James T. Flexner's brief history (1950) when treating post-Civil War work follows the now familiar thesis of either expatriation—Whistler and Cassatt—or strong native realism— Homer and Eakins—citing LaFarge's work as demonstrating the "lesson" that foreign culture does not transplant fruitfully. Weir is not men-

tioned at all, nor Hassam, and Twachtman's "delicate version" of Parisian Impressionism is consigned to a phrase. John I. H. Baur's *Revolution and Tradition in Modern American Art* (1951) groups Weir with Twachtman, Hassam, and Robinson in a brief consideration of "light or more orthodox impressionism" indebted to pointillism rather than to the darker brushwork of the Munich tradition of Chase, Henri, and Luks. Edgar P. Richardson's excellent history, *Painting in America* (1956), raises important general questions about American conditions, and his discussion of luminism notes the quieting of a gayer French Impressionism; but Weir's work remains unidentified, its special qualities obscured in an inevitably encyclopedic survey. Nor is an understanding of Weir's style conveyed by Wolfgang Born in his studies of *American Still-life Painting* (1947) and *American Landscape Painting* (1948), perhaps because of a genre approach that tends, in Weir's case, to classify on the basis of a very few examples.

More rewarding is Oliver W. Larkin's discussion in *Art and Life in America* (1949). As a historian of culture Larkin sets Weir in the frame of his times with sensitivity and insight. He notes the "quiet unforced landscapes" of Weir's late years, his "quiet probity," the "Scotch thoroughness" which "gave the Weir brothers a grip on palpable truth," and their "characteristically modest" use of the new language of Impressionism. Larkin was necessarily brief but added, "One would like to know more of this man who never bragged in paint and who so often seems aloof from the personality or the scene before him."

The best critical account of Weir's work remains Duncan Phillips' essay written for the Century Club memorial volume in a mood of gentle retrospection rather than in the excitement of new discovery appealing to modern sensibility. The man, his work, and his moment are kept together in a lucid analysis of Weir's "reticent idealism," the "unconscious austerity" of a style of painting which matched a style of life.

III

There are several aspects of this work which merit special mention for their uniqueness or for new light thrown on events, personalities, and historical styles of art and life. We are presented with the story at first hand of an artistic milieu previously unrecorded, if exception is made of the rambling reminiscences of Will H. Low and Edward Simmons. Especially notable is Weir's detailed correspondence from Paris for the years 1873 through 1877, allowed to tell its own story, the story

of an American student's reactions to atelier training in the early years of Beaux-Arts eminence in American art. Most of the letters are written to his father and brother, both painters interested in specific judgments and representing artistic experiences related but dissimilar. The narrative of Weir's American years brings to light his friendships with Sargent and Whistler as well as new records of the personal and artistic relations among Weir, Twachtman, Robinson, and Hassam in their Impressionist explorations. The correspondence of Albert Pinkham Ryder with Weir adds to our knowledge of Ryder and qualifies the familiar theory of Ryder's alienation from American life. The narrative of Weir's last twenty years includes an extensive correspondence with Charles Erskine Scott Wood, poet, lawyer, Indian fighter, and connoisseur, an ebullient figure who deserves a biography in his own right. It was Wood who summed up Weir's situation so justly in a 1902 letter: "I still insist you are the most fortunate man I know. Enough to keep the wolf from the door, a clear conscience to keep ghosts from the window. Loving and lovely children, a sympathetic wife and an occupation which is always coaxing you, not driving you."

For any appraisal of Weir's art as a whole, Mrs. Young's analysis of his stylistic development is important. She was an artist herself, as was her husband Mahonri Young; and she has reviewed all her father's work, distinguishing three broad phases: academic (1874–90), experimental-Impressionist (1890–98), and a final mature period (1898–1919). Weir's style pivoted on problems of light. He seems to have been searching for tonalities to infuse the whole with his special sense of life. Light is the vitalizing element in his best paintings and perhaps for that reason the most unstable.

At first Weir followed the academic rules instilled by Gérôme and confirmed by the taste of the day in New York—careful, precise drawing and modeling, dark tones, smooth brushwork, and an emphasis on studio portraits. By 1890 his dark palette had lightened dramatically, especially in the landscapes to which he now gave most attention. A transitional hazy light lifted rapidly into the clearer atmosphere of a long series of Connecticut countrysides, painted with vigorous, clear brush strokes.

Weir's work of the nineties was animated by the excitement of experiment in many mediums: etching, engraving, lithography, pencil and ink drawing, pastels, water colors, even murals for the Chicago Exposition and stained glass for a church memorial, and of course oils. Landscapes, many of them with figures, were his special delight as he turned whole-

heartedly to nature. His studio work in the eighties had seemed difficult and arduous; in his new style Weir felt more at ease. In 1891 he wrote his brother John, who had been shocked by his recent work, "My eyes, I feel, have been opened to a big truth; and whether or not I can develop . . . I know not; but one thing I do know is that painting has a greater charm to me than ever before and I feel that I can enjoy studying any phase of nature, which before I had restricted to preconceived notions of what it ought to be. I do not say that I am right, but I do say that if nature and art have greater charm to me owing to my 'hypnotism' as one of the papers calls it, then I cannot be far wrong, my art is my life."

That Weir's new style was clearly his own was nowhere more evident than at a joint showing in the spring of 1893 with Twachtman and the two French Impressionists, Monet and Besnard. The French work had a flamboyance, a "splendid, barbaric" color, as one critic commented, contrasting sharply with the more delicate, muted range of the Americans whose greens and blues tended toward silver. Yet to those familiar with Weir's earlier work his new departure seemed more like consistent progress than an abrupt break. As the perceptive Clarence Cook remarked, "What he loved in the beginning he loves today."

Weir's shift from his accustomed style brought poor sales and critical abuse. His public reputation reached a low mark in the nineties as his own sense of growth increased. "If this is how nature really looks to some people," exclaimed a Boston critic, "there must be something wrong with their eyes."

With the shows of "Ten American Painters," beginning in 1898, Weir entered his period of mature work. He painted now with a hard-won confidence in a style that set him apart. He saw pictures on every side, in the city at night, around a campfire, in the winter woods. In fact he was an "American Scene" painter without knowing it. In his palette he avoided the extreme tonalities of both earlier periods. His brushwork was often loose but always controlled, the over-all feeling one of moderation and restraint. In his best work Weir achieved an intensity all the more moving for a quiet beauty that catches one almost unaware, as though it could not be taken in at a glance but demanded a shift in mood, a slowing down for a long look. Weir's brush offers no quick intimacies; it suggests rather the essential privacy of beauty.

The paintings of Weir's mature years were successful among fellow artists and a growing group of patrons. He won honors and prizes consistently, sold enough to live comfortably, and set his own pace and stan-

dards. But his work was never widely popular. It neither accommodated the prevailing taste nor won notoriety by flaunting. To a public which wanted photographic realism and meticulous finish he offered neither. Ignoring the taste for grand scale Weir painted intimate scenes, yet they were seldom sentimental or picturesque, the popular kinds of intimacy. He painted no historical or military subjects, and his sporting scenes were confined to his own beloved dogs and an occasional hunting or fishing party familiar to his family and friends. He avoided anecdotal or literary themes. Except for necessary portraits and some early still life requests, he was his own master and stubbornly independent of the market. His style changed rapidly enough to unsettle the critics and the public, especially during the nineties, yet without fanfare or manifestoes or the reassuring presence of shocked bourgeoisie. Weir urged no aesthetic dogmas, wrote very little about his own work, and avoided both the stasis of academicism and the orthodoxy of revolution. In short, Weir had no taste for self-promotion either in his own time or with an eye on posterity. Integrity was its own justification.

William Dean Howells, the leading man of letters of his time, was some fifteen years older than Weir, but their experiences show many parallels. Howells died in 1920, a year after Weir, and both men could look back on full, peaceful lives. In a sense both Weir and Howells were transitional figures between the world of Thomas Cole and Ralph Waldo Emerson on the one hand, and the worlds of John Marin and Ernest Hemingway on the other. But the age of Howells and Weir was more than transitional; the two men embodied ideals which are part of their grandchildren's encounter with the past.

The easy, natural pace of Howells' boyhood in an Ohio river town in the eighteen forties and fifties gave him a taste, much like Weir's, for the normal, simple pleasures of country life. Weir's sense of Hudson summers never left him; Howells remembered a friendly, sunny community with "Saturdays spread over half the week." Recalling pleasant childhoods, both Howells and Weir enjoyed and loved their own children and the mothers who managed them, even though illness and death brought sorrow to them both. Toward girlhood and womanhood Weir and Howells felt a respect which it would be difficult to exaggerate. The American girl was more than a sentimentalized heroine; she was romanticized, surely, but she existed, too. At her best she stood for nobility, purity, and the virtues of grace and beauty, the ideals and amenities which seemed nearly able to transform life into its "smiling aspects."

If she seems sugary in retrospect, too good to be true, she stood for an ideal at the center of the comfortable family life of Weir, Howells, and many of their friends.

Weir and Howells agreed that grace, not shock or brutality, opened one's eyes to beauty. Howells' grandniece might plead for a virile literature, "very strong, don't you know; and masterful; and relentless; and makes you feel as if somebody had taken you by the throat; and shakes you up, awfully; and seems to throw you into the air, and trample you underfoot." Howells' reply would have suited Weir: "I hope I'm a gentleman even when I'm writing a novel." This was in 1906.

The ideal of the gentleman artist included for both Howells and Weir a moral and professional seriousness that urged sighting high and working hard. Howells wrote, as Weir painted, with a strong sense of craft and a responsible attitude toward fellow professionals and the organizations which provided forum and market. Both men gave generously in time and support to younger artists and new ideas, at the same time insisting on training and traditions. Howells recalled the "richly satisfactory" experience of his youthful apprenticeship among Boston's literary Brahmins in the sixties. Their cosmopolitan culture (further broadened by his consulship in Venice) gave Howells the kind of perspective that Weir's years in Paris provided the painter.

Neither Weir nor Howells hesitated to criticize America, but they held a deep faith in American possibilities. Howells believed Americans to be "a people so much purer and nobler and truer than any other" that he remained fundamentally optimistic in the face of marked social injustice. Weir seems to have had little social consciousness; few artists of his day did. They felt it sufficiently important to reverence the beauties of everyday life.

What Weir represents, in company with Howells, is a significant moment of confidence in the development of America as a land in which to live and create. Weir assumed that this confidence was shared widely enough for him to paint with an intimacy that would be understood, with a reticence that would be received as appropriate and no less intense for its lack of an easy flamboyance. Mrs. Young's biography and Weir's best work remind us that personal expression need not be obscure and that the noise of avant garde revolutions may lead to a confusion of excitement with beauty and to the equation of art with tension and protest.

To experience Weir's *Christmas Tree* or *Visiting Neighbors* is to

encounter a sensibility across a historical divide that seems much wider than it is. At its widest the division is between a rural, largely homogeneous, insular America of strongly New England values (the South excepted) and a metropolitan culture geared to rapid motion, mass markets, and international tensions. It is often difficult not to judge Weir's round of life complacent, but this is to deny a part of our past and ourselves under the pressure of contemporary attitudes. Weir's love of a commonplace, natural world, a private life, and a modest art cannot be dismissed as nostalgia in an age of forced social consciousness and agonized sensibilities. *Visiting Neighbors,* as Duncan Phillips puts it perfectly, "is first and last just a vivid glimpse of the real world at Branchville, Connecticut, and of a little girl who had a good time with that particular donkey, and who used to tie it to that particular rustic fence which her daddy had noticed took on just that grayish violet tone at that hour of the sunflecked green midday." Dorothy Weir Young's faithful biography invites us to revisit Weir's paintings and reminds us, properly, of Weir's wonder at "what a beautiful world it is."

Mrs. Young's manuscript represents some forty years of recording and research begun during her father's lifetime and ended only by her death in 1947. In editing her narrative I have been guided by her clear emphases and detailed record. In the case of her father's letters, Mrs. Young tended to correct gaps in punctuation and remedy indiscreet usages; I have restored the text to reproduce Weir's own style, on the basis of the very few originals available and the typed transcripts made by Mrs. Young. Although date lines on the letters have been regularized, emendations have been made elsewhere only in the scattered instances where a passage was not clear. For convenience all titles of paintings have been set in italics. A complete list of persons mentioned in the letters, giving full names, is provided by the index; footnotes are reserved primarily for persons and events figuring in the narrative.

LAWRENCE W. CHISOLM

May 1960
New Haven, Connecticut

THE LIFE AND LETTERS
OF
J. ALDEN WEIR

CHAPTER 1. WEST POINT
BOYHOOD, 1852-73

JULIAN Alden Weir grew up in the highlands of the Hudson Valley, and the world of nature remained at the center of his art and his life. The woods on a frosty dawn, the fields in the hot July sun, these shaped the challenge for his painting—the challenge to render "the mystery that it all is." The road from the valley of the Hudson to the rolling hills of Connecticut, where he finally settled, led him through Paris and London, Brittany, the Low Countries, and Spain; and his professional life centered in the city of New York. But his heart was bound up with the quiet rhythms of the land, with his family and his friends.

From the beginning his family offered every encouragement to his career as a painter. There was evidently never a question of anything else. Julian loved to draw and paint; his older brother and closest friend, John Ferguson Weir, was an artist and teacher; and most important, his father, Robert W. Weir, was prominent in American art circles first as a painter and academician and then as a teacher of drawing at the United States Military Academy. Julian, born at West Point August 30, 1852, the fourteenth of sixteen children, was a favorite of his father; and the pattern of the elder Weir's career provided a model of diligent training, professional responsibility, and a settled and sufficient family life. Robert Weir was nearly fifty years older than his youngest son. The art world in which he developed in the eighteen twenties and thirties was substantially different from the milieu of the seventies and eighties in which his son Julian developed; but his progress to his final studio in the family house high up on the plateau of West Point sets a frame for the portrait of his son.

Julian's father was born in 1803 in New York City, the son of a Scottish shipping merchant, Robert Weir, who came to the United States in 1795, and Mary Katherine Brinckley of Philadelphia. As business prospered the Weirs moved to a pleasant country home in New Rochelle with grounds sloping down to Long Island Sound. But before

long disaster struck. In 1813 the French seized several of Weir's cargoes. He was forced into bankruptcy, and in one year all his property went to satisfy creditors. As a result Robert W. Weir, age ten, was taken out of school and put to work at a spinning jenny in a cotton factory.

For the next seven years he worked in mills and offices, getting what schooling he could at intervals, living for a while with an uncle in Albany, and finally at seventeen settling in New York determined to become a professional artist. He had always loved to draw (a caricature had cost him his first mill job), but his final decision he ascribed to reading Dryden's translation of Du Fresnoy's *De Arte Graphica*. "I read it with enthusiastic delight; every word sank deep within me and caused tears of joy and shouts of ecstasy to escape at every page; my soul swelled with pure zeal for the art, and when I finished, I felt better and happier and resolved to be a painter."[1] His father at first tried to dissuade him from such an idea; but finding his son determined, he ended by promising to help in every way possible.

In 1820 opportunities to study painting in New York were almost nonexistent. The American Academy of Fine Arts, organized in 1816, was housed in a long building formerly an almshouse on Chambers Street in the rear of City Hall Park, and it supposedly ran an art school. But "As for instruction or advice given to the student," Robert Weir reported, "such a thing did not exist. Mr. Trumbull, who was president, was never there. I used to go at dawn . . . and work all day. Sometimes for weeks I would be alone there. To explain how little art was a vocation then, I may state that in 1820 you could buy neither colors nor canvas. One single apothecary shop in Chatham Street kept artists' materials."

Robert Weir worked hard, largely self-taught, drawing continually and studying anatomy and Italian in hopes of a chance for training abroad. At last his work atracted the attention of Henry Carey,[2] a wealthy art patron who offered generous assistance. And in December 1824 Robert Weir set sail for Europe, landing in Leghorn after "a tedious passage of sixty days." He proceeded to Florence where the works of the old masters were a complete revelation, and he settled down to "the drudgery of studying with the greatest care and precision."

[1] These and subsequent recollections quoted below follow R. W. Weir's autobiographical sketch in William Dunlap, *A History of The Rise and Progress of The Arts of Design in The United States*, 1834 (New edition, Boston, C. Goodspeed, 1918), *3*, 176ff.
[2] Henry Carey (1793–1879), publisher, economist; he married a sister of Charles Robert Leslie (1794–1859), a painter who preceded Robert W. Weir as instructor of drawing at West Point in 1833.

After a year in Florence spent studying frescoes under Benvenuti,[3] copying in the galleries, and working on several of his own commissions, he turned South. "My face was set towards Rome," he recalled, "and my heart many leagues in advance."

In Rome at last his fondest dreams were realized. Here he found his friend Horatio Greenough, and they took rooms together in a house on the Pincian Hill "opposite to that which had been occupied by Claude Lorraine, and between those known as Salvator Rosa's and Nicolo Poussin's . . . in the midst of such, to us 'holy ground' our enthusiasm was not a little excited. There we set ourselves most industriously to work."

Now began an idyllic period such as only the combination of youth, enthusiasm, and an unquenchable love of art could give. There were long delightful days working in the school or wandering through the galleries and "after supper, all the artists met at a place called the Greek Coffee-House, where we had our coffee and chatted until seven; at which hour the life-schools opened and we separated, some to the French or Italian, and Greenough and myself to the English; where we studied from the life until nine o'clock; and then, if the night proved fine and the moon shone bright, we formed small parties to go and dream among the ruins of Imperial Rome. This formed our round of daily occupation; we lived and moved in art."

Greenough's poor health brought the idyll to an end, however, and in 1827 Robert Weir took his friend back to the United States and opened his own studio in New York City, turning his attention to the difficult task of earning his living as an artist. It was heartbreaking work, but he refused to be daunted and "painted everything and anything, dogs, hunting scenes, portraits, landscapes." In one way or another he managed to earn enough to live on and to make a name for himself among artists, for not long after his return from Europe he made his debut on the walls of the National Academy of Design with a landscape entitled *View at Belleville*. In 1828 he was made an associate academician, and at the next annual meeting he was elected a full academician.

The year 1829 was an important one in Robert Weir's career, for a few weeks after his election to the Academy he married Louisa Ferguson, the daughter of John Ferguson, who had at one time been mayor of New York; and in December he started his first teaching assignment when the Academy appointed him professor of perspective; "a grand

[3] Pietro Benvenuti (1769–1844), Italian painter then working on frescoes of Hercules in the Pitti Palace.

title," he observed dryly, "full of honor, but not in the least remunerative." The struggling young society "had a room over a tailor's shop at the corner of Reid and Broadway and could hardly pay the rent. One year two or three of us—Mr. Durand and Mr. Cummings[4] were of the number—had to make up the amount out of our own rather empty pockets."

New York was delightful, especially for its wealth of congenial friends, writers like Washington Irving and Fitz-Greene Halleck, as well as a lively group of painters. But when Robert Weir was offered the vacant professorship of drawing at the United States Military Academy, it must have seemed providential. He hàd two small children, another child was expected, and things were none too easy. A settled professorship with time for himself in which to paint solved many problems. He moved his family to West Point on May 10, 1834. It was to be his home for the next forty-three years.

West Point was somewhat remote after Rome and New York, and there was some cleavage between military and civilians; but Robert Weir had his professional work, his wide interest in art history, a burgeoning family, and a group of congenial friends at the Point and scattered through the Valley. Washington Irving lived down the river at Tarrytown, sitting for his portrait at Sunnyside. John Bigelow[5] had a house at nearby Highland Falls. And here, too, William Cullen Bryant used to come for the summer. Above all there was Gouverneur Kemble, known as "Gov," who lived across the river at Cold Spring. Kemble was the original proprietor of the West Point Foundry, suppliers of government cannon. He was a wealthy bachelor and an ardent art patron. His collection, extensive and famous in its day, included paintings by both old masters and contemporaries. Kemble was an unrivaled host in the best traditional Hudson manner and was noted for his delightful bachelor dinners held regularly for over forty years.

It was Robert Weir's passion for his profession, however, that completely absorbed him; and all the time not needed for his teaching was spent painting in his studio. His interest in art was unusually catholic. He painted portraits, historical scenes, genre, landscapes, occasional altar pieces, made numerous illustrations for books, etched; and the work for which he is best known is a mural, *Embarkation of the Pilgrims,* painted in 1843 as one of the historical series for the Rotunda in

[4] Asher B. Durand and Thomas Seir Cummings were both founders of the National Academy.
[5] John Bigelow (1817–1911), editor, author, diplomat.

the Capitol at Washington. He had an unusually strong interest in the great work of the past as well as an eye for all that was going on in the art world of his day. Although most of his life was spent far from any artistic center, he kept himself well informed on every aspect of art. As far back as his student days he had begun collecting prints, books, and drawings; and as his taste and knowledge matured, the collection grew until it became an education in itself. In the days before public galleries and art libraries, before photographs and easy reproductions, Robert Weir's collections, particularly the engravings of old masters and contemporaries, gave his artist sons John and Julian a rare background. Many long evenings were spent poring over Raphael and Rembrandt, Rubens and Reynolds, Breughel, Dürer, and Constable as well as works by such Hudson River men as Thomas Cole and Asher B. Durand.

Robert Weir's passions for painting and art history converged in his studio—or painting room as it was always called—located in a specially built extension at the west side of his house overlooking the Hudson. To his sons it was a never failing source of wonder with its large north window and high ceiling, and its promise of the great world beyond. At a time when flamboyant taste was flourishing, entering this huge room filled with its treasures must have seemed like stepping into a foreign and romantic past. Its walls, high up to the ceiling, were covered with paintings, framed and unframed, while leaning against them, often hiding the pictures beneath, were stacked canvases of all sizes, some large enough to have covered the wall of an ordinary room. On one side stood a tremendous, heavily carved old oak cabinet, which had been given to Robert Weir years before by his friend Régis Gignoux, Inness' old teacher. Facing it was an old deal cabinet, made by the local carpenter expressly to hold etchings and prints; and on every available surface stood plaster casts, wooden manikins, and bottles of oil and varnish, in profuse confusion. Bits of armor, old halberds and swords were hung on the walls or leaned against the furniture, while in the corners of the room were stored dozens of portfolios containing the drawings and sketches of years. In the center of the room stood a high, old-fashioned easel, with a rod along the top on which could be hung a curtain if the artist wished to draw it dramatically to one side to show the painting beneath. There were also a model stand, painting stands, a set of Elizabethan turned chairs that Robert Weir had found in Plymouth when getting material for his Embarkation picture, and a roundabout

chair in which he himself always sat. The whole effect was striking, and even as late as 1871 a New York newspaper correspondent wrote of it as "something like an old chapel,—a rare retreat in this land of novelties."

The house itself was built of cut granite with sandstone trim in a simple style, and its interior reflected varied and discerning tastes. There was delicate early American mahogany, an occasional fine piece from Europe, and of course other furniture in the current style added for comfort or convenience, while pictures hung everywhere, on every available wall space. The effect of the whole was an air of culture and good taste not common in the America of that day and unique indeed in an army post.

The house was ruled with a firm hand by "Mr. Weir," as his wife addressed him customarily, and proprieties were carefully observed. He had very definite ideas of a woman's place in the world. For instance, he refused to let one of his daughters study art even after she was a grown woman; it was not what he considered fitting for a girl. His children all loved and admired him but they also feared him, and his authority as patriarch was absolute.

Robert Weir was a deeply religious man, and this was reflected in the whole family life. His was not a creed set apart from everyday life, but a living thing that entered into his every act and deed in a way that is not known to today's generation. It showed itself in the subjects he chose for his paintings, the books on his library shelves, in his daily conversation and letters and, above all, in the way he brought his children up. Though he had left the Presbyterian church of his youth to become an Episcopalian, there was always a stern strain of Calvinism running through his veins, no doubt inherited from his Scottish ancestors. He held definite opinions of right and wrong, and his ideas on the Second Commandment were inexorable. Sunday was not a day like other days, but one to be set aside for the worship of God; no games, amusements, or work were allowed, and even reading was chosen with the Sabbath in mind. Every day the whole family assembled in the painting room for morning and evening prayers, and one of Julian's earliest recollections was connected with these gatherings. The room had one particularly comfortable chair which each child coveted; there was always a scramble among them as to who would be the lucky one to get it. In this the small Julian, being the youngest boy, was never successful; but at last one night victory was his. Alas, that triumph was all too brief; the chair was so comfortable that he fell asleep among its cushions and after

that indiscretion was forbidden to enjoy it again. Another family legend is that Robert Weir always counted the children when they got upstairs at night, and one night Julian was missing; he was found, still on his knees, asleep in the studio.

In 1845, eleven years after settling at West Point, Robert Weir's wife, Louisa, died, leaving a family of nine children to be cared for. When he was searching for a suitable person to look after them, a mutual friend suggested Susan Martha Bayard. Susan was the daughter of Lewis Pintard Bayard, an Episcopal clergyman, the first rector of St. Clement's Church, on Amity Street in New York City, which had been built expressly for him by one of his cousins. In 1813 Lewis Bayard had married Cornelia Matilda Rhea; and Susan, born on August 6, 1817, was one of their eight children. Lewis Bayard sailed on a pilgrimage to the Holy Land in 1840, but died at sea on his way home and was buried at Malta. His death left his family very badly off financially, and Susan had taught school before coming to look after the little Weirs at West Point. There she proved herself so indispensable that on July 15, 1846, she and Robert were married and before long a new family of seven more children was growing up, making a total of sixteen. Two of Louisa's and one of Susan's children, her first, died in infancy; but it was no small number to feed and clothe, even for those days.

The household perched above the broad sweep of the Hudson was filled with the life of people coming and going and the series of emergencies that go with growing up. But by the time of Julian's birth the older set of children were beginning to leave home, the boys to seek their various fortunes, the girls to marry. In fact, a few weeks before Julian was born his eldest sister, Louisa, married Truman Seymour,[6] Robert Weir's assistant in the art department. As the youngest son, Julian was a special favorite of his father and reportedly the only one of the children who was not afraid of him. Except for the strictly enforced Sabbath Julian was free to explore the mysteries of his father's studio and more often to roam the countryside he grew to love.

During Julian's childhood in the fifties and sixties few signs of civilization were to be seen as one looked out from the Point. Most of the houses built along the shore were hidden by trees, and except for river traffic, much greater then than it is today, the scene was little changed from what met Hendrick Hudson's eyes when he sailed up the river in

[6] General Truman Seymour (1824–91), West Point '46, taught drawing 1850–53, retired from the Army in 1876, and settled with Louisa in Florence.

search of a Northwest Passage in 1609. There still lingered a trace of
that fascinating veil of romance that Washington Irving had cast over
the highlands and their neighboring Catskills with his tales of the deeds
—ghostly or otherwise—of the early Dutch settlers. And stories of In-
dians and of Revolutionary battles still seemed firsthand accounts. All
these combined to create an atmosphere to stir the imagination of a
young and ardent nature.

Julian came to know the region around West Point intimately in the
course of long walks and rambles over its hills and valleys, from his
first exciting hunts for "Indians" down through the time when he was
old enough to be trusted with a gun and could go off shooting squirrels.
He often rose before dawn to go hunting or fishing, for the peace and
freshness of early morning held a particular fascination for him; and
later he put those impressions on canvas again and again.

Perhaps what stands out in greatest contrast between the childhood
Julian and his brothers and sisters enjoyed and that of children living
the more complicated existence of today was the slow tempo at which
their lives were lived. It gave them time to know themselves as well as
their surroundings. Aside from lessons and a certain amount of family
discipline and chores assigned to each one, they were their own masters
and had to rely entirely on their own resources for what they got out of
life, which they did most successfully. Their childhood differed little
from that of youngsters in the eighteenth century. Children were taken
casually, and possibly at West Point they were allowed a trifle more free-
dom than elsewhere from the added sense of security that the presence
of the military must have given their parents.

Each year the never-ending cycle of the seasons brought its own wel-
come variety. Partridges, quail, and woodcock were plentiful, and hunt-
ing in the fall and winter months was one of the young Weirs' favorite
diversions, particularly as it furnished an excuse to be out of doors,
tramping through the fallen leaves in crisp, bracing weather. In sum-
mer they went swimming, usually in the river, where they were cau-
tioned against going out to Gee's Point, the actual tip of West Point, the
swiftest and deepest part of the Hudson. At other times they went out
beyond the mill pond, near the soldiers' vegetable gardens, where a
cascade of water fell into a deep, cool pool, a most refreshing place to
bathe on a hot day, or down to "Washington's Valley" where the water
from the cascade ran to empty into the Hudson.

It was Isaak Walton's gentle art of angling, however, that lay closest

to Julian's heart as a boy and throughout his life. Its fascination was not only in the number or the size of the fish added to the string—though that was never to be scorned or taken lightly; the pleasure lay far deeper, in the delight of just being out of doors in the first spring days, wandering along the banks of streams still swollen from the winter thaws, or casting a fly over a quiet pool shaded by hemlock trees; or again sitting motionless in a boat for hours, under a hot July sun, waiting patiently for a bite, but never too much occupied to miss such important things as a changing effect of clouds or the way the sun slanted under the trees or the notes of the wood thrush on the evening air; these were all part of the joys of fishing. As a boy at West Point Julian knew by heart every fishing possibility within walking distance of his home, beginning with the Hudson itself, where they fished for shad or tommy cod off some rocks near the old Riding Academy. There were also numberless ponds and streams in the back country where the wily trout or fat bass were waiting to be caught, and sometimes they would build small stone ovens and cook and eat their fish there on the spot. Not only was fishing fun, fish made a welcome change in a diet not so varied then as now.

In the fall there were the delights of nutting, for during those crisp autumn days when the first frost brought the nuts tumbling down, out where the Eagle Valley Road ran down to Buttermilk Falls, chestnuts, hickory nuts, and butternuts were to be found in profusion. The children had to be early in the field, because to their despair their rivals, the cadets, used to be out to gather pillowcases full.

As winter approached, the first fall of snow was eagerly watched for; and when the sky clouded over and it began to look like a storm, they would rush hopefully to their mother, who was blessed with some unusually useful kind of neuralgia, to find out if "she felt snow in her head yet." When the snow did come, the coasting in that hilly town was superb. And skating, one of Julian's favorite sports, was equally good. They skated on the river, which was often full of dangerous air holes, hard to distinguish from the black ice. The wind would howl down from the north, chilling the very marrow of their bones, but on they would go for endless miles up the river to Cold Spring and sometimes even to Cornwall. In addition good skating was to be had on the reservoir toward "Fort Put," and they also skated on the "flats" which ran along the bank and flooded over and froze up in winter time.[7] There were winters when the river froze so solidly that one could drive a horse and sleigh across

[7] These have been filled in for the West Shore Railroad to run over.

to Cold Spring; but sleighing was not a frequent pastime, as Dr. French, the chaplain, was the only person at the Point who kept a horse, and horses were hired from the stable when necessary to get somewhere, not often merely for the pleasure of the drive.

In the evening the family gathered together around the lamp to read or talk or sew, or the boys and girls met at each other's houses and played games or sang. Julian would recall with nostalgia in later years how on winter nights before they went to bed "one of the boys," as he put it (although his sister Carrie dryly added: "It was generally Julian"), would disappear into the cold north pantry and dive into the barrels, to return laden with apples and nuts for a feast before they all retired.

Long winter evenings gave them plenty of time for reading, and Washington Irving's tales and histories and the novels of Sir Walter Scott fired their imaginations with stories of high romance, of beautiful ladies and brave knights. Shakespeare they read, not in school but at home, as something to be enjoyed in itself and which really entered into their everyday experience. Julian loved to quote Shakespeare all his life; his descriptions of landscape he particularly delighted in, and lines such as "Full many a glorious morning have I seen" and "How soft the moonlight lies on yonder bank" expressed for him, as well as for Shakespeare, exactly how a place would look at a certain moment. When he was sixteen, in a letter to his brother John, who was traveling in England, Julian charged him to "make sketches of every grand place of note, such as Shakespeare's tomb, etc." It is hard to imagine any boy of today caring very much how Shakespeare's tomb looks, but one must remember that in those days photographs were still comparatively scarce. Julian was not an omnivorous reader, but he never cared for trash, and when as a young man he began to buy books for himself he chose almost always from the classics, preferring Milton and Dante to fashionable writers.

It seems rather surprising that in spite of Julian's ardent patriotism, intensified by his upbringing in a military academy, the Civil War made no lasting impression on him. Perhaps he was too young. West Point, of course, was deeply involved, for the Military Academy was the alma mater of both Southern and Northern officers; and all five of Julian's older brothers and his two brothers-in-law, General Seymour and General Casey,[8] served with the northern forces.

[8] Thomas Lincoln Casey (1831–96), West Point '52, taught engineering at the Military Academy 1854–59, during which time he married Emma Weir. In 1888 Casey became Chief of Engineers, U. S. Army.

Only a few of Julian's boyhood letters remain, all written to his brother John, but they throw light on some of his interests and occupations. In January 1869 he wrote:

I took a walk this afternoon, up to the Magazine, and the scenery was magnificent; the air was just like spring. Tonight the moon is shining gorgeously, it is about three quarters full, and it is almost as plain as day out. From where I am sitting—in the painting room—with the gas burning bright, I can see the stars shining, out of the large window facing north. . . . I went skating yesterday on the flats and enjoyed myself very much. I am going to keep chickens by way of amusement, if I can succeed in getting a chicken coop built. . . . After school this afternoon I went out to try and get some game for Mr. French, but did not succeed. . . . I have been taking lessons on the guitar again, and have almost succeeded in learning a piece.

The social life at the Point in those days was unpretentious. Entertaining, particularly for the children, was simplicity itself. There were frequent picnics in the summertime, when they would build a fire and cook their supper; and one of the most popular spots was an old quarry outside of the North Gate. Or they would make molasses candy and have a candy pull. On winter Saturday nights band concerts were held in the Library. Everbody dressed up in his best, and the band played Von Suppé's "The Poet and the Peasant." But in 1869 Julian complained to John that the winter had been a very dull one.

The children received a good general education in mathematics, Latin, history, and all the regular studies considered necessary at the time. Julian, however, was not this sort of student; learning out of books was always a struggle for him and never really held his attention. There is a story that he enjoyed recalling how one day his father, meeting Mr. Keep,[9] the teacher of the one-room school, stopped to inquire into the progress of his three sons. "Well," said Mr. Keep, "Willie is doing excellent work in mathematics, Charlie is getting along nicely with his history, and Julian—well Julian is a good observer." That was as far as Mr. Keep felt he could go; but for a potential artist this was more valuable than book learning.

Julian's real education, in art, went on around him every day of his life. No one can remember when he first commenced to paint; he began at so early an age that it was always taken for granted. But his

[9] Robert Porter Keep (1844–1904), Yale '65, taught at West Point before receiving a Ph.D. from Yale in 1869. He was American consul in Piraeus until 1871, conducted research in Europe until 1874, and returned to the United States to pursue a teaching career, notably in Norwich, Conn. Keep was a scholar of Greek and a man of wide interests in music and the visual arts.

letters to John in 1869 show how constantly even then, as a boy of six-teen, his mind dwelt on art and all that concerned it.

"Yesterday I painted all the morning on Father's portrait, but don't seem to get along with it very fast." "Father has changed the picture of Mary and Joseph at the cross of our Saviour very much, he has put another ladder and has changed the drapery and lightened the picture, very much to its improvement." "Try and get photographs of the pictures of the old masters if you can, so when you come back you can point out the beau-ties of them to we ignorant ones." "I am painting another one of those plagued views of 'Up the River' for Mr. Cozzens so that I can get some money to go up to Vermont with Scott."[1] "Father is painting several small views of the Hudson, one is very pretty, much prettier than the rest; it is a twilight scene, the furthest hill has a purplish mist over it which is very pretty."

A small red commonplace book, inscribed "Julian A. Weir, West Point N.Y. Aug. 29th. 1871," shows how eager Julian was to become thoroughly conversant with his chosen profession, on the intellectual as well as the material side. The book is filled with passages taken from many sources, neatly copied out in ink and carefully indexed. The book begins with two pages from Du Fresnoy's *Art of Painting,* the book that had so impressed young Robert Weir, and there follow notations from Eastlake, Ruskin, Northcote's *Life of Reynolds,* etc., on such topics as "commencing a picture," "glazing," "laying a ground," etc. He has cop-ied out four pages describing Hogarth's short method of acquiring knowledge—that must have sounded particularly alluring!—and there is an observation of his own on methods used in a Veronese copy of *Christ Disputing in the Temple* that was owned by Gouverneur Kemble. Several maxims were jotted down for future incentive; and on the fly-leaf Julian noted:

> Of all vain fools with coxcomb talents curst
> Bad Painters and bad Poets are the worst.

To this he added an injuction, "Nulla dies sine linea," while the same page bears a faint sketch in outline of an extensive view up the Hudson under which is written: "From the top of Cro'Nest, Sept. 3, 1871."

When John left West Point, Julian took over his bedroom as a studio of sorts; but this was on the third floor and in summer became uncom-fortably hot. So when a new woodshed was needed, Robert Weir had a little room made in the shed, with a slide window in it. Julian jubilantly

[1] Julian Scott (1846–1901), painter of army life. Cozzens was the manager of the West Point Hotel.

announced to John, "I expect to use [it] as a studio in the summer when it will be too warm to work outdoors." How exciting is must have been to have a studio to work in that he could really call his own, and how it must have stimulated his secret dreams and ambitions. As a boy Julian always went on the assumption that portrait painting was to be his métier; and now with his own studio he began to paint his first portraits, getting his family and friends to pose for him. There was "old Bentz" as he was always called, the Bugler, a West Point hourly institution; and Piano, another member of the military band; a deaf boy named Eiseman; and Swing, their old gardner.

Painting at home was a delight, and his father's advice instructive, but as Julian grew older more extensive training was in order. Accordingly, on winter visits to New York, the first probably in 1867–68, he studied in the school of the National Academy of Design. During his brother John's European trip of 1869 Julian shared John's New York studio. And it was during these years that he first came to know Albert P. Ryder and William M. Chase, who began studies at the Academy School in 1868 and 1869 respectively.

Julian was back in New York in 1871 studying hard, as reflected in a December letter to his father.

This week has gone by without my writing home. I don't seem to be able to find time to do half that which I ought to do, and I feel more than ever that happiness depends mostly on knowledge and that can only be gotten by study. I have worked the greater part of this week in the Antique School as I want to get at the Life as soon possible, I think that I will devote most of this week there, as I know that I would not be able to finish my picture the way it ought to be finished . . . Scott saw it and seemed to like it very much. . . .

Last evening on my way home from the lecture on perspective I stopped in at the exhibition room on the corner of Fourteenth St. and Fifth Ave. and saw some very beautiful Antique furniture and some Turkish rugs, which are to be sold by auction, but I suppose will go very high. I met Mr. Avery[2] there . . . He said that he heard that I had painted a picture for Mrs. Coleman and asked me what I was doing, etc. . . .

I take breakfast with two students Hitch and Eldrige; we make a pot of coffee and have rolls and eggs and enjoy it very much. Charlie[3] and I like our room very much and we manage to arise an hour earlier.

During this winter Julian was taken desperately ill and the doctors feared that his lungs were affected. Two of his mother's sisters had died

[2] Samuel Putnam Avery (1822–1904), art dealer and connoisseur, U. S. Commissioner of Fine Arts at the Paris Exposition of 1867.
[3] Charles E. Weir, Julian's brother.

of consumption in their youth and his parents became frightened at the
prospect of what might happen; so the following fall he was sent out
to Rochester, Minnesota, to spend the winter with his mother's brother,
William Bayard. While he was there he painted several pictures, both
landscapes and portraits, among the latter being a portrait of his uncle.
A newspaper clipping speaks in glowing terms of a portrait of the Rev.
Mr. T. M. Riley "painted just before his departure for the East by Mr.
Julian A. Weir . . . In point of likeness, fidelity of expression and, par-
ticularly, as a fine piece of coloring, it is a work of superior merit and
indicates the touch of one who is more than ordinarily gifted with ar-
tistic genius." This must be the first published criticism of Julian's
work.

Early in the summer of 1873 he returned home and set himself
seriously to work again, getting his little studio in order and preparing
himself for hard study, as he was becoming more and more absorbed in
his profession. Although at the time he did not realize it, those few sum-
mer months were the last that he was destined to spend at West Point;
the world was calling him and the days of his boyhood were over.

Two doors away from the Weirs at the Point lived the Frenches. Dr.
John W. French was the chaplain at the Post; and the young Weirs and
Frenches grew up together, almost as one family. They were drawn still
closer together when in 1866 John Weir married Mary French. Lillie,
the youngest of the Frenches, was Julian's contemporary and in later
life she wrote down her recollections, which give a vivid picture of him
as a boy.

I can never remember the time when I did not know him, nor can I ever
forget him as a child, so beautiful in a manly way, was he, so endearing. More
than that I have not one single disagreeable recollection to overcome. He was
different from all the others in those early days at West Point, where in the
late fifties we began to grow up together. Three qualities or gifts set him
apart from other boys, beauty of person, generosity and refinement. His
Greek profile he inherited from his mother. But Julian's head distinguished
him as one on whom the very gods had smiled as if in remembrance of Olympus
where he belonged. Beautifully modelled as a head, and covered with com-
pact curls as it was, fitting close, yet never suggesting in the remotest way
anything having to do with ringlets. He was always laughing, gay, rollicking,
quite stout in those days. I remember once taking my father's horse, Duchess,
out of the stall, with its man's saddle and going around back of all the barn-
yards at the Point, getting Julian up behind me when he stole out of School.
Duchess shied and Julian rolled off in the road, but only laughed. I can never

remember him as cross or ill-natured, but I don't remember playing alone with him. He was always off with the boys. Yet when we all played together, he was full of fun and pleasantness.

His refinement strikes me now almost as a revelation. I don't think that any of us could have done or said a thing before him that we couldn't have said before his father or mother, and this was not because he was a prude or finicky or carping like some of the boys. It was just Julian; and when he was with us, he dominated by means of some subtle inner quality. I see this now, though as a girl I took it for granted without ever stopping to analyze the quality or its effects. I suppose that we felt about it all, as children do about the sunshine; we accepted it and were cheered by it, but thought it only natural.

His generosity and some fine inner sense are best proved by the following incident. My own father was ill, and my mother to tempt his appetite had ordered a few delicacies from New York with game of some sort. They came as everything did in those days by "the sloop" but were delivered at the Weirs instead of at the Frenches. Thinking them a present, the Weirs consumed them; but when Julian discovered this he was overcome and took his boy's savings without telling anyone and sent to New York to have the order duplicated, and saw that this time they were delivered at the Frenches. During all my life I have remembered it . . .

If I ever went into the studio in the old barn it could only have been at rare intervals. None of us would have gone there to romp, for back of all his cheer and laughter he had a seriousness we could not over-step, any more than we could that of his refinement. From the very first he was serious about his work. I have a vivid recollection of his joy when telling us of his being allowed to go away to study and paint, and our realizing that the studio in the old barn had been outgrown, yet that his work there had been a preparation for work in a wider field, a reward somehow, for doing things worth while.

There is another side of his boyhood that cannot be overlooked and that affected him and his brothers—particularly his brother John—very strongly. Life at West Point revolved, naturally enough, around the Military Academy, and the result was quite a different sort of community from the usual society of a country town of its size. It differed from a regular army post because of the sense of permanence given by the professors, most of them scholars of eminence selected from civil life to instruct the cadets and appointed for life with the rank of colonel. With their settled homes and families they provided a stability that was lacking in the army instructors who came and went; but nevertheless the emphasis lay entirely on the military. Civilian life was not valued very highly and anyone not in the army was referred to rather slightingly:

"Oh, he's nothing but a cit." They had the delightful feeling that West Point was a little hub in itself around which the world revolved, and they were content to have it so. All this was accepted quite naturally by the small children; but later the boys began to sense the difference, slight at first, increasing as they grew older, particularly when the girls, who till then had been their companions on a friendly footing, began to be old enough to go to the Hops and to have friends among the cadets. Then the boys became aware of a real cleavage between the military and civilian life; and as few of them cared to compete, they were thrust back upon themselves and left to a more and more solitary existence. To the young Julian this was not the hardship it was to John; his was a happy nature and he found compensation in his love of art and in turning to the nature around him. But unconsciously it must have influenced him tremendously and strengthened his self-reliance. Julian, for all his capacity for friendship, had no *close* friend from his childhood days with the exception of his brother John, eleven years his senior. Permanent friendships are built on similarity of taste, and there appears to have been no other boy who shared his interests. He and John lived their own inner lives and this must have helped to strengthen the bonds between them. And it was through John's ability and loyalty that Julian was given the chance to study abroad and begin a professional passage toward maturity.

In 1866 John painted a picture, *The Gun Foundry*, which when shown at the Academy made a striking impression and at once established his name as an artist. It was exhibited the following year at the Universal Exposition in Paris, where again it created a sensation, no small triumph for a young man of only twenty-five. Colonel Parrott, the owner of the foundry, had been so pleased with the painting that he bought it for two thousand dollars before it was finished, promising to add another thousand to his offer if the picture turned out a success. On the proceeds of this sale John and his wife went abroad in 1869 for a year, taking with them letters of introduction from John Bigelow to the French painters Doré and Couture. They traveled slowly through England, France, and Italy, studying the old masters and enjoying the great art of the past. In Paris, somewhat to his surprise, John found himself greatly impressed by the work of some of the contemporary painters. Delacroix, Meissonier, Rousseau, and above all Millet moved him profoundly; and he sensed that great things were stirring in France. A short

time before he sailed for home he accepted the deanship of the art school being organized at Yale; on his trip back home he must have reviewed the art schools abroad with a particular interest and concluded that they offered opportunities not yet available at home. Probably this impression was enhanced by the romantic tradition of his father's training in Italy, although by this time the stream of American students going abroad had shifted to the École des Beaux-Arts in Paris—Munich shortly afterward becoming a competitor, while the art schools of Rome and London faded into insignificance.

Before John went to Europe he had not considered his young brother's work at all remarkable; but when on his return Julian took him out to his studio in the barn and showed him what he had accomplished during his absence, John was so impressed that he proceeded to buy some of the pictures and take them back with him to hang on the walls of the art school at Yale. And more important, John decided that the thing that would start Julian on the right path would be to see that he had those advantages of European training that John felt so strongly he himself had missed. The family finances would permit of no such expense; but when John was visiting their old family friend, Mrs. Alden, he broached the subject of the great benefit to be derived by the boy from a course in the European schools.

Mrs. Alden's husband, Capt. Bradford R. Alden, had been commandant at the Military Academy from 1847 to 1852, and during those years the Aldens and Weirs had become devoted friends. Julian was born during the last year that the Aldens were stationed at the Point. Captain Alden was asked to be his godfather, and his name was added as Julian's middle name. After leaving West Point Captain Alden was so severely wounded while fighting the Indians in southern Oregon that he was forced to resign from the army. He then went into the petroleum business in Pennsylvania, where he initiated some of the most successful petroleum enterprises in that region.

After his death in 1870 the Weirs' friendship with his widow continued as warmly as ever. Mrs. Alden was an unusual woman, warmhearted, intelligent, interested in life and in those around her, most sympathetic to the younger generation, and unusually generous. She not only agreed to send Julian abroad but with a truly big gesture she wrote John: "I beg you will insist upon *generous* living, and a visit to the doctor if ailing, and do not I beseech you, let this enthusiastic boy suffer,

because he ought to live on $75 a month. I wish to do the thing as a parent would do."

Julian was overjoyed at the prospect and on September 10, 1873, he sailed for England on the *Java* to begin the serious training of a professional painter. He would remain an apprentice for some years to come, but the shape of his future was already sketched, outlined by various lights and shadows: his home and his family, especially his father and brother, his devotion to art, and the moments of lonely rambling back in the Hudson Valley when nature stirred his soul.

CHAPTER 2. NOUVEAU IN PARIS, 1873-74

JULIAN WEIR arrived in England on his way to Paris with exuberant spirits and high purpose. He was determined to secure the intensive professional training in art that his father and brother had urged. His father would continue to remind him in letters that time was too valuable to be "squandered" and that the seriousness of art required discipline and application. But Julian needed little urging; his own sense of duty impelled him to take advantage of every opportunity, whether it was the chance to see great paintings of the past or to meet the reigning artists of the day, looking always for that combination of high principles with talent which he considered the mark of the first-rank artist.

The few days spent in London that September of 1873 were filled with sightseeing and the wonders of the great collections and monuments. At the National Gallery Julian concluded that Turner was "certainly a wonderful man," that "his pictures which hang beside Claude's do equal them and surpass." But even more charming were the less sophisticated landscapes of Constable—*The Cornfield* was "very beautiful, cool, and sunny"—and Julian felt awed in their presence. And there were the pleasures of Gainsborough, Murillo, and Hogarth as well as Rubens and Rembrandt and "Sir Joshua Reynolds, especially."

To his father Julian wrote that he felt "like a small atom in this immense city, wonderful in its greatness and beauty." St. Paul's Cathedral seemed a sacred shrine of art: ". . . Grand dome, statues, monument of J. M. W. Turner on my way down to the Crypt. Before me lie the remains of Sir Thomas Lawrence, Benjamin West, Henry Fuseli, Sir Joshua Reynolds' remains lie beneath where I make these notes." In his diary Julian enlarged on this incident in a touchingly youthful note: "Returned back to Sir Joshua's slab—under which he is buried—Great God, may I follow in his footsteps, be like him a man of honor a gentleman, and a true Christian, that when this life is over I may rest like him

in peace. God grant this for Christ's sake—Amen. I have kissed the stone under which the great man is buried."

On Sunday Julian heard Canon Kingsley preach in Westminster Abbey, and the next night he was in Paris, settled in the Latin Quarter with three former students of the New York Academy School, Will Low, Wyatt Eaton, and Arthur Daventry. The following week, on October 6, Julian entered the École des Beaux-Arts.

This famous school under the direction of the French government offered free tuition, even to foreigners. The school included eleven ateliers, three each for painting, sculpture, and architecture and one each for line engraving and the cutting of gems. In Weir's day the painting ateliers were under the famous trio, Isidore Pils (1813–75), who apparently had little influence on the American students; Alexandre Cabanel (1823–89), who had a number of Americans under him; and Jean-Léon Gérôme (1834–1904), whose studio was the one most extensively patronized by the Americans.

A keen rivalry existed between these three ateliers, and each was always on the alert to detect any sign of weakness in the others. But academic standards were high in the École, and although each atelier had its own methods of instruction, the three masters were united in insisting that draftsmanship was the rock on which all painting was built; more novel theories were left to be carried on in private ateliers outside of the Beaux-Arts.

Once enrolled, the student entered the "antique" class. After he had proved himself there he was promoted to the "life," where he continued to draw in charcoal, for he had to pass another period of probation before he was permitted to touch color. Every two months a *concours* or examination for "place" was held in the class, and each man received his position for working from the model according to his standing in these *concours*. In addition to the practical work with charcoal and brush there were lectures on history, archaeology, anatomy, and perspective.

Gérôme, the master chosen by Weir, had come from his native Vesoul as a very young man to study art in Paris. He entered the atelier of Delaroche and three years later promptly followed his master to Italy. When only twenty-three years old he painted the *Combat des Coqs* (in the Louvre), a picture which so impressed Delaroche that he suggested Gérôme send it to the Salon, where the sensation it created made the young man's reputation. About this time the classicism of David was becoming outmoded, while the romanticism of Delacroix and his follow-

ers was still far from being popularly understood; Gérôme offered another point of view, which, although new, was pleasant and easy for people to grasp. Choosing his subject from history or from the Orient, he was careful to avoid anything that savored of the allegorical or heroic; each detail was studied so that it should be historically correct, and the whole was then painstakingly drawn and painted. It was excellent craftsmanship; there was nothing to disturb the public—they could admire without reserve the lifelike realism of the gladiator's shield or the sumptuous splendor of Louis XIV's apartments. Other artists were quick to follow where he led; and Gérôme found himself, while still a young man, the head of the Neo-Greek school.

Gérôme, as Weir described him later, "was a broad man indeed, with a tremendous academic capacity ... I knew him as a man of high nervous temperament, strung always to the pitch in his emotion as a taut violin string. He was distinguished in appearance and dressed with extreme care and fashion. His mind was fertile and alert, and he invariably inspired respect first and love later."

This appraisal goes far toward explaining Gérôme's success as a teacher. He allowed his pupils to be themselves; he did not try to impose his own point of view upon them. It is hard to trace his influence on the later work of Eakins, Thayer, Brush, or Weir; but his students felt grateful to him all their lives for the solid foundation of draftsmanship that he had given them. He had no easy recipe and scorned eccentricity; but when their work pleased him, his generous appreciation warmed their hearts.

Under Gérôme's discriminating eye Julian worked hard, thoroughly absorbed in art as were his friends, most of them fellow students. For a while the world of ateliers and galleries seemed the whole world. Weir's letters to his parents and to his brother John tell their own story, a story of education and discovery.

PARIS, OCTOBER 7, 1873

DEAR FATHER:

... Yesterday I entered Gérôme's studio and got to work from a cast, to show him what I don't know. As soon as I got inside the door, the students began holloaing like fiends "un nouveau," and I was surrounded and bawled at. The making of faces, groaning etc., made me think of nothing but a lot of wild men. I had to pay my "bien venue" and also treat them to wine and bread. After I had returned with a basket of bread and four bottles of wine, which is what all new students have to get, the gendarme locked the door and

the Frenchman who was with me put his bottles down and ran as hard as he could. In the meantime the students, knowing what was going on, broke the door open and brought all the things into the studio and by the time the Frenchman had returned, all was gone. I was called out by the students, who number some twenty-five or thirty and told to put a towel on the roller and place it. The stand was about ten feet from the floor and about six feet from the floor there was a ledge which one had to climb to, so as to reach it. Fortunately I found that they had soaped the ledge, and so was careful to place my foot in a safe place. As I was getting up I heard the laughing and chuckling, expecting to see me slip down. Again I was called out to sing, but got off of that. A Mr. [Walter] Blackman of Chicago, it is understood, is to enter, so they propose having a mock duel between him and myself, both stripped to the waist to fence with paint brushes, one dipped in Prussian blue and the other in caput mortuum, each perched on a stool. I hope this will not come to pass. . . .

PARIS, OCTOBER 12, 1873

DEAR MOTHER:

. . . In Gérôme's Atelier the old students act towards the nouveaux, as they call them, as the cadets to the plebes. The last nouveau has to get bread, milk, paper or carry in wood or anything the old students want. In consequence of this I came very near having two or three fights. They are the meanest, most cowardly set of men I have ever come across. Twice my portfolio was taken so I could not work until I found the man who had it and called upon one to translate into French what I wanted to express. They will steal anything they can lay their hands on, there is no honor or anything else among the French students. They called upon the new students to sing, and although it was much against the grain, we had to go through it and we did it with the best face possible by singing "John Brown." I am fortunately not the last of the nouveaux, so I get off of running for small erands. The one who is last, is a gentleman from Chicago, about twenty-five years old, so it tries him very sorely.

My rooms . . . are in a quiet place and are furnished very nicely, for which I give eight dollars a month and one dollar for attendance. Living, also, is cheap. A Sunday dinner costs me but about thirty cents in American money, but there are many little things which will make the first two or three months the heaviest, for an allowance must be made for misinterpretation, bien venus, clothing, etc., which, when I get fairly started, will not count. . . . At present I am going to keep at drawing from the antique and life. I have been looking for a letter from home the past week, but hope my anticipations will be realized this week. . . . I find it hard to get used to candles after having gas. When I get settled I will get a lamp. My candle is going out, interrupted my finishing touch!

PARIS, OCTOBER 19, 1873

DEAR FATHER:

. . . I have engaged a studio with two small rooms adjoining for four hundred and fifty francs a year. When I get settled there I will be able to paint

in my spare time . . . Last night I went to the Sketch Club, having been made a member, and met there the son of Mr. Inman, who asked after you.[1] . . .

I have about passed the stage of nouveau, the same as the cadets term plebe, so many more have come in after me that I am more respected. The only way to treat a French student I have found is to threaten to thrash him and he will respect you. As a rule they are a vulgar, mean set. Most of them can draw well and some two or three have a wonderful eye for color, one especially, a Guardi, a nephew of the great Guardi. He brought some sketches which I liked so much that I asked what he would ask for one, which although small was very rich in color. He told me and being such a small sum (four dollars) I was tempted to get it. Gérôme in criticising this sketch said "very good," so I feel by his approval of it that it is fully worth it.

I have scarcely been anywhere as yet. I have seen none of the public churches, the Bastille and other places which soon I hope to find time to get a sight of. I have been in the Louvre and Luxembourg once or twice but as they close at four o'clock which is the time I get out of the Beaux-Arts, I can't very well see them without taking time from my drawing which at present I don't feel that I can do. . . .

I went with Mr. Bass last week to see a panorama of the Siege of Paris.[2] This is the most wonderful thing of the kind I have ever seen or imagined. It was painted on a circular wall . . . In front of you lie real shells, cannon, guns etc., and it is almost impossible to tell where the painting begins. They have also sand bags, gabions, etc., which are painted so near nature that it is painfully deceiving. If you walk toward it you undergo the sense of sea-sickness. The things all seem to approach you, so that when one wants to change position you have to look on the floor. You are represented as being in the French Fort Issy, which when taken by the Prussians commanded the city and terminated the war. Now the government is building some fifteen or twenty forts outside of there and making the old forts larger in case of another war. The last news that I have heard is that the Count of Chambord has consented to bear the [tricolored] flag, so everyone thinks he will take the throne, although he will be voted on.[3]

This evening I went with Mr. and Mrs. Bass to the American restaurant where I had a piece of pumpkin pie which was relished, but I think the greatest luxury would be a glass of iced water. . . .

PARIS, OCTOBER 24, 1873

DEAR FATHER:

My bankers being Drexel, Harjes and Co., I have only inquired there for letters for the past two weeks, but before that I went to Munroe's and finding nothing there concluded you had waited until you had heard [from] me to write, but yesterday I received yours, Mother's, Cad's [a nickname for his

[1] John O'Brien Inman (1828–96), American genre painter, son of Henry Inman (1801–46), New York portrait, genre, and landscape painter.
[2] Painted by Henri Gervex and Alfred Stevens.
[3] Henri Comte de Chambord (1820–83), French pretender, son of the Duc de Berry, refused the tricolor and failed to win the monarchy.

sister Carrie] and Charley's. I can't tell you how fast it was opened and the contents gone through. It was a feast and it would have been hard to find a happier person than I was when I found it and saw you were all well. In it you mentioned having sent some letters in care of Munroe, and I went there and got them, which made eleven letters and the first I had received since I left home a month and a half ago.

I put my letters away safely and started for home when I found I had but time to get my dinner and go to the concours for the life in the École-de-Médecine. I expect it will finish this week. I somewhat fear this will be but an attempt as the majority of the men are far advanced. I spied there some from Gérôme's atelier. However it will be a good thing for me to show how I stand with reference to others. I still keep at the antique drawing all day and examination from seven till nine at night. . . .

[In the Louvre] I have had a perfect feast and while looking at Titians, Van Dycks, and Holbeins, (which, by the way, I admire very much), I wished to myself you were there to look over their beauties with me. *The Dead Christ* by Philippe de Champaigne is wonderful in drawing. Rembrandt's are good but the copy of the one you have makes me think it finer than any I have seen. Titian is a wonderful man, his picture of *The Burial of Christ* is magnificent in color. I saw his *Flora*, which I suppose has faded a great deal. Murillo's picture of *The Nativity* I hope to make a sketch of, so luscious and true in color. Rubens' coloring and drawing is wonderful, yet many of the subjects, although they may be fine, are incomprehensible to me. There is no end of pleasure one could derive from visiting the Louvre and henceforth I think of spending Saturday afternoon there for recuperation. Then I will be able to take notes and be able to tell you about some of the fine works it contains.

I have now finished my examination and await the results. Over one hundred and fifty are trying and only sixty are to be admitted, so I fear my chance is small. . . . I found a notice about me in the American Register which I will send you. I can't imagine how it got there, as I know no one who has anything to do with the paper. . . .

I will move next week. In the meantime I am getting things moved and buying furniture and so forth. There is an open fireplace in the studio and a skylight facing the north and a window facing the east, and in the room where I intend sleeping, there is a window facing the east. The rooms are on the fifth flight of stairs, and on the same landing the massier [of Cabanel's studio] who is the head man, has his rooms.[4] I have been introduced to him and so I hope, by his being so near me and such a good draughtsman and colorist, to benefit by his knowledge. This week has gone by so fast I could not believe that it was Saturday.

A Brazilian, who entered Gérôme's atelier, would not go for bread and

[4] This was Edgar Melville Ward (1839–1915), American painter, later an instructor at the National Academy of Design; he was a brother of John Q. A. Ward (1830–1910), sculptor and first president of the National Sculpture Society.

run errands for the students, (as is the custom with every nouveau), [so he] was put out of the studio by them. He went to the minister and told him of it, so the minister went to the French minister, who sent word to the massier that if he was not received the atelier would be closed. So he came back and they asked him if he would submit, which he refused, so they, en masse, carried him out of the atelier and told him to go. In a short time the gendarme came and said he had received orders to close the atelier, so all had to leave and since then it has been shut and it is supposed it will be closed for two weeks, such is the rumor. As I am not working from the life yet, it affects me very little, as I have access to the Antique Room, and so continue. But the atelier is shut and the men are mad with anger. It is understood the Brazilian intends coming back, so they are going to strip him and paint him with Prussian blue. They are the wildest and most regardless set of men you can imagine. . . .

PARIS, NOVEMBER 2, 1873

DEAR JOHN:[5]

I have begun two letters to you, but as they were not exactly long letters when I had to leave them I concluded to wait until I had got settled in my new apartment and things in running order so that then I could give you my candid idea of how things really were, here in the Latin Quarter of Paris. You were right in starting me off here and I never can thank you enough for it. Now if I can study here long enough there may be hope, but I am convinced if I had remained in America until I was older my whole life would have been full of regrets concerning my art, for I know I never should have appreciated what it was to draw well, and what art was without it. As soon as I arrived here after going through a good deal of "red tape," I succeeded in getting admitted to Gérôme's atelier and since then I have been there working from the antique. I began with simple things first and have at times been encouraged by Gérôme by his saying "pas mal" and the last drawing was "mieux." Tomorrow I am going to change my course of study a little by drawing from the nude model from eight until half past twelve and the rest of the afternoon until four drawing from the antique. Last week I made a concours in the École-de-Médecine but have not yet found out whether I am admitted. If I do pass the examination there I will spend two hours there during the evening. If I do not there are others which one can have access to so that an art student here has every advantage that could be desired.

This morning I went to the Louvre and passed several hours there looking at the marvelous wonders, but I must say that the only men who impressed me at first and thoroughly came up to my anticipations were Van Dyck, Titian and Holbein, that is here in the Louvre, but since I have been to each of the wonderful men in turn and examined their work, they grow upon me and I feel a heaving inside and I feel like starting back to my studio for work. Murillo in some of his things is wonderful. Rubens' works, although grand

5 Julian's brother, since 1869 Professor of Fine Arts at Yale.

in design, look coarse and lack feeling. I have seen none of Rembrandt's that I like as well as the copy father has from the one in Florence, I hope to see that some day. I can't see how Leonardo da Vinci made such a wonderful name. Andrea del Sarto I like very much, but one saying that he likes this one and dislikes that one is rather absurd, for there are, in the majority of the pictures of the Louvre, things about them all that are fine and much that one can learn. The finest portraits I have seen and those you know interest me more than anything were those of Titian and Van Dyck and there were two heads by Titian in the Louvre, near his portrait of Francis the 1st that to my mind are the most marvelous things I have seen yet, as you look at the faces they seem to move, they are thoughtful earnest portraits of the highest type. [There was] one of Van Dyck which I saw at Warwick Castle of the Duke of Alba, when I saw this portrait there I was awe struck. I had been taking notes of the ones I saw, but when I stood in front of this I did nothing but look and if ever I have a chance to go to England again I will make it a point to go there and see this and other fine portraits by both Van Dyck and Sir Joshua which are there. . . .

PARIS, DECEMBER 17, 1873

DEAR FATHER:

. . . The other afternoon, with a Mr. Stimson[6] I went to the Louvre to see a celebrated work by Rembrandt which the Government has lately purchased. It is merely a piece of beef hung in what one might take to be a slaughter house. I have never in all I have seen, seen such an exhibition of genius. To look at it close by is I must confess a puzzle, even to men who know much of art, but viewed at a short distance [it] is a marvelous piece of painting and to my mind one of the wonders I have seen. My heart seemed to pump as I passed through the room of drawings and my idea of the study of the old masters is decidedly changed. They were certainly noble, hard workers and no humbug. I saw things that made me wish often for you. Raphael's drawing of a head which you have a stipple facsimile of, his sketch of the Pope being carried in church on a chair, Leonardo's drawing on canvas of the drapery which you also have a copy of. This is merely a drawing touched up with white chalk. Some of Raphael's, Michael Angelo's, da Vinci's and del Sarto's drawings were superb. I am going there again to see them, and will take some notes for you. . . .

I have lately seen some copies by Henry Regnault, of Velasquez, who was greater than many of the old masters, and if I study any of the old masters he will be one. I am going to get photographs of some of his pictures and send you, and if there [are] any that you would expressly like to see, write me and I will get them. Some are quite dear, as high as two or three dollars, but these are the largest size. . . .

The students gave Gérôme a banquet which they said was fine—some say

[6] John Ward Stimson (1850–1930), American painter, student of Cabanel and Jacquesson.

that it was finer than anything they had imagined. After the dinner, which took several hours, they had a theatrical performance and music. Everything was gotten up in the best manner. I did not go feeling that as there were men to represent America, my work would be of more benefit. Greeks, Swiss, Spaniards, English, Roumanians and several Americans were there. . . .

PARIS, JANUARY 11, 1874.

DEAR JOHN:

Last week I received your letter which gave me real pleasure in reading. I had almost given up hopes when your reply came. I feel that my coming over here has been the most fortunate thing that could possibly have happened to me. My eyes have been opened to see many things that otherwise I know I would not have discovered for years had I continued in the manner I studied when at home. Now my manner of work is entirely different as you will see. After being here a short time I entered Gérôme's atelier where I began at the casts, drawing the heads in and merely blocking out the principal shade, for he considers that that is the first thing for a student to understand thoroughly. After drawing for a month I passed a concours which they have every two months, and entered the life. I worked here another month, making slow progress naturally, but still encouraged by Gérôme. On account of a cold I caught and the bad air of the atelier where sixty men worked and those smoking who felt inclined I was forced to leave here and get in an atelier where the air was purer and better warmed. Stimson advised me to go to Jacquesson de la Chevreuse who was the master of Niemeyer.[7] I went there a little over a month ago and expect to stay there during this month, but after that I intend to return to Gérôme.

Julian's decision, so airily expressed, to leave the Beaux-Arts only two months after he had entered it was not entirely the matter of his own free will that he here implies; nor was it as simple as he makes out. He had made the mistake of entering the atelier one day with his hat on his head, a thing no nouveau was supposed to do but a rule he did not know. A stool was promptly thrown at his head, which he as promptly resented; and a fight ensued, an Englishman joining in on his side. The two of them, with their backs against the wall, succeeded in holding off the roomful of young men. The immediate result of this fight was great distinction for them both from the rest of the school and an enormous reputation as fighters; for a long time afterward they were known throughout the Quarter as "les deux boxeurs." Officially, however, they were not so successful, each of them being suspended from Gérôme's atelier for two months. Needless to say, this was nothing to boast of at home.

[7] John Henry Niemeyer (1839–1932) taught drawing and art history at Yale 1871–1908, assisting John Ferguson Weir.

Mr. Jacquesson is a severe, hard, dry man who makes one stay at the casts, allowing his pupils a life model but once a month. This is an exceedingly good thing I now think, for my ideas are very much changed in regard to the best way for a student to study. I am convinced that one has to tread slowly to tread surely . . . so for this year I will do little work with my brushes except at times when the atelier is closed. The difference between Gérôme and Jacquesson is this, viz. the first makes his pupils practice blocking in and drawing in outlines with merely the principal shade, striving entirely for the action of the figure. If one does not get the exact portrait of the man, but has something good in the head, he will commend you. He believes in leading the student on slowly, not allowing him to finish up highly until he knows how to draw the figure in well. Then by degrees he pushes one on in modeling and wants him to model and carry his figure as far as he possibly can, but not to attempt this until he becomes acquainted with the figure and knows what he is about, otherwise he considers it as so much time that could be spent more profitably.

On the contrary, Jacquesson puts one in front of a cast and if one seeks the shape and action as I have been used to do with many lines, he wants to know "what the use of so many lines is" and says the model has but one out-line and that one must not attempt to draw it until he has studied each line . . . now that you have studied the silhouette of its shape, go to work and study the silhouette of its form and carry it as far as it is possible to carry it. So you see that these two men teach differently and so it is with all the different ateliers here.

Carolus Duran, who is the great portrait painter of France of the present day, teaches his pupils still in a different way. He puts them in front of the living model with the brushes in their hands to represent the model as well as possible, making them draw and paint both at the same time.

In regard to the article you speak of in the N.A.D., that Gérôme found fault with the elaborate drawings that the Americans of the N.A.D. made is misunderstood. He said that they attempted to make pictures out of them and that severe study was shunned. He believes in elaborate drawings but not until the student knows his letters does he want him to read.

John, if it is a possible thing, come over here in May when the exhibition of the Salon is open, then all the artists are here. Boughton and Hennessey come from London and all send the best pictures they have painted through the year and I have been thinking lately what a grand thing it would be if you would send your *Forging of the Shaft* or rather come over with it and spend two months or so. Last night I called on a gentleman, one of the Legion of Honor. He at once asked me if I was the brother of the American who painted the *Interior of a Foundry* that was exposed at the grand exhibition.[8] He seemed glad to know it and told me it made a great impression on everyone, so much on him that he has never forgotten it and at the time he said he wrote a long article on it.

[8] The Paris Universal Exposition of 1867.

I think I can be of service to you, old fellow, in getting you specimens of work done by the students and I will do all in my power for you. If you are anxious for the studies of heads this year, I can go to work and make some agreement in a casual way with some of the strong students, but if you are not in a very great hurry I can go about it differently and maybe do some myself.

I study sculpture or rather modeling in clay during the evenings from seven until nine and I find it an excellent practice. Our lectures on Anatomy come twice a week. Mr. Taine has commenced his lectures which this year are on art in Greece. He is defective in one eye so that he squints, he is very pleasant in his manners, he addresses his audience sitting, makes many quotations and equally enjoys the jokes, that in the first two lectures he got off. In the lecture room you know is the great picture of Paul Delaroche of all the great artists. What a superb thing it is.

I am glad to hear your school is getting on well and sincerely hope, John, that you will if there is the slightest chance avail yourself of it and come over here if only for two months. You can live with me and we will study together. . . . I will write you more of the details of the schools and everything which I think you would like to know of, but the field seems so large I will give you accounts of the things that occur through the day and of the different manners etc., but if there are things special you can ask me in your replies. I would keep the students at drawing and ground them well in that, for that is considered the principal thing here. . . .

PARIS, FEBRUARY 19, 1874

DEAR FATHER:

I have put off writing on account of the examination, until tonight, the concours begins today.[9] At eight o'clock this morning we had to be at the École des Beaux-Arts. We stood outside of the door in the large courtyard, and on the doorstep of the Perspective Department stood the Director and a gendarme; one by one he called the names off, and each one had to take a ticket and pass upstairs. My name was called among the first, but [the Director] having such a strong French accent, I did not recognize it, so had to wait until near the last until they were recalled. Upstairs we were kept outside of the door, and let inside by threes; as we entered, the gendarme directed us to the Prof. and the director No. 2, the one [who] gave each the problem, and then we had to sign our names. From here we passed into a room about sixty feet long and partitioned off on both sides with stalls, where there was a table and chair. I was much confused, and it was not until near the last, that I understood it, so did not quite finish it, but did enough to show that the principle was understood. The problem was turned about to mix me, and given in a different way from what I had lately studied in preparation.[1] The guardians were placed all about this long room to prevent any talking or copying. The

9 The concours for Yvon's class. Adolphe Yvon (1817–93), French historical and portrait painter, had been a student of Delaroche.
1 Here he drew a sketch of the problem.

time that was given was two hours and a half but it seemed too short, and if I had had a half hour more, I could very likely have finished entirely.

Saturday comes the anatomy, at two o'clock, I will be glad when the affair is over, for it rather unfits me for work, but this week the École is closed, with the exception of this examination, as it is Mardi Gras, the carnival before Lent. The day before Ash Wednesday they had a grand masked ball at all the concert places here. Eaton and myself dressed up as darkies and went to the Bullier, which is called the students ball; it is here in the Latin Quarter, and as it was the last masked ball of the season, we took holiday. We started there about ten o'clock, on our way up the boulevard we met quantities dressed up in costumes, blowing horns, singing, shouting and trying to have in the last night, enough jollity to last them through. We, being in costume, were greeted and shook hands with many, and as we passed those who were masked, each would give a loud whoop as a kind of recognition. We came in sight of the brightly lighted entrance and on the outside of the street stood a long line of lookers on, who, when we passed, shouted at us in strong language. We entered, Eaton and I stood at the head of the stairs (he with his big carpet bag in his hand, and I with fancy red plaid swallowtail, striped vest and patched pants, faces blacked with lard and burnt cork) we stood there, looking down on the sea of heads and began to attract much attention, and as we descended, they shouted and pressed about us; many came up and said ours were the best characters of the evening. I met many of the students who said the same. We danced clog and were much laughed at. We left about two, we went and had something to eat and got home about three. After many changes of water and much scrubbing I regained my native color.

The next morning I had to be up at seven, as I had a model engaged. . . .

[Postmarked February 21, 1874]

DEAR FATHER:

For the last week or two I have been painting in the afternoon, often working in the École in the morning. I have begun two heads of myself, which I think an improvement on my former ones, both in drawing and color. A Mr. Hinckley,[2] the strongest man in Carolus-Duran's atelier, called on me a short time ago and seemed to like them. He has asked me to come to his studio some time next week and give him a sitting of two hours, and he do likewise, to see who can do most in the time. Duran is considered the best portrait painter in France, and has painted many crowned heads, etc. I have not seen any of his work yet, but I understand that he teaches the men to try and paint up at once, and use as large brushes as possible.

At our last lecture on Anatomy they began on the muscles of the chest. I do not get the entire benefit as much I do not understand. After the lecture I went into the dissecting room and saw Mr. Bonnat with the Prof. They had just received a subject, and at the opposite side of the room I saw an immense

[2] Robert Hinckley (1853–1941), American portrait painter, lived in Paris 1864–84.

cross, but thought nothing. Bonnat said he had not much time to stay and wanted the gendarme to hurry up, so two of these soldiers and a hired man took the subject out of the room, brought the cross out and laid it on it. It was then whispered around that Bonnat had a commission to paint a crucifixion, had bought the subject and had the cross fixed, so as to be able to study the action of the muscles. Some of the students, hearing what was up, crowded in; this attracted Bonnat's attention, and he got the gendarme to close the door and lock it. We went back to the lecture room where we draw the bones, and while sitting there we heard the nails driven in. We finished; Mr. Blackman and myself went out together after all had gone. At the door we met a guardian and bribed him to let us see the subject, which he did, and standing up against the wall was the large cross with the subject crucified on it, a horrid sight; but it shows how these French artists believe in truth. . . .

Yesterday afternoon I walked outside of the fortifications with Mr. Eaton; we passed the entrance to the Catacombs and went through old streets. The evening was very pleasant, we passed out one of the gates and walked outside the parapets, passed another gate and thought that the next one we came to we would enter to go home. We came to a railroad, climbed the fence, and, while trying to get up on the other side, some gendarmes about fifty yards off called to us to go back. We pretended not to hear them, and the next moment they were all after us. Then, inspired by fear, we retraced our steps, and you can believe me if I tell you we ran after getting over the wall, nor stopped till we considered ourselves safe. We were satisfied to enter the gate we had passed and reached home after dark, having had a pleasant walk. . . .

PARIS, MARCH 1, 1874

DEAR MOTHER:

. . . I took breakfast at the American Restaurant; we had some good rice cakes and molasses, which tasted like olden times. When we finished we walked through the garden of the Tuileries, which was filled with people. I stood for some time looking at a priest who was there with his school of boys; he was playing with them in a game much like one I used to play at school which we called "prisoner's base." A large crowd of men, women and children surrounded them, those others who were not engaged in it were playing marbles, etc. It struck me as being a queer sight to see this reverend man? running and shouting after the boys. . . .

I painted a piece of still life this week in the shape of a leg of mutton. As I passed the butcher on the way from the École I saw a fine leg, so went in and hired it for two francs an afternoon. Yesterday I finished it. Three of Duran's men called later in the afternoon and seemed to like it very much. . . .

Good-night, with much love to all I remain

Affectionately your son

Julian A. Weir

I guess I will have to sign my name J. Alden Weir now as a recognition of Mrs. A's great kindness.

PARIS. [Postmarked March 20, 1874]

DEAR FATHER:

. . . This afternoon I took Mrs. Anderson[3] and her daughter to see Mr. Healy's[4] studio, being his reception day. He has lately finished a portrait of Mr. Thiers and Mr. Washburne; the first was by far better than any about the room and stronger in color and drawing. He has a red curtain behind him and has studied well the values of color, and painted it masterly. Mr. Washburne's although it has many good qualities, I do not like as much as the former. One of the Prince of Roumania is very fine, but the Princess looks very weak in drawing and color also. These two he sends to the Royal Academy in England, and the two former ones he will exhibit here in the Salon. He wished to be very warmly remembered to you. He is a rather eccentric gentleman, who is unfortunate in making puns.

Mrs. Blodgett has invited me to dine and meet her husband on Sunday. She asked me to bring some of my work to show him, but I have nothing but unfinished portraits, for I have kept closely to my Academy work. I have succeeded in hiring an outfit for this most auspicious occasion, so will be able to *swallow* much. . . . I have been thinking of going to England to get some clothes, but will wait until later, when I will try and stay over long enough to make a copy. There are some rare things in the National Gallery which I want to make copies of.

I called on a young Swiss painter today, Mr. Berthoud. He is painting his first picture for exhibition; the subject is an old monk buying ducks of a very pretty country girl. Everything is well studied. While I was there a box of ducks arrived, which he had hired to study from. The composition is quite pleasing. I crossed over to Eaton's studio, whom I used to know in New York. He is making wonderful progress, and is now engaged on a picture for the Salon; it is a woman standing in front of a looking glass. It is a very pleasing picture and rich in color, and [he] has treated them very broadly. He and DuBois,[5] whom I wrote you had sent two landscapes to the N.A.D., are I think the most promising of the Americans. . . .

Wednesday I have learned the result of the Concours. I have not been received; some of the French students seemed to think I was not fairly judged, but the Committee were men who I think would give their unbiassed opinion. I do not feel discouraged, although very disappointed, and will hope by faithful study to forget it until I have another chance to try again. . . .

After work today I went to see a collection of English pictures to be sold, one very fine Constable and Romney, but Turner and the others that were represented I did not like. The French think more of Constable and Bonington than any of the English painters.

[3] Elizabeth Clinch Anderson, widow of the general, Robert Anderson (1805–71), who commanded Fort Sumter in 1861. The Andersons had lived near the Weirs at West Point for several years.
[4] George Peter Alexander Healy (1813–94), American portraitist. The portraits were of Adolphe Thiers, president of the French Republic 1871–73, and of Elihu Benjamin Washburne, American minister to France 1869–77.
[5] Charles Edouard DuBois (1847–85), American landscape painter; he settled in Switzerland.

I have read your letter to several students, as I think your suggestions were excellent. One, a very fine colorist, an Englishman, enjoyed it exceedingly, a Mr. Peppercorn. He is now sitting for his portrait. I will take my color box antique week and paint from the cast instead of drawing, and try to get permission to paint from the life. . . .

The sketches for the prize of Rome were exhibited today; ten were selected to make a study of a half length figure, and they select from out of them for the prize. But one of Gérôme's men was in the ten and more of Cabanel's than any other master. The sketches were not bad as a whole. I have been thinking of trying to get in Cabanel's this next year, as I think he has more strong men than either Gérôme or Pils. . . .

<div align="right">Paris, Sunday, March 30, 1874</div>

Dear Father:

. . . I must now tell you some real good news as regards encouragement. Last week I painted from a cast of Masaccio. Gérôme did not come until Saturday. I had put the last touches on it before he got there and looked forward to pleasing him with that and a portrait of Mrs. Bass, which I had brought to show him. He walked around criticizing the drawings, and when he came to mine he said nothing at all about the drawing, but gave me a most savage talking to about the value of color and got up as if mad and went in to the small antique room; when he came back I had the portrait of Mrs. B. on an easel for him to see, but being a nouveau had to wait until he had seen some drawings of an old student. He turned suddenly from looking at his drawings to my portrait, then turned about and asked who did it. I answered in a rather sheepish manner, expecting to be blown up much worse than before, but he said "Ce n'est pas mal du tout, du tout!" Then put on his coat and went out. When he closed the door I received all kinds of congratulations from the old students, who said that he seldom ever praised one any more than this. He has also told me to paint from the life model this week, so that I now feel like taking hold with a new vigor.

I . . . have ceased calling on those I know to a great extent, for I find if I go out invitations are given me to parties, dinners, etc. which if I accept will lead on to others, and I do not care to take the time this year any more than I can help.

My balance in the Bank is not too large; I have not been extravagant and I have spent none of it in any way but what I can give a good account of. I have not entered a theatre or opera this winter, but I have spent money for engravings and photographs from pictures which I knew if I had to leave I would never regret; these with some casts and the furniture of my rooms may be called for me extravagant, although they are intended to make my rooms pleasant and for my improvement. On or about the first of October I made a deposit of 3500 francs, and now I have a balance (including the amount you sent) of 1402 f. 20 centimes, which is about $293. I think this will last me the year out; I try to be as conscientious about what is entrusted to me as possible,

but have endeavored to take every advantage that I could to advancing myself in my art. This month I join a class to draw from life from one until five under Boulanger[6] and some other strong man; this will be another extra, as are models also. I think that as Mrs. A. has really meant me to take advantage of all that will inspire me I ought to do so, for I feel that this time if spent to the best advantage possible, will be worth more than two years of moderate dragging on as many of the French students do.

When you can find time to write again tell me what are your ideas and whether modelling at night, as I do now would be as well as studying French.
. . .

[West Point, April, 1874]

DEAR JULIAN:

I received your letter last evening, and am glad to learn that you arrested the attention of Mr. Gérôme with your portrait of Mrs. Bass.

As far as I am able to judge, your method of gaining instruction in whatever way it offers to further your progress in art, is, I have no doubt well done. You must consider that you are working out a problem of great moment to you just now, as your success will depend in a great measure on the knowledge that you acquire, and the dexterity with which you can express the character, color and form of the subjects that you paint. I am glad that you have been wise enough to resist the temptations of the society that surrounds you, and to defer the delivery of letters that you took out with you. Time to you just now is of too great value to be squandered in making fashionable calls, or in doing anything that is not absolutely essential to your advancement.

I think that the practice of modeling in clay conveys a more definite idea of form than simply drawing: as you work with two senses, both *seeing* and *feeling*, the impression is much stronger and more lasting. At the same time, however, do not sacrifice color, for its charm will save a picture from going to the garret: and where it is given to feel its beauty it should be carefully cultivated.

When you draw, do so with the utmost care, it is the ground rule of Art, while light and dark may be regarded as the *syntax*, or method of putting things together. Study expression with the utmost diligence as its qualities with the thoughtful are inestimable. Prints and photographs from works of high order are valuable, as they assist to retain the impression of the originals and give an idea of the treatment of works and character of individuals either in nature or art. Be careful of your health, take exercise in the open air, and if possible accustom yourself to *stand* when you paint. God bless you.

Your affectionate father,
Rob't W. Weir

[PARIS,] APRIL 21, 1874

DEAR MOTHER:

I sent Father a statement of my accounts. This year being a "nouveau" I suppose I have spent more for things than I ought to, but I have found things

[6] Gustave Clarence Rodolphe Boulanger (1824–88), French Neo-Greek painter, student of Delaroche.

much dearer than I expected, I suppose owing to the late war. None has gone to the operas, which I have often wished to go to, but there are so many little ways. But now I know the cheap places, so that another year I will be much better prepared; still next year I expect to have models often, and those are all the same price, five francs for four hours—much cheaper than America, but here they think nothing of studying on a picture from the same model for several weeks, whereas many artists there would finish several in that length of time. . . .

I am in such excellent good spirits now, owing to the encouragement Gérôme has given me. On Monday last I went off for two days, not feeling very brilliant, I suppose owing to the spring weather. We went to a place called Melun and walked from there a distance of five miles to Barbizon, there we made sketches. This place is just at the edge of the large forest of Fontaine-bleau, a very picturesque village and one much visited by artists. The great Millet lives there. Von Paul, a Norwegian[7] who some say is one of the strong-est landscape painters in France, Paris, and Barye the sculptor, these live there the year round. They dress much like the peasants, wearing the sabots or large wooden shoes, and blue blouse. Everyone seems glad to see you, and when we went away the whole family came out and shook hands. I made a sketch there that Mr. Von Paul complimented me on, and Mr. Paris said it was very "dis-tingué." This I left to be placed on the wall of the dining room, which is nearly covered by pictures of artists who have been there, among them were some by men who are now distinguished. . . .

[WEST POINT, APRIL, 1874]

DEAR JULIAN:

I do not think that small pieces of drapery will give you the information or instruction that you need. It is the character of the folds that I want you to study—their breadth and grandeur, and the facility that practice will give in rendering their essential quality.

There is a manner about the Venetians in painting it, especially Paul Veronese, that may suggest what I mean,—they seem to use a flat general colour, with a flowing full brush, and then deepening the shadow, and after-wards putting on the lights. The object is to do it rapidly, and if possible in one painting.

R. W. Weir

PARIS, MAY 4, 1874

DEAR FATHER:

. . . I received Mother's letter and your addition. I will follow your advice and study drapery. I see that it is a great help and I appreciate its difficulty now more than I used to, for it is the simplicity that is to be sought. I often go to the Louvre to study Paul Veronese's drapery and arrangement, and I think it was done in very much the manner you spoke of. I am glad to tell you that the students tell me that my work this week is an improvement on any

[7] Probably Ladislaus Von Paal (1846–79), Hungarian landscape painter.

that I have done; if I can keep at the academical work long enough, it will be a good thing for me. . . .

[PARIS, MAY, 1874]

DEAR JOHN:
 . . . I was so sorry to hear that those two fine pictures by DuBois were hung so poorly [at the National Academy]. The papers that we see here are incensed. The work he sent was strong, vigorous and healthy and such as would do our landscape painters good to see. I suppose it is jealousy. If you can look at them and if you feel well inclined, write an article on them. He is a good young healthy artist, a man entirely engrossed in his art, no flippery, conceited fellow, kind and the same to all and it seems a great shame that he has been so treated. He has every inducement to live abroad and I fear he might if those who know so little about art treat him so. I look on him as one of the truest students over here. He has just left for America and . . . he has promised me he will go and see Father. He has seen the Salon and the great exhibition in the Palais de Bourbon here which the French say is one of the most liberal and largest collections of private pictures that has been gotten together here for many years and it will like enough be a life time before such another comes to pass. He meant to stop at London and see the Royal Exhibition and when he got to New York he promised the Sketch Club to write us [the] way ours compared and where it looked weakest. He is a real sterling man that we want many of and John, old fellow, as doing a good act for me as well as I know it will be for yourself, show him a little attention the short time he will be in N. Y. and if not putting you to too much inconvenience, have him down to see you. He has spoken very highly about your works and he can give you information about the Salon where he has often exhibited.
 "Old Brown,"[8] keep mum, I have just got over a quite serious sickness which there is no use of their knowing at home. I suppose I caught cold which settled in my stomach so I was impoisoned with dysentery and inflammation of the bowels, but through the knowledge of a skillful physician, Dr. Colris, I was brought through with flying colors and today I went to the Beaux-Arts but had to take it quietly. It has weakened me very much, but by the prescription of the doctor, the best wine, and plenty of beef, I hope by next week to be a man again. I don't think it strange, old fellow, that my accounts came out so badly. I keep constant communication with the doctor which is a big leak. They give me every reason to believe that I am sound, healthy etc. with the exception of catarrh, which this treatment is doing much for. I only have to go now about half as often . . .
 There is now an exhibition at the Beaux-Arts of Prud'hon's works for the benefit of his daughter. I passed a short time there today but was afraid to walk about much. He left a great number of sketches, many were very fine. He was a great composer but had a poor eye for color. His two small figures, one a boy holding the scales, the other a boy holding a club, representing

[8] A nickname for John.

strength and justice, of which father has a lithograph, these were also very fine compositions.

I feel much encouraged now in my work and this week I will get to work with new vigor. I would like to send my studies home, but do not think it worth while unless I get a good chance. This Paris is certainly as you told me the place for a young man to study art and Gérôme teaches it in such a healthy way. He will not let one dodge about for effects glaze or attempt any tricks as he terms it, but he must try to study the value of color and paint solidly. First he says unless one has the action and character it is nothing and I feel he is justly right. . . . I don't think that the same allowance that I have had this year is too much although my expenses will be smaller in some respects. Still I hope to have many models next year and these eat an allowance. What can I do for you? Shall I lay hold of some good studies at the Beaux-Arts? I have seen several lately but how about the cash? Ha! After next week when my month will be up at Boulanger's I will begin making sketches in color in the Louvre in the afternoons. Goodbye with much love.

PARIS, MAY 9, 1874

DEAR JOHN:

First of all let me congratulate you. I have seen a criticism on the picture you painted and speaking of it in very high terms; as Rob would say, now is the time, old boy, to fire your big guns. Keep in mind, old fellow, the favor I asked, to reserve the *Interior of the Foundry* for the next year's Salon here which opens the first of May. I have been delighted by having the students ask me about you and if you had sent anything to this Salon. I tell them no, but expect you will for the next one. It will give you a name here, which will be a grand thing for you and now that I have seen this year's Salon I feel confident that it will take a good place and stand a chance of a medal. Go for the strong effect, action of the figure and grouping. How I regretted that it was not there when I entered for the first time.

Now I must tell you about it. There were thirty six hundred received and I understand about five thousand rejected. The exhibition is in the Palais de l'Industrie on the Champs-Elysées. Of portraits Carolus-Duran, the court painter has two very fine ones, one of his child standing up against a green piece of drapery. This is very powerfully handled. The other a kitcat of a countess sitting in a chair, one hand resting carelessly on the arm and the other in her lap. The values throughout this are equal to a Velasquez. The flesh is painted solidly and in a masterly way, preserving the character although very highly worked up. He has a figure of a Venus, which is cold, bad in color and a horrible background, not at all like his work.

Bonnat has two works, one the Crucifixion which as a study of the anatomy of a figure is a marvel, the strongest thing of its kind I have ever seen. (I saw while at our lectures this winter the subject he had to study from. He had a cross made and got old Bozie, one of our models who is known to have killed half a dozen people, etc., to nail this subject on the cross and after he left I

saw this man crucified, it standing against the wall in our dissecting room).
All the muscles are strained and decidedly marked, but a very unpleasing
subject. But he has another picture about eight by twelve inches which is a
masterpiece, three sisters standing in Turkish costume. This is very beauti-
fully painted and fine in effect. . . .

Gérôme has three, one which I think is the finest he has ever painted.
It represents Molière and Louis XIV sitting at a table, the first reading some
play. This I would like to see by the side of one of Meissonier's interiors, as it
is painted freely, rich in color and has preserved a breadth that I doubt can be
surpassed in so small a work. . . .

A portrait by a student of Cabanel is very strong. It is of his grandfather
sitting outdoors. This is as good a head as any in the exhibition. There are but
four or five that have the real go in them. One by Henner of a lady three
quarters size with her hat and sacque is very fine. Healy, (our great American
portrait painter) has three. They look very weak and shaky I am sorry to say.
Eaton, who is a fellow American student of mine in Gérôme's studio, has a
head there that is the best representative of America. There were a great
many of the American painters refused, but there was such an amount of
trash there that I can't but think the jury were somewhat influenced. Cabanel
has a large portrait group that does a good deal of harm for him, poor in
grouping, color etc., but a figure of Abel by him is very good. Wahlberg, a
Swede, has one of the finest landscapes there. It is the interior of a forest. This
and Daubigny's I think are the two strongest landscapes there. In closing the
frame out, one could imagine that you were looking out at nature. . . . There
is a portrait of the young prince Napoleon. The day I was there there was
such a crowd about it that it was almost impossible to pass through that room.
The government sent word that if it created any signs [of disorder] then it
would have to be removed. . . .

PARIS, MAY 19, 1874

DEAR MOTHER:
. . . This week there are between seventy and eighty men working in the
atelier, so we are well packed in and no room to spare in order that all can
work from the model; about the middle were some of the old students who
are of considerable reputation, one of them was insulted and slapped his op-
ponent's face, which led to a desperate fight. They knocked over about a dozen
or more easels, men were all covered with paint, and in a few seconds the
whole atelier was in a terrible state. A Frenchman who sat beside me said that
there would be a general fight; so I, as many of the rest, put my study aside,
moved the chairs and easels back, and kept myself in as one of the reserve. For
over an hour there was the clamor of all those voices and no chance of work;
the model had got down to avoid it. It ended in a challenge to fight a duel,
which we all did our best to prevent and I think it will blow over; but I have
never seen such an infuriated crowd, for the friends of the two men came to
the rescue. They fight with anything, a chair, easel; but most generally kick-

ing is their greatest hold, and unless [under] great excitement they are a cowardly set. This is but one of the frequent brawls that has occurred here. . . .

PARIS, JUNE 11, 1874

DEAR JOHN:

. . . I have not forgotten you, old fellow; I have my eye on a man in our atelier whom I think more of than almost any artist I know of. His work has a deal of knowledge in it and it was only this last week that I had a chance to speak to him.[9] The head that he is doing this week is of a mulatto . . . I have made him an offer and will go as high as fifty francs, for it is a work of more knowledge in the line of drawing and modeling than any I have yet seen. I have tried to get a chance to get some of his works to send to you to see and study, not for your school but for either you or me. His work is studied in the most serious manner possible and there is no man I know of here who paints so broadly. So far he has promised his studies to some of his old fellow students. If I see any other good works, I will get them. I feel that in this matter, as in many others, I must not be too hasty. I find my taste and knowledge of art changing; and I want to get nothing but real good things for you, for I now know the value of such to an artist.

I drew this afternoon in the Louvre and looked up some old Egyptian statues which [the] Professor in Archeology spoke of. . . .

John, this winter has passed [and] I feel that I have merely learned what is required and in a measure how to study. I am determined to wear my elbows off over anatomy, perspective and drawing next year before I will let them keep me in subjection. . . . For some time past I have been getting up at five o'clock and working in water colors to try to get some knowledge of the use of them. . . .

[Later] . . . Wencker's sketch of the head of a mulatto has come into my possession; I have not seen a better study; it will show how broadly he works and how he studies every touch, and that the head is beautifully drawn and modeled. I got it for 21 francs. I will keep a look-out for others.

Last night I had my second lesson in Spanish. It makes the evenings pass very pleasantly and keeps one in training.

Now, old fellow, as to the state of my accounts, they are very low. I was captivated with fine photographs of celebrated works which I could not then resist. I have been unfortunate in being sick several times, owing I suppose [to] not being acclimated. My furniture is now my own, but this year I have been ignorant of the way the Frenchmen live but could not have done so if I did, so the expense in this line and in being cheated, of course, will be greater than in another year. I think I can give you an idea of what the general expenses will amount to, but there will be models and likely unforeseen things that will require a little over the general requisites. I want to get draperies, casts, photographs, things of this kind as well as books so as to acquaint myself

[9] This was Joseph Wencker (1848–1919), French genre and portrait painter.

with the works of others and learn from the great minds. There will also be
lessons in French for I want to get a first class teacher next winter.

Studio rent	$160.	800
Clothes	70.	350
Meals	300.	1500
Attendance	12.	60
Fuel-oil	52.	260
Paints, Canvas, etc.	52.	260
		3230 f.

This is about an estimate of the general expenses for the year, but outside of
these there were occasional sprees and trips into the country. This next winter
I hope to do some good work and expect to have many models, but as to the
result that will remain to be seen. I think $75 a month I can get on with, but
there are so many valuable works, photographs, etc. which will be in after
life when I have returned invaluable, that I feel that such would be so much
capital.

 . . . I was challenged the other day, but smiled at it and offered to go off to
a quiet place and with my fists give him all that he wanted. He said he was
willing but after my getting my assistant, he cooled off and apologized so had
to buy kirsch for the crowd—laughable . . .

 The challenge Julian so casually mentions may be a toned-down ac-
count for home consumption of an affair that was carried much further
than his brief description here would indicate. In later life he recalled
this *passage d'armes* with laughter; it was a story he enjoyed telling on
himself, and he would picture vividly his fright and dismay while the
proceedings were going on and his utter relief when it was settled peace-
ably. He always felt somewhat guilty at having been the cause of an "af-
fair of honor" and never told us the reason for the quarrel; but his old
friend Col. C. E. S. Wood[1] remembered the story well, and the account
that follows is as he recalled it, with a few incidents that I remember
myself:

 Julian was in some general gathering one evening in Paris, not in his own
atelier, and there was a very smart, temperamental French artist there. He
had some ragged trousers on; the seat was worn out and the bare skin was
showing. I think they were cooking something over the fire, and this young
man got up and stooped over; and Julian, who had a great sense of humor,
grabbed a paintbrush and gave him a dab of blue. When Julian realized how
insulted his victim was, he tried in vain to explain that it was just an impulse,
that he was sorry, etc., etc.; but nothing would soothe the young man's injured
feelings and he left in a rage, announcing that he would send his second to

[1] On Wood, see p. 203, n. 2 and p. 210 ff.

call. To Julian's dismay, the following morning another Frenchman appeared—with a challenge. Nothing Julian could say would change things; the man was going to fight, and his envoy wished only to be referred to Julian's second. Julian, who was naturally quick-tempered, got irritated and agreed to a meeting, and through some instinct picked as his second a tall fellow from Indiana who was very skillful with a pistol. This was, I think, John Love, one of Julian's colleagues at the Beaux-Arts, who came from Indiana.

When Julian explained things to this lanky American, the latter went into an explosion and announced that they would "give them a handful—for of course you have the choice of weapons." Julian replied that "a French duel always means swords—I used to know a little about fencing when I was a boy." "No," said Indiana, "we'll have shotguns—you can't miss with those." This was not at all to his opponents' liking; they said that it was no gentleman's duel, that it was bloodthirsty, and so on. But Indiana was adamant; the affair was in his hands now and it was going to be carried out as it should be. Poor Julian grew more and more miserable at the prospect; he had no wish to kill anyone nor did he care to be shot himself, and his predicament was not made any easier by Indiana's insistence on his staying up most of the night, practicing in some shooting gallery. The next morning at dawn Indiana called for him; they breakfasted on many cups of black coffee; and before they left, Indiana ordered some raw potatoes to take with him. They reached the appointed place in the Bois first; and just as they saw the others arriving Indiana ordered Julian to throw a potato in the air, which Indiana promptly shot—but to those coming up it gave the appearance of Julian's hitting it. Indiana also just then shot at a tiny target he had previously tacked to a tree, and hit the bull's eye, then turning said to their opponents, "We were just having a little fun; my friend Weir, here, shoots much better than I do; but he didn't think it would be etiquette to practice." This was enough for the two Frenchmen, who retired and held a conference; presently the second came up and reported that he had been talking things over with his friend and they had decided that the matter was too simple and should be arranged. Nothing could have pleased Julian more; by this time he would have been willing to do almost anything to get out of the affair. But to his horror and amazement he heard Indiana refuse a settlement; matters, he said, had gone too far unless there was unconditional apology on the part of the Frenchman. The Frenchman by now was apparently feeling very much as Julian was, and Indiana's firmness broke down his resistance; he came up and made the apology. Julian immediately repeated that it was only a boy's prank, that no insult had been intended, and the incident ended amicably with all going to a café and the Frenchman treating them to drinks.

[Enclosed with letter of June 11, 1874]

Sunday night.

After church I took a boat to Meudon, there met a friend and went off in the hills to have a good walk. We spent some time in the park of St. Cloud and saw the "chateau" which the French burned by shelling the Prussians out

of it. The remains of it give one an idea of what a beautiful place it must have been. We walked from here through the village of Sèvres to the battery of the Crown Prince, a superb outlook, Paris lies like a map; from here Mount Valérien, which was the strongest of the French forts, could easily be seen. We went from here through large woods where was the heaviest fighting, saw several houses certainly at one time of great magnificence, in complete ruins; one of the houses which must have been struck from Valérien while trying to drive out the battery of the Prince Charles, a ball struck one corner of the roof ripping it completely open the whole length. We returned to Meudon to hear the music in the park and ordered our dinners at half past six at a good old woman's where we had dined before at the Pavillon du Bel-Air, a superb view here looking over rolling hills and large orchards in the back of the house. We went back to the soldier's encampment but were disappointed to find the music did not play that day owing to a fête, so then we went into the woods, gathered flowers and ran about like young kids, met quantities of people taking their dinner out there, sang at the top of our voices, went up hill and down valley. I felt as if I had been let out of school. At about seven we returned, found the old lady in good spirits. She told us that her house was almost destroyed by the Prussians but had been made new again. The dinner of beefsteak, new potatoes, peas, bread and cider, and with cherries and strawberries for dessert, with of course café and cigarettes, was a feast for a king. She told us not to be afraid, that Sunday was made for a feast day and that we must eat heartily, which I assure you we did, which amounted to no more than we could pay for here in Paris. After the repast we went out on a side hill to see Paris lighted up. We laid down on a cock of hay and could see a few lights in the great city which was only distant five miles. My friend told me the history of his early life, his hopes and his ambitions. There was a fine sunset and as the lights in the city began to appear, the rich purple of the sky was gradually fading and one by one we saw the stars shine out. At half past nine I left and am home again but feel like a new man. . . .

PARIS, JULY 21, 1874

DEAR MOTHER:

I am writing this in my restaurant while waiting for Ward, who will dine here today. We are among the last of the Americans that are in Paris—most of them have gone to the country.

Yesterday I moved into my studio, and last night I must confess it, I was homesick and blue up among the chimney pots and the roofs of the adjoining houses, the weather so warm and everything in disorder. I have a nice little studio in Rue du Pont-de-Lodi near the old Pont Neuf, still in the Quartier Latin. Ward and I expect to go off together in Brittany and start on Thursday . . . Today I have been getting my clothes together, been to the depot to find out about trains, get canvas, paints, etc. for the summer. I also bought a trunk for two dollars, substantial enough for the trip. Saturday was the last day of school; there was a great shaking of hands and with somewhat of

sadness mingled with it. At eleven o'clock, one hour before the last sitting, Pils' students came in and said they would give a musical service at 11:30, so we all went in then; the stools were arranged at one end for the invited guests, at the other they were piled about ten feet high, and on the top sat the leader of the student band. There were four fifes, flutes, cymbals, and all kinds of loud, sharp instruments; some kept time by slamming chairs on the floor or wall, making a noise nothing less than awful. The first was a waltz in which all the students danced, then they had gymnastic feats and sleight of hand, etc. and finishing with the Marseillaise Hymn, which brought the guardians in, or rather they tried to get in but the doors were all fastened tight; many canvases chairs and easels were devoted to the gods by being smashed by the excited, happy students. When we left the room it surely looked as if a riot had taken place there. In saying good-bye all wished each other a good voyage and hoped they would bring back plenty of work. The school now is closed and the streets seem deserted, for before that one would be sure to meet some one he knew besides the shop people. Along the Rue de Seine, where most of the students pass in going to school, there are many old shop people and pretty girls who recognize an old purchaser and nod kindly, so that in going along there one feels quite at home. . . .

Day after tomorrow I hope to leave Paris, and right glad I will be . . . I never felt so disgusted with the city . . .

I have received the money which Mrs. Alden was so kind to send, four hundred and twenty dollars.

It is very much the same here in Paris as far as news is concerned. Most of the upper class have left for their resorts. Mrs. Anderson with whom I dined on Sunday, expects to live at Baden this summer. She wished to be kindly remembered to you and father. . . .

<div style="text-align:right">

PORTRIEUX, BRITTANY,
SUNDAY, JULY 25, 1874

</div>

DEAR MOTHER:

. . . This morning I arose about nine o'clock and went to the beach and took a bath, then came back and had my coffee and bread with good butter. I then went out to explore the village and suburbs. I met two artists, one of them I asked about getting models, etc., which he said was a very easy affair. . . . Having kept my promise to Father I do not work on Sunday, but today I felt very much like it. Here the French do work on Sundays the same as any other day. . . .

This evening I walked several miles over the rolling country—fine bits of scenery to paint. I saw several old mills. While sitting down enjoying the view two peasant girls with their reapers in their hands came towards me out of some wheat, they had their arms over each other's shoulders and were singing together; they stood still and presently a man came out of the wheat, sang with them, and they sharpened their knives and went back to work again. It struck me as a picture of perfect happiness. I think I will start a picture of this as I was so forcibly impressed with the whole scene. . . .

Tuesday night.

I did not finish this last night as the fête here had just begun and I went out to see the peasants enjoy themselves. The place was crowded, peasants from all about the country came, and the same thing that they have at any fête—the hobby horse arrangement seemed to be the principal attraction, old and young got on the wooden horses and had their two sous worth of riding, while a hand organ, a bass drum, and a pair of cymbals kept their excitement up until the fiery steeds were brought to a standstill. . . .

This evening a gentleman introduced himself to me and invited me to his room; he is a decorated man, a sculptor, who during the summer paints.[2] He showed me his studies and spoke very kindly to me of America. I told him of our academies, and he said he knew Ward and that when he was over here he helped him select casts for the N.A.D. He said he thought America was going to be a great country for art. I hope certainly this will turn true.

PONT AVEN, FINISTERRE, AUGUST 3, 1874

DEAR CAD:[3]

. . . I was there [at Portrieux] a week entirely among French people, and, although I enjoyed it and would have stayed there (were it not that the price this year has been changed) it seemed queer not to find anyone speaking one's own language when I thought of it, but it made little odds to me as I was at work nearly all the time. I had forgotten entirely the days of the week, strange to say, and found myself en route for this place on Sunday. Mr. Ward came down two days before I left, and as we were intending to spend the summer together we left there so that our minds might not be ruined with the thought of continually being swindled, as the little place had become quite fashionable, and of course the prices were much higher. Here we pay thirty-five dollars a month for rooms and everything, except of course the models. This little town is very queer, the houses are quaint and the peasants are very picturesque, different from Portrieux, the white cap which they wear is larger, they wear queer short dresses and wooden shoes. The men wear long hair, plenty of brass buttons on their clothes, and short breeches with buttons at the knee, black stockings and wooden shoes, together with a large hat. . . .

PONT AVEN, SUNDAY, AUGUST 8, 1874

DEAR FATHER:

. . . I am glad if those studies pleased you. I anticipated when I came here of making much faster headway and doing better work, and felt that there was a chance of their giving you a bad idea of improvement. Gérôme does not care for color and wants a student to do nothing but conscientious work, which he says I do not do, so I strive to follow his advice, and this year I feel that my work is neither one thing nor the other. Many of the students

[2] Frédéric-Auguste Bartholdi, sculptor of the Statue of Liberty.
[3] Julian's younger sister.

(those of course young and who do not know much about art) have told me repeatedly to leave Gérôme as he would spoil my good color? but I feel as he says, that drawing is the thing to be learned, and when one can draw he can do as he pleases with color. Now through my summer vacation I dare let all rules go, seeking for the richest color, but trying to master the drawing. . . .

Last evening I walked down to an old mill to hunt a sketch for a single figure. The old miller asked me into his room in the mill which serves as kitchen, bedroom and dining room. He sat in a chair in the large fireplace; and I took one; he asked me all kinds of questions about America, about the mills there, about the Indians, and what kind of wild animals, etc. we had there. I talked with him for a long while, and then told him what I had come for etc., and he showed me about. In the room there was a large clock like the one in our dining room, a large piece of carved furniture with brasses, bright as a dollar, on the old cupboard were all the plates nicely arranged against the wall. There was no floor to the room, and the bags of flour were piled even in the room. It was very picturesque. He talked continually, offered me a pinch of snuff, which of course I took, wished me good health, and asked me to come again. When I left I found that he was blind, but he knew the mill and all its corners.

I have your and Mother's photographs here with me; they are good, they bring you right before me and make me think of your painting room, when on a day like this we all used to be in there. . . .

NEW HAVEN, JUNE 13, 1874

MY DEAR JULIAN:

I am writing in my studio, and in a few minutes I must go into the Gallery to begin hanging the Exhibition. My studio is filled with some of the finest things we are to have, a fine example by Decamp *The Turkish Street Patrol, Smyrna* from J. T. Johnston's Collection,[4] also Gérôme's *Death of Caesar* from the same collection. This latter will be the central interest of the Exhibition. Gérôme may think it a strange fact that one of his greatest masterpieces should find its way into so out of the way a place. I have had it in my room for about two weeks and so have had good opportunity of studying it carefully. It is a great picture. Its interest is not only artistic, but learned and scholarly. It is certainly one of the greatest works of modern Art. I have also Father's *Microscope* which is most admirable. The exhibition will be a very fine one. . . .

A day or two since I got a package by Express from West Point—which on opening I found to be a study of a head—a Spanish looking chap, good and strong and clever. There was no word with it but I suppose you must have sent it with something else to the Point—for me—and they sent it on. This is the sort of thing I want, and some good strong things by you. In color and manipulation you can beat this, but in character it is strong and vigorous.

[4] John Taylor Johnston (1820–93), American railroader, art collector, first president of the Metropolitan Museum of Art.

I must only write a line now, but in a week or two I will write a long letter. You must write often, old boy. I will reply briskly when you tell me your whereabouts. . . .

Affectionately,
John F. Weir

PONT AVEN, FINISTERRE, AUGUST 15, 1874

DEAR JOHN:

I have just read your letter over for the third time as I do most of those I receive from you. I thought I wrote you that I had sent that study of a head to you and all about it. It is a study by the best man in Gérôme's atelier (of about eighty men) and admired by many of the old students who tried to get it. I like the broad simple way in which it is modeled and would have kept it was it not that I thought it might be good for you to see. Don't give it to the institution but always have it around, for that is the kind of work, as you can easily see, that is strong and healthy. Mr. Wencker, who painted it, has his first large picture in the large gallery at Strasbourg. This year in the Salon he had a picture hung on the line in the best room with Alma Tadema and the strongest men of the day and it lost nothing. He is the man that we look on as being the big gun of the atelier, his compositions are good and he is as earnest a student as I know of. I am glad the study arrived safely; you better have it put on a new canvas so as to preserve it. When I get back to Paris again I will keep my eye open for some good studies and send what I can. . . .

PONT AVEN, FINISTERRE, AUGUST 30, 1874

DEAR FATHER:

Today, my birthday, has launched me into manhood (i.e.) according to law. I had hoped to have a large picture finished and have been able to sign my name today, using my middle name, which I want to put on it, as this will be my first picture (if completed). I invited Mr. Wylie[5] to come and see it today, and he spoke very well of it and gave me considerable encouragement on my work. He invited me to go to his studio and showed me all his work; he has a picture of four figures sitting at a table listening to a person reading; the character is as fine as any I have ever seen expressed in my life. He has a large picture under way of Breton history, which takes in some dozen figures. He also showed me the second class medal he received in the Salon of 1872. He spoke of John's picture at the Universal Exposition and said that the French liked it very much. He related a case in which that was the only picture a French artist remembered of the American work. He hoped John would send another. . . .

Before I left there was considerable talk among the French students about there being so many foreigners in Gérôme's. None of his men passed the examination for the Prix de Rome, which has caused a great deal of talk.

[5] Robert Wylie (1839–77), American landscape painter, described by Julian as "a quiet gentlemanly man and a strict Presbyterian, a man of excellent principles and a strict observer of Sunday."

A student of Cabanel took it. For me no man could suit my case better than Gérôme, he is a very superior instructor and one whom everyone honors and respects. To show how serious he is in his work; while he was at work on his gladiator picture the only suit of brass armor of the time was in Rome; he went down there, got permission to have it cast, came back here and had one made exactly after it, which cost him over three thousand dollars. People think that these men paint pictures at pleasure and not cost them anything. Girardet, son of the great engraver you have specimens of in your *Musée du Louvre*, told me that Bonnat said that the small picture which he exhibited this year cost him over a hundred and twenty dollars for models alone, and there was only a woman and a baby. Meissonier they say has paid more for his models than he has sold his pictures for. So one sees how very expensive it is for such great artists as these, and here the models are so very cheap. The models here at Pont Aven hire out for the day, the highest charge is forty cents, in Paris they charge two dollars, but what would it be in America!

[SEABRIGHT, AUGUST, 1874]

DEAR JULIAN:

Your Mother has left a page for me to add a few lines to her letter, I do not know if she has called your attention to the spelling of some words in your letters, there should be two Ts in Brittany, etc. etc. In learning French you must try to think in French, and not in English and then translate. John came to see us just before we left for Seabright and was much pleased with your two oil studies: when you make a study with crayon do not spend time on such parts as are never left exposed in pictures—a slight piece of drapery about the middle is sufficient. Try to keep yourself *pure* and avoid all Godlessness. I am glad that you adhere to keeping Sunday holy by not working on that day, sin comes on by little and little, so that you must be always watchful. . . .

[Robert W. Weir]

PONT AVEN, FINISTERRE, SEPTEMBER 15, 1874

DEAR MOTHER:

Today has been like one of our regular October days at West Point, the air was still and pleasant! At half past five I went out for a walk, and starting off alone after a good day's work brought back those long walks I used to take. I went through woods on the hills west of the town, the sun was setting, the sky was magnificent, and I was delighted to discover the disc of the new moon. The leaves are all brown and the roads were strewn with them. I thought of you all and pictured to myself what each one would be doing should I have been able to walk in. . . .

I must tell you one adventure I had the other day. I was bringing this study from the house where I had been working, and passed two French-men, who, being curious, dared to inquire where I lived, and soon knocked at my door; when I opened it they asked permission to see my work, which I was

glad to show them; one said that he had been a pupil of Gleyre, and had studied with Gérôme. After talking quite a long while over my studies and putting on so much flattery that I feared they wanted to borrow money, he said that my touch was delicate and characteristic, and my manner of painting solidly was in the best school. This is not all; he said: "I see you will be a great man, a light, a star." Nor is this all. He asked me with all the elegance of a Frenchman if I would give him my autograph; this made me vexed, so I said in a laughing way that he was blagueing me, which he assured me was to the contrary. He showed me his sketch book, we exchanged cards, and in leaving invited me to take coffee with him in the evening, which I respectfully declined. They were travelling through Brittany and only stopped here over night. Although I believe the man was deranged I was glad for the encouragement. . . .

Father says he doesn't know whether you called my attention to misspelled words, such as Brittany, etc. in which he says there are two t's. I don't know how it is in *America,* but here they spell it with one. I would like to be home to have a good laugh over this—I found myself laughing just now in reading his letter, which made me speak of it. Whenever you see that I have a sore thumb you must let me know. . . .

We are having the English walnuts now, which grow here in great abundance, plenty of fish and fruit, and excellently bad wine, together with more fleas than one man can attend to—one is forced to go flea hunting several times through the day. I wish Charley was here to go hunting with me, for some are so big he could 'most take them for partridges. . . .

PONT AVEN, FINISTERRE, SEPTEMBER 21, 1874

DEAR FATHER:

I received your welcome letter. . . . What you advise I agree almost perfectly with, about studying portraits; this I have not in the least forgotten this summer, but I have tried to put the ensemble in practice, so have employed a good deal of time on two studies (for they can hardly be called pictures). Unfortunately I will not be able to finish either as thoroughly as I would wish to, as on the 25th of this month I will return to Paris to be ready for the opening of school, as that is what I am over here for. I have so much study of the head in the atelier, this that I have done will serve as good experience, and as I have tried to do *conscientious* work I don't think it entirely lost time. I will bring back with me eight heads, six landscapes, one study of eight figures, besides my two large studies, so you see my two months have not been idled away. I don't think I have passed more than one day without working except Sundays. I have also a study to give to the hotel to be fixed as a panel in a door of the dining room. I feel as enthusiastic about portraits as ever, and if possible will do as you suggest and get some old draperies to study background effect, etc.

I was disappointed the other day in my model and went downstairs to see about getting someone and happened to pass an open door where I saw a baby

asleep; the peasant was glad to have me make a study of it. Being afraid it would wake I was forced to make as careful and rapid a study as possible. I have compared it with work which I have spent much time on and find that there is an atmosphere and fleshiness which is hard to get except in the first sitting. I have just been in my studio to make a sketch of the head of the old woman in the study of spinning wheel picture; this is a little less than half the size that I have painted it. Girardet . . . came down to see it the other day and seemed to like it very much. The head, coif and hands I painted in two sittings each, but the old man who sits in the chimney has given me a great deal of trouble as I was forced to lower the tone of the background, and so had to repaint him entirely (Fig. 1). I took my large study out today, but could do but very little as the sun came out. I fasten it on my umbrella stick and carry it over my shoulder. When I was about to descend the hill a gust of wind struck it and nearly blew me over, much to the amusement of some peasants. . . .

I received a splendid letter from John and a criticism on my studies on account of the hardness and coldness of the flesh. Being a "nouveau" I had to take my position in the last line, which was about fifteen or twenty feet from the model. Gérôme himself told me that I was making moonlight effects but I tried to represent as truly as possible what I saw. With seventy or eighty studying after the same model those who sat nearer had less space for their work. That accounts for the eye of one of the studies I sent you not being made out, as I always got where there was no one behind me. . . .

PARIS, SUNDAY, OCTOBER 4, 1874

DEAR MOTHER:

One year ago yesterday I arrived at the École des Beaux-Arts, a "nouveau." So one year has passed and that very quickly.

I got my studies which I sent by "petite vitesse" almost ten days ago, and since have arranged them on my wall, amounting to seventeen pieces. Some students came in yesterday and thought I had more than any of the students that they had seen, still mine may be more quantity than quality. I imagine that the kind of work which I have done this summer has done me much good and has prepared me for more serious studies this winter, which I hope I will not be disappointed in.

Tomorrow the École opens, and I expect at eight o'clock in the morning there will be hearty salutations.

I received a splendid letter from Father and John; both have seized me up on what I had a slight suspicion of. John tells me my studies look hard, cold and bad in color, although I improved in drawing. I am glad he spoke of it, for although I am surrounded by the best examples, one is apt to get astray; and Father tells me of the seriousness of art. These two letters have keyed me up for the winter. There is nothing that does a man more good than to have the truth told him when he is able to accept it. Yes, I will work at heads and hands, and intend to study drapery, not as I have studied it before. I don't know how many times I have read these two letters over.

I spent a good deal of time this last week in going through the galleries, and how I relished seeing those fine works after being away all summer where one was deprived of such luxuries.

Last night at our restaurant I met several who had just come in from the country, amongst them Mr. Knight,[6] who told me Mr. John Durand[7] had been inquiring for me. I will find out where he is staying and call on him. Alas, I did not present his kind introduction to Mr. Taine. . . .

A few days ago I got some more fine photographs—three large ones of Michael Angelo, two of which I have hung over my table. My wall is covered with red paper and hung with sketches, and here and there pieces of drapery, etc. I am very much pleased with it, and when I get my stove going and my carpet down I will be ready for work. From my window I can see the Tower of St. Jacques, the beautiful spire of Sainte Chapelle, and the two large towers of Notre Dame. I am only one block from the river and in a street that is remarkably quiet, Rue du Pont de Lodi. . . .

I met this last week a young Mr. Sargent about eighteen years old and one of the most talented fellows I have ever come across; his drawings are like the old masters, and his color is equally fine. He was born abroad and has not yet seen his country. He speaks as well in French, German, Italian as he does English, has a fine ear for music, etc. Such men wake one up, and as his principles are equal to his talents, I hope to have his friendship. . . .

[6] Daniel Ridgway Knight (1839–1924), American painter, student of Meissonier.
[7] Translator of Taine, founder of *The Crayon* (1855), son of Asher B. Durand.

CHAPTER 3. ARTISTS OF PRINCIPLE, 1874-76

The atelier of Gérôme remained at the center of Julian's artistic development during his second and third years in Paris, but his horizons were broadening. Most significant were the close friendships he formed with men who shared his passion for art, all of them artists of first rank in the rising generation, men of principles and talent. There were the Frenchmen, Jules Bastien-Lepage, Joseph Wencker, Jean Dagnan-Bouveret, Gustave Courtois, and Charles Baude; the Finlander, Albert Edelfelt; and later the Italian, Filadelfo Simi. The enthusiasm of these men who lived and breathed art helped draw Julian out of Paris, beyond the limits of his first-year excursions, beyond Barbizon and Brittany to Holland and Spain, to Frans Hals and Velasquez and the Alhambra. So delightful were these years that Julian was tempted to live abroad indefinitely, but his sense of family responsibility was, after all, deeply rooted.

PARIS, SUNDAY, OCTOBER 19, 1874
DEAR MOTHER:
I received your letter as usual, glad to hear of your doings at home, and have often thought of you all lately as we are having that delightful weather now which is more perfect in America. I often imagine your walks with Father out to the end of the new road, trampling on the beautiful fallen autumn leaves. As I went through the Tuileries today I went out of my way merely to walk on the dried leaves, and it brought back my strolls about the Point, grey squirrel expeditions, etc. . . .

PARIS, SUNDAY, OCTOBER 19, 1874
DEAR JOHN:
I have your splendid letter before me which I received while in Brittany and since must have read it over at least ten times. Your stirring me up on color, etc. I hope will do me much good. I began to feel the same thing, but being a nouveau, as it were, in acquiring facility more by studying my every touch than by slashing about for pleasing color, I have no doubt I have lost

some quality which formerly was more prominent in my studies, but, John,
I feel that I am on the road now and although as you say, art is not a mechani-
cal pursuit, still there is so much mechanical work to be gone through with
and as I am almost too much "au contraire" I feel that it would be greatly to
my advantage in after years . . . to *stick* to the academies and schools, in order
to overcome those mechanical parts of the art. It is the same as a college of any
kind of learning where a man graduates after having sound principles ground
into him. Then he is ready to begin life. For instance, old fellow, I recall a
saying of some teacher I studied Latin under (this you know I never got along
with) it was always easier for me to give a *free translation* catching words here
and there, but the master halted me and said that he must insist on a literal
translation for I was a mere beginner. One gets careless and depends too
much on his own power of interpreting a great man: Nature is the great man
in my case. Now I must do very hard dry study and try to give as true and
literal translation as possible. The question has often come to me in regard to
many of our painters at home who have spent years over here and returned
scarcely any better off than when they came; all have gone in for color, their
main idea is how to produce a Titian, whether he painted on absorbent
grounds or whether his richness did not come from his priming. Now, John,
between you and I, of the pictures I have seen here of Titian and the other
great masters, their color takes the third or fourth place. For richness of color
a portrait by Tintoretto goes ahead of all that I have seen. Titian was cer-
tainly a colorist, but that was not the greatness of his art. His two portraits in
the Louvre are exceedingly disagreeable in color to me, but I have never seen
two men who appeared to live and think like those. His *Entombment of
Christ* is drawn and composed with wonderful knowledge and to me these two
qualities exceed the color, although some say that this is one of the greatest
pieces of color in existence. Raphael was no colorist at all, but now John,
color with drawing and composition lends a charm to a picture that makes it
a thing unquestionably to be sought after. . . .

You ask about the examinations here; for Yvon's class we have to pass in
perspective, anatomy, drawing from the ornament and then the life. In perspec-
tive each has a problem given him, then is driven into a long room with about
a hundred stalls just wide enough to work in and two hours are allowed to
finish it in. In anatomy the professor gives a part of the skeleton to be drawn
from memory, two hours for this also and in the ornament we have six hours.
The one this year is an urn something like this[1] to be drawn on the regulation
paper, ordinary size, all shaded up; then they make a standing in these three.
Generally some thirty or forty are dropped and according to your standing
you choose your seat to draw after the model. There are about a hundred and
sixty and out of these they select the seventy best who are admitted for six
months to draw from four till six from the life model. This winter I expect
to be a strict attendant at all the lectures and as much as possible I will work

[1] A tiny drawing here.

from life and the antique and intend having models in my studio to study the finer qualities. . . .

I called on Mr. John Durand today; he had seen Father a short time ago and gave me great pleasure. He talked rather disparagingly of art at home and said although they were getting up galleries, they had men at their heads that knew nothing of art and much money was wasted on trash, but it does not change my ideas that America has a splendid future for art, but the way *you* are going about it will do more than a thousand galleries. Still John, you mustn't sacrifice your art too much for others, you have endowments that you can't afford to let stand idle. Make up your mind to finish the Foundry picture in your strongest way, fill it with nature and send it here. I know that it will do you good. All that recall your work here speak of it in the highest terms. Turn the blast furnace on the Promethean fire and wrought out your twenty inch to explode a shell in the Salon of '75. You can do it. . . .

PARIS, SUNDAY, NOVEMBER 1, 1874

DEAR FATHER:

I have been looking forward to writing my letter home this Sunday with double interest, as I have good news of my examination. When I found that I was so well received in the night school I had given up the idea of being received in the other and so consoled myself, but to my great surprise I found my name No. 31 among the fortunate 70! It was the same examination that I tried for last year but missed. The professor is Mr. Yvon. And, [the class] being made up of the strong men from all the different ateliers, I look forward to a great benefit from it, so I will now be able to draw from the life from eight to twelve at Gérôme's and from four till six at Mr. Yvon's and from seven till nine at la Petite École under the instruction of Millet, Fauré, and two others who come four nights out of the week, and from eight till nine we have a lecture there on perspective once a week. I paint at Gérôme's, and will work on still life and composition in my own studio from one till four; besides this I find time for French lessons three times a week. My health never was better, and time never passed so rapidly. It seems that nothing but fortune has favored me since I came back and there must be a stay in the tide soon. Yesterday Gérôme told me that I had made a great deal of progress, but I can't but think it must have been accident. In the same concours an American who has been at Antwerp for a year, and a man of a good deal of talent, was refused; he is very poor so it was a hard blow for him, not having a studio nor being able to pay for models, living on almost nothing. I found that all last winter he did not even have an overcoat; thin as a rail and having to undergo the hardest economy in order to stay here. It seemed as if I took the bread out of his mouth in being received, so to make it right I gave him enough money to pay for an afternoon school, and by good chance my overcoat, which I have grown out of, just fitted him. He is such a hard, earnest worker that it is a great pleasure to help him. We have found a good cheap restaurant where

things are better prepared, and as I take my coffee in my room I will be able soon to make up the difference.

This week being Antique Week at the school I will have a model during the mornings. The picture that I painted in Brittany the students who have seen it want me to finish up for the Salon, but I think of painting it over on a different canvas, and will have a costume sent up from Brittany by Mr. Wylie, who has been kind enough to offer. . . .

Last night I dined with Mrs. Anderson who is so excessively kind that I fear she has serious intentions on me, as has been suggested in Mother's last letter, but at present I am bullet proof! . . .

I have almost finished a large still life of vegetables, which I find a very pleasant variety.

My entry in this school will give me a free ticket to the Salon and I will be able, in going to the Theatre or Opera, to go in ahead of the crowd and have the choice of seats not reserved, but I fear I will not find much time for this. . . .

RUE DU PONT DE LODI, 5
PARIS, SUNDAY, NOVEMBER 8, 1874

DEAR MOTHER:

I have just had my cup of coffee and allowance of "the staff of life." I have now so far improved myself in the art of bachelor housekeeping that I really have a good and enjoyable breakfast every morning; while I am engaged in putting the finishing touches on my toilette my tea kettle is singing merrily, and having a coffee pot such as you use at home I have no difficulty in extracting the delicious juice and preserving the aroma; then robed in the vestments of affluence, the dressing gown and slippers, I proceed with all the dignity of a monarch to the arm chair in my adjoining studio, where surrounded by the images on my wall peering from behind the rich curtains of dust, I amuse myself either by the perusing of a Republican newspaper or by the hidden treasures of some thumbed volume.

I had an early visitor this morning a Mr. Edelfelt a Finlander whose good Republican ideas and social sentiments have made him in my eyes an enviable companion, together with his more than ordinary talent, for although but twenty, I think him the most talented and well balanced student I know, an industrious worker and lover of his art. This is but to introduce to you a man who is my "chum" so to speak, and who next month will live with me and together share the expenses. Having spoken French since a child, he is as a Frenchman but with more noble ideas, and fortunately for my improvement in the French language, he knows no English. He came this morning to say that he would give congé today (here you have to give one month's notice for lodgings under three hundred francs, and over four hundred francs, three months'). So next month we expect together to besiege the temple of knowledge. You will see that I am in excellent good spirits as I yesterday laid my

oblation of work before my patron, Gérôme, and in the presence of the atelier I first showed him my smaller studies, some of which he liked, then came the larger ones; on my landscapes he complimented, on one he said that I had well chosen my subject; he liked also a portrait, and of my big Breton study he said more to me than ever before; he liked the head and hands of the old woman, and the handling he said was not bad, the general tone "pas mal"; he advised that I should get more variety in the old man, and a few other suggestions; the heads done in one sitting he had the pleasure of saying were bad, but strange as it may seem, some of the students liked those the best. But you know this does not prove that my summer studies were good, but merely that it pleased him to encourage me.

My health is so very good that I am attending all the schools that I have been received in and making myself toe the mark. I will turn my attention to composition in my spare time with ambitious hopes of making the dust fly in my studio this winter. . . .

Tell Father I am thinking seriously of working a picture up for the Salon and will try and send a portrait also. . . .

RUE DU PONT DE LODI, 5
PARIS, NOVEMBER 13, 1874

DEAR MOTHER:
. . . I went to Church and stayed to Communion in the morning; in the afternoon heard a sermon by Rev. Dr. Morgan, and this evening after having a cup of tea and toast at the American Restaurant, B.[2] and I called on Mrs. Sargent[3] and met there three young lady cousins, three most accomplished young ladies, who have travelled almost all over Europe, highly refined, and not in the least spoilt, very sensible and beautiful. It is society like this that I would enjoy mingling in with, and what a difference to the ordinary flippant silly society girl, who buzzes, laughs and tries to overcome by her surface charms the unfortunate caller. Not that I would have you think that these young ladies were blue stockings, as they vulgarly call them, but general knowledge and ladylike willingness to perform on the piano without any of that coaxing and long string of apologies which is generally the case, made the evening pass delightfully; and their knowledge of Art and Belles Lettres was surprising. I wish our girls would appreciate more the great charm that such knowledge gives to a young lady, for when one is out in the world one is able to detect this, and it is that makes a delightful companion, for beauty lasts only when one has youth, and few men there are but look deeper than that when seeking a good wife. I think our girls have a good quality in being good housekeepers; one must expect to meet hardships in this realistic world, and how much better to have a good understanding and look at it in a philosophical light. . . .

[2] James Carroll Beckwith (1852–1917), American painter, student of Carolus Duran.
[3] John Sargent's mother; the cousins were the Misses Austin.

PARIS, SUNDAY, NOVEMBER 22, 1874

DEAR MOTHER:

I have just put my room in order (swept my room) and had my comfortable breakfast and, as I generally do, allowed myself an hour of reading, which was *The Life of Margaret Davidson* by Irving (which I picked up at a second hand place on the Quai). If Father has it in his library I would advise the girls to read it. . . .

This is a beautiful day, the beautiful mist still hangs over the city. I have just been looking at the towers of Nôtre Dame and the beautiful spire of Sainte Chapelle, gilded with sunlight and the lower part lost in the mist, the smoke from the chimney pots circling up, leading one's fancy to imagine all varieties of pleasure.

Yesterday I walked through the Louvre, looked carefully at the works of the early Italian Masters, Perugino, Luini, Andrea Mantegna, Leonardo da Vinci and others; it is surprising with what purity and simplicity they told the story as regards color and richness of tone and execution. Bellini, Perugino and Luini are better represented in the Gallery of the Louvre than almost any of the other early Italian Masters. In the next Gallery I looked at Titians, Paul Veroneses, Rembrandts, Velasquez and Murillos; . . . Whenever I come out of there I feel like flying back to my room to get to work.

I have been busy lately thinking up the pose for the portrait that I want to try and paint for the Salon. I have seated myself in all kinds of ways, stood, bent and zigzagged myself to shun the accustomed poses and have at last struck on one to introduce the two hands, and come to the conclusion, "there is nothing new under the sun." It remains but to [have] knowledge and execution to treat the ordinary in the highest and simplest way. Everyone talks of the Salon now and gets enthusiastically excited over it. I find models engaged even up to the week of the opening—about one chance in five of getting in and that only on merit. My enthusiasm rises like the thermometer on a sudden transition from cold to heat, and if I can get ready what I want to without neglecting the Academy work too much, I will send a portrait, figure and landscape, all three of which I have been carefully thinking over. My future room-mate Edelfelt is getting things together for a historical picture and wants to send a portrait also. We soar high and live in hope. He is wonderfully clever and has a solid foundation, one of those men that leads one on, a fearless worker in the right way. . . .

PARIS, DECEMBER 1, 1874

DEAR JOHN:

. . . The grand examination of the year came off three weeks ago. About two hundred entered in competition for the seventy places in Mr. Yvon's class (which is called the École des Beaux-Arts propre) because [it is] the one that requires a little knowledge of anatomy, perspective and above all drawing from the life, which counts more than any other two. I heard that the "affiche" was up at four o'clock, but fearing the consequences did not dare to

go see it until after dark. My friend Edelfelt and myself went together supplied with matches. We looked over the whole list and saw neither of our names and really my knees shook. We looked again and as luck would have it found both, he 15 and I 31. Seventy were admitted so I stand above the middle. This caused champagne that evening and afterwards we took a long walk; two happier fellows it would have been hard to find. Poor Stimson did not get in. Then after that came the "affiche" of the little École, seventy-two competing there. I astonished myself still more by finding myself no. 5, Edelfelt 8, and Stimson 25.

Now, old fellow, the advantages I now have are more than I imagined even in Paris. I have the life (nude model) 8 and ½ hours a day and so arranged as to lose no time. I paint in Gérôme's from eight till twelve, draw at Yvon's from four till six and draw at the little École from seven till nine and you see I have from one till four to paint "chez moi," and oh! John, happy is no word for it. Art from sunrise until long after sunset and growing more and more interesting. I sometimes get *awfully* discouraged, as I have been for several days past, but I feel confident if I hammer away I'll bend the iron provided the anvil doesn't break.

I took my summer sketches to the atelier and showed them to Gérôme, he spoke very well of them so that I waxed strong in ambition and planted my banner on the outer wall, on which imaginary banner is a motto: "shoot at the moon if you stick in the mud"; for I now think of getting ready three pictures for the Salon if possible, a figure piece, a landscape, and portrait. The last I had the first sitting on today, it is a student who being poor I have hired to sit. He has a stunning head in color, rich reddish brown hair, red moustache and beard. The head is well up, the background is a greenish, yellowish, red piece of tapestry, finely varied. I will introduce two hands and try and paint it boldly. What an atmosphere this is to work in and how I wish you were here. . . .

All the old students are working on pictures for the Salon; everyone lies low and tells no one, but their irregular attendance at the schools creates suspicions and so it gradually leaks out. . . .

On Thanksgiving Day Beckwith and I started off in the early train for Montmorency. We had our turkey there and after dinner started to walk back to Paris. It was so very cold that it was freezing in the sun in the middle of the day. At Montmorency I saw in the old church which bears the date of 1540, some stained glass windows that surpass any I have ever seen, even Westminster Abbey, a higher class of workmanship and richness. They are like well preserved pictures by the old masters. I stood there a long while enjoying them and so pleased that I think of going out there at some future time to make some copies. We stopped at St. Denis, saw the Cathedral there and the tombs of many of the royal families of France, the tombs of Catherine de Medici and Henri IV are fine. We got back at half past six after a splendid walk of fifteen miles.

I have my eye open for sketches for you. I am invited to visit Bonnat's

School. They are entirely different from Gérôme's, much more freedom and color. Still for me I think I am in the right place for the present. . . .

PARIS, DECEMBER 9, 1874

DEAR FATHER:

. . . Xmas is very near and as the École des Beaux-Arts will be closed you must not be surprised if you hear of me in Holland, Antwerp, Haarlem, the Hague, etc. However, I will write again before then. I feel that now as I am here and things look so prosperous I could not find a better time. Frans Hals, Rembrandt, Van der Helst and the great Dutchmen have completely turned my head, although I do not the less love and admire the severe draughtsmen and those of more refined sentiments. My idea now is to leave my portraits and pictures to get hard and dry and go and look well at the works of the great men who thoroughly understood all the parts of their art. I will take notes and if possible, hasty sketches, and store my mind in a way that can't but greatly improve me even at present.

My Swiss friend[4] says he intends living in Italy, and as he has already lived there for two years he knows well the language and how to travel in the most reasonable way; he is anxious that I make a trip with him next Spring, which I have in course of meditation, although I know nothing is better for a young student than the Academical work, still I fear from the continual work there and among men who, generally speaking, go by rule, I fear to lose that part of my art which I feel is most essential, the ideas of purity, grace and knowledge of composition. However, this is far in the future, and I hope you will tell me what you think. If I went I do not know whether it would be worth while to do more than see and study the works well and return as soon as possible, to not lose too much time from the life.

How great the field of art is! I feel even now that I am only beginning to comprehend the simplest things, but still somehow or other it does not in the least discourage me. At times I feel as if I will be able to study all, but of course there are tricks. . . .

PARIS, DECEMBER, 19, 1874

DEAR JOHN:

. . . We had our banquet last night and Gérôme was in all his glory. At the end of the dinner each of the students rung glasses with him and champagne flowed freely. What a tingle of delight passed through me when I heard the click of our glasses, the touching of his glass was an event in my life. I turned and bestowed a jeu d'ésprit on Boulanger and clashed glasses with him; to the very dregs I drank, not leaving a drop of the consecrated liquor! Imagine over fifty assembled about him with eager desire to drink to the everlasting health of our more than loved patron. From here we went to the reception room where we had cigars and café and there it was that I had the pleasure of speaking to him. I told him that I was thinking of making a tour in Holland to see the works of Frans Hals. He said he went there last summer for that express

[4] Alfred Henri Berthoud (1848–1906), landscape and portrait painter, student of Gérôme.

purpose and gave me some valuable information in regard to finding his best works. I told him that we had one in our National Gallery in N.Y.[5] which he thinks was the one that was sold here some years ago, and seemed pleased to know where it was. He left about half past ten as his little child was sick. He said that for the past week he had scarcely done any work on that account. He seemed to be very much pleased and entered into the affair with the same spirit as a student. They proposed that next time we should get up something different, all appearing in costume. Afterwards a bunch of students, some fifteen or twenty of us, went to a celebrated café in the Latin Quarter, danced, raised a row, sang, and those who could walk dragged their miserable carcasses to repose in their respective garrets. It was the jolliest evening I think I ever spent.

I am working entirely at the schools now, but when I come back from my trip I will "pitch" in on the pictures I have begun. . . .

<div align="right">PARIS, XMAS EVE, DECEMBER 24, 1874</div>

DEAR MOTHER:

A Merry Xmas and a Happy New Year. I have just come in from hearing midnight Mass at the Church of Saint Roch; it is after midnight, so by right it is Xmas day. The ground is all covered with snow and has been for the past two weeks, so you see we do have occasional snow here. . . .

The École is closed for a week so that the time I take to study the Dutch art will not be taken away from my studies.

I received your good letter as well as one from St. Paul, so I feel that I have received my presents and am sitting by my good fire to write you all the first greetings. My friend Edelfelt has gone out to a reunion of his countrymen. I went out to make a call and to hear some fine music. Tomorrow, not having an invitation out, I expect to dine alone. My dinner nowadays costs me about thirty cents, but will undoubtedly swell the bill on this special occasion—very likely dine at the American Restaurant, where they have buckwheat cakes and plum pudding. Wherever I go I will drink your and Father's health as well as all at home.

This is the third Xmas that I have spent away from home. How I wish that we only had the means in our country for a student to pursue his study, but it is not so, and I see that it would be almost ruinous, unless one was strong, to be placed among money making men, for there is nothing that has spoilt many a good [man] more than this.

Last night I sat over my fire recalling all the reminiscences of Xmas time. Charley and Will will be with you I hope as well as the three girls, so that the Xmas turkey will not feel slighted. . . .

<div align="right">ANTWERP, DECEMBER 28, 1874</div>

DEAR FATHER:

You see by the heading that I am really started on my trip to the Netherlands. I did not expect to leave Paris before Saturday, but as Xmas day was

[5] *The Malle Babbe*, in the Metropolitan Museum.

very disagreeable I concluded if possible to leave in the afternoon to avoid the blue thoughts which a rainy day in Paris always gives one, and especially on that day [of] all. I rode to the depot where I fell in conversation with a French official on the subject of a Republican form of government. I found that he had served in 1848 and was true to his colors; when we parted he shook me warmly by the hand and we exchanged cards. It was then five o'clock, I had missed the train and he told me it was well I had, for I would have arrived at Lille at about two A.M. and it would have been very disagreeable, but the eleven o'clock train got in at seven-thirty and was much the better. I returned then to Mr. Beckwith's studio, where I met Mr. Hinckley (the best of Carolus Duran's students). He had just returned from America and insisted that I should dine with him and we could talk over what had passed. He is one of the most enthusiastic students over here, and although he is flowing in wealth, is scarcely equalled among the students in the amount of work he does. Mr. Hunt[6] of Boston has sent photographs of a number of his works over to some of the French artists. We toasted your health and all at home and had quite a jolly Xmas dinner after all. That night I left for Lille and arrived there at seven-thirty; the night was extremely cold but I had the big shawl wrapped around me, red handkerchief tied around my head, the knit jacket that Mother gave me, and in fact all the wearing apparel I had with me. My two companions were very amusing, one a hunchback Frenchman, and the other a Turk. They talked of war nearly all the time; when one would fall asleep the other would wake up half frozen and recount some incident of the late war when many were frozen on just such a night as this; then we would all set to work stamping, shouting, and light a fresh cigar. It was a night of adventure for me, and I do not regret it in the least.

I got a good breakfast at Lille, then went to see the Gallery. I found there a rare collection of Raphael's drawings, sixty in number, some exquisite, and besides a most superb bust in wax by him, one of the most impressive heads I have seen modeled.[7] This collection of drawings by the old Masters is large and very choice. I found many pictures that I had wished to see—a large figure piece by Duran, Delacroix, a superb Daubigny, Corot, and many other specimens of the school of today. They have two fine heads by Van der Helst and one Frans Hals. I introduced myself to a Frenchman who was copying it, and soon we became friends, and he told me that if I wished I could make use of his palette and colors, but said it would be impossible to do anything in so short a while; he had been at work at it for two weeks and had not finished the head, etc. However I accepted his kind offer and went out, bought a canvas and returned at about one o'clock. The guardian cleared the way for me and I lost no time. He returned in about a half hour and found me at work with the color. There were some six or seven people standing around me, and

[6] William Morris Hunt (1824–79), American painter, trained at Düsseldorf, student of Couture and Millet, brother of Richard Morris Hunt, the architect.
[7] This head made such an impression on Weir that two separate photographs of it always hung on his walls.

when the gentleman came up the guardian said to him in a confidential manner, "He knows the road." I finished the sketch at three, carried it to a marchand de tableaux and left my address to have it sent to Paris when dry; went to the depot where I was just in time for the four thirty-five train for Brussels; got in about eight [and] lodged with a family my friend gave me the address of. On Sunday I saw the Annual Salon, which was not very good, but among them there were some few very fine works. Unfortunately the Musée National was closed on account of work, so I could not see the Frans Hals which is there. I went to the Church of Ste. Gudule, which is very rich in architecture and has stained glass windows that are exquisite. . . .

I saw also the Musée Wiertz, a collection of pictures of a crazy genius; the drawing showed the man to be a great student, but the fancies and ideas were certainly horrible—one for instance, a woman cutting up her child, a person buried trying to get out, Napoleon in Hades, battles, slaughters, nightmares, etc. one figure some thirty feet high and such like. Curious but not interesting at all to me.

I was delighted to see the Town Hall or Hôtel de Ville; it is a piece of magnificent workmanship, the architecture is very florid—statues, buttresses and curious windows beautifully piled together. In front or rather opposite is the old house in which the Count Egmont and Count of Hoorn were imprisoned the night before they were beheaded by order of the Duke d'Albe. It was very interesting to see these things after having read Motley's *Rise and Fall of the Dutch Republic*. Verboeckhoven, the painter of sheep and pastoral scenes, lives there and I learned that, although he was in his eightieth year, he painted still and in a way that would shame many young artists. . . .

At five o'clock I went to hear Vespers at the grand Cathedral; I heard delightful music by a choir of monks, the organ is very fine and the pulpit is magnificent—large figures, birds, etc. most beautifully introduced. I thought while sitting there that the great Rubens, Van Dyck and other great men of the time had often trod the same pavement. The great picture of *The Descent from the Cross* is here, but is only uncurtained at certain times of the day. . . .

30th. I spent the morning again in the gallery; Van Dyck's compositions charm me, full of the most delicate sentiment. And I must confess Rubens' greatness was unknown to me before I came here. I made a water-color sketch of two of V.D.'s compositions and a figure, also a head of a girl by Rembrandt. I gave my letters of introduction today and was kindly shown the Academy which I found comparatively weak—the thing that I like so much about it is that all the students are forced to follow all the lectures and bring in a drawing of a skeleton once a week, as well as a drawing from the anatomical figure. They only have the model nude to the waist. For a very young student and one that is not very sincere I can imagine no better school, but I can't compare this Academy with the École des B-A at Paris; there is much more drawing there, and I don't think we have the mannerisms which I see so prominent here. De Keyser who is the Director, lectures here on composition once a

week and the students are forced to bring in a drawing which is criticised by him; this is another thing which we lack, still we have a sketch club where we try and bring a sketch once a week. . . .

At four o'clock a student called for me and we went out on the Dike where I met some eight or ten men from the Academy. I hired a pair of skates and enjoyed the "Dutch Roll"; we had quite a jolly time. . . .

I bought some yellow ochre of the famous color merchant here, Tyke, whose colors are so well known all over the world. . . .

<div align="right">HAARLEM, HOLLAND, JANUARY 2, 1875</div>

DEAR FATHER:

I am now at Haarlem, the town that I revere! the birthplace of Frans Hals! How to begin to describe this wonderful man of genius is more than I know, but let me say that of all the art I have seen so far I place him by the side of Titian, if not ahead of him, in portrait painting.

. . . [in the Hague] as you know I had a treat fit for any king—Rembrandt's *Lesson in Anatomy*. This was of much interest, it was painted very thinly and finished very highly—everything very carefully studied; there was none of that dash which is to be seen in his later work. Paul Potter's *Bull;* this was very fine, but had not that interest to me that I had expected. A portrait of Philip II of Spain by Velasquez was all that one could wish for in a portrait . . . There was a very fine portrait by Rembrandt; this I marked as being the finest head of Rembrandt I have ever seen—man with a slashed hat on [with] large feathers, I think you have an engraving of it. The celebrated picture by Titian, a Venus, a man playing at an organ; this deserves all the praises that are heaped upon it—a marvellous work. These were the gems of this collection. . . .

The Dutchmen here are terribly dear. I have tried to take all precautions [against] being swindled, going in little wayside taverns to lodge and sailing under a false name, deVere de Paris. I found in Belgium that the tavern keepers looked on English and Americans as the most delicate morsels to devour, so I speak nothing but French, and when they tell me I have an accent I tell them I came from the Provinces. Here, *mein Heer Van Looz* is a quiet Dutchman who is always drinking tea. I asked for my bill tonight to see how I was getting on, and from its size I find I will only be able to digest two meals a day—forty cents a meal—just double what I give in Paris. If this trip costs the coat off my back I wouldn't have missed it, but I mean when I get back to Paris to make up for it. The wonders of this one great Dutchman[8] are worth a journey around the world for an artist; he is marvellous, the individual character and amount of nature which he has in his works is astonishing. I can't believe that Rembrandt surpasses him . . .

<div align="center">Goodnight. With much love</div>

<div align="right">J. Alden deVere—his mark for Belgium
and Holland</div>

[8] Hals.

HAARLEM, HOLLAND, JANUARY 3, 1875

DEAR JOHN:

. . . I came here yesterday and, John, never in my life have I seen such works; the King of portrait painting. There are ten large groups of portraits which are marvelous. Now if ever you want a copy of a figure piece for your college, have one of these and you will have a gem, Reynolds no. 1—no one that I have yet seen has approached him. Had I the money and were it not that I must return to school, I would make some copies life size but alas! mortal I am, nevertheless, John, I would attack them. . . . Did you see these works? I forgot whether you took the trip up here. I hope so. I am staying at a tavern having to shun the expensive places, but all places are expensive here in Holland. I travel third class and manage on one square meal with "snick snacks" in between. Yes John, a man could afford to starve for the sake of seeing these great wonders. I see *they* had no theories, all they sought was expression and representing what they saw in a simple but *devilish* knowing way. I will throw my whims to the dogs when I get back to Paris and dig in at the schools, as a simple representer of nature, searching for the character and individuality of the thing that is before me. . . .

NEW HAVEN, FEBRUARY 25, 1875

MY DEAR JULIAN:

. . . It sends a thrill of pleasure through my veins and I seem to be back in the repose and serenity of an artist's life. Your last gave me an account of your trip to Holland. . . . I sent it on to Father and he returned me the two last they had received from you. To read them over seemed to carry me away bodily to the places you visited, for in every instance you spoke of just those places I myself had visited . . . old boy, isn't it glorious to see these statues of artists in the midst of the common life of the market place, the pride and boast of the people—the glory of cities. "Emigravit" is the inscription on the tomb-stone where he lies (Dürer). Dead he is not, but departed, for the artist *never dies*.

Your travels remind me of a young Sir Joshua. You dash off a sketch in the Gallery. Carry it wet to a dealer and have it forwarded when dry to Paris. Old boy, be true to yourself and your Art and you may carry your dignity any length, for it's hearty and genuine and has the nonchalance of the artist about it. I seemed to be with you over every foot of the road. In the nightride, in the crisp air—the blowing of fingers, the stamping of feet. You'll do, old boy.

And now that you are back again in Paris, tell me what you did not tell in your letters, fill up the gaps. Tell me of your return to the studio—of your work, of your pictures for the Salon, of all your efforts, the smaller the detail the better for they help out the portraiture of your situation. By the way I wish you would write me out the programme—in regular order—of your studies in the Beaux-Arts—from first entering until a student leaves, as I want to model our plan upon it to some extent. . . . Especially tell me just how they

begin with a new student in color, after he enters the Painting Atelier. It won't take you long to dash this all off—and I want it as soon as you can let me have it as I am about to get out a pamphlet on the subject. . . .

You must see Italy too before you return. Perhaps next summer you might go after the École closes. See Venice, Siena, Perugia, Parma, Florence, Rome, Naples, Sorrento. Paris is but a modern museum to the mystery and poetry and pathos that fills the soul in visiting these. You will see the visions of your inmost soul a reality in Italy, so don't fail to get it. Titian and the Venetian masters can only be truly seen in Venice. Michael Angelo and Raphael in Rome. Corregio at Parma, etc. There is a world of earlier Art to break in upon you, which was the school of those great men. Don't return, old boy, until your veins flow with the rich mother's milk of Art, fatten on it, and then let your own genius ripen with the experience of it.

Everything here is just as you left it. Father has not been very well of late, but is now up again. Indeed let me tell you that were you to return you would scarcely think you had been away. While absent we imagine great changes are taking place at home—the heart-strings are strained and we fancy how pleasant it would be to reappear among old friends. Don't believe it! the sensation is exhausted in 24 hours and you become an old story. So stay away and perfect yourself in your art—return already great. Make your reputation over there, for it's [a] hard and *vague* thing to make here—if made over there, it is more enduring and profitable—so if your resources should ever give way, remember it is quite as easy to make a living over there as here—perhaps easier. I would give five years of my life to be with you doing just as you are doing.

I saw a fine head by Cabanel at Mr. Walters'[9] Gallery in Baltimore . . . There also I saw Delaroche's original *Hemicircle*—from which the large one on the wall of the Beaux-Arts was painted— It was *splendid*. Walters' is the best Gallery in America—full of the finest things by the best French artists. I delivered a course of lectures in Baltimore and this is how I came to see it.

We are all pretty well. We all enjoy equally your letters. They are seized upon in the evenings and read aloud. Do write often, old boy. Send me a sketch of your picture for the Salon. Have for your motto—nothing short of absolute excellence— There are lots of second rate artists in the world but only a dozen or so of the first class—the immortals. Stick to the heads—the portraits. Fame and fortune is to be found there with less vexation and dependence upon other things.

And now goodbye— Answer the questions in this before you have had it 24 hours—let your letters be full and long. All join in love.

Your affectionate Brother,
John F. Weir

[9] William Thompson Walters (1820–94) and his son Henry Walters (1848–1931) were both wealthy collectors of art in close touch with European developments.

[WEST POINT, JANUARY, 1875]

DEAR JULIAN:

In some of your last letters you said that you intended commencing over again the picture that you began in Brittany—by doing so [you] will take the time that is growing valuable to you for other purposes to make what will only be a furniture picture of costume. You had much better confine all your study for the present to painting a *first rate head*. This can only be done by careful study in drawing, when this is done with the paste crayon, you must be careful in the eye, nose, mouth and ear, and the distances between them. When you work with the brush you must get at the character and expression as rapidly as you can, and before you take another sitting on the same head, make a careful study with crayon and then go to work with brush. Do not neglect the hand. At all times have paper and crayon (either red or black) ready to fill up odd moments. Try to simplify the method of painting flesh. Sully's palette was excellent. Do you remember it? The old masters did not elaborate much. Titian or Paul Veronese, what they did was quickly done. Look at Van der Helst's *Spanish Ambassador*. Frans Hals was more brilliant.

The only way to become a perfect master of the brush is to understand thoroughly what you want and how to do it. When you make *studies* of anything, whether faces, hands or drapery, do it as well as you *possibly can,* then when you take your brush to paint it, you must express yourself with facility.

I am afraid that Mr. Durand was disappointed in your work, or method of study. A perfect master will know what can be left out without detriment to the subject. It is not because he cannot do it, but because he knows what is essential. In drapery, when you have made your study, paint rapidly, and keep your mind engaged with the effect it is to produce. Paint warm and with a good body and avoid the foxy or tanned leather effect in flesh.

Your affectionate father
Rob't W. Weir

PARIS, JANUARY 31, 1875

DEAR MOTHER:

. . . In Carrie's letter I enclosed a photograph of the "costume picture." Father suggests that the time spent on it might be better spent on other study that would be more inspiring. I hardly understand him, as the time which I have to spend in my own studio out of school hours is but two hours in the afternoons, and the work which I am working on is nothing but portraits and figures. Having studied seriously here for a year at academy work, this picture has been a relief, . . . and be assured that if I once thought that I was working at it for the mere sake of painting a picture regardless of study I would recover the canvas. No one surely can feel the necessity of serious study more than I. I work that I may return home, but still I feel it will be long before I shall be master of my art. With the exception of Sundays I scarcely miss a day of four hours of painting at Gérôme's and four hours

drawing in the afternoon and evening schools. The more I can study, the more I find there is to be learnt; an artist can say what branch of the art he will pursue, but a student, should he be a portrait painter would be a stronger one if he understood thoroughly the figure, landscape, still life, and in fact nature in any of her different varieties; and when will an artist have the chance of studying them if not when a student? I hope Father will look more favorably on it, as this study I am trying to do most conscientiously, but if he will tell me anything which strikes him, regardless of the picture—for it can hardly be called one—I will be able to change it. The costume, which I sent down to Brittany for, cost me three dollars with the freight included, so that if it was badly invested it was fortunately not much.

. . . Sunday (yesterday) was a charming day—one of the few clear days we have had for a long while. I spent nearly all the time in the open air. I went out to the Bois de Boulogne with Mr. Swan[1] an English student, whose compositions and drawings have a finer feeling for nature than any I have seen for a long while; he will certainly be one of the great guns. He has only lately begun painting, but all the other requisites of his art he has at his control. He and I are the best of friends, and I have learned much from him. He is a highly cultivated man in learning, and an artist ought to be surely the most learned of men. Although I never despair of being great, I must confess I feel as though I were in a small boat in mid-ocean, my hard strokes seem to count for nothing. . . .

What Father wrote me in his letter is very excellent advice, and I will follow it with the two portraits that I am now working on. Drawing is still my bête noir but if perseverance will overcome it, I have yet a chance. . . . Yesterday the Assembly by one majority established the Republic on a firm basis, and now all hope for prosperity.

[WEST POINT, FEBRUARY, 1875]

DEAR JULIAN:

I received the photograph that you sent in your letter to Carrie and am much pleased with it. What I objected to was simply a *costume picture,* such as you may see at all times executed by those who cannot do anything better. I like the character and expression of the head of the old woman, but think that the hands do not give the best expression by their action, and if the left hand was raised up a little from the wrist, it would look easier. I tried to give some idea of the improvement in the light and dark of the picture, but as I wet it afterwards in order to get off the cardboard, it has nearly obliterated the work. You can however make out some of the suggestions indicated. I brought the right knee of the old woman forward a little so as to vary the line from her waist to the foot, and introduced a little more light just behind the upper part of her head. On the other side of the picture I have indicated the jamb of a small window, and by hanging a tin pan or other object to get

[1] John M. Swan (1847–1910), English animal, landscape, and genre painter, sculptor, student of Gérôme.

a sparkle of light to enliven in a subdued manner that part of the picture. Or if the old woman had something of a reddish drape on, you can repeat the color by making the pan of copper. As the light comes dimly in from what may be supposed a small smoky window, it will light up the old man, and if he is reading from the Bible, it will give an opportunity for a sparkle of light on the corner of the leaf or on his hand. The light may strike on his head and on parts of his lap, so as to make [it] interesting although subdued. The mantel shelf I would start from the old wall or jamb and introduce on it some old candlestick of tin, or cup or jug for a little color. I put more light on the spinning wheel and also on the ground near it. All of this has been washed off in getting the paper from the pasteboard, but I think you can make out the suggestions indicated.

I do not think that I call this class of picture drapery work exactly. You must always remember the higher qualities of art, and endeavor to attain these first. I did not like the idea of your beginning the work over again. I have heard some of the best colorists say that they preferred round brushes to flat ones, as they got a greater variety of tints by it. Reynolds painted with round ones, and Lawrence with flat ones—the latter they say had a water color effect.

<div align="right">

Your affectionate Father
R.W.W.

</div>

<div align="right">

RUE DU PONT DE LODI, 5
PARIS, FEBRUARY 24, 1875

</div>

DEAR FATHER:

. . . Your letter which I thought to reply to, is to me a prize. What you say I feel is right and just and I will follow your advice as well as I can. So far the schools have been my only place of study, and being one who does not readily acquire anything, I thought it best to force myself to be as academical as possible and leave the studying in the galleries until the summer time when the schools would be shut up, as this year, if not too warm, I will remain in Paris in order to take advantage of the galleries. The old Italian masters will be my principal study, to search for the composition; Masaccio, Filippo Lippi, Andrea Mantegna, Bellini, etc., and even before [the] renaissance of art in the fourteenth century. There is a new gallery in the Louvre containing good specimens by these men, even as far back as Giotto, Fra Angelico and others.

In one of my letters I sent a photograph of my Breton study which I think I can appropriately call: "John Anderson, my jo, John." I have finished it, and I am pleased to tell you that all the students who have seen it like it and are anxious it should go to the Salon. Since the photograph was taken I have painted all over it and improved it very much, having worked it all up on a lighter key without destroying the effect. I intend to give it to Mrs. Alden as my first picture. . . .

You would like to hear [how] "Taine" is thought of here. His works are

much esteemed but considered as readings [for] leisure hours; his lectures are attended by men of letters and those of curiosity, but very seldom by artists. When I first went there this winter there was a good attendance of students, but as he has a bad voice and his lectures are not practical, they have greatly dropped off; still there is a certain poetry of expression in his writings that makes them always works valuable to an' artist for leisure hours. . . . During his lectures he often makes jokes to wake up his audience, and unfortunately he is the only one who laughs.

Of the colors used by the French artists, they are about what we have. "Silver white" is considered the safest and best, but I think the English colors are much superior, especially the white and yellow ochre. The yellow ochre which I brought from Antwerp I don't altogether like; it does not seem as clear or fine as the English. The French School [stresses] the value of color, or rather the value which one object bears to another, and nothing is done (I mean the greater part) without nature. There are many who will not touch their work without nature.

I visited Girardet's atelier today and saw a picture of his which he has lately sent from Africa where he has passed the winter; also a very fine picture by Bernard, a Swiss. Afterwards I went to see an exhibition of Harpignies' works and saw him there. He is considered one of the great painters of landscape. He is about middle-age, tall and looks in the best of health; finely cut features with a sandy beard. . . .

RUE DU PONT DE LODI, 5
PARIS, FEBRUARY 28, 1875

DEAR FATHER:
. . . Now Father, I can tell you of the studio of the great Gérôme, as I called on him this morning with a student who brought some studies to show him. On entering the courtyard there are several beautiful greyhounds and some statues in the niches of the building; on both sides of the staircase as you mount to the studio are suits of armor, beautiful Chinese vases, banners, bronze statues, all artistically arranged. On the third floor we knocked at his studio door and he called out "Entrez." We went in, found him at work, and two gentlemen looking over sketches—I suppose one of his portfolios. He came forward and shook hands with us, and then asked us if we had brought him something to see. He criticized the sketches and made a joke on one in which were introduced some animals, but I didn't hear as I was looking at his picture on the easel. He came back laughing, and said a few words about my trip in Holland, then took his palette, and humming a tune, sat down to his easel to work again. I asked him where I could find the book which was written by Mr. Lenoir of his tour in Egypt, as I told him I wanted to send it to you. He said he would gladly write me the name and I could easily find it.[2] While he was talking to me I took the chance to show him the photograph of

[2] Paul-Marie Lenoir, *Le Fayoum, le Sinai et Pétra, expédition dans la Moyenne Égypte et l'Arabie Pétrée, sous la direction de J.-L. Gérôme*, Paris, 1872.

your picture which I had in my pocket. He seemed to be very much pleased with it, and said of the [portrait] of Mr. B. that it was *very well* composed.[3] He asked me about you and wanted to know if you painted still and where. He was exceedingly kind and entertaining. His studio, which is about the size of yours but much lighter, is filled with gifts given him by kings and crowned heads; from the ceiling hang all kinds of curious lamps, lots of choice drapery hangs on the walls, an immense model of a ship, entirely rigged, stands on a beautiful old cabinet, choice copies of a few of the great works are on his walls; the floor is polished wood with a few mats; two or three rich screens with costumes or drapery carelessly thrown over them give all the air of elegant luxury. Adjoining his studio is a small room with a sky light as well as a side light, and in which is a gas or charcoal fireplace where he often poses a model, closing the windows up, and has a real fire light effect. In this room is a lay figure of a horse, life size, rigged up with a coat of armor, and about the walls hang Chinese curiosities and odd bits. The carving about the fireplace and rooms is like the Moorish of the Alhambra, very rich, with divans with richly embroidered cushions. He was "Planted" in an immense pair of slippers and seated in a low wicker chair. He shook hands, said he was glad to have seen us and bowed us out. I anticipated to meet him more as at the École, but he was as pleasant as possible and I was delighted with my visit. As we went out I noticed that the statue of Julius Caesar stood nearly in front of the entrance, showing his preference [for] Roman history.

. . . I am thinking of painting something for the Centennial,[4] as that would be a capital time to make a strike; what I have been thinking was a group of the students here, those of character and promise; there are some fine heads among them and I think I could make an interesting group. I made a sketch which the students seemed to like. . . .

RUE DU PONT DE LODI, 5
PARIS, MARCH 1, 1875

DEAR JOHN:

. . . Now John, keep your eyes open for the coming exhibition in N.Y. If you see a picture of mine (which by the way, I sent to Henry's[5] charge, 18 W. 54 St.) have the kindness to see that it does not go in unvarnished, as I had to paint on it up to fifteen minutes before sending it off. It is a study I made in Brittany last summer. I fear it will be killed, if not hung out of the way, so if you have any friends on the Hanging Committee you might suggest something. I don't want Father to know anything about it till the exhibition, so you need not mention it to him. I am working on a portrait for the Salon, which I fear I will not be able to finish; I received the frame today, but I learn he[6] has been drafted for the army. Still I hope I will have a few more sittings anyway. . . .

[3] *N. P. Bailey and His Family.*
[4] The Philadelphia Centennial Exposition of 1876.
[5] Another brother.
[6] The model.

RUE DU PONT DE LODI, 5
PARIS, MARCH [21,] 1875

DEAR JOHN:

Yesterday was the last day of the reception of the pictures for the Salon. I sent two portraits, which has caused me no little anxiety; one with two hands I was almost wild over, the fellow having disappointed me in the three last sittings, and the other I began just one week before, so you can have somewhat of an idea of my feelings. A number of us students went up there in the afternoon to see the fun. I gave mine to my color man at one o'clock and at a quarter of six they had not yet arrived. I was sick with despair, imagining they were doomed. Those around were all leaving; I lagged behind until among the last, when I caught sight of my color man coming in on a double quick; I rushed to his rescue to help make room for him in the crowd. On the way up the staircase there would be bursts of applause for just arriving in time. I saw Duran there, Harpignies and many of the great guns. I understand that some eight thousand have been received, although it will not be known officially for some time. Out of all these there is but place for eighteen hundred so you can imagine that I have no very lofty hopes.

A Swiss artist invited me to finish a bottle of some excellent kirsch which had been sent from Switzerland to him. It was a glorious sight, we were both quite merry having looked over his sketches and photographs, seated on an elegant divan and surrounded by magnificent draperies, old furniture and quaint relics. He soon poured out the last glasses and then said, "Before we finish we will wake the night owls." Then taking down a guitar he improvised a song which was as good as anything I have ever heard. He seemed to lose himself entirely, a man whom before I never imagined could sing a note, and of so sedate a nature that no one would ever accuse him of being merry.

I took my portrait up to show Boulanger and Jalabert, but unfortunately one was out and the other had a sitter. Gérôme has gone off to Nice as he has not been well lately.

You ask about the manner of study at the Beaux-Arts École; each student that enters goes to the antique until he draws a tolerably fair figure and then directly to the life (not the d--n insane ideas of Jacquesson keeping a person for several years at the plasters) and when one draws tolerably well from the life (which of course is to be judged by the prof.) then he goes to painting, by only doing a part, a head, an arm, a torso, etc. and what is a great merit of the strength of the French art is that the student has his palette and color and studies to paint what he sees, without any receipt or Mother Goose's remedy or, in other words, to represent what he sees honestly with solid painting. The students who paint the whole figure generally spend two days in drawing it in. As regards to a student leaving, he ought never to leave until he has arrived at a state where his work does not improve. There are men in Gérôme's who have been there for thirteen years, but this might be said to be too long. The models they have are selected by the students from those who show

themselves every Monday, mostly men and rarely children as they can't pose well. Generally once a month we have a female. In the drawing they use the stump, shading just enough to express the darks and half tints and always they make them take in the whole of the paper, the head within a quarter of an inch of the top and the same of the bottom if standing. They find where the middle would come and then how many heads high the model is, looking for the grand lines. Perspective, anatomy, history of art are each twice a week, but the most necessary and the greatest advantage of the École is that we have the life model four hours a day to paint from and then in Yvon's school the seventy best have from four till six every afternoon. If you could get someone to leave some money or endow a chair for a model four hours each day, it would advance your school more rapidly than in any other way, for there they can study color and drawing, not as Rembrandt, Rubens nor Gérôme, but as nature inspires them. In Gérôme's atelier he comes around twice a week, Wednesdays and Saturdays; in Cabanel's he comes but once a week, and in Pils' he only visits his atelier occasionally. Pils they say is the strongest in color, Cabanel next and Gérôme the last. Gérôme is very severe with the drawing and in representing the model as near as possible, which I think is the school for a student. He is liberal and says nothing to the manner; what he wants is to have the student's study serious (which I must confess I have not yet learnt, comparatively speaking). In using the stump he will not let the beginner put in anything but the principle darks and not until he has advanced will he let him put in the demi-tint. With regard to the new student in color, give him no theories, he has nature before him, let him represent it. After he draws the model in with charcoal he sets it by pouring milk on and then when dry rubs over it a general tone of the flesh and the background in the right value with it; they have draperies of different tones to change occasionally. Make the student paint the background as it is and not à la mode. In Gérôme's there are about seventy students. The model is on a raised platform or throne. . . . The light comes in a large window so you see the painting and drawing from the life are both in the same room. If there are not enough stools or places in front, the draughtsman takes an easel but not unless.

I am sorry you have not got your *Forging of the Shaft* finished. I am now going to begin studying in the Louvre. Goodbye, much love. I have some more studies for you. Good night.

<div style="text-align:right">Affectionately your brother,
J.</div>

<div style="text-align:right">NEW HAVEN, APRIL 17, 1875</div>

MY DEAR JULIAN:

Your letter giving me an account of the system at the Beaux-Arts reached me some two weeks ago . . . I wish, if there are any official programmes or pamphlets bearing upon it you would send them to me. And now let me

gossip about your picture which is in the Academy. I went down to the opening. At the Century Club, the Saturday previous, I met Hicks[7] who said he had seen your picture at the Academy while the Hanging Committee were at work, and he complimented it highly—said you were already an artist, etc. and on Varnishing Day, E. Johnson, Mr. McEntee and Mr. Whittridge[8] all spoke well of it. It is pretty well hung—on the 2nd line—and shows well at night, being right in front of one of the reflectors. I took all the Aldens to the private view and the next day took Mrs. Alden down to see it; she was greatly pleased with it and was very glad you gave her the first results of your studies. It was just the right thing to do. There was a brief complimentary notice of it in the *Times*. I was greatly pleased with the progress it shows, and particularly with the fact that it was unlike anything else and full of the freshness of nature throughout. The old woman's head was admirably painted. If you want my criticism I should say that on the whole, it was too *black*. Not perhaps for a good strong light, but for ordinary lights, and these are what we must paint for. Then some parts were a little foggy—the woman's skirt uncertain in its folds as if not painted directly from the stuff, or hurriedly. But these are secondary matters—though it is well to be vigorous and accurate throughout. The old woman's head is most admirably painted and the arrangement of the picture capital. Ward's brother[9] had two or three pictures, carefully painted, both of them sold on the first day: one I saw, for $300. They were painted with great care and finish, though with an affected boldness. Both good pictures in their way. My criticism of them would be that they were, however, things—with perhaps the exception of costume—that had been done time and again. They reminded me of other similar pictures. Now if study abroad leads to an adopted manner, following in the footsteps of others, I think it certainly very pernicious. Don't lose individuality.

MAY 4

I have been unable to finish this letter on account of press [of] work, and my eyes have troubled me a good deal, so that I gave up everything except painting. I enclose a notice which appeared in the *Nation* of your picture. I hear complimentary things of it all around. . . .

[John F. Weir]

PARIS, APRIL 5, 1875

DEAR MOTHER:

. . . I am in great suspense just at present, as the letters from the Jury are being sent out, and [I] have already found a number of friends with sad countenances and with good reason. Tomorrow I suppose will bring me my

[7] Thomas Hicks (1823–90), American portrait painter, was a nephew of the Quaker painter, Edward Hicks (1780–1849).
[8] Eastman Johnson (1842–1906), genre painter, trained in Düsseldorf; Jervis McEntee (1828–91), landscape painter; (Thomas) Worthington Whittredge (1820–1910), landscape painter, president of the National Academy of Design 1875–76.
[9] On the Wards, see p. 24, n. 4.

news which I fear will not be of the most consoling nature. One of Duran's strongest men wanted to bet me a champagne treat tonight that I would get in. I accepted the compliment but not the bet. I look on it as being no disgrace to be refused but a great honor to be accepted; but out of so large a number which they will have to reject (viz. between five or six thousand) I can easily imagine les miens.

. . . I have been thinking of taking a trip down to Italy in Oct. [with] Wencker, one of the strongest of the atelier and already an artist. He spoke of it some time ago but I almost fear that I would not derive as much benefit as I would a year later; still a chance like that I suppose I ought not to let slip. Again the other day Mr. Mendez came to me and said that he was going to return home to Madrid and was anxious that I should go with him. But this year I feel confident I would derive more good here studying at the school—in fact I almost despair of ever learning to draw. . . .

<div align="center">

Rue du Pont de Lodi, 5

Paris, April 10, 1875

</div>

Dear Father:[1]

It is with great pleasure that I steal this time from my evening school to tell you that one of my portraits has been received at the Salon. I received a very polite note this evening from the director saying that one of my numeros had passed the Jury; it being so much more difficult this year than formerly I am led to suppose it to be a feather in my cap. I am sorry to say that there is but one of the American students I know received besides myself, and some dozen or more who have been unfortunate.

The standing in Gérôme's was judged today and I have for the next two months the thirteenth choice; having lost two days I could not carry it as far as I would have wished to.

I called yesterday on Mr. Stewart[2] (by invitation). His gallery is considered the finest private modern gallery in Paris. He received me very kindly, even surprisingly so. He took pains to go about with me and show me his different pictures. Never in my life was I more surprised and delighted; he has some nineteen Fortunys, a number of fine Meissoniers, Gérômes—in fact the finest works of the greatest men. He was Fortuny's patron, so has any number of sketches, and I must say never in my life have I seen water-colors that could equal his, most of which Mr. S. told me he did in the evenings. His work although small is broad, and by the side of Meissonier's and Gérôme's looks like life. Madrazo was Fortuny's favorite pupil and is now considered the strongest of that school. These men although they paint small, have nevertheless painted on a large scale also. A picture of Fortuny's which Mr. S. showed me a photograph of was 45 ft. long by 25 ft. high, a battle scene. It looked as if it had been photographed from nature and was beautifully

[1] At the top of this letter there is a tiny drawing of a hat with a feather in it.

[2] Alexander Turney Stewart (1803–76), American merchant and art collector; his son Julius L. Stewart (1855–1920) was a painter and a student of Gérôme and Madrazo.

grouped. Mr. S. in the course of remarks invited me to join an atelier which his son was going to start under Madrazo, the limit of students being 12, eleven of which have been selected, and he invited me to take the last. Madrazo will be able to devote more attention than Gérôme, there will be more room, and I expect a better class of men. This I think a grand chance as he stands at the head of the Spanish school. He will take great interest in trying to form a good school. Although I understand it will be quite expensive, I see in it a great advantage and will do my best to join. Fortune seems to have smiled on me, and students seem anxious to have me paint their portraits, which I take for a good sign. I traded off a copy that I made in two days to an Englishman for a very fine edition of Bacon's works, and am now painting his portrait for a choice of a fine pipe.

I forgot to mention that Mr. Stewart wished to be remembered very kindly to you; he spoke of having met you several times and wanted to know if you worked now, and was surprised when I told him of what you had done. He was exceedingly kind and told me to come often and whenever I pleased.

Tomorrow I am invited to dine at Mrs. Sargent's where I enjoy spending an evening as much as any place I was ever at....

RUE DU PONT DE LODI, 5
PARIS, APRIL 20, 1875

DEAR MOTHER:

... My portrait which has been accepted at the Salon is on a large canvas, so that I have introduced the two hands. It has given me a good name, being more difficult to get accepted this year with a portrait as two of the best portrait painters were on the Jury, Cabanel and Carolus Duran. It will give me pleasure to write to Mrs. A. of it; it may be pleasing for her to see her encouragement has not been entirely wasted. Still this does not signify anything, but it will give me a gôut for some more important....

The first of May Gérôme goes to Constantinople and then I think I will go to Madrazo's studio as I understand that it will be open during the summer. I have thought a good deal of the idea that I entertained of leaving Gérôme, and now I only think of leaving during the time that he is away. The last two times that he has been to the school he has seemed to speak so encouragingly, and advises me to be severe with my drawing. Knowing that this is my great weakness, I feel that maybe it would be a bad idea to go with one who would give me more freedom.

Last Saturday evening I was invited to a dance at Mrs. Watts', and the same old story follows, but fortunately this time I found a student whose dress suit fitted me, as one of the men said "as if I had been shot into it." Next year I must try to force myself out more in society. I go so seldom that it is one of the greatest bores imaginable....

I saw an exposition of Mr. Millet's works, who died this winter. Some of the most artistic and beautifully composed figure pieces I have ever seen. He was a peasant and rose to be one of the greatest of them all. His subjects were always rural life—the peasants at work or repose; a wonderful student. Some

of his pictures he has had on hand for years, trying to leave out as much as possible, expressing only the essential parts.

Yesterday afternoon I spent out sketching at Graselle on the Marne. It was a most charming day. We took dinner there by moonlight and got back towards midnight.

On my way home from school this afternoon I passed Gérôme on horseback. It was a beautiful animal and he carried himself so splendidly! He never works more than four or five hours a day and generally takes a horseback ride in the morning and afternoon. . . . P.S. The swallows have come and the trees are quite green.

> Direct: Rue du Pont de Lodi, 5,
> Paris and put the right postage on,
> as I have to pay double if not.
> April 27, 1875

Dear John:

. . . Now, old Brown, I must offer three cheers as I have succeeded in geting a large portrait with the two hands in the Salon. . . . With Cabanel and Carolus Duran on the jury, two of the best portrait painters, I am led to think it my first success. Day after tomorrow will be varnishing day and then I will have a chance of meeting the greatest of the French painters assembled there. I will leave this letter open and add to it after I have seen the collection.

. . . Alas John, I have seen my most miserable portrait, it lacks effect. I was almost ashamed to be seen varnishing it, but was much pleased to find that it gained greatly. Still I now feel sorry that I sent it. However I have learned much by seeing it among the good works. I saw any number of good works, one of the finest portraits I think is by a friend of mine, Mr. Bastien-Lepage and I should not be surprised to hear of him being medaled. Duran has a good portrait and a figure piece of women bathing which is remarkably strong. I went up at eight o'clock in the morning and found the place crowded. Gérôme and Alexander Dumas were strolling around arm in arm. It was a most amusing sight among the students to see some with long faces and others beaming, whose pictures happened to be well placed. Doré has the largest of all and almost the worst. The part that I am most satisfied with is that I have a free ticket and have the privilege of going in two hours before the public, which is considerable as it is always crowded. . . .

Did you send anything to the Academy this year?

I took a lesson in etching a few days ago and this evening got a proof which although bad [is] so much better than I had expected I will feel encouraged to go on with it. . . .

> Rue du Pont de Lodi, 5
> May 30, 1875

Dear Mother:

. . . You speak of people asking how long I expect to remain abroad. I would come back at once were I far enough advanced, but before I return

for good, I want to spend a summer at home (maybe the next), and when I return, go to Italy and study the other schools, but I must continue at school until I have acquired knowledge in the rudiments, for should my studies be broken into now it would be more difficult to go on with them later, and yet it would be necessary to do so. My last studies at the school have all been the full length figure, and the students tell me they are the best I have ever done. Maybe I am beginning to come out of my lethargy? No, Mother, I do not want to return without taking a medal at the Salon. So far there are not more than two or three Americans have done it, and so it cannot be done without much study.....

I will send you a pamphlet this week with the caricatures of the Salon in it. I went to the Salon yesterday to see the medaled pictures, and was much surprised to find that they had changed my portrait and put it in an excellent place. It is now in the room where the strongest portrait of the Salon is, that [by] Bastien-Lepage, and has improved from the position, but the drawing looks worse than ever. This will be a capital lesson for the next year's work. I had a good sitting this afternoon from Mr. Paupion, a student of the École; this will be one of the ones I expect to have for next year, and am much pleased to say that so far it is the best that I have done, but whether I will spoil what I have done or not will be seen. In this I have two hands and will make them a thorough study. . . .

<div align="right">RUE DU PONT DE LODI, 5
JUNE 22, 1875</div>

DEAR MOTHER:

. . . It was only yesterday that I answered a letter of a person writing the lives, or rather biographical sketches, of our American artists, and [who] wished I should write some statistics of Father's and mine also. This past week I received a letter also from a Frenchman who asked me to give him some notes of my existence as he was writing biographical sketches of the artists exposing at the Salon. This year I thought I had better not as it would look too much like posing among the students, so I did not answer it. Then I received another [letter] saying he had seen my work and requested it again which I took no notice of either. And a few days ago I received a third. So I wrote a few lines but I imagine it was too late; I understand the book has been published. My best friends are among the Frenchmen who are serious and who might think I was playing too much the role of an artist "à la mode."

I dined with Bastien-Lepage and Wencker tonight; these are two of my best friends, with Dagnan also. The first has taken a second and third class medal at the Salon, which is as much as Cabanel, his master, and the pictures that Wencker and Dagnan exposed this year have been bought by the Government for a gallery, so you see these men are already "arrivés." Wencker told me this evening that there was an atelier in his house to let, so I think I will take it, as it is out of the way so there will be few persons to bother me. My friend Edelfelt expects to return home in August so that I will be able to

break up house then conveniently, and I shall never room with another fellow should he be the best in the world, as there are a thousand little ways one is annoyed and interrupted.

Wencker is making studies for a large scriptural picture for a church for which he wants me to pose for the saint who is being stoned to death.

Mr. Hicks, the portrait painter of N.Y. called on me the other day and was much pleased; he stayed several hours and looked over all my things and then asked me to show him where I got my photographs of Velasquez. He talked much about art and especially portrait painting and he gave me some excellent ideas; he said that in painting a head he always begins with the eyes, which struck me as being very drôle. He was formerly a pupil of Couture; he said he was abroad for five years.

I heard that there was a notice in *Scribner's* of my picture.

. . '. You ask about Ward's brother. He is much better but goes to some water cure for a month. He has had success but you must remember that he has been here for four years and is a man of thirty-eight or forty years. Launt Thompson[3] told me the other day that he [Ward] has exposed in the Academy for ten years past so it is not so marvelous that his pictures have good qualities. He tried to persuade me to go down in Brittany with him again this year, but I will not, as everybody is going down there to paint Breton subjects this year, and I know I will learn more and be more serious if I remain with the Frenchmen, and then he is not a very agreeable fellow and has few friends. . . .

I went the other day to see the exposition of Corot, the great landscape painter. He was certainly one of the greatest that the world has yet produced I think, though there are many who think just the opposite. . . .

RUE DU PONT DE LODI, 5
PARIS, JUNE 30, 1875

DEAR MOTHER:

. . . I have begun taking lessons at the gymnasium and am one of the luckiest I know of. Mr. Wencker invited me to go and join the class which had just begun. I went and found myself with about ten of the most promising of the French students, two sculptors whose work was bought by the Government this year; four artists, Wencker, Dagnan, Silvestre, and another whom I forget, besides two who head the list, Courtat who took a first class medal of which there were only three given, and Bastien-Lepage who took a second class medal; so you see I am in an atmosphere of the coming great men and the only foreigner and man who has done nothing yet. Their conversation is mostly on art. We sat at a café the other night after we finished and they began telling anecdotes of Ingres, who is the greatest of all the French draughtsmen, or I might say artists, who died in 1867. His great saying was "Dessin est la probité de l'art" (Drawing is the honesty of art) which has been written on his monument which stands in the École, and certainly nothing more true was ever said.

[3] American sculptor, 1833–94.

Sunday will be the "fourth of July," glorious day of our history. I suppose it will not be celebrated until Monday. The students talk of doing as we did last year, dining together at the Palais Royal, but if I go to the country I will likely dine alone.

I am now waiting for my next allowance so that I can engage my models and go to some village and make my studies. There are but two weeks more of school and I will not be sorry when it closes; at this time of the year the place is close and the air horrible. I will make a few purchases in the Louvre to take with me to keep my eye up, but will try to keep close to what I study even if I tend to hardness and coldness. . . .

SUNDAY, JULY 4, 1875

DEAR MOTHER:

Today glorious to all who feel themselves thorough Americans! The recollections of early days and our doings at home I have brought back with fresh pleasure; the salute at Fort Putnam has I have no doubt already sounded, and the band passing in front of the house I suppose awoke all to a new celebration.

Edelfelt awoke before me this A.M., sneaked into the studio where he dressed himself up in a sheet and came into my room carrying my flag. I raised up in bed hearing a noise and saw him marching in trying to sing "Yankee Doodle." I was up in a minute and he assisted me by holding on to my nightgown while I climbed out on the roof and fastened the flag. . . .

I must tell you what occurred to a student whom they caught stealing an umbrella in school last week, although he was one of the old students and a man of about twenty-eight with quite a heavy beard. After tying his hands they took off his clothing and put on a white gown, then put a stick through his arms and knees so that he could not move; they then put one table on top of another and a stool and sat him up there, wrote a large placard, the accusation; after this was fixed, with a palette full of color and a large brush they painted one half of his beard red and the other half yellow, red streaks across his forehead and a large foolscap on his head; they then sent invitations to the other ateliers to view the affair. When some two hundred men, architects, sculptors, painters and engravers were there they got cartons and paper and built a fire around him yelling like fiends. Then when the flames almost touched him several were ready with buckets of water which they dashed over the poor creature. One can hardly imagine a person allowing a thing like that to die, especially here in France, for revenge to a Frenchman is one of the sweetest things in life. . . .

Tomorrow the Americans intend having a game of ball; I might go out in the afternoon to look on, but will not partake. . . .

I expect to make a speech to the Frenchmen of my restaurant tomorrow and offer them a glass of wine, coupling the names of Lafayette and Washington. . . .

RUE DU PONT DE LODI, 5
PARIS, JULY 5, 1875

DEAR JOHN:

I have your letter before me which I have been waiting for time to answer as it ought to be. You make use of a remark which I find very common amongst our American artists and which was breathed in my ear by the high and mighty Page.[4] However, yours was in a more "cocasse" way suggesting that if in studying abroad one loses his originality he might as well study at home. . . . When I first went to Gérôme all that I looked for was for trying to produce a good effect of color and, as we in our ignorance say, "use the model," but by degrees Gérôme led me on, until I found out that there was a human being before me which I was to represent as well as possible. . . . Now, old fellow, in the copying of a locomotive it does not suffice to copy the outside forms, the thing won't go, all the machinery must be studied, the forms, the joints and screws. One must know where to put the bowels of the machine, then after all this is done a person can know where to put the red, white and blue stripes. So it is with art, you must know where every bone is and the attachments of muscles and for this reason, Gérôme says, schools are necessary. In school he says: "There is your model. Represent it as close as possible and before you touch your canvas know what you are going to do." In this way one will make intellectual progress and when one returns to his own room, let him use what he has learned and do as he thinks. So you see, John, one cannot lose his originality unless one is a very weak mortal and then it would be the best thing for him. Originality means mannerism. Delacroix and Delaroche have both said at the end of their careers that the greatest painters are those who paint with "naiveté." This undoubtedly is the way to study and, John, old fellow, you will see that in a school such as this every man will do his best to represent the nature only as he sees it. So next year I will study more earnestly and I hope more intellectually. I feel that if I had known what I do now two years ago, I would have made a decided improvement by this time, but as that is impossible I am going to do my best to remain three years longer at the least. Your criticism on my studies was just: they are not carried far enough. It is not because I am afraid to spoil what I have done or that I am satisfied with my work, it is ignorance which disgusts me, so that towards the end of the sittings I am fagged out. . . .

P.S. You always put too little on your letters. I have to pay two francs and a half on each which takes away much of the juice. Put on ten cents for an ordinary letter.

NEW HAVEN, JULY 22, 1875

MY DEAR JULIAN:

I ran on to West Point last week and spent the night with Father, who left the next morning in the Powell for the sea shore. We talked of you in the

[4] William Page (1811–85), American portrait and antique painter.

old studio, and looked over your studies, while I read over many of your last letters. I brought away with me the female study that I wrote to you about, and of which you had written Father. I have just had it put on a stretcher, and as the man brought it in I set it down before my easel and have been studying it attentively. It beats me, old boy; it shows a training and discipline that my work too evidently lacks. There is a solidity about it and a free handling that I know little of.

On my return home . . . I found your letter in reply to the one I wrote criticizing your picture. I was glad, as I always am, to see your familiar hand, and a letter from you is an event. You seem to have been a little piqued over my remarks about "originality," which perhaps did not explain my meaning. It is quite true that one's originality, if we have any, is simply one's own way of doing a thing and of looking at things, and we do not acquire this in any school, and you are right in saying that if one *has* this he does not lose it by discipline and certainly discipline does not supply it. It was always a matter of surprise to me that such a painter as Correggio, for example, who never went to Rome where the great schools of Raphael and M. Angelo were attracting art students from all parts of Italy, but remained by himself in the then village of Parma (for it was not a large place) and set up his own academy with two or three antique fragments; should have formed for himself a style and method of work which has made him perhaps the first of painters (as such). . . . It is not the method which makes the artist, but the style and expression of his work, and this of course, no academy can furnish, for this is what the man individually supplies. But your studies show how advantageously you have spent your time in Paris and they evince the benefit of your discipline. What I said about young Ward's pictures was with reference rather to the fact that they were no contribution in any sense to the higher things in art. And then I should say with respect to your choice of subject in the *Brittany Interior* that it was commonplace. Do not misunderstand me, you know we are to talk freely to get at the real things, and we must not be thin skinned, and you are not. The element or motif of your picture was "the picturesque"—and I think the *picturesque* merely, belonged to the last century rather than to this. Artists then sought material that *made a picture* rather than a theme that pictorial expression made vivid to the mind and the higher faculties. Winslow Homer's *Prisoners from the Front* was in the true sense a contribution to Art, for although the technical execution was immature perhaps, and crude, it was vigorously in keeping with the spirit of the occasion, and the whole characteristic of the struggle between the North and the South, with the typical qualities of the respective officers and men faithfully and astonishingly rendered. This indicates the *seeing eye*, to appreciate character and the respective values that compose it, so unerringly. . . . The notions current in the schools are born of *mediocrity* . . . But you will notice that the marked ones will gradually separate themselves, as you and your few friends, and then again each of these will set up his own standard and hold to

his own views. There is a distinct inner voice in each of us that points the road through the strongest tendencies of our sympathies. The thing is to *obey* it. But this is quite enough of this sort of talk.

One remark you made in your last letter to Mother, which they sent me from West Point—you say you find yourself talking much of late about what you are *going* to do. Now from the fact that you observe this yourself, that shows that you are all right and that "your head is level." But let me suggest in addition that when one speaks of what he is going to do, he loses just so much of the power of doing it as is based upon the secretive sense of effecting a surprise, and this is always considerable in Art. There are incentives—strong ones—in keeping one's purposes absolutely secret in Art, for the chief reward the artist gets is the surprise and admiration of his brother artists. If they are prepared for it, they seldom manifest much interest. You want to surprise people into committing themselves unawares. But I am using all my paper without referring to your letter. I cannot express how interested I am in hearing from you, how every detail pictures in my mind your present life. I want to see it prolonged. For once you interrupt it the spell will be broken forever. "There is a tide in the affairs of men, which, when taken at the flood" etc. you know. This is just the very brightest period of your life and you will in the future always look back to it as such. See that it is without regret. You should get down on your marrow-bones under the overbearing sense of the importance and happiness of every moment of this *free*, invigorating atmosphere in which your present life is steeped and plunged. The sun will never again cast so few shadows as it does now, and it will never seem quite so full of mystery and light. You have my very best wishes with respect to your attachment, old boy. But be a painter *first*—that will carry off all the rest in triumph. "Gather the Eagles and master the sword," and the rest will follow in good time. . . .

I am delighted that you have withdrawn yourself from the unprofitable riff-raff of the schools and formed your intimacy with the few stray ones; like seeks like, and this is your *true* school worth going to Paris for. . . .

Your fond brother,
John F. Weir

RUE DU PONT DE LODI, 5
PARIS, JULY 19, 1875

DEAR MOTHER:
. . . I have just had a visit from Mr. Becker, an old student of Couture, a gentleman of about fifty-five. Here the young and old visit like fellow students.

Yesterday I invited Wencker and Bastien-Lepage to call with me on Mr. Stewart to see his collection. Mr. S. seemed glad to see us. We met Madrazo, the strongest of the Spanish School; he was painting a portrait of Mr. S's daughter. We met also Mr. Saintin, a Frenchman who stands well among the

artists. I said to Mr. Stewart that the small picture of Bastien's was for sale; he urged me to ask him the price, so as we were about going down the stairs I hurried and asked him. Mr. S. then politely said he would write him a letter.

In the afternoon I called on Bastien and saw a portrait of his mother which is something wonderful. He has had more than a hundred sittings. He goes in for the real art and not to make a likeness to sell; his work has not the least dash, it looks earnest in the extreme. His father and mother are peasants, a little above the common class, the real good respectable kind. While I was there he was expecting Cabanel to call and see his work. I have learned a great deal from being with him and Wencker, and I feel now that I know in what direction to study if I can only have the time.

Yesterday I was up at five o'clock getting my studies ready to show Gérôme for the Exhibition. I brought three portraits and five Academy studies of the full figure, all of which he marked for exhibition. As there were some hundred studies shown him they were passed in front of him as rapidly as possible and he would only stop to make a remark [on] a good or bad study. When he came to my portrait he asked who did it and spoke very well of it. I cut the head out of the one I exposed in the Salon and sent that there too; that however he didn't speak of, so I think the one I last painted was much better. . . .

<div align="right">

Rue du Pont de Lodi, 5
July 27, 1875

</div>

Dear Father:

The Exhibition of the works of the students of the École des Beaux-Arts came off on Friday, and Saturday while at dinner I overheard a Frenchman reading a copy of the affiche, in which I figured as taking off the third prize, which amounts to 100 f. Bastien-Lepage told me that this was considered better than taking a medal in the School, for all the medalists compete, [but] I am sorry that it has come in the shape of money which will be a hard prize to keep and nothing to show.

A copy of the affiche has appeared in all the journals of Paris; I will send you one with this letter. I am very glad on Mrs. Alden's account, for I think it will please her, now that my standing has been placed by a jury of French artists among the students. I understand that I am the first American that has ever taken one of these prizes, so it hasn't a common air among the students.

I went in yesterday to see the exhibition of the pictures for the prix de Rome. My friend Bastien-Lepage I feel sure will take it without a doubt; his picture is not ordinary at all, very strongly in the subject, rich in color, and very simple; it reminds me of a very fine old master, and what I said in speaking to Mr. Avery[5] (and which he laughed at) I still say and stick to, that this man will revolutionize art here in France. I begin already to see his influence here among the students. He is earnest and sincere in all that he does, and never tries to show his skill with his brush or in drawing, but tries to get in the sentiment of the nature before him and as he is but 25 years old has a good

[5] On Avery, see p. 13, n. 2.

time before him to "étonner tout le monde." While I was looking at the picture old Mr. Etex[6] came up and congratulated me on my prize, which put me in an excellent humour.

We had a great time the last day of school. We had a number of musicians amongst us; we danced and then sang all the old atelier songs, and then came the parting—bearded men with tears in their eyes; the feeling was very strong, many of them we will never meet again, as some were drafted in the Army and others finishing their studies, left to continue their studies in their own province. It was quite a relief when it was all over. Our examination begins day after tomorrow. . . .

PARIS, AUGUST 7, 1875

DEAR JOHN:

. . . As I was told by my friend Wencker a short time ago, the next two or three years of my studies will be worth any ten years of my life afterwards, and he advises me by all means to do my best to stay here, but why I could not see you all for a short time which would be necessarily spent away from the school, I do not understand . . . Now John a word between you and me, I fear I will never return to America to live; when I do return, it will be a visit if I am even forced to stay for ten years, but when I have amassed enough material in the way of knowledge, and become possessor of such costumes and draperies as will enable me to paint the class of subject that has always been my dream, I will then hope to return, to follow your example, but the gulf between this time and that is dark and the happy time may never arrive . . .

WEST POINT, AUGUST 8, 1875

DEAR JULIAN:

I received your letter dated on the 26th of July, and am glad to learn by it of your success at the distribution of prizes, and to congratulate you on the advance that you are making in your studies. It is no little affair to be judged by "jury" of proficients in any class, and to be commended for your progress. The paper that you sent containing an account of the affair, was received. Did you send Mrs. Alden one, and also John?

I have often said that the practice of fresco painting gives great facility to the hand, simply because they are obliged to paint quickly, and in order to do so they must draw correctly, and also prepare a cartoon with everything made out, and the light and dark definitely settled; this is all done before the colors are taken in hand, and then with rapidity the work is pushed on. Knowledge in drawing is the great motive power for executing, and when you have thoroughly studied your subject, its character and the effect, the accomplishment is a source of pleasure. Sir Joshua Reynolds knew very little of drawing, and at the time that he visited the schools on the Continent he was too old to give that time to the subject that it required; and the method that he adopted

[6] Antoine Etex (1808–88), professor of sculpture and architecture at the École des Beaux-Arts.

to bring home recollections of what he saw, was of infinite value to him, more than he had any idea of at the time—it was rapidly to rub in the effect that he saw with a lead pencil; and by this means he produced the light and dark of the picture, and consequently it gave him that knowledge in the production of a picture that arrests the attention in a crowded exhibition, that will make you cross the room to get a nearer view. His practice in rubbing in the effect of light and dark educated his eye to something that was of use to him practically as long as he lived. If you will observe, his effects are skillfully made and in all his pictures, of a pleasing character, and conducive to better elucidation of the subject.

As Mrs. Alden left town before the close of the Academy, she said that if I wished, the picture might be sent here and kept until her return. On looking more critically, I think that it is not pleasing in its form, being too square; it would be better if it were cut off just in front of the spinning wheel, making it an upright and giving it a better shape, as well as retaining all that is essential to the subject.

You have frequently mentioned certain photographs that you intended sending to me, of Velasquez and others of the old masters, but I have never seen any. Did you send them?

I hope that you cherish your highest duty, and keep yourself unspotted from the world. It is that higher life that will give dignity to your character as a man and to your works a lasting endurance among the thoughtful. We all send love. God bless you.

<div style="text-align:right">Your affectionate father,
Rob't W. Weir</div>

<div style="text-align:right">Rue du Pont de Lodi, 5
Paris, August 1, 1875</div>

DEAR MOTHER:

. . . This week I have been unusually cross and yet at the same time elated by my partial success; but my friend Bastien-Lepage who deserved without the slightest doubt the prix de Rome, did not get it on the ground that the angel in his picture did not have the light about it which was stated in the program, which is no more nor less than the jealousy of his master Cabanel. His picture is a masterpiece and I would give a great deal if we could only have a few works of that kind for our "Metropolitan Museum." The subject of the composition was "The Angel appearing to the Shepherds."

On Wednesday night I went to the banquet of the grand prize of sculpture and engraving. We were about eighty in all, architects, engravers, sculptors, painters, etc. They had a very elegant dinner, and champagne flowed like water. About nine o'clock two immense bouquets were brought in and a live rabbit and a crown of laurel. After each was crowned and the song finished, the live rabbit was handed to him, which is the emblem of success. They then brought in a platform and placed the prizewinner of sculpture on it, crowned and raised him in the air walking about the room singing; then the engraver;

and then with one acclaim they carried Bastien on their arms and placed him on the platform, and the crown on his head. The poor fellow cried like a child, and they all cried "Vive Bastien" until one would have thought the roof would have gone off.

About eleven o'clock we left the restaurant, not losing a man, and walked through the streets shouting and singing at the top of our voices, and carrying on our shoulders the grand prizers. We were surrounded by policemen a half dozen times, but when they knew it was the prix de Rome they let us go on. There was a large *café chantant* where maybe two hundred people were sitting listening to music and taking their coffee and beer. We entered there one by one, passing right in front of the music and singing and dancing as if mad. We circled around and then all sat down and called for coffee, but the proprietor would not serve us, so one of the leaders gave the signal to turn over every chair and table that was not occupied, and dance out with as much noise as possible, which, if you had been there you would have thought we did. We got home about half past one; it was the jolliest affair that I have ever witnessed. . . .

WEST POINT, AUGUST 18, 1875

DEAR JOHN:

I return the letter of Julian's that you sent to me . . . I think that his mind is getting much strength on the subject of art. He found his deficiency out in time to make a successful effort at correction, and he has acted wisely in associating himself with the strongest men of the schools. I have been much pleased with his remarks on the works of others, like most young persons he is carried off with the latest novelty, but he has sense enough to mature his thoughts before he is led far in the wrong direction.

He seems just now to think a great deal of Bastien-Lepage who I think, over works his pictures, but this will do no harm as Julian is rather careless in his study. In his letters to you he justly attributes it to ignorance.

I think that he has made great progress since he has been abroad and by associating with the most clever men he will soon find where his weak points are and strive to correct them. . . .

We received a French paper from him giving an account of the distributio of prizes in which M. Weir has taken the third prize in the atelier of M. Gérôme. I thought of sending it to Mrs. Alden as I have no doubt she would be pleased to see notice of his progress. . . .

God bless you all
Your affectionate father,
Rob't W. Weir

3 BIS RUE DES BEAUX-ARTS
PARIS, SEPTEMBER 23, 1875

DEAR FATHER:

I do not feel as if I had half replied to your letter which, when I wrote, I could not find although I had read it half a dozen times. Your letters I prize

highly, and not only read them over and over again, but allow some of my best friends to read your solid advice.

I came in town intending to go through, after I had seen Thompson's baby baptised, with Wencker, Meyssat and Baude to spend a week with Bastien-Lepage, but as they could not get off until Friday, I have taken this time to move into my new atelier, with which I am very much pleased. It is very large and fine and what will be inspiring to me is that it was once the atelier of Ingres, the greatest of Frenchmen. My bedroom is adjoining and is very large and commodious.

On my way uptown I met the nephew of Madrazo (a Spaniard), who asked me to go with him to see some things that his uncle was working on, as at present he is out in the country and we could see all in the studio. He has an old château for his atelier; all about is the ruin of former magnificence. His atelier where he paints is in the conservatory where the flowers were once kept, a place larger than your studio. It is hung about with elegant tapestries, silks and costumes of all kinds. There was a portrait of Mrs. Fortuny which was very fine, and one large life-sized portrait of a lady, very nicely drawn and freely painted. There was a head of a young woman that was as beautiful a piece of modelling as I have ever seen. We turned around all his canvases and saw some very fine work. This is the man Mr. Stewart wants me to [study] with, and if I could arrange to go there in the P.M. I might do it.

After leaving Madrazo's studio we went to young Stewart's where I saw some very good studies. He has made a great deal of improvement. He gave me a study of a head that is very nice. His place is fitted up like a Meissonier or a Gérôme's atelier with costly elegance on all sides, armor, etc. and an elegant large parrot with a long tail of rich color perched on one of the canvases, making a very unpleasant noise.

I have got entirely moved and my atelier costs me, with service, 800 francs, $160 a year, and this winter I will expect to do better work. The one I was in before was too small and the light too low.

I will do as you say about making sketches in the Louvre. A friend has promised to give me some lessons in fresco painting this winter....

I will write lots when I get down at Bastien's house....

> Damvillers, near Metz and Verdun
> at the home of Bastien-Lepage.
> SUNDAY, SEPTEMBER 25, 1875

DEAR FATHER:

"Me voila." I have arrived at Bastien's home, where I have already passed four days. They received me like one of the family whom they had not seen for years, having heard of me through their son ... The "grandpère" and the "mère" wish that I express their pleasure in making the acquaintance of your son and send their warmest compliments to you and Mother. The first night of my arrival they drank to your health and Mother's and to long life. The grandfather is 84 years old and still gay and sprightly as a man of 21. This

morning Meyssat, Baude and Wencker arrived just in time for the fête, which began at early morning. We sit thirteen or fourteen at table.

Meyssat sang the songs that he sang in my atelier, which I already wrote you about, the night that Bastien had only received the 2nd grand prize of Rome—these songs I will never forget; they touch the very heart and soul.

Mrs. Bastien is charming; although they are only peasants, I have been more fêted and feel more highly honored than if I was in the palace of a king. Mrs. B. is cook as well as mistress of the house, and I assure you she fills the *deux places* like a queen.

Jules has the portrait of his mother and father to expose this year; and I assure you that if he had not exposed those two portraits last year, which gave him equal honors with Cabanel, he would go ahead with these two; but now he is "hors concours," that is, he cannot compete for any other medal but the medal of honor, which they never give to one so young.

Think of these people having two such brave sons, Jules and Émile; one having taken the honors in painting and the other, but 21, having a half a dozen honorable mentions in architecture.

Wencker spent the night with me before I left Paris, and I went with him the next morning to see his picture which was not commenced when I saw him before. I was surprised in the extreme to see this immense canvas covered and a separate study for each figure and piece of drapery. It is immense in drawing and color. I am to pose for the head of the saint when I return from my summer's study. He will undoubtedly be medalled this year.

I will try and leave tomorrow afternoon, but they all tell me I must stay. I presented Mr. Bastien, or "le père" as we call him, with a pipe which I bought a long while ago and which Jules took a great liking to.

Tonight we will all dance; the music has already arrived.

As Weir recalled later: "That evening at the fête, I danced with the little cousin of Jules, who proved herself the most graceful waltzer in the village. She asked me if I was the American; I told her I was, 'but,' she said, 'Cousin Jules told me he was a savage, with feathers in his nose, a red tint and rings in his ears.' I assured her I had gone to a good doctor and had all these signs removed. With that she stopped in the waltz and scrutinized me, but with a pretty laugh showed that she did not believe a word of it. I was called for a long time afterwards, the gentleman with the feathers in his nose."

These people are peasants, the most aristocratic of the village, and the nicest people I have ever come across. Jules and Émile Bastien, Mme. B., "père" and "grandpère," Meyssat, Wencker and Baude, a young engraver of great talent, send their warmest regards to you and Mother.

Good night. I am anxious to return at once to get to work. I feel inspired to work harder than ever before in my life...

3 BIS RUE DES BEAUX-ARTS
PARIS, NOVEMBER 5, 1875

DEAR MOTHER:

. . . I came in town yesterday for good, and glad to get back again. My rooms are very pleasant, and beginning to look quite cosy. Monday I will get to work at the École bright and early, and look forward to doing some good study.

This coming week I will pose for Wencker for the head of St. Stephen, so you see I must be getting quite saintly in the eyes of my friend. . . .

In our atelier now Gérôme gives out a subject every week for us to make a sketch of; these are criticized before all the students. The subject this week is "Ulysses sitting by the sea bewailing the loss of his country," from Homer's *Odyssey*. This is a capital idea, and will force us to study costumes and set our faculties at work.

I spent part of the afternoon in the Louvre, and I felt as if I could go and shake hands with all my favorite portraits and bow down in reverence in front of some of those masterpieces.

I called on Sargent this evening. He has brought back some very nice sketches. . . .

3 BIS RUE DES BEAUX-ARTS
PARIS, NOVEMBER 16, 1875

DEAR MOTHER:

. . . Your letter quite startled me when I read it, about my making you all a visit. If Mrs. Alden would withdraw her kind offer of course it would be foolish for me to return, for, as Wencker told me today, all depends on the next three or four years of my life, and if it should be broken in with it would take ten years to make it up; but, when I spoke as I [did] I had imagined that the two or three months which I would spend in the country might be passed at home among you all, and to visit Miss Goodrich,[7] to whom I am engaged, and bring back with me studies of you all, which would be a great pleasure to possess. But if it is understood, as John has expressed it, I can't but agree with him in thinking it best to stay.

John has been excessively kind to me, and I shall never forget his smallest kindness; as a brother and an artist he has given me advice, like father's letters, which I have read for the benefit of my friends. Certain things which father and John have written me I look on as the soundest reasoning, and if I am strong enough to carry out but part I could be sure of some day arriving, and they tell me I am the last to be discouraged, but when I think [of] home, where money is the only thought, and where it *has* to be, I cannot imagine how art can thrive.

My friend Wencker is now painting a picture for the Salon, on which he expects to pay four hundred dollars to complete it; (he pays two dollars a day here for his models); . . . one of the best men of Gérôme's atelier and one

[7] May Goodrich; the engagement was broken off the next spring.

whose drawings are done with the knowledge of a master. Still he studies every little thing, to seek its simplest and grandest form, and, although [so] poor [he has] to go in debt for his eating (and this is a cheap country; what would be a parallel case in ours?). This is love of art. He and Bastien are both such men; they actually live on art here. My only hope is that as a tree can be grafted when young, so as to bear fruit, so I hope it may be in my case, and I suppose this must take a reasonable time, and to transplant it for a short time I cannot see how it should wither . . . I think surely a change of air would do it good. However, I will joke no more on a subject so serious, but try and accept that which is the most rational philosophy.

If I had not fallen in love I think now I would give up all ideas of ever marrying, but this girl inspires me to try and be great, and loves me equal to the love I bestow on her. You see I have now expressed by letter that which I wanted to express by word, which weighs more in frankness. And I will write and tell John also, who may laugh at what he calls wild.

I hope you will do as you spoke of intending to do, viz: to send the money which I believe came from one of my studies, and if I can get enough I will begin a large picture just as soon as possible. . . .

3 BIS RUE DES BEAUX-ARTS
PARIS, NOVEMBER 18, 1875

DEAR JOHN:
. . . We made a concours for medal last week in Yvon's, but they are too much for me yet. Using the stump and using the brush, to me are two different things and, as many of the men have been working there for years, they have a great advantage. . . .

I have just had a visit from some New York people who wanted to buy a picture, but could not make up their minds. The expression of one of the figures looked like a friend of the lady's whom she disliked, which I might have told her could be changed, but at the time, felt provoked and let it go, and from the actions of the husband, I now imagine that his anger was raised by my nude studies which I forgot to cover up, forgetting they were Americans. So it is. If ever I am able and strong enough I will never sell my things except to dealers, but the Lord knows when that will come, I don't.

Since the death of Pils, Lehman has taken his place in the École and when he went to correct he brought a pair of slippers to put on so as not to make a noise in walking about. When he left, the students who do not like him at all as Prof. burnt one of his slippers and painted the other one all over, then made a large caricature of him on the wall. This enraged him, but he kept cool and the same day they sent a delegation to his house asking him to resign and in place of doing as would please these rascals he dismissed them all, and only accepted those who came forward and made their excuses, so that now the atelier is not half the size it was before and those men had to go in [an] outside atelier. . . .

Last night, Saturday, a body of us went to meet Bastien at the station. He

has just arrived from the country. He has just received a command for a picture for one of the cities, also a portrait to paint for le Secrétaire des Beaux-Arts. He has brought with him the portrait of his father and a landscape which is "sans pareil," delicate in tone but rich in the feeling of nature. The first question he asked was about the Salon, which question all the journals of Paris have been full of, viz. to only have a Government Exposition every four years. He was wild in excitement as was every student who wants to see fair play. This scheme has been gotten up by the old fogies who are already getting jealous of the rising men. . . .

<div align="right">CHEZ DUBOIS, NOVEMBER 29, 1875</div>

DEAR MOTHER:

This is our chess night, and there being now an unequal number I resign my place to have a little chat with you all at home. Once a week we meet at each other's studios and play chess and have a quiet and enjoyable evening. This time we have congregated at DuBois' studio, Émile and Jules Bastien; Wencker and Dagnan have just left, so but the five remaining warriors *remain*. These meetings are excessively interesting as we have a mêlée of the two serious arts and we have often very interesting conversations on *art*, which counts even more than our chess playing. . . .

I understand that the Munich students are making a great effort to overshadow the American students here, which I would not be surprised if they did, as most of the men here feel as if they could not afford the time from the schools, etc. to make an effort to paint pictures, but whether these ideas are right or not is another thing.

The more I study the more I feel that I would like to be able to make a first-class study before I go to work painting pictures, although we work at compositions, etc. continually; but art which once seemed so pleasant and easy seems now more and more serious and difficult, and I sometimes think if it continues so by the time I am sixty years old I will know nothing. . . .

From all I understand I will have the portrait to paint of a child of Mr. Thorne[8] of Fifth Avenue, which I have been promised by young Avery. . . .

<div align="right">3 BIS RUE DES BEAUX-ARTS
PARIS, DECEMBER 20, 1875</div>

DEAR MOTHER AND FATHER:

. . . Now I will go back and tell you what has taken place within this past week. We had a "bien venu" . . . We decided on having the dinner at Clamant, where some thirty of us arrived after a short ride in the cars. The country was robed in its beautiful snow dress, and we had a tramp in the snow of about three miles before reaching the châlet where our "massier" had ordered our repast, and after knowing exactly the location of the place, we started off in parties to get up a good appetite and enjoy the country. Our little squad was composed of Dagnan, Courtois, Bastien and Wencker. Our conversation

[8] Samuel Thorne (1835–1915), American businessman. He had retired in 1872.

was art of course, and we went even so far as to strip to see how flesh would look against the white snow. Some took notes of some winter tones, to impress more firmly on their minds. We got back about five, and before dinner we had the "nouveaux" sing for our edification, which was somewhat drôle. The dinner was a perfect success, wine at free disposal after dessert. We all tied our napkins around our heads, which is the custom, and while we were having coffee, each one sang a song, and Meyssat sang his famous song "Les Sapins," one of the finest things I have ever heard. At half past ten we turned our steps back towards the depot singing "en masse" all our old atelier songs. Some of the nouveaux, who became "anciens" that night, lost their bearings and were carried on the backs of their chums. I had a very interesting talk with Bastien on portrait painting, which he is wild with enthusiasm over. We arrived in Paris about 12 and separated at the station. . . .

Thursday we went to the Grand Opera, where we heard Faure, the great singer, in *Don Juan*. This opera is so full of exquisite melody and airs that one could never take it all in; it is one of those masterpieces that one can never get tired of. I met Bastien and Wencker. B. was invited by Mr. Wallon,[9] "Minister of Fine Arts," a very distinguished man. I met a great number of students there. The French students are almost as fond of music as art, and why not? They are bred on it from their youth. You see often the poorest students there who eat a ten cent dinner, occupying a dollar and a half seat. Living is the last thing they think of. We saw the magnificent foyer which was decorated by Baudry. . . .

Then on Friday night we went to see the celebrated tragedian Rossi; he played Macbeth that night and, although it was all in Italian, I was never so impressed at a theatre before. He was called out four times and large bouquets were hurled on the stage, and a beautiful gilt crown. I never saw such enthusiasm. He was simply immense. . . .

<div align="right">

3 BIS RUE DES BEAUX-ARTS
PARIS, JANUARY 3, 1876
</div>

DEAR MOTHER AND FATHER:

A Merry Xmas and a Happy New Year I hope you have all passed at home. And your *too* bountiful gifts . . . I thank you for with all my heart, as funds had given out, and the long looked for semi-annual letter has not yet arrived, but I felt when I got it like going out and getting something to send back to you all. I imagined you all and the old Xmas book,[1] and Edgar Poe's works which we always used to devour. . . .

On New Year's Day I arrayed myself in my war paint with my swallow tail and went out with a Mr. Johnston from Philadelphia and made some fifteen or sixteen calls, but did not make all the rounds; had a delightful call on Mr. Stewart and met Mrs. S., who recognized me as the young man who

[9] Henri Alexandre Wallon (1812–1904), French statesman and historian. At this time Bastien was painting his portrait.
[1] *A Book For Christmas and The New Year* was a collection of articles published in the *Illustrated London News* since 1842, when it first appeared.

had painted a portrait which her husband had talked much about. The said portrait of the old peasant Mr. S. encouraged me again to go out and finish up for the Centennial. . . . I accepted an invitation at a Russian lady's house on New Year's night After wishing the compliments of the Season, I was invited to drink her health. I left the gorgeous Salon and followed, much embarrassed before the roomful of guests. We went to the dining room, where were spread the luxuries of wealth, and was presented a glass of wine, which I drank in accordance to her health; then she, taking a cigarette, offered me one, and we took a few whiffs and returned. This she informed me was the custom in her country, which I thought assez drôle. However, the evening was charming. An opera singer who has been engaged for the Grand Opera here, but, owing to her delicate health, has not yet performed, sang that night, and such a voice as I have never before heard. If you could only have seen your accomplished son getting off his best French to the fair damsels who are never allowed to even sit alone; their mama is always near or behind them, and surveys each of your remarks, so that the position is all that is embarrassing. . . .

ATELIER DE M. DuBois
PARIS, JANUARY 11, 1876

DEAR MOTHER AND FATHER:

You see I am again occupant of my old friend M. D. tonight. It is biting cold, the thermometer has been away below freezing for the past four days, and this evening I accepted his invitation to write by a good fire and drink some famous Kirsch, so here I am. Old Bunce, the Venetian painter,[2] is asleep on the sofa, from whose corner of the room you occasionally hear a sonorous note which brings back to my mind the old sofa in our front parlor. Is such now the case, where Mother would take her five minutes for collection of thoughts?

Yesterday was a glorious, clear, cold Americana. We started off, instead of going to church, for a walk, and, apropos the cold weather, we carried our skates along. We had a jolly little breakfast at eleven and walked up the Champs-Elysées through the Arc de Triomphe on along the Cour de la Reine to the Bois de Boulogne, where we thought we might find some good ice. But this the gendarmes would not permit as the ice was not thick enough for a large crowd. So on we went, gossiping on art, which takes the place of a band of music, and one thinks only of the conversation. We found ourselves about three o'clock at Suresnes a walk of fifteen miles. There we had some hot coffee, and walked down the Seine to St. Cloud, where we found the skating also forbidden. And, while looking at the view of the old château, I remembered a pond in the bois de Meudon, where we knew no gendarmes could be, and, as that was only five miles further, we started off, passing through Sèvres, where the great porcelain manufacturings are, and Bas-Meudon, then mounted the hill, and after a good walk in the bois we saw a wall, which, on

[2] William Gedney Bunce (1846–1916), an American painter, had a studio in Venice.

climbing to the top of, we saw a fine pond, so we got each other over and about five o'clock had our skates on and had a jovial time. The big full moon was up, so that it was very light, and the most beautiful effect. Although quite tired, we enjoyed a fine skate, and left at half past six. I took them to a farm where I had been last summer, and we had some good milk and a talk with this good, honest old woman, who was living in a miserable place, but being so cheerful and happy. We made up a little purse of money and I slipped it into her pocket and told her on leaving that she would find her happiness in her pocket, but which she did not quite believe, but on putting her hand in she wanted to embrace us all. At Haut-Meudon we had a good dinner and returned to Paris in the 9 P.M. train tired but delighted with our day's walk. . . .

I have just had another invitation to that Russian Lady's house, but will send my regrets. . . .

<div align="center">

3 BIS RUE DES BEAUX-ARTS

PARIS, JANUARY 16, 1876

</div>

DEAR MOTHER:

. . . Now gloire à les Arts! The child's portrait is finished, the parents pleased, and me *paid*, which will give me a head start, and answer as an Ex. Portrait for the N.A.D. Now I will return to the large portrait of Miss A.,[3] and tomorrow begin the interminable sittings which I hope will last until it is brought through the sea of discouragement to the haven of partial success. Why it is I do not know, but each thing I do now gives me more pains than ever and discouragements to boot, but at the end it turns out better than any that has gone before, but when things go wrong all the encouragement I get weighs as nothing. Undoubtedly I am becoming better acquainted with myself.

I have just been up in Ward's studio. He has brought back a half dozen pictures from Brittany, some very good things. He has gone into painting pictures which will do him much more good in America than studying the way I have gone about, but his age demands it, but with my *case* I want to go on in the way I am for some time yet, to try and wean myself from the American way, as John has expressed it, of painting pictures with system of humbug, etc. Nature is what I am going for in as intelligent a way as possible, and I intend to stick to the schools as long as I possibly can, for the longer I live the more I agree with Ingres, the greatest painter of France (that was), "Le Dessin est la probité de l'art" . . . Here at the schools boys begin from ten till fifteen to commence to draw, and if I had had the same chance I believe I would have been a happier person at present. However, things are moving slowly. I made a concours for Medal last week, but fear my chance is small. Unfortunately one can only do his best, and when it comes to drawing among sixty it has to be judged by comparison, so nothing but good work is even considered. . . .

I called the other evening at M. Dejean's, an art student et père de

[3] Daughter of Elizabeth C. Anderson. See p. 32, n. 3.

famille, and there I met Mrs. Healy,[4] who displayed the most woeful taste in dress, endeavoring to pass for a girl of sweet sixteen. She reproved me quite severely for not having called on her, so that I must go up some time for conscience sake. This is the worst of knowing people. But for my studies I would enjoy it, but they do not go well together; but I seek for the happy medium.
. . .

I must tell you of a little spree we had the other night. We went to see some old draperies which a gentleman had gathered together in the south and east, which were exquisitely fine. We stayed there rather late, and when we got near our quarter we proposed to make him a combined gift to show our appreciation of his cordial reception, so we carried off and tore down all the signs we could find in a number of streets until we were loaded down with them; we carried them up to one of the men's studios, where we had them packed in a big box and sent to him. One big tin sign was about a yard high; many of exquisite pattern; a barber's sign, umbrella, and other quaint and curious bits. As they were sent incognito we have not yet heard—the part where the laugh comes in—still we imagine that such will be the case, and we will have a good roar. This is what we call and have learned to look on as a quiet joke. . . .

WEST POINT, JANUARY 16, 1876

MY DEAR JULIAN:

I hope that you continue well and that you are faithful in your duties to God. You must remember that we are not only continually in his sight, but that He knows the secret thoughts of our hearts. Always try to improve yourself in the choice of your companions, as with the refined and pure you will become refined and pure.

What is Mr. Sargent doing? Is he studying art?

You must do all that you can to paint a *good head*—the foundation of this is to draw the head and hands well, to color well, and produce a pleasing effect of light and dark.

Live carefully, and be careful of the means afforded you for study.

There is nothing doing here except in the way of portrait painting; other pictures sell for little more than the frame and canvas. There have been a number of sales lately, and all at a sacrifice. Huntington has had as much as he could do, but all the other artists, even Gray, can scarcely get enough to live.[5] There have been a great many failures in England, which have affected our merchants and caused a number of failures here, with a desire to contract expenses as much as possible—and as they can do without pictures, do not buy. There is a bill now before Congress to cut down our pay, if it passes it reduces me 1240 dollars. I sent to you a Bill of Exchange some time ago which I hope you have received. . . .

4 Wife of George Healy. See p. 32, n. 4.
5 Daniel Huntington and Henry Peters Gray, both historical and portrait painters.

John was here about two weeks ago . . . He is making great progress in portrait painting, and is determined to excel. He had a picture at the last Century Club meeting which all the artists spoke of with the highest praise.

With a thorough knowledge of drawing, and a good eye for color and effect, you can paint a picture in five or six sittings that will command from three to five or six hundred dollars. Huntington has raised his price to $750.

We are tolerably well, with much love from all,

<div align="right">Your affectionate father,
Rob't W. Weir</div>

<div align="center">3 BIS RUE DES BEAUX-ARTS
PARIS, FEBRUARY 7, 1876</div>

DEAR JOHN:

Another snow storm has come and with it comes also a curious thought of fellow warriors in the field of art. Father writes me that you are making great strides in portrait painting and that a picture exhibited by you at the Club, has received much praise among the artists. How often I have wished to see your things and become thoroughly understood "avec nos idées," but as I have seldom become well enough acquainted with any person to understand his reasons for things, so I doubt if we will ever know one another perfectly in our art. We all have different ideas, which we cannot compare, for as one progresses, new ideas arise and we wonder how we could have continued in the way we have just left . . . Reynolds says that the head and the hand must be both educated together, here I differ . . . The mind is the only means by which the hand can be cultivated, but as for composing a picture, for the present I want to be as bête as an enfant of ten, by *these* rules of art one is constrained and the naiveté is lost which to me is one of the greatest charms and which you will find that the old masters all endeavored to get, but being trop habile sought another course. To me therefore there are no rules except those which your own feelings suggest and he who renders nature to make one feel the sentiment of such, to me is the greatest man. I have within the past two years been trying to paint in a manner different from the way I now think and feel, so now if there is paint on the canvas or not as long as it makes you feel the influence that nature has had on you it is good art. You find this in Velasquez more than in almost any other artist. But above all color painting etc. comes drawing, without which an artist can never live, so I attend all the evening schools possible and before painting work over and over my drawing, trying to leave nothing to chance. If I could have been drawing until my eighteenth year I might have done something by this time, but now it will be long before I do anything étonnant. However, I have all the espérance if I only have the time to continue slowly and [am] not forced to paint for money, the great drawback to all our American students. Even here in Paris they are forced to paint pictures against their own ideas, in order that they may be bought by American dealers and travelers. . . .

3 BIS RUE DES BEAUX-ARTS
PARIS, APRIL 8, 1876

DEAR FATHER:

You will be glad to hear that both of my pictures have been received at the Salon. The large portrait of Miss A. I felt very uneasy about as I did not finish it as I wanted to, but sickness prevented. Now the thing to be seen is how they will hang it. I am told that more have been refused this year than the last, 4000 out of 6000. The Jury have been at work since the 20 of March and finished on Friday last. . . .

I can't help from feeling sorry that I allowed John to influence me in [not] sending to the Centennial. I think if my works are good enough to be accepted out of four thousand to be exhibited at the Salon they might pass in America. . . .

3 BIS RUE DES BEAUX-ARTS
PARIS, APRIL 24, 1876

DEAR FATHER:

. . . The concours for the ten students to go in loges for the prize of Rome has come off. Dagnan from our atelier went in the first, Wencker fourth, Courtois eighth, and Bastien ninth. This is the order in which they were placed in the painting of the figure. The ten best selected from the thirty best, who were selected from about two hundred or more. I never felt so like being naturalized a Frenchman as I did during this examination, as only Frenchmen can try for it. They were locked in their rooms, and even had to sleep there, not being allowed to go out for thirty-six hours. Now they have to stand by the sketch, and if they alter the pose of their sketch they are ruled out.

Bastien has got me to make a copy of his little *Première Communicante*, which he exposed last year at the Salon, and from which I think I have learned much in regard to simplicity. His work is more like a Holbein than any I have ever seen.

Yesterday I went up in the afternoon to see the works of Manet, who has been creating a great talk. He, like our friend and crazy compatriot, Col. Fairman, was refused at the Salon, and now exhibits his works with the idea that the public have been deprived of a great pleasure. Still he differs from our countryman in that his value of color is not bad; this, however, is all I can say of him. His portrait of a man full length has no bones in his leg, which he considers a trifle, as color is the great thing in art, but the French Jury has enough good sense to differ with him on that point. His atelier [is] elegant, and he a good friend with the paper correspondents. He had a book there for people to write down what they thought of his work. This was the best of all; almost all making some joke on it. . . .

3 BIS RUE DES BEAUX-ARTS
MAY 3, 1876

MY DEAR MOTHER:

. . . Now I must tell you of my pictures in the Salon. On Varnishing Day, which was the first, the doors were open at seven and I was there not long

afterwards. After hunting the Salon all over some ten or twelve immense rooms—the smallest about the size of the largest in the N.A.D.—I found my large portrait badly hung on the second line and in close vicinity to two fine portraits by Baudry, which completely killed mine. It is not carefully enough studied and lacks decided accents. The head of the little child however is pretty well, and I have already received a great compliment from a Mr. Duveneck,[6] who I am told is the best portrait painter in Munich. He on his second visit walked all over to find this head, not knowing by whom it was.

I met Gérôme when I was having my pictures varnished, and had the pleasure of shaking hands with him. I saw most of the greatest artists in France that day; it seemed one continual shaking of hands all around. Du-Bois, Bunce, Ward and Bridgman[7] are on the line. D. and B. have already sold their pictures at a very good price. Among the best is *Cain and Abel* by the sculptor Falguière; Bonnat, *Jacob Wrestling with the Angel* (life size); Bastien has the strongest portrait; Wencker's picture is full of good work and drawing but lacks some strong accents. Carolus-Duran has one good portrait of a writer. Alma-Tadema has a very good small picture, a Pompeian subject, which he treats as no other one can. There are a great many small pictures which are very fine. . . . Doré has an immense canvas which is the laughing stock of all the artists; it is simply horrible. . . .

Last night I went to a ball at Mrs. Healy's and met Madrazo's sister, a Spanish lady of great beauty. It was a very stylish affair. . . .

<div align="right">3 BIS RUE DES BEAUX-ARTS
PARIS, MAY 27, 1876</div>

DEAR MOTHER:

. . . I am beginning to get so disgusted with my incapability to do *anything* that you must not be surprised if you hear of my going off to Munich to see the schools there and see the work the men do who seem to acquire success in so easy a manner. I wanted to begin a large canvas, so I think I had better go off for a while. My love in art is changing, and I do not want to paint portraits (except "to procure the fuel for the engine"). Whether or not I am capable remains to be seen. In this branch you have no liberty and everyone is free to judge you from the shoe-maker to the hair-dresser. We are not in the times when persons could be painted as they really were, and so the real art is not there. . . .

<div align="right">NEW HAVEN, JUNE 10, 1876</div>

MY DEAR BROTHER:

. . . I wish I had you here with me. But you must stay over there as long as you can. There is *nothing* doing here in art now, absolutely no interest whatever.

By the way, I met on our Board at Philadelphia Mr. Saintin (the French Judge); he asked me if you were my son. He spoke in the highest praise of

[6] Frank Duveneck (1848–1919), an American painter from Cincinnati.
[7] Frederick A. Bridgman (1847–1927), American painter, student of Gérôme.

you, of your speaking French like a Frenchman, of your being the favorite pupil of Gérôme; and he drew himself up and squared his shoulders to show me how you appeared physically. Goodbye.

Your fond brother,
John F. Weir

PARIS, JUNE 12, 1876

DEAR MOTHER:

. . . I wrote you from Rouen, where I had a delightful time. The town is as picturesque as any I have yet seen, and my trip seems like a dream. I travelled comme étudiant, lived and prowled about in like manner. I was discouraged I must confess when I left, but since I have come back I have got to work again, and now have determined that I will do something after all. I have a queer nature; sometimes I can imagine no one more happy than I am, and at others I am just the opposite. This is evidently a weakness, which must be conquered, but with me easier said than done. . . .

CERNAY-LA-VILLE, JULY 5, 1876

DEAR MOTHER:

Yesterday was the glorious "Fourth." I celebrated in a quiet way by leaving Paris in the 8 A.M. train for this place. I have brought my large canvas with me, which I expect to finish for the ex. of the end of the year.

The air is delightful. I rose (or at least I arose this A.M.) at four o'clock and got to work about half past six. Fortunately the old peasant is in good health and glad to earn something, and, as I am the only one in the hotel, I lose little time and all goes on well. How different from the forced work at the school, which, although I need more of it, still after a certain time it becomes rather monotonous. My day's work has been one of real pleasure, four hours in the A.M. and the same in the P.M., and it only passes too quickly.

I dined out under an arbor this evening, and as dessert was being served the round full moon rose over the planted fields, not a cloud in the sky, and the air most balmy. I thought of you all and wished that you could have been with me. After a good day's work a beautiful evening is more than ever appreciated. . . .

You will be surprised to hear what I am going to tell you. Gérôme has put it into the heads of my most intimate friend, Simi (the Italian)[8] and myself, to go to Spain and study Velasquez and other painters, and, in fact, make a tour through there, taking in the Alhambra. He says we can do it very cheaply, and as there is no one that I would as soon go with as him (excepting Wencker) I have decided, as far as possible, to go. He is a hard worker and a clever artist, with a keen sense of composition and drawing. We have calculated the trip at $200. We will enrich ourselves with knowledge and get studies which I have no doubt will be of great service. I see no better time for making this trip, which of all Europe I prefer the most. I have been to

[8] Filadelfo Simi, painter and sculptor, and one of Gérôme's students.

see several Spaniards, who have given me renseignements for hotels, galleries, etc. We will have English, French and Italian to start with, and we both are devouring the Spanish vocabulary and grammar as a reserve.

I wrote to Mrs. Alden and told her of the same that I write you, but maybe she might not care to advance the amount without knowing more about it. We want to leave in about three weeks, and return about the end or middle of Oct. . . .

In my letter to Mrs. A. I told her frankly that I do not know enough yet to leave the school, and suggested that one year more at school and one year in traveling in Germany and Italy would do much to ripen my school knowledge. This is no small suggestion; still it is now or never, and I want to be an artist above the ordinary, if such a thing is possible. . . .

PARIS, JULY 11, 1876

DEAR FATHER:

On Sunday I went out to see Gérôme at Bougival. We told him of our intended visit to Spain, and mentioned that we were awaiting your reply. He spoke very encouragingly to us, and as he was at work, we did not stop long for fear of annoying him. Today he gave me a letter for you, and not knowing your initials or title, wrote it there, which accounts for the colored ink. You can get Prof. de Janon[9] to translate it as it is too flattering for me to do. I hope you will write an acknowledgment, as I would be glad in every way to keep up the interest he seems to take in me. Mrs. Alden will be glad to see this short note; it may please her to see that he still has such a good opinion of me. . . .

I went out to Cernay to finish my large portrait of the old peasant woman. Having received a telegram from one of the students concerning an examination, I had to return earlier than I expected . . . For fear anything would happen to my large canvas, I hung it on some pegs. After we had gone about a mile and a half in the bus I discovered that I had forgotten my canvas, and, as he would not turn back, having ten miles to make, I got out to run back, being assured that I would never catch the train. The day was very warm; still I did my best, as everything counted on my canvas. When I arrived at the hotel I was well tired; however I started the boy off to get the best horse in town and to bring it immediately saddled. I cooled off and took a glass of wine, then mounted the charger with my canvas on my arm. Missing the stage at the station where it stopped I galloped on to Chevreuse. The peasants along the road that saw me coming climbed up the bank, and people seemed to gaze harder than ever when I got to the town of Chevreuse. There were all the peasants filling up the road, as it was market day. In the most dangerous part where pots of butter, eggs, etc. were strewn about on the ground my horse balked at something, and walked all through the butter and egg pots. The peasants were bawling at me at the top of their lungs. Having my whip in my left hand as my right was more capable of carrying my

[9] Professor of Spanish at West Point.

canvas, it was some time before I could change. Then, after inflicting punishment on my horse, the "old white pelt" went at full speed through the quiet little village and I arrived at the other end where the stage I found just ready to start. They all applauded my energy, and said that it was étonnant how I had arrived in time.

When I told this at school the fellows laughed to split, and for me to get here and find that the examination has been deferred another week, makes me feel as if I would like to scratch out my ride, as I am lame from the effects of it yet. . . .

BOUGIVAL, 9 JUILLET, 1876

MONSIEUR:[1]

According to your son's desire I write you these few lines. That young man has worked well, and his progress is very satisfactory. I have no doubt with the will that he has, he will reach serious results. In short I am satisfied with him. At present he expresses the wish to go and spend his vacation in Spain, with one of his comrades of the studio:—I think that the trip might be useful to him, and I advise you to authorise him to go, for he is advanced enough in his art, so that that sojourn may be profitable.

I am, Sir, yours very respectfully,

J. L. Gérôme

M. le Professeur R. W. Weir

PARIS, JULY 13, 1876

DEAR FATHER:

After writing you a letter telling you of my desire to go to Spain, Gérôme wrote a letter to you, in which he spoke of the advantage it would be to me. This I took for granted would be the same as your approval, and which I will act on accordingly, knowing him to be a just and discreet master. Therefore, dear father, by the time you receive this letter I will be on my way to the birthplace of the great Velasquez. . . . We expect to be gone for three months, and we intend to astonish the students we have so much respect for.

I will get Drexel Harjes and Co. to advance me 1000 f., which we expect to make cover our expenses, and I trust it will not be money lost, as we are most serious in our intentions, and my friend Simi Philadelpho is a man of a great deal of character and a strong draughtsman. . . .

We take with us on our trip a photographic instrument, which we intend to use, with the idea of photographing the things we make studies of, which will serve if we paint pictures of the things for the detail.

Gérôme advises us to spend most of our time at Madrid and the Alhambra, and has raised our enthusiasm to the extreme height.

I bought canvas today, the small strips which we expect to make good use of. We will carry very little baggage, and will go armed, taking every precaution regarding our health and safety, and determined to bring back work

[1] The text follows a translation in R. W. Weir's hand enclosed in a letter to John F. Weir.

that will please Gérôme. His nephew, Maxim Lafine, goes down a little later, in about a month, but, as we want to make some studies of the Pyrenees, we will precede him, and will likely meet him at Madrid.

We will have letters from the Spanish students here to their comrades at Madrid and Seville, and will by their recommendations be able to accustom ourselves to the ways of the country....

I will send my studies to John ... with some fine specimens by the best men in our atelier and Cabanel's, and which will show to you my ignorance as compared with them, but, as I hope to work next year with all my force, still hope to arrive. These I give to the school, provided they be made a permanent fixture. They are souvenirs of these my friends which I would like to keep myself, but think would be more beneficial to the students there, as they are fine specimens, and by men who are l'avenir of France....

BAYONNE, JULY 29, 1876

DEAR FATHER:

... [In Bordeaux] I had a letter of presentation to a French wine merchant, who I found one of the nobility there. He rode out in the country every evening to dine and wanted to insist on our accepting a horse and accompanying him. We begged to be excused, having made so long a journey. He asked our address, and said that he would count on our dining with him the next day at eleven. That night to me was the most terrible I have passed for many a day. I retired in a most splendid bed, which we two were both anxious to have, but arranged for it by drawing lots; it fell to me, and I *fell asleep* with all the confidence of a tired traveller, but awoke with all the evident signs of a mutiny, lit my candle, and deliver me from such a sight again—fleas and bed monsters were in the height of their ravenous undertaking. I awakened my friend and made haste to put all the covering back on the bed, and, tired to death as we were, we stretched ourselves on the floor, but only to find that harder than the cars. So passed the first night of our travels.

The next day we dined with the gentleman, who was exceedingly polite, "a real gentleman of the old school." We dined in the most stylish place, and a feast such as we have counted would last us for many a day. On leaving he told us that he had sent us some trifling things which might be agreeable on our journey, which we found on entering [our compartment] to be two books in English and two in Italian, also a large package of Havana cigars, and a bottle of fine old Cognac. We have often since spoken of him with much tender feeling.

FONDA DE LOS LEONES DE ORO
30 CALLE DEL CARMEN, MADRID
AUGUST 5, 1876

MY DEAR FATHER:

At last I write you from Madrid, where we arrived yesterday A.M. at 9:30, after a journey of fifteen hours in an express train from San Sebastian. In

passing the Pyrenees mountains it was very cold, but, being provided with our overcoats, we were able to enjoy with ease the grandeur of that range. It was sunset when we were descending, and the heavy black clouds hung about the tops of the bluffs, while at apparently no distances at all the whole side of the mountain and the beautifully indicated[2] valley was bathed in a golden sunlight, and the heavy clouds touched by the light seemed banks of snow tinged with the most delicate hue. After leaving those noble hills from Vittoria to Avila the country seemed a waste, a desert. Valladolid we passed in the night, so have no idea of that city. But on this long line of railroad there seemed no fertility at all; the country seemed dead. We saw several ruined villages, which we suppose were the marks of the late war; but our ejaculations were "from where come the riches of this country?" The shade trees, and in fact all kind of trees, are scarce here. "The Prado" which is the Champs-Elysées of Madrid, has a line of trees, but here in the day time one sees few people, but after the sun goes down the "hermosas and mujers," accompanied by the sage and ugly señora and other members of the family, amuse themselves strolling along the favorite promenade.

After dinner last night we thought that "viemus al passe del prado," so we started off first to get a celebrated cigar, hoping that through this medium our thoughts would be more enveloped, and that we would enlist ourselves in this so called poetic existence. The moon was full and the Prado crowded while we wended our way along keeping our eyes open for a cigar store. On and on we went, then turned up a street, and we must have walked full two miles before finding that renowned harmonizer of man. Then it was late, so we came back to our hotel, wondering what kind of a city this really was.

We went yesterday, although much fatigued, to see the celebrated Real Museo; the works of Raphael astonished; Velasquez' did not produce the effect I had looked for, his work showed bad drawing all through except in the head. Titian has several fine works, and the original of Mr. Kemble's Paul Veronese is here, the *Christ Disputing in the Temple*, which is fine. The strongest portrait I have ever yet seen is here, a Raphael, a young Cardinal. Goya's works are trash, there is but one good—that is a portrait of an old man, the head is a chef d'oeuvre.

I will write you more about these jewels, which I am not yet able to give a just criticism of as such things must be seen several times. Velasquez' *Drinkers* is very fine; this is undoubtedly his chef d'oeuvre.

We had expected to stay here two weeks, but now I would not be surprised if we should leave in a week, so as to get to work at nature. . . .

MADRID, SUNDAY, AUGUST 12, 1876

DEAR MOTHER:

I am still as you see at Madrid, where [the] richness of its gallery has charmed me beyond measure. At first I was very disappointed in Velasquez,

[2] This appears to mean "indistinctly made out, suggested"; likewise, "indications" on p. 105 seems equivalent to "suggestive effects."

and in fact the Spanish School entire; now this has worn off to a certain extent, but the uncertainty of Velasquez in his drawing fills me with regrets. Had he had the force of Raphael with his charming color or vice versa there would then have been one perfect artist. Raphael has that in his work which I need most to study, the form, purity of drawing, and his grand composition; even in a single figure by him he carries his composition to the full height, and the more I study the more I see that this is the only road, and the more I feel my weakness.

I am doubly glad to have taken this trip with Simi. He is very strong and sure of his drawing and an intelligent person in his art. We have been studying the cause of the rise and fall of art in the different schools. The decadence of art begins when too much freedom is taken and drawing is neglected for color. This latter in all the old masters was the last thing thought of, and this is why today Spain is in its decadence and France in its height. To be sure, Fortuny was a Spaniard, but he, as we have found by his early works, was inspired by the early Italian Masters who worked with a soul and consciousness in his early studies. . . .

I have now seen the Dutch, Flamand and Spanish schools, and their rise begins with these early [Italian] masters . . . The examples which we have of Raphael during his early career show the severity with which he kept by the ideas of those who went before him, keeping in mind the côté bon and mauvais, which shows that these old masters must be studied with intelligence . . . I think John's school, if he is allowed to carry out his ideas, will be the real foundation of art in America. He has the intelligence, inspiration to found a good school, and knows, as do all great men, the necessity of having good men around him and of *refusing frankly* those who have a bad tendency, viz: the chair of Art Critic, which with us is the last thing necessary, a mere encumbrance. . . .

SEVILLE, AUGUST 27, 1876

DEAR MOTHER AND FATHER:

As you see I am now at Seville, and so far am completely disgusted with Spain. It is in one word a vast *desert*, with little variety; and that which makes Madrid a city is its gallery and its Prado, which latter is the great resort in the evening, when everyone turns out to promenade. This rich gallery—more rich in many respects than the Louvre, but which is so badly lighted and arranged that the marvellous works found there are lost to a great extent—we paid, feed and implored the guardians to open side galleries, when for want of guardians they had to keep them closed. In one of these salles below we found a most choice collection of Albert Dürer and Holbein, but which we had trouble to see, being so badly lighted. There are over forty Titians, some marvellous, and Raphael charmed me more than all. One, a group of a Holy Family, the most complete work of art I have ever seen. But, strange as it may seem to you, for the first time in my life I was disappointed in Velasquez. I had expected too much! In his color and pose of a figure he is maybe

the greatest, but his drawing—which now I regard as the greatest thing in art, and which I feel is my weakest point—showed his uncertainty. So I determined to resist the pleasure of making copies of color, as I feel I must take the step immediately to correct this greatest of faults. . . .

From Toledo here I did not see a tree as large as the little cherry tree which used to be in our front yard, and where the charm of the country is I have not yet been able to find out. Toledo, which is high and has the river running by and a moderate amount of green bushes, and Seville are the only two places I would call in the least inhabitable.

*I had expected from what I had read and heard that the Spanish were a people of great learning and advanced in the arts, but, if not mistaken, this reputation comes from the Moors and Arabs who once inhabited this country, and who, if not hunted out by what they call Christians, this would have been a great country in art which is a mark stone of an intelligent people. . . . But the Turks and Moors, wherever they were you find elegant specimens, mutilated by the *un-christian* Christians . . .

SEVILLE, SEPTEMBER 5, 1876

DEAR MOTHER AND FATHER:

I have just been made delightfully happy by having received my letters forwarded from Paris, three from home, in which you speak of Father's having received his official orders [for retirement]. When I first read it I felt very sad for you all, but when I found on further reading that you took it in the right way, above all father and you, who I am confident will be much more agreeably situated in your own house among sympathizing people and no longer subject to orders. For me I feel very sorry that I now had not decided to go home when I could have been of service in helping pack up, keeping time with an old paint brush, or bawling some of my old atelier songs. As for me I have no regrets. The grounds about the old house have all been changed, but father's painting room and the sky parlor[3] I would like to have seen once more, still maybe my illusion would not have gained much. I went to sleep last night thinking of the old place and took a walk all over, visiting the places where I had so often trod in the days dearest to me, in my imagination. I hauled down father's portfolios last night, climbed to the top of the old cabinet and got dressed in his armor and covered with dust. I rummaged in the two corners where the mannequins are, found several old familiar relics and lots of good canvas, ground paint in the table in front of the large pane of glass, imagined I heard you call out to know if I would take a walk out towards the foot of Cro'Nest. Father, you and I started off, had a talk about Paris, and I remember I told father that Spain was a myth, it had no beauty but its Cathedral at Toledo and here, that the Alcazar had been renovated for the Queen and spoilt, etc. When we returned old Fido barked at us in front of Mr. Mahan's house, and when we got by the black gate[4] we

[3] Julian's name for his old studio in the barn. See p. 12.
[4] The north gate of the West Point quarters.

saw the girls and Charley returning from parade. We all dined together and afterwards saw the sun set from the front porch. It seemed to me today as if I had really been with you all for I retraced those good old days with so much pleasure.

I hope in changing you will be careful with the old relics father has, the swords and old arms, which I find very rare and serviceable to an artist and now difficult to have, and father has many such rich bits, which, to one not knowing their use seem mere trash, but which are very valuable. . . .

<div align="center">

CASA DE LA ALAMEDA
GRANADA, SEPTEMBER 12, 1876
</div>

DEAR FATHER AND MOTHER:

I have reached at last Granada, the most charming of all the places I have yet visited in Spain, and for the first time since my departure from Paris, I am thoroughly happy. This city is full of pictures to paint! We have completely changed since we arrived; we are both happy as can be. We go to bed at nine o'clock and are up at dawn, return from work at nine and allow ourselves but a quarter of an hour repose after dejeuner; from eleven till five we are at work in the Alhambra, a palace for the Gods! Oh! if you could only see it! What artists the Moors were! Every part is exquisite and full of inspiring studies.

Now for the first time I appreciate Spain. Here there is always a breeze; the air is like among our dear mountains—it makes you feel like work. My only regret and chagrin, which I feel deeply is that we have lost so much time in other places. We had read and heard so much that we thought that it was our non-appreciation that Madrid, Seville and Toledo did not make us work, even though the thermometer produced gigantic feats, but now we know that it was because those places were not what they were reported to be. We made studies, but we worked mechanically and not with the love that makes good work, and we were always out of sorts. Three times we decided to part and continue our journey alone, always discussing some subject that did not concern us in any way, but here we only talk of work, prepare our canvases, or draw in from some sketch or photograph the work for the next day.

Granada is lovely. Here one sees trees—the park of the Alhambra is full of large ones. The works of Washington Irving are poetic inspirations. I read them before leaving Paris, and fixed in my mind an entirely different place. The palace of the Alhambra is about an eighth the size that I imagined it to be. It is so magnificently situated on the top of an elegant slope, and commands an exquisite view. You see in the distance the Grand Sierra Nevada, the most picturesque and grandiose I have ever seen. They rise to an immense height and surround Granada on the north. On the tops there is always some snow, and at sunset when they are golden, or in early morning to see those elegant indications[5] (which Gérôme renders so well) with the vast

<hr>

[5] See p. 102, n. 2.

plain of vineyards and the old town, with the views of the great wall, all touched as by the greatest artist, you feel like leaping in the air. I haven't felt so young and wild since I left old Cro'Nest. If I had not to return to meet my kind protectrice I would remain here till cold weather set in.

I have begun a sketch in the Alhambra of the Barbuchero de las Dos Hermanas! a place where the women put their slippers before entering the salle. It is of most exquisite workmanship, and I hope to make a picture of this when I return. I will also make careful studies of the Sala de los Embajadores, where Ferdinand and Isabella received Columbus before his discovery. This will serve me as historical notes.

In the old city there are still Gitanos, a kind of gypsies, the real old Spanish stock, from which descended the real Spaniards. We hope to make studies from these people when it rains, but we, not having seen any sign of rain for so long, are now beginning to be a little inquiet for it to begin. The streets here are also very picturesque and make one feel like stopping au chemin to make a study. I hope I will be able to stay here until I have studies which will serve me for pictures. I search more than ever after the design, and here if one does not draw the studies can be of little use. I feel that in that one thing this trip will be of great service to me.

From Seville here the scenery began to get more and more interesting. We were twelve hours in the train, choked with the dust and great heat, but that night we ran about like children. On our way up from the depot we saw the amphitheatre where they have the bull fights all in flames. We were glad as we would not then be tempted to go. It is most brutal sport, but full of pictures. The last one we saw at Seville they set bull dogs on the dead bulls when they were being dragged out by six mules at full speed. When a picador is overturned by a furious bull they laugh, shout and applaud as if it was a capital joke, and the poor horseman is carried out, with injuries that none but he can appreciate. . . .

GRANADA, SEPTEMBER 16, 1876

DEAR MOTHER AND FATHER:

This city grows on me every day, and since my arrival have lost no time that could be put to good purpose. I discover more and more the richness which it offers to a painter, and therefore regret the more my time which I wasted in the other cities. . . .

This time during the early morning we use for making sketches in the streets or having models, and the rest, from eleven till five, we are in the Palace of the Alhambra. I am at present working on a study near the most beautiful room called Lindaraxa, where I have no doubt Washington Irving wrote some of his sketches. It has two beautiful arched windows with those exquisite columns in marble; they look down on a beautiful garden where there is a fountain continually playing. . . . To sit in these windows and enjoy the cool breeze with that most enchanting play of light and shade, and hearing the continual drip of the fountain, is the most refreshing I ever remember of enjoying. . . .

There is a world of art here, and I find myself equally as enthusiastic as when I used to work in the old barn not knowing the serious côté of the profession. The character which one sees in the heads here makes one feel like attacking an immense canvas, and so here all that one could wish for to execute an historical picture is to be found, the history of the Moors or the Spaniards which was most picturesque. For the first time I understand the enthusiastic letters of Regnault, which were written with the same spirit which he painted his pictures.

The antiquities—I mean those things which an artist needs—can be had here for one quarter what they cost at Paris. Tomorrow there is a bon homme who is going to show us some old carpets and things which the Cathedral gets rid of when they get out of mode or shabby. We imagine that we can have these things very moderate. If such proves the case I will write to Paris to borrow some money to invest, as such have always an artistic value, above all at Paris. . . .

ALHAMBRA, GRANADA, OCTOBER 4, 1876

MY DEAR FATHER AND MOTHER:

At last you see I have taken up my abode in the Alhambra même. We succeeded in arranging to have a room in the Puerta del Justicia, which I have sketched at the head of the paper. Room corresponding to No. 1. on the other side is our bedroom, and 2 is the dining room—magnificent views from both sides. The man and woman who live here are very accommodating and have made everything very comfortable for us. Our rooms look out down over the city, which we only catch a glimpse of; over the high trees in the extreme distance is the blue line of the Sierra Nevada; cutting against the dark sky is the other tower where hangs the large bell, which has been rung every night in memory of Ferdinand and Isabella since subjugation of the Arabs. The only sound we hear is the running of water under our window, which runs through the city. And what is more agreeable than to hear the fall of water when one is fatigued![6]

We save now about four hours every day, and as I have only a few days more here will be able to "make hay." I could stay here two months longer and not lose an atom of enthusiasm, that is to say, work as I work now from morning to night. The difficulty which I found in arriving in front of the palace when in sunlight made me think it an impossibility, and I still think it near that now, but as Fortuny succeeded there is no reason why another might not approach. I believe I have learned much, as each thing I have attempted I have had to study seriously. . . .

ALHAMBRA, OCTOBER 9, 1876

MY DEAR FATHER AND MOTHER:

Nous voila! encore le temps passe trop vite. I think I can rightly say that I have never before worked with such energy and in so short a time, and I

[6] Another sketch of the Alhambra is drawn here.

think made so much progress. I find the sayings of Gérôme true, which before I did not understand, and am therefore encouraged to work harder than ever.

The tricks in the art which I acquired when beginning I find have prevented me from taking ahold rightly at once, but now that I am learning to see nature simply and to place the tone as near as possible at the first start, studying each brush mark, and abhorring nothing that I see, but that all should hold its place in the grand mass—that a sharp line must be rendered sharp, and that a stone must be painted different from mud—in fact, each object has its own values. . . .

I must now tell you a very amusing and interesting incident. While working in the Alhambra (palacio) I noticed a very retired looking gentleman with his daughter, who informed me he was a painter, but not by profession, and that he was going to make some studies of that wonderful palace. His manner and that of his daughter betold those of a truly bred gentleman and lady, and I did all in my power to show them what attention was in my power, even to drawing in of several pieces of architecture, which I found him puzzling over. We invited them today to visit our house, and showed them what sketches, etc. we had, and showed the grand view from the walls of the tower. This afternoon he said he would trouble me to look at his work, and when there he gave me a pressing invitation for myself and Simi to déjeuner with them at their hotel, which is very stylish. It was very embarrassing—we have only the clothes on our backs, and I replied that we were but students en voyage with our knapsack, and that we regretted much we would not be able to accept, but he insisted, and said that he would dine in his private parlor, and we would have a pleasant chat on art. In the midst of drawing in his sketch I stopped to rest, and got in conversation with him, and he then presented me his card, and who should he be but Sir Henry Thompson, the famous surgeon who operated on the Emperor Napoleon, one of the first physicians of Europe.[7] He was well acquainted with Dr. Van Buren,[8] and spoke of him as an intimate friend, and said that last year he started to go to America to make him a visit. He said that he gives artist dinners every week, and Alma Tadema is always there. He promises me if I come to London he will bring together this most distinguished artist and Boughton and Whistler. I asked him about the latter, and he said that at present he was working from some old china which he had lent him. He is also intimate with Gérôme, and said the last time he was in London he dined at his house! He seems to have taken a fancy to us—maybe because we are industrious—and we feel honored in making so distinguished an acquaintance. We are invited to déjeuner tomorrow, and he returns the compliment by dining with us. We will have tea served à cause de la demoiselle *sur la tour* à 8 heures, where we will all repair, and where we will offer Sir Henry a *real* Havana and a magnificent view.

[7] An Engishman of wide interests including cremation, astronomy, and collecting china, he was noted for his "octaves," dinners of eight courses for eight guests.
[8] William Holme Van Buren (1819–83), New York surgeon.

How often have I thought of your fine prints of Sir Joshua, Constable, and Turner. Many a time I have wished I could look over them with you again, but I must return an artist.

I hope to work harder than ever this winter, for this is my last year at school, and it is now or never. I take courage now and hope it may continue to rest by me. . . .

<div align="right">HOBOKEN, N. J., OCTOBER 27, 1876</div>

M. J. L. GEROME,
DEAR SIR:

I thank you for the kind interest that you have taken in my son Julian, to which he often alludes, and which makes me desire to add my acknowledgement for your kindness.

I hope that his visit to Spain will not interfere with his progress in drawing, as that is the great language of art:—the rendering of color, seems to be a natural intuition, by which one is enabled to appreciate the particular tone suitable to the subject, as sound does in adding force and beauty to sense.

Please accept my thanks for your kindness, and with sincere wishes for your greater success.

<div align="right">With great respect, Yours very truly,
Robt. W. Weir</div>

<div align="right">MADRID, OCTOBER 29, 1876</div>

DEAR MOTHER AND FATHER:

I am again at Madrid, where I have to wait some twelve hours, as the third class wagon does not leave before nine o'clock tonight, and am lodged in a café, where I have just finished my frugal meal of coffee and a piece of bread, being strapped down to hard economy, having just money to pay my car fare to Paris. Having passed through such times before, know how to keep the machine running under similar circumstances. . . .

After depositing my bags here at the "station norte," I sought the greatest refreshment of a voyager, a good pail of cool water, and after I took my rations I started off with my sketching umbrella under my arm in case of rain to stroll in the Botanical Gardens, the famous gallery not being open till ten o'clock on Sundays. The avenues of trees and flowers of all descriptions seemed more charming than ever, and being the first visitor, [I] enjoyed the quiet and beauty of nature as a lover of the same only can and when I wound in and out among the flower gardens so beautifully laid out, where the dead leaf often covers the bursting bud, and of a sudden I came upon a trickling fountain where the fallen leaves had checked its regular sound so that its noise did not deaden the sound of the occasional venturesome bird, and there with sublime poetry I mixed the solemn prose, counting all my sous and "chabots" (which is $\frac{1}{4}$ of a cent French money), and coins set aside as souvenirs of a drôle pays. And had I had a few francs more, I could have left at three in an express. However, having learned to put the present to as good

use as possible, I started off for a feast of pleasure in the gallery, where I stayed until half past one, and found Velasquez not as I did on my first visit, but the leader of the Spanish art, together with Alonzo de Cano! Titian pleased me more also, but Raphael, Albert Dürer, Holbein, Quentin Matsys, and such serious draughtsmen I always approach with awe and reverence. . . .

CHAPTER 4. APPRENTICESHIP CONCLUDED, 1876-77

As he began the final year of his Paris apprenticeship Julian still felt the "awe and reverence" for "serious draughtsmen" that had made him revise his opinion of Velasquez. And he determined to concentrate more than ever on the disciplined schooling which the ateliers provided. During this last year he naturally became more concerned with the prospects for painting in America, and his letters reflected both reluctance at leaving and enthusiasm at returning. Once the decision to return to New York was settled, however, he worked at drawing with an unflagging industry that would have won his father's approval—and Mrs. Alden's too.

<div align="center">
3 BIS RUE DES BEAUX-ARTS

PARIS, NOVEMBER 5, 1876
</div>

MY DEAR MOTHER AND FATHER:

Last Tuesday night I arrived here at half past twelve in the A.M., and in the morning after my arrival I found Mrs. Alden out, and in the evening called there. Both she and Miss Sarah[1] seem about ten years younger than when I knew them in America. Miss S. seems to me one of the most distinguished young ladies I have ever met. I have been with them every day, and have become better acquainted than ever before. I wish our country could boast of many such; it makes one feel proud to be an American in their society.

This morning I took my work up to show Gérôme, and was very gratified that he spoke so well of it. He said that I must not neglect the school this winter. I asked his permission to bring Mrs. Alden up there, which he said I might do at any time, and that he would be very pleased to meet her. It will give me much pleasure to introduce him to a real American lady. . . .

Percy[2] dined, or rather lunched, with me yesterday in the Quartier. I showed him the school and my atelier, which he seems to be quite pleased with. They expect to leave this week for England. I wish they were going to

[1] Mrs. Alden's daughter.
[2] Mrs. Alden's son.

be here all winter. . . . Mrs. Alden is the first person that I have met since I have been over that has made me feel homesick, and I wish I was going back with them. However, I must not allow these thoughts as I have much to learn yet, before I can carry the name with honor. This winter I hope to make a decided march.

They have had another fight in Gérôme's atelier, and an Englishman was expelled. The Frenchmen have made the rules stronger now, and made it harder than ever for a foreigner to enter. They act like children, even the oldest. . . .

My money has entirely given out, from the effects of the trip, and, being so delicate a subject, I dare not speak of it, but, if it is possible to sell either of the two pictures, I would be glad to have what you can get for them. . . .

Mrs. Alden tells me that the girls are very pretty. I hope they keep up good readings, as it is always easy to find a pretty girl, but not so facile to discover an intellectual girl. . . .

<div align="right">

3 BIS RUE DES BEAUX-ARTS
PARIS, NOVEMBER 12, 1876

</div>

MY DEAR FATHER AND MOTHER:

At last my best of friends have left. I went to the station with them, and saw them in the cars. Since they left I have felt rather blue; their queenly bearing has renewed my once exalted idea of American ladies, and were I a prince of learning, I know where I would pay my tribute.

At the same time I tell you of my joy at meeting and becoming so well acquainted with them, I must tell you of what has befallen me, as pleasure is always counteracted by grief. My engagement, which I took so much pleasure in telling you about, has been broken off for some six months, which when the proposition of going to Spain came up, I was only too happy to go, to try and forget the past, and content myself with my studies; and now on my return I will cut off my acquaintances here as much as possible, and take up some studies in the evening. I beg you will never refer to this in any of your letters. I will always have great esteem for the young lady. . . .

Tomorrow I begin work at the school, where I hope to be one of the most regular. I begin also a course of Spanish lessons for the next two months, and this winter I will try and be more severe with myself than ever before. . . .

I brought Mrs. A. and Miss S. over to see my studio, so they can tell exactly how I live. They seemed to be pleased with my rooms and with the portrait of Miss Anderson. If they had stayed here this winter I would have aspired to have painted both their portraits, although I would surely have fallen short. They spoke of Father's great kindness in presenting them books, I was delighted to hear it, as there is no more regal present one could make. If you sell those two small sketches of mine, I would like to put the money in some French works, if I could afford it, as now I would be able to get them better than later on. . . .

3 BIS RUE DES BEAUX-ARTS
PARIS, NOVEMBER 19, 1876

MY DEAR MOTHER AND FATHER:

. . . Sir Henry Thompson was here day before yesterday. I breakfasted with him, and afterwards took him to see Gérôme, who was unfortunately absent, hunting. We, however, saw his atelier and the piece of statuary which he is working on, and which is wonderful, *The Gladiators*. He is now going to do it of a colossal size. I took him also to see Mr. Stewart's gallery, with which he was delighted. He left yesterday morning for London, again giving me a pressing invitation to go over there Xmas week and meet the English artists, Leighton, Alma-Tadema, Boughton, etc. who dine with him once a week. . . .

I have begun with my Spanish, and next week will take up fencing for exercise from five till six, when too dark to see. . . .

Tomorrow I must be up bright and early to work at the school, when I now have a great relish for work. I am getting my time laid out now, and hope I am strong enough this winter to prevent any little breaks. I see nothing but good, hard and interesting work, which I think I now have experience enough to balance with exercise. I have made arrangements with an architect to make plans of a studio after my ideas as to light, which will be an exchange for which I am to paint his portrait, and, if ever the time arrives when fortune favors me, I will have it built; for a portrait or figure painter I believe in plenty of light.

I have never heard from John since I sent my things. I fear he thinks them not worth a reply, but I hope if it is possible to sell anything you will. I want to get some works of French literature, fearing I may never have another chance. . . .

I saw in one of the French papers a short time ago an abominable article written by the French Chargé d'Affaires at our Exposition, insulting our American ladies. Mr. Washburne fortunately, however, has taken it up, and several letters have been exchanged. I hope America will resent it promptly, as an American, as it is, has not too good a name abroad. It makes one mad that such an insult should come from France, but the class of Americans that one generally sees over here are not at all creditable to us, which to Europeans is their only means of judging, as they think us not more than a money-making people, with little history, and here it is only the rich who travel, and they prefer more to visit the countries which art and history has made great than to visit a country young as ours; but I feel proud when I visit their countries to see how far ours surpasses theirs in universal intelligence and industry. . . .

[Postmarked DECEMBER 4, 1876]

DEAR FATHER AND MOTHER:

. . . Thanksgiving Day has passed. I went out in the afternoon to see a football match, and in the evening called on Mrs. Sargent, who said she had

a very pleasant visit at our house. She told me of you all, and how you were in point of health. It was very pleasant to meet someone who had seen you! She is a very charming lady. We talked over our comparative voyage in Spain, which was very interesting. She travels so unlike ladies in general, preferring the stage-coach routes and out of the way places to the guide-book rules, that she has amassed a quantity of interesting knowledge, which makes a country interesting in an artistic point of view; but for this, one must have enough esprit to overcome the many difficulties and inconveniences which are always to be encountered. She had been at Granada in the Spring of the year, at which time she speaks of it as one of the most beautiful places she has ever visited, and this I can easily imagine. I hope I will be able to return there next Spring and cross in to Africa. Only in the north at Tangiers . . . they tell me the real Arab life is to be seen, and there it was that Regnault painted some of his wonderful pictures. From there I could cross to Italy—say Venice, where the climate is healthy, and remain there until the suitable season to visit the great cities of art, returning by way of Munich through Germany on my way home. Then I think I could return home without reluctance, after having a royal chance at education, and travelled enough to enlarge my ideas —so very necessary to an artist. Could I do this I could make my trip doubly pay, and would have material enough to be an everlasting benefit, and for such, youth is the only time.

I am going on with my Spanish with a determination to get ahold of it. . . .

I had the pleasure this week of refusing two invitations to parties—one at a French lady's house, which I would like to have seen out of curiosity. . . .

NEW HAVEN, NOVEMBER 20, 1876

MY DEAR JULIAN:

I was mighty glad to get your letter yesterday . . . By the way, we had your friend DuBois here—he dined with us twice, and we thought him a capital fellow. . . .

Now let me speak of your work—the studies etc.—Your studies astonish me— they are so excellent— I never saw such studies as these you have sent— They are invaluable for our Art School. I have them stretched and framed and hung up in the Painting room. The little head that you had in the Salon is the work of an Artist— it is capital— The past year seems to have worked wonders with you. I wish before you return you could spend a few months in Munich. The School there is working wonders. There are three or four Americans who have been studying there who sent things out to the Phila- delphia Exhibition, who equalled the best I have seen done by those study- ing in Paris. The names were Chase, Slade, Walter Shirlaw and David Neal. We hear here that the Munich school is surpassing that of Paris. Certainly what I have seen in Boston and New York of the work sent out from Munich, I think it remarkably fine. Eastman Johnson bought one study of an old woman by Chase for $500, and thought it like a master. Now you will laugh

at what I say of Munich, but I wish you would just go there before you return to see what they are doing. You *may* find I am mistaken— their methods seem to be more after *your* own natural tendencies. . . .

<div align="right">

Your affectionate Bro

John F. Weir

</div>

<div align="center">

3 BIS RUE DES BEAUX-ARTS

PARIS, DECEMBER 8, 1876

</div>

DEAR JOHN:

. . . My voyage to Spain has left me penniless. Do you know of someone who would like a copy made in the Louvre? I would like to do something of that kind this year and will get some small pictures ready to send across. . . . Give me an insight into the way things go on at home and let me know what you think of the Academy giving medals. It would be much better to establish a prix de Paris, this would be much more sensible; this also would be a capital thing for your school and would draw the best students. Try and advance it and let me know.

<div align="center">

3 BIS RUE DES BEAUX-ARTS

PARIS, DECEMBER 10, 1876

</div>

DEAR MOTHER AND FATHER:

. . . I have so far had five invitations, but which I refused, consoling my-self with a French and Spanish grammar. I have almost finished Lord Macau-lay's *Life and Letters*, which Mrs. Alden gave me, and which I find very interesting. Father I should think would enjoy this. Now that you are all settled in a civilized part of the world, you must have already subscribed to some good circulating library, so that in this way one has all the late books. In Father's library, however, there are enough for one for a good many years, and which when I go back I hope to set upon and devour.

How do the girls come on with their French? I could send some good books over now and then if they would like. I want to read Balzac's works this winter in my spare time, and would enjoy much possessing them. . . .

Victor Hugo, who is now in his [seventy-fifth] year, made a speech a short time ago, in which he put forward a great scheme, that of joining France and America, making a united Republic. His views would be less favored by the Americans I fear, than they were by the French. . . .

A short time ago Johnston[3] and I were disputing as to a date; we both felt certain of it, so, as he had just ordered the *Saturday Review*, said if he was wrong he would let me have it for a quarter, and as luck would have it I won, and now I have a chance at an insight of the political world as set forth by England! In this week's number there is a very scathing article en-titled "The Dark Americans." I wish that some of our able men would take up and defend us from such impudent publications . . .

[3] Probably John B. Johnston (1847–86), American landscape painter.

3 BIS RUE DES BEAUX-ARTS
DECEMBER 20, 1876

DEAR MOTHER AND FATHER:

DuBois has just arrived and told me about you all—in fact, of his whole summer's campaign. He gave me the porte-monnai which you and Charley were so kind as to get. You must never think of me in the way of presents. I consider the privilege of studying here the lifelong one, and it only makes me feel bad when I can't send things home to you all. DuBois told me how each of you looked, and what pretty sisters I had. . . . I was very glad to get dear little Louisa's photo. I have looked at it often since I got it. She seems just the same. I will hope to see them when they come abroad. I hope, however, they will not come to stay; the ordinary class of Americans abroad make it unpleasant for all others, and one is continually insulted. However, there is much to make up for this. Still, the love of one's native land is hard to outgrow.

I borrowed today a catalogue of the [Philadelphia] Centennial. I see John had four or five works. How badly it seemed to be arranged for finding one's work, and the annexed department seemed to me ridiculous. John has never said a word about it. Did he get a medal? I see that there were more medals given to photos, lithographs, and all the lower branches than to painting. The artists from here who were over there say that they were awarded to men for their reputation, not for the work they exhibited, and that the Art Committee should have allowed that head modelled in butter to have been exposed as it was, shows that they considered art as a kind of a boyish trick.[4] . . .

I got a letter from one of the old students who returned last year to America, and has gone out west painting portraits, but does not seem to find much to do; complains of the hard times, and says that the election holds everything back. . . .

3 BIS RUE DES BEAUX-ARTS
JANUARY 2, 1877

DEAR MOTHER AND FATHER:

I wish you all a happy New Year and many of them. . . . I made no calls, but sent my card to about ten or twelve places.

I have given myself up to reading of late, the school being closed, and next week will get to work at the school with renewed energy. I hope next week to finish a small picture of a simple Spanish subject. I want to send two small genre pictures to the N.A.D., which, in case I make a strike with my larger ones will sell, I hope readily. I doubt if I send anything to the Salon except it might be a portrait or a "nature morte."

Last night the streets were gay with the pleasure-seekers. I heard the shouts and blasts of trumpets from my room, where I enjoyed myself with books. I imagine I am getting quite philosophique. Pleasure this year I do

[4] *Sleeping Iolanthe*, modeled in Arkansas butter by a Mrs. Brooks, was shown in an iced tin frame.

not find in the crowd, and hope it will so continue. I have made the acquaintance of a graduate of Oxford who has a fine library, and we have taken quite a fancy to one another, so I have access to his library, and will likely undertake a portrait of him.

Gérôme's banquet came off on Saturday, but was nothing especial. He left early; Boulanger and a number of distinguished artists remained, and no sooner had Gérôme left the room than Boulanger shouted out "à cheval." Each one, turning his chair sideways with the table and straddling it, galloped around this long table like boys of sixteen, making a terrible racket. It was amusing to see two gray-haired artists, and, like the greater part, in swallow tails and white cravats, going it with all their might, while Boulanger gave the several commands. After it was over we strolled down through the streets, making considerable of a racket. Here the old artists enjoy mixing with the young men, so that they make a regular brotherhood, and there is very little ill feeling amongst the men of reputation and the aspirants. . . .

<div align="center">3 BIS RUE DES BEAUX-ARTS
JANUARY 7, 1877</div>

MY DEAR FATHER AND MOTHER:

. . . This coming week I am thinking of working over at the Louvre, as I want to make two copies, and I intend to begin making sketches in color, but time seems so short.

My old friend Bunce has just arrived from Munich, where he says the fellows are doing wonders, but, as he belongs to what may be called the color school, I will wait to see. Duveneck, who is one of the strongest fellows there and a particular friend of mine, has proposed to pass next summer together at Venice. I have heard it said that he is one of the strongest portrait painters over here, so maybe it would be a good thing for me. He sent word that he was going to send me a study. They say the poor fellow is over head and heels in debt, otherwise he would come to Paris.

<div align="right">Wednesday A.M.</div>

Yesterday the weather was so spring-like, Bunce and I started out in the country at three o'clock, to see the effects. The sky was filled with the most beautiful clouds. Three cents on the little "bateau mouche" brought us down the Seine to the fortifications. From there we were soon in the country strolling along the river. We had wandered to quite a desolate part where we were conjuring on making a study at some future time. We were strolling along until quite dark, and then, finding a small cabaret, we entered and I made arrangements to have a dinner for forty cents apiece. All went on well; we entered a little off room, where we were served, and it seemed quite an armory, guns and pistols were suspended about the wall, and things looked quite warlike, which rather surprised me in such an ordinary tavern. We sat talking until about eight o'clock. The loneliness of the place never struck us, nor its isolation from the other houses along the bank. On going out, we

complimented the old woman on her cooking and put down what we had bargained to pay her, when she presented a note of twice the size, which we refused to pay and started to go out, when the man entered with two good sized lads and said we should not leave until we had paid every cent of what we owed. With that I lost my head and swore I would leave if we had to fight for it. He then drew out an immense revolver, which he gave to the old woman, and told her if we left to shoot us. Shortly he returned with a shot gun and said if we left without paying the whole he would bring us down like a fox. Seeing we were cornered we could do nothing but pay. However, on leaving I went to see the Commissionaire de Police, and today we appear at his office to make our charge. I will put the man through to the last letter of the law, if such I can bring to bear against him. I think I can have him jugged for carrying concealed weapons. In all my experience I never met with such a dastardly affair. It was undoubtedly a nest of thieves, and, thinking we were foreigners who knew little of the country, they thought they could impose on us. I will write you the results in my next letter. . . .

NEW HAVEN, FEBRUARY 3, 1877

MY DEAR JULIAN:[5]

. . . What I now turn to is far pleasanter. It is the full recognition of all your kindness and interest in our Art School, and the desire to help it on, but above all my admiration for your studies—and for that head you sent Father. It is the work of an artist. . . . I want you to reap the full harvest of your study in Europe, and not return till the crop is all in, to get through with the *School*—and then see Italy—after all, *that* is the land of art—not of Art-Schools, or Art-discipline but of Art-production in the past under its natural growth and in its own peculiar atmosphere. If I can help you on in this I will hope to do so. There is one point I would speak upon— It seems to me to return to this country now would be a great mistake. There is no interest in Art here now—the outlook was never so discouraging. Stay over there as long as you can. . . .

3 BIS RUE DES BEAUX-ARTS
FEBRUARY 5, 1877

DEAR JOHN:

. . . You are right in many respects as regards a single man having but half the grievances of a man of family and yet there is such a thing as a bachelor not being a good economizer of time, etc., which amounts to about the same thing.

I would write more often if I thought I could make my letters interesting, but Paris life is about the same thing and my studies also, such talk is without savour . . . [unless] enlivened with something extremely interesting. I generally lunch at one restaurant and dine at another with Frenchmen and Spaniards, work at the school in the morning and at home in the afternoon.

[5] The first part of this letter is about an order for casts for Yale College which had drawn Julian into much red tape in Paris and had led to misunderstandings between John and Julian.

Very occasionally I go to the theatre, but would go more often if possible. I have seen but few of the great French plays and when one has such a good opportunity, it is regrettable; many of us are going to the Opera tomorrow night, we sit in Paradise for sixty cents where one is pretty well, for in Operas it suffices to hear only.

Gérôme has gone to Rome; so we have Boulanger who criticizes in his place. My friend Wencker has also gone to Rome to occupy the place of this year's prize. Bastien is at work on a full length portrait of a lady. Courtois will have a portrait in the Salon, Dagnan *Orphée in Purgatory*, Wencker a full length portrait of a young girl. These are all large canvases, or, as they say in America, important works.

I saw a very flattering notice of your work in a Swedish journal, it spoke very well of *The Iron Foundry*. I am sorry that you have never said anything about the Centennial, I suppose everyone thinks the other has written of it. It was by accident among the fellows I heard that you had a medal. . . .

<div align="center">3 BIS RUE DES BEAUX-ARTS
FEBRUARY 19, 1877</div>

DEAR FATHER AND MOTHER:

Last week I received Father's most welcome letter, together with yours and was delighted to read it more than once. Do not ever be afraid, I have grown to be quite a politic fellow and run very few risks.

I am sorry if this affair in which I happened to be one of the actors gave you any uneasiness. I knew the strength of the law against a man carrying a weapon and the Commissaire of Police, who was very polite, said he would have several months of prison. The last time I went to Boulogne, we were questioned. The unfortunate man and his wife were there, who this time did not consider it such a good joke. They asked to be let off, but for the public good, I told the Commissaire that I would leave it in the hands of the law. Had I not been inspired with interest for the bien public, I would have pardoned them after they had been reprimanded, but I concluded to let the law take its course. . . .

Saturday I had an examination in history ancient and modern to pass, so for two days before I sat up nearly all night and my friend Mr. Beer made researches for the Assyrian and Egyptian history for me. Friday night, the night before I came up I came in from his house about twelve and got down to work, when about half past one my oil began making capers and I found the lampiste who had just arranged my lamp had soldered the part into which the waste oil drips and in trying to get it off I made it worse. The only bit of candle I had was not more than two inches in length. I was, as you can imagine in the utmost despair, but, as necessity is the mother of invention, I at last got a wine glass, filled it with oil and put the candle in it and in this manner I got enough light and was able to work till four. I came up about half past nine and did not get any of the subjects I hoped, although they were not very difficult. In Ancient History I had the principal history of the

Dynasties of Egypt and the Patriarchs and the great writers of the Renaissance and under whose patronage they were, so that I imagine I have got through all right.

I expect to get my pictures off day after tomorrow. Then Mr. [], the *Herald* reporter, is coming over to see them and will send it to N.Y. with this Friday's dispatches, so you must look out for the article. My Spanish picture the fellows seem to like, although I am not myself quite pleased, as the composition is very ordinary in figures, but the press of time must be its excuse.

Miss Anderson's portrait has been so much impaired by the cleaner, who took the varnish [off], that I have had to retouch the head and tomorrow will paint in the hands and arms from a model. This has been a good lesson. I will trust no one with such a job again.

I wish if Father is on good terms with Huntington,[6] he would ask him if, in case my pictures arrived too late, that they would be admitted. I hear that unless one has influence, even a day late excludes them. Avery's son was in today and he pronounced my Spanish picture a very salable picture. . . . I must close now as I want to write to Wadsworth Thompson, who I understand is on the hanging committee. He is a good friend of mine, and though I am sure he would do his best for me, there is nothing like refreshing his memory.[7] . . .

<div align="right">

3 BIS RUE DES BEAUX-ARTS
PARIS, MARCH 6, 1877
</div>

DEAR MOTHER AND FATHER:

. . . I am at work on a portrait for the Salon, although it scares me when I find my sitter missing so many sittings. We get to work now at seven o'clock and more than ever I advocate my cold bath system, for having to rise so early, I fear I would hardly be awake. An alarm clock and a bath tub I look on as requisite to a student.

To return to what might interest Father in my work, viz. this portrait. I am working up under the influence of the primitives and the inspiration of Bellini. There is an excellent example of his (of two brothers) in the Louvre, done in a manner that shows more his love of his art, than the work of today, when one tries to astonish people with boldness. Bastien has much influenced me and when I saw his portrait lately, I was astonished with the step which he has taken. Courtois and Dagnan are on the same road, but their work shows more knowledge and has not that simplicity and research which I have learned to admire in the Florentine School!

After seeing their work I went with de Ochoa[8] to see Madrazo, the great Spanish painter, who sells most of his work to Americans and English and

[6] Daniel Huntington was then president of the National Academy of Design.

[7] Alfred Wordsworth Thompson (1840–96) studied in Paris for several years during the Civil War. He spent the summer of 1875 in France, and Weir had seen him frequently in Paris.

[8] Raphael de Ochoa y Madrazo, Spanish painter, student of Gérôme, and nephew of the better-known painter, Raimundo Madrazo.

never exposes. What he had on his easel and is a fine example of his work (*After the Masked Ball* for Sir R[ichard] Wallace) is exactly the contrary of these men. It is what I should call decorative art, very adroitly done, pretty in color, and pleasing to the eye. Surface work.

Carolus-Duran is also another style of art. He depends entirely on the value of one color against another and his heads, although good are conventional and one does not feel the great individuality of the man he paints but rather the artist. Although I do not say that an artist ought not to have a manner of his own, still that ought to be the last thought, for what painter that ever lived did not have his manner, and there is but one time to acquire a good manner and copying nature closely when one is young at school is the only time that one has that liberty.

I met Hunt[9] . . . He has been abroad over a year and now has just returned from Munich and brought with him a portrait by Duveneck who is considered as the great portrait painter and in America they went wild over him. All I have to say of it is that it is very clever work, badly drawn and constructed, exaggerating the eccentricities of his model, the flow of color the only thought, which we here think the ruination of a man . . . for a bad or slovenly principle seems to always hang by one. So to me the great thing is to start right under such a man as Gérôme, who knows no tricks, or in fact under any one who observes form and drawing. And to learn this one must go to the school earlier than I did. If I had my time here over again I think I would have gone three years for drawing only but will do the best now that I know how and hope it is not yet too late. . . .

Many persons have asked kindly after you all and speak of Father as one of *the* men of our country. A French lady, who speaks some English and has heard much about him always says, "Your father is a holy man" and you must follow him. . . .

PARIS, MARCH 12, 1877

MY DEAR JOHN:

 . . . I have just been to see the works of Fromentin, which are exposed at the Beaux-Arts. He was a great man, and possessed a great knowledge of the line, although his works in color do not impress me as much as his drawings do, I feel him to be a great artist. He wrote a criticism on art in the north,[1] which entered him in the Academy of France. It is more interesting than Taine's works because he compares things artistically, so that one all but imagines that he sees the work. It was very interesting for me to read it, having travelled over Holland and seen the works of which he speaks. It makes one feel like returning, which, if ever the case, I would carry it with me. I want to possess it as soon as I can afford it.

I often spend my evenings in the Library, where I drink in the lives of the old Florentine masters, as well as the painters of the north.

[9] The painter, William Morris Hunt.
[1] *Les Maîtres d'autrefois, Belgique, Hollande,* 1876. Eugène Fromentin's art criticism impressed many of Weir's fellow artists, including Hassam and A. Q. Collins.

The fellows were talking the other day of your chances for being on the Jury, sent from America for the Exposition of '78. If so, we will return together. . . .

BARBIZON, APRIL 6, 1877

DEAR FATHER AND MOTHER:

Day before yesterday I left Paris to make a study of a background for a sketch of which I hope to paint a picture! This is the place where the great Millet lived and at this hotel, where I am, is the place where the artists stay. There are generally two or three that pass the winter here, and rarely miss a day's work in the forest. It makes rarely any difference whether it rains or shines! After coffee each one takes his traps and goes off to his haunt. Then nature seems more rich than ever and full of charm, which one can only appreciate by being away from it. The city life, where one is imprisoned amongst walls, makes one's faculties more appreciative.

The first day I arrived I started off immediately to visit a part of the forest, although it was then six in the evening. After passing a winter in a city, even the smallest moss covered rock seems in itself a picture. I came here to make a study of some rocks in cloudy weather. Every day it sets in beautiful, the sky without a cloud, but about two o'clock the sky is overcast. Yesterday three storms came up during the day, but as I work near the Brigand's Cave, I carry my traps in there when it rains hard, for the place where I work is so exposed that even in comparatively mild weather, I have to tie stones to my easel to keep it from blowing over. Simi has a large canvas which he has been working on for several weeks and yesterday with a gust of wind, easel, umbrella and all were sent flying.

The nightingales have already begun to sing and the merle, which is also one of the finest singers makes the woods echo with its notes. I was awakened this morning by the singing of the birds! It is scarcely more than a stone's throw from here to the forest and on the very edge, seen from my window, is a pretty little thatched roof cottage, where an artist and his wife live. They were out in the garden digging when I opened my window. She was singing a pretty air while they raked the scrubble together. I was reading *Rasselas* last night (which I picked up on the Quai before leaving Paris) and thought, as I looked on that happy couple, whether or not there was anything but happiness in their house.

I am invited to go on a wild boar hunt and will, I think, accept if the time is fine. I saw several large hares in the forest while walking about and succeeded in getting my foot caught in one of their traps. We always wear high gaiters and heavy shoes so that we get over the rocks with safety against the vipers. The walls of the dining room are all covered with pictures which have been given by the artists. Deer horns are hung up as hat racks and an immense deer's head, stuffed, hangs opposite the door. There is a piano also so that those musically inclined have full sway. We are lodged and boarded for one dollar a day, food and wine such as we don't get at Paris without paying double and this is not so fresh and good. . . .

3 BIS RUE DES BEAUX-ARTS
APRIL 15, 1877

DEAR FATHER AND MOTHER:

The trees are now all out in leaf and the warm spring days are making rapid progress. The gardens are filled with children, which I look forward to as much as I do the flowers. They make the gardens so gay.

I wrote to Percy Alden that I had quite decided to return in the fall, not that my studies are finished or that I was far enough advanced, for it seems as if I know less than I did ten years ago. I want to return and be with you all. I think I could have gone home two years ago maybe feeling more confident, but this last year, although my life studies are nearly all painted out and apparently I have not done much, but I feel that my study has been more profitable. I have been searching for something in my painting that before I detested. I make often trips to the Louvre to study the early Italian masters in their work and the Holbeins. I find that which I greatly admire and which makes me regret much not having seen Italy, but it may do no harm to have my thoughts and ideas more ripe. I have a dread of the things I sent home and which I fear will look bad, but I hope you will let me know exactly. I have no delicate feeling on the subject at all, let come what may. They were not good enough to do me good and I would almost wish that they were severely condemned. For myself I feel it is bad to exhibit a thing mediocre. A work of art ought to be cited as good or bad. I work at the morning and evening school regularly and only wish there was a school convenient to work in when I return. . . .

I went across the river the other day to see an exhibition of the work of a new school which call themselves "Impressionalists."[2] I never in my life saw more horrible things. I understand they are mostly all rich, which accounts for so much talk. They do not observe drawing nor form but give you an impression of what they call nature. It was worse than the Chamber of Horrors. I was there about a quarter of an hour and left with a head ache, but I told the man exactly what I thought. One franc entrée. I was mad for two or three days, not only having paid the money but for the demoralizing effect it must have on many. . . .

3 BIS RUE DES BEAUX-ARTS
PARIS, MAY 1, 1877

MY DEAR FATHER AND MOTHER:

I have stayed home from the Salon today to write you of what is going on and what I saw yesterday, which was the varnishing day.

The most remarkable among the Americans are Bridgman and DuBois who have both fine places on the line. Now to speak of the great Frenchmen. Jules Breton, Paul DuBois (the sculptor), Wencker and Bastien are among the distinguished. Paul Laurens has a wonderfully fine historical picture from the war of 100 years, which I consider as the success of the Salon. The

[2] This was the Troisième Exposition des Impressionistes.

works of the four that I mentioned are full length figures, three of which are portraits which [are] wonderful. Do not think that because two of them are my friends that I mention them. Their works are remarkable and have places of honor in the best rooms. Bastien's is a portrait of a lady in an Elizabethan costume with the high ruff, white satin and is treated very broadly. Wencker's portrait is of a girl dressed in grey with brown stockings and black shoes against a rich brown background, which reminds me of an old master by its simplicity. Paul DuBois has a portrait of a princess and Jules Breton a large life size figure of a peasant woman returning home at evening with a sheaf of wheat on her shoulders. This is very remarkable, not the clever handling of the brush, but the wonderful sincerity of the love of nature. Meissonier has a small portrait of Alex. Dumas which is not remarkable for him. Carolus-Duran's works are simply bad. Alma-Tadema has a fine picture which was exposed in London last year!

While there yesterday who should I meet but Sir Henry Thompson who has just returned from St. Petersburg, where he performed a successful operation upon the Czar. He said that his daughter has just finished writing a book[3] and he would do himself the pleasure of sending me a copy and he said that as for the book of Whistler which he promised me, he would not give it to me until I came to see him in London. I think the Salon of this year is better than that of the past few years.

I am working with all my force now to not lose a moment, but I fear my going home. I am neither tadpole nor frog, which is a dangerous moment. To grow fast and learn to float, it must have the right soil and atmosphere as well as good instruction. This may strike you as a queer simile but a poor artist is less to be envied. However you may count on me when the school term is closed. . . . I am no genius and to rise from the dishonor of a poor artist is no short road and the advantages of good schools must be had and I see here even, how easy it is to go astray. My mind is still weak and young for what it ought to be, compared with my years and experience and still I feel that I can and will succeed if I can carry out my ideas and keep at school. Gérôme himself told me that he felt this view of school work. Art as I understand it is one of the most serious of professions and one above all that necessitates sound and severe surroundings and where models can easily be had. . . .

71 BOULEVARD ST. MICHEL
PARIS, MAY 9, 1877

DEAR FATHER AND MOTHER:

I have just received your letter in which you ask about my coming home. You may count on me as soon as the school term is ended. I feel that I am making progress now in composition and drawing, which I work at a good deal and which has always given me fear. I have given congé of my atelier for the 15th of July and taken a small room in a more healthy part, which forces me to take a walk before getting to work at the school. . . .

[3] Kate Thompson, *Public Picture Galleries of Europe*.

The Emperor of Brazil,[4] who is here at Paris now, is, maybe, the monarch the most savant of those reigning today. There was much talk this week about him in the high elite and ignorant society, because, being invited to a ball he went with a black cravat and dressed in ordinary costume, but he is far above them in intelligence, knowing the philosophy of life and the mere material value of money, that he thought of something greater than money could display; the emptiness of it is too apparent to him. Our family in the greatest poverty is superior to our rich relations. Do not let such ideas make any impression. This instance alone shows the worth of knowledge. That one who has an object or a love of knowledge has always a world within himself. Philosophy, Art, Music, offer to all who will only seek after them a source of thought that vibrates only with nature and the great minds.

I imagine none of us have any idea of the distress and care of wealth and for our good I hope we never will, for it is only one in a thousand, who has wealth, knows what real enjoyment is . . . Knowledge is the first thing to be gained and in that alone there is a world of enjoyment. No matter how trifling the object you have in view in regard to knowledge, when that is attained there arises another which excites you on.

I wish the girls had one line of embroidery, reading or music which they could turn their objective to, for without that a girl must pass many a weary and lonely hour. It is necessary for them to marry and a man would prefer his wife to know some one thing well. Parties turning night into day over nonsense is the reason that there are not more great persons today. I am writing too much of what we all know, but which we can never be too well impressed with.

They talk of decorating Bastien-Lepage, so you see I was not far when I cited him as one of the figure heads of the Salon. . . .

<div align="right">3 BIS RUE DES BEAUX-ARTS[5]
PARIS, MAY 12, 1877</div>

DEAR JOHN:

What word ahoy! Let the portcullis fall. Your good welcome letter reached me this past week and what you say bears a stamp of sound philosophy, but I feel it my duty, old fellow, to return, to be if possible a comfort to Father in his old years. Nothing seems to me more sad than old age. My advantages have been great and although I am far from being ready to return, I would never forgive myself should anything [happen] to Father. My future looks dark when I reflect and I feel confident that another year would revolutionize me and work wonders. I am more ready to grasp good counsel now than ever before and it distracts me when I think of returning.

You very likely know my engagement was broken off before I left for Spain which had an infernal effect on me and I have no doubt Spain would

[4] Dom Pedro II (1825–91), constitutional sovereign of Brazil 1831–89. A direct man with little taste for pomp, he once remarked, "If I were not emperor, I should like to be a school teacher."
[5] Though Weir moved his sleeping quarters to 71 Boulevard St. Michel, he seems to have kept his studio in the rue des Beaux-Arts.

have appeared different to me had I gone under other circumstances. A philosopher is a philosopher when his mind is healthy and strong, but to be a good artist and a strong one, other things must be added and all depends on the temperament, which I have long since doubted whether I possess.

I have already written to Mrs. Alden telling her of my intention to return and so I will look at it as for the best, but I will return abroad here again when I have some means of my own, if the time ever comes, to continue where I have left off. I feel that I am at present making progress, such as would tell could I continue. However, it will place me on the right road, which alone is a great advantage and for which I can never be too thankful to Mrs. Alden. . . .

I will do my best to get as many good studies as possible for you, but I fear there will be little money over and the money which I owe you for last year I cannot now return as I have not had a cent for the last three months, as Spain did me up entirely and those abortions in the Academy do not sell. Still, do not lose faith, circumstances may change and the sun may still shine. I am putting all my time now in at the schools and composition. . . .

<div align="right">

3 EAST 40TH STREET
MAY 22, 1877
</div>

MY DEAR JULIAN:

. . . You write to me about coming home. You must use your own judgment about it and I suppose with such aspirations you would never feel that you had accomplished much. It has been a great delight to me to have been the means of aiding you and you have amply repaid it over and over again in yourself and in the way you have expressed yourself about it. You know that I wish you every success in your profession and believe that you may do much at home from your knowledge of training in the schools. Perhaps it would be wrong to deprive your Father of any more years. Mr. Dominick will send you the money as usual in July and Percy talks of going over in June so I hope you will wait to see him.

I wish very much we could repeat the pleasure of being with you again for a little while but I am afraid our duty comes before pleasure too, this summer. I hope in your young lives, trips to Europe may not be infrequent, for they are the great pleasure to those who have imbibed a taste for art and scenery. I admire your pictures very much at the Academy and Miss Anderson's portrait seems very striking to us. . . .

<div align="right">

Affectionately your friend,
A. C. Alden
</div>

<div align="right">

3 BIS RUE DES BEAUX-ARTS
JUNE 2, 1877
</div>

DEAR MOTHER AND FATHER:

I have just had my letter from home with a cutting from the *Tribune* enclosed. In the same mail came also a letter from Mrs. Alden acknowledging the receipt of mine and relieving me from duty. It scares me when I think of returning and my studies incomplete, the acknowledged fault of all the

Americans who study over here. However I have no reason to complain and do not but fear it will be a regret more serious in future years. But to look at it philosophically, who knows but what it may lead me to seek another road, with not so high an aim but in which I may be more successful. I have written to New York to a friend who has some influence to try and get a position as instructor in some evening school, although I suppose such places are hard to be had at present. If they have evening schools, I would much prefer that. However if any such chance offers itself I will think well over it before accepting it, as I must think more of the future than the present. . . .

DuBois and Bunce have left for Venice. Most of the men will go there this summer. The Munich students also so it will do much to unite them, as the American papers seem to place us apart and so some feeling seems to have grown up. Duveneck and Chase will be there also. . . .

<div align="center">NEW YORK, JUNE 5, 1877</div>

MY DEAR WEIR:

I have just received your letter today. I am delighted to hear from you and for myself to know that you are coming home.

Your things in the Academy have attracted a good deal of attention and most favorable. You will find yourself less unknown in this country than when you left—and I believe that things will go easily with you. There is a demand for "lessons" and you will be able to find easily a few private pupils which will pay current expenses, and if there is a vacant place in Cooper Institute I can promise it to you—as the principal, Mrs. Carter is a great admirer of your work. But I trust that you will not need it. We want you to work and I believe that you will make things go without taking too much time from what you want to do.

I give three entire days per week to the teaching—it is dreadfully fatiguing and I am not able to accomplish much at painting—I should not give so much time to the school if it were not for repaying the money, and interest on the money which supported me while abroad—once that my debt is paid—good by to teaching! However I do not dislike teaching, I believe that it is instructive to the teacher—and much more agreeable than painting portraits to order.

N.Y. is not such a bad place to live in after you get acquainted. There are a great many instructive and interesting things in the Metropolitan Museum—a *splendid* Frans Hals, a fine Rubens and in the Historical Society Rooms there is a really *fine* collection of "Old Masters"—originals and very fine copies. Since seeing the last collection I am quite contented to remain on this side of the water.

I believe there is no reason why we should not go on progressively here as well as abroad—Swain Gifford, Thompson, Homer Martin, Winslow Homer, Tiffany, Inness and some others are going ahead splendidly. Shirlaw and Dielman from Munich are settled here—they are both very strong and are fine fellows—I have met some people of splendid taste and in full sympathy with art—and you will be received by them as I have been, with open arms.

Bring with you all that you can in the way of photographs of paintings,

etc. also plaster casts—the reduced frieze of the Parthenon, for instance—they are not to be had here—also the Florentine reliefs.

Bring a quart of Siccatif de Courtrai if you use it, it costs 2 fcs. (40 cts) per bottle here—colors are the same price here as in Paris—canvas also, other things much dearer—be sure and bring all of your studio things...

[Wyatt Eaton]

71 BOULEVARD ST. MICHEL
JUNE 27, 1877

DEAR FATHER AND MOTHER:

... I wrote you some time ago about having an invitation to dine with Cady Eaton.[6] He was very agreeable, spoke of having a little disagreement with John but said it amounted to little or nothing at all and that it was all made up now. He introduced me to a Mr. Elison of Philadelphia, who he said wanted to buy some pictures, said he was a wealthy gentleman and ... would like to see some of the artists' work. I offered to take him about but was never more disgusted with any person in my life. Everything he saw was too dear and ... he began to jew the men down until I was forced to tell him that he was in a gentleman's studio and [should] take them at his price or let them go. After spending my time in taking him about, he decided on nothing at all and thought that their prices were very high, although the highest was but two hundred dollars. He sickened me to such an extent that I have decided if I ever came in contact with such a person again to show him the door. If these are the people we have to deal with at home, I would rather starve here than go into such transactions. The men's work[s] which were fine and meritorious, he thought looked unfinished etc. and ... the worst of all, [by] an American who has always been refused at the Salon and has no reputation amongst the students as an artist, he thought the finest of all he saw. When I was going in to see a man in the same building, when he saw another studio he cooly said that he had enough of pictures for that day. I wonder now that I had not kicked him then and there. They have an idea that an artist can be insulted at leisure and is a poor dog that one must jew down. Never will such a thing pass me without resenting it on the spot. . . .

I have lately met several men who have just come over here who say there is nothing whatever doing in art in N.Y. and they came over here on that account, however I hope things will take a change. If when I return I find things on the standstill, I will go off to some western town and "portraitfy" the savages. . . .

[PARIS,] JULY 3, 1877

DEAR MOTHER AND FATHER:

Voila! the day before the anniversary of our noble day of Independence has arrived. At home I suppose things are being prepared to make the day hid-

[6] Daniel Cady Eaton (1837–1912), Yale '60, professor of art history and criticism at Yale 1869–76 and 1902–09.

eous with noise. I appreciate your feelings now when we were boys and deafened you with this most awful of all American sports, the shooting of fire crackers. Here we would never have known the day was so near, even among the Americans. Each one has his work, which to him is more interesting and more necessary, but I am again sure champagne will nevertheless be opened, and compliments thrown in from the Englishmen. They are I am glad to say a sensible set of fellows, and I might justly say that they are a better and more honorable set of men, than what we have over here. I am sorry to say the men who left here last year left debts and disgrace behind them.

Yesterday while working in the school I had a visit from Percy Alden. . . . He tried to persuade me to return with him, which at last I accepted to do. Being on an expensive vessel I told him frankly I could not afford it, and was already making arrangements to go home another way, but he assured me that he had taken a whole stateroom, and expressly desired me as a favor to go with him. He was very kind, and told me I ought not to return, and led me to think that I might stay over here for ten years if I thought fit. However this I accept as a kindness. When I next return I hope I will be able to do so on my own means

<div align="center">4 JUILLET, 1 P.M.</div>

I have just got in from breakfast, having drunk to the fraternity of the two Republics, and expressed my regret to the students of having to return, or rather to be forced to leave them soon. It does, I assure you, make me feel bad, the idea of having to leave these men, who are so sympathetic, and with whom I have studied for the past years. I am the only American who dines there, and find more pleasure and unity of feeling than with the American students here (in general), although some are warm friends! Art has not grown to be their cherished thought. . . .

The evenings I generally pass at a café where Falguière, Français and many of the greatest sculptors and painters go. How different from America. One sees Français the painter, Mercié, Falguière, two of the greatest sculptors, as well as many others there, in their linen coats, smoking their pipes and quietly talking over art; evident that they are ennuied by the society, and collect together, where their congenial thoughts mix. In so living one can easily imagine how these men become great and philosophic in their art.

Gérôme came to the school this morning. His just and severe criticism I will miss, but hope what I have received will not be forgotten. . . .

<div align="center">71 BOULEVARD ST. MICHEL
JULY 9, 1877</div>

DEAR FATHER AND MOTHER:

. . . I am now getting enthusiastic over the idea of returning, and I even dreamed the other night that I was in father's studio working on his portrait.

I want to do that if possible to send over here for the Exposition, if there will be time. . . .

I see by the papers that they fear another rising of the Indians in the west. Were they less hostile I would like immensely to go among them, but my study has taught me to appreciate my scalp. . . .

<div align="right">

71 BOULEVARD ST. MICHEL
JULY 18, 1877
</div>

DEAR MOTHER:

I feel now like a retired soldier, I have not only given congé to my atelier, but also the evening school from four till six is closed. I have, however, tried to finish two copies which I have begun at the Louvre, but there are so many old women copying there that it is worse than the noise of the school. Only three are allowed to copy at the same time, so I am being continually chased away, and when one is under sail, it is far from being amusing.

I don't think I have been so homesick since I have been here. What with looking forward to returning and being without my atelier, I feel quite at sea. Louise[7] wants me to spend two weeks with them in London, which I will do! I hope to leave here about the first week in August. I will have to wait, however, till the casts are finished for Yale College and get them off.

Many of the men have left. Edelfelt has returned to his country (Finland). Simi returns to Florence shortly, another one of my good friends, Ribéra expects soon to go to Rome, having the pension of the King of Portugal, which gives him four years more of study and eight thousand francs a year. I have an invitation to dine with him before I leave. Dagnan and Courtois who are now in loge for the prize of Rome want me to dine with them also before leaving. These are all men of great talent and knowledge and it will surprise me now if all their names are not among those of the best painters of ten years to come, if they enjoy good health. Encircled by the many students, one, I think, can judge of their future careers, knowing their character and their work. It is not always those who produce pictures, but who show research and who do not try to produce much work but good work.

I took a present up to Gérôme of a piece of sculptured marble that I found when I was in Spain. He was not in but after correcting in the school this morning, he came up to me and thanked me very heartily and said he was sorry to hear I was going to leave him. However compliments under such circumstances are as they say in French "les gentilles mots." However I owe much to Gérôme which I never can repay and, had I the means, would have made him a regal gift, but as he is a man of "esprit," he will appreciate it as much as he would one of great value.

The Exposition of the ten pictures, made by the students who have been locked up for the past three months "en loge" will be on the 25th. . . . No one has seen them yet and everyone is in a great suspense, every one counting on his friend as the lucky fellow. I look forward to Dagnan or Courtois. . . .

[7] For earlier mention of Louise and her husband, Major General Truman Seymour, see p. 7.

PARIS, JULY 20, 1877

DEAR JOHN:

. . . The regrets of leaving my old camping ground are weighing heavy upon me, however, I return with determination and con amore. . . .

I want if possible to get one of the pieces of the Parthenon for my own pleasure, the original size. I am all upside down and in trepidation of forgetting important things which will be precious at home.

When I return I intend beginning a portrait of Father and a landscape which I intend making the principal work of next winter. Gérôme I regret leaving, his influence is great, but I feel that I have not become ripe enough to imbibe enough of the essence. However, we will help to fertilize the art soil of America, but history shows us that no great geniuses have been produced and flourished until the ideas of the country were in a ripe state. . . . Plant the good seed, we are the manure which will do it good, although the 19th Century will not see the effect. I feel that we are, however, bound to be a great art nation and hurrah! for America.

I am writing this note in the Garden of the Luxembourg, my favorite of all the parks and gardens that I have seen excepting the little patio of the Alhambra, where the trickling of water is in perfect keeping with all the surroundings.

I expect to spend a couple of weeks with Louise and Seymour in London before going back. We will revel in the riches of art there. . . . I only wish you were to be there too, however, I will look well and we will have chats over those great demi gods.

Give my love to all and keep your spirits up. You are sound, the fertilizers are what we want, so when the seed is turned up by the storm there will be a chance of its taking root. Nature and art are founded on the same principles.

I will collect all possible that will be of benefit and will leave friends who already have a keen interest in us.

80 NEWMAN STREET
LONDON, W., AUGUST 3, 1877

DEAR FATHER AND MOTHER:

I arrived here day before yesterday and am nicely settled in the same house with Louise and Seymour. They are enjoying thoroughly London, and in a way of their own, or, I might say, as an artist would. They have comfortable lodgings and dine out where they happen to be. Every day we start off about ten o'clock and do not return till night. We have visited together the Royal Academy, National Gallery, South Kensington Museum together with the National Portrait Gallery and various other galleries of art interest. I am extremely delighted to find them such lovers of art and Louise is really a wonder. She sketches well enough to make it interesting and in her admiration does not content herself with the mere surface. They love what they study and study intelligently and I regret more than ever that I did not have

a year with them in Paris, so as to . . . see them nicely settled there before I left.

London is gloomy, sad and dirty to me after leaving Paris, but it presents an aspect of seriousness that Paris has not. The sun that shines here is not bright and cheerful and one feels as if one has the weight of the whole nation on him. The people are semi-barbaric, the language sounds harsh in the streets and, in a word there is no poetry and I do not believe there is in any of the Saxon race. However we have our great qualities which must not be overlooked and one is deeply impressed with the solidity of Britons.

Time is passing here most delightfully. We think of nothing but art, often neglecting to furnish fuel to our physical machine. Sir Joshua is glorious but we have had a lasting dispute over the worth and reputation of Turner whom Seymour swears by and does not flinch from.

I will very probably call today on Sir Henry Thompson who I hope will not forget his offer to present me to some of the great artists such as Leighton, Alma-Tadema, Boughton, etc. Yesterday we saw some of Whistler's work and I was agreeably disappointed. He has a great quality in his work, which we will talk over. I met Mr. Madrazo and his charming daughter in the South Kensington, a real type of Spanish beauty. . . .

80 NEWMAN STREET
LONDON, W., AUGUST 10, 1877

DEAR FATHER AND MOTHER:

I have just been down at West Horsley visiting one of my old friends, Mr. Peppercorn, a landscape painter. He is married and settled there in a very pleasant house; quite an ideal artist, a good painter with a happy wife and child. I went down with the idea of merely passing the day but two days passed by very agreeably before I could break away. He drove me about the country to show me the landscape and the subjects which he was at work on. I made a happy sketch of his child, which I intended carrying away with me as souvenir of my visit, but the mother was so delighted with it that I presented it to her. He is in the old camping ground of Constable and his work has an equal charm. He goes to nature for everything and interprets her mood simply. I think we may look for him as being one of the big men here, judging from what I saw at the Royal Academy, there is none who has a keener eye for English landscape. The Americans who have exhibited here stand well, Bridgman, Parton,[8] Boughton and one or two others hold us up well.

I received a letter from Percy Alden, in which he says he will not be able to sail until about the middle of Sept., so I will have a good chance of doing some study here. I have decided to wait for him, as it would hardly be right to sail without him after his kind offer. My time will be usefully employed, and it will give me a chance of making some memorandums of some of the fine works here. . . .

[8] Arthur Parton (1842–1914) and his brother Ernest Parton (1845–1933) were both landscape painters.

We are talking of going down to Chelsea to call on Whistler. I have now seen some of his works. They are fine as far as they go, but are not more than commencements. I hear that he has brought suit against Ruskin for some criticisms that he wrote on some of his Exhibition pictures. . . .

80 NEWMAN STREET
LONDON, W., AUGUST 22, 1877

DEAR MOTHER AND FATHER:

Yesterday we all went out to visit Turner's house at Chelsea. We afterward went and called on Whistler, who we found a snob of the first water, a first class specimen of an eccentric man. His house is decorated according to his own taste. The dining room is à la Japanese, with fans stuck on the walls and ceiling, according to his own liking. He showed us some of his nocturnes in the different minors, rather flat, however a certain harmony and best seen in a demi obscure room with the light softened by passing through several thicknesses of curtains. He showed us afterwards his studio, or, as he called it, his work-shop. His palette was a mahogany table about three feet in length, with the colors set thereon. A portrait, which he brought out was not positively bad but what one would take for a good ébauche or first painting. His talk was affected and like that of a spoilt child, hair curled, white pantaloons, patent leather boots and a decided pair of blue socks, a one eyed eye glass and, in escorting us to the boat, he carried a cane about the size of a darning needle. Alas! this is the immortal Whistler who I had imagined a substantial man! He wished to be warmly remembered to you and wanted me to say that he regretted that you had not sent me to him to study in place of allowing me to go with Gérôme, whom he did not seem to patronize, at which I "boo booed" in his face. A harmless man. Today I wanted to settle him decidedly in my estimation, so went to the British Museum and looked over his prints, some of which are certainly remarkably fine and more decidedly bad. In etching he always manages to get a good tone, which is I believe a great deal in etching. However I afterwards looked over Albert Dürer's and his (W) seemed child's play by the side.

Sir Henry Thompson has been very kind to me and I have assisted at six operations on the stone, taking part as assistant in the most interesting [part], that of cutting, which he performed very skillfully. . . . Sir H. kindly told me if I knew any Americans here, to invite them to see the cutting operation, but unfortunately I knew of no one. Monday he cut and crushed within an hour on two patients, having to walk about four blocks from one patient to another. In crushing he caught the stone three times, extracting about 20 grams each time and all was over inside of twenty minutes. In crushing he performs so beautifully that it seems as nothing to do.

I went out to the gallery of the Duke of Westminster, where I saw Reynolds' *Mrs. Siddons As The Tragic Muse* and Gainsborough's *Blue Boy,* far better than anything Sir Joshua ever did. I will have much to tell you about all those pictures and will try to make a copy of some of the principal portrait painters. . . .

80 NEWMAN STREET
LONDON, W., AUGUST 22, 1877

DEAR JOHN:

Old fellow, you very likely, and maybe justly, think me an ungrateful "cuss," but letter writing is most disagreeable to me although I often think whole letters to you I fail to write them. We will see one another soon however, and I will get down and have you cudgel me to your heart's content and mine also, for I feel I deserve it.

Yesterday Seymour, Louise and myself went out to Chelsea to see the house in which the great Turner died. Unfortunately some old Briton was sick with the gout, so we could not enter.

We then turned our steps towards Whistler's place and were ushered into an eccentric waiting room or parlor where the Chinese art prevailed. On the walls were several nocturnes and hemi, demi, semi, quasis, which he afterwards showed to us, desiring us to move to the other side of the room and these works being small, the work was much improved from afar. Ah, ha. Mi lord enters, thin, slick, frizzled haired and to all appearances a coxcomb. He introduces himself with gracious smiles and after keeping us waiting a full half hour, makes his excuses for not having looked at our cards Major General Seymour, Mr. Weir, etc. Ah, yes, turning to me, Major General Weir. No, Milord, and so it went on. When he was straightened out the conversation began, he striking an artistic position displaying a pair of howling socks, patent leather boots of exceedingly old fabric and plenty of London assurance. Ah! ha oh! Yes ah-no-ah-yes ah ha yesssssss. He remembered W.P.[9] etc. However, he showed behind all this an observing man, his eye is sharp . . . We went into his studio where his palette consisted of a mahogany table about three feet in length covered with the demi, semi etc. tones of Whistler, a portrait which he showed us, I thought was well laid on, which he considered finished etc. and so on. I went, however, today to see his etchings and some are really remarkable and many more absolutely bad to me. He sent his compliments to Father and said: "You tell him that I regret he did not send you to me. Ah Pooh! I think nothing of Gérôme." It was below me to reply to such an eccentric remark in his own house. . . .

Seymour and Louise are enjoying themselves and studying like real students. I am in clover with them. We pass most of our time in galleries, all of which we will talk over at leisure. . . .

80 NEWMAN STREET
LONDON, W., SEPTEMBER 12, 1877

DEAR MOTHER AND FATHER:

This week I went down to the office to find out the exact date of our departure and found that P.[1] was not able to get a berth for the 13th. and has taken them for the 27th., so again you will be disappointed. However, I am

[9] At West Point as a cadet from 1851 to 1854 Whistler had studied drawing under Robert W. Weir.

[1] Percy Alden.

making good my time here and will be able to show Father some sketches from some of the celebrated portraits of the National Gallery.

I dined the other day with my friend, John Varley, grand-son of the great water color artist, as well as nephew of Mulready. He showed me many fine water colors of his grand-father, Prout, Hunt, and in fact all the great water colors men of the day. He also is a water colorist and does fine work. For ten years he journeyed in Egypt, where he has collected many fine works. He has very kindly offered me some small sketches of his grandfather as souvenirs of my visit to him. He showed me also many fine large Prouts, some of the finest I have ever seen, so that in all, you may imagine how pleasant my visit was. We all went out to his studio knowing the General would like to see good water colors. He was much pleased. We, however, only looked over his Nubian work. . . .

Seymour and Louise left yesterday to make a trip over the western and southern parts of England to see the Cathedrals and old bits of architecture. Yesterday they went to Oxford, where I have very pleasant reminiscences of the place from my trip there four years ago and would like to have made it over with them did I not feel the necessity of staying by the Galleries and trying to carry off as many sketches of the great works as possible.

I wish you were here to look over the Rembrandts and in fact the etchings of all the great men. Having a ticket to the Print Room, I can see all the rare etchings and prints of almost any man. I was looking at the proofs of some which you have, such as *The Hundred Guilders* and will be much interested in examining yours when I return. I am sorry to say that almost all the works of Wilkie, Sir Joshua and in fact the best of the English school are already almost gone. Those which are not cracked are faded and many whose works were painted solidly and frankly have been painted on red grounds so that they come through. Still Hogarth is an exception and his works stand better than any of the others and increase in tone and stature every day.

Millais, the portrait painter here, has just built a house which cost him $200,000. In consequence he does horrible work. I suppose in order to pay his bills. He now paints by receipt. . . .

80 NEWMAN STREET
LONDON, W., SEPTEMBER 22, [1877]

DEAR MOTHER AND FATHER:

This is very likely the last letter that I will write you from this side. I hope this time there will be no more disarrangements in getting off.

The weather is getting very cold and I fear I will have a cold trip. However, I have just invested in an immense ulster. When I walk down a sunny street, people begin to wonder what is up; the sunlight being so completely obscured. But it will be a jolly good thing at home, but still will have to hope the winter will be good and cold, in order that I will not be too warm in it.

My old friend Peppercorn discovered me in the gallery the other day

and insisted on my taking a run down to his brothers', where I met them and their wives and children; a jolly household. I will not be able now to do any more sketching in the Gallery, there being but two days a week that students can work there, which is an absurd rule. I look forward with pleasure to the time when I will be settled down again to work. The surmises which have gone through my head as to how I will find you all and that you will find me, I fear, grown more corpulent in my physical and the want of keen observation still uncultivated, which I recall as a point Father often used to comment on. However, in art if nothing more, I flatter myself I will carry home one or two healthy ideas, which can be built on.

> Hurrah for the ship Germanic
> That's going o'er the sea.
> A roaring lot is the lot of mine
> To have a berth in thee.
>
> I'll drink a bumper for good luck
> Another I'll drink to thee
> For my heart is gay
> I'm going away
> Back to my own country.

With much love and an empty pocket you'll see

Your affectionate son,
Julian.

CHAPTER 5. PORTRAITS IN NEW YORK, 1877-83

Weir returned to his native land glowing with enthusiasm and high ideals, filled with youthful energy and an ardent ambition, not merely to make a name for himself in his profession but also to devote himself to the cause of American art, which was beginning to show unmistakable signs of a new birth.

There had always been a strong vein of materialism running through this country, the quite natural result of the struggles of a young nation fighting primitive nature for actual existence, with little time for amenities. But slowly and gradually another side of the picture had emerged, and by the early part of the nineteenth century native talent began to be recognized. Many of our literary men were as well known in Europe as in America, and the painters of the Hudson River School found quite adequate patronage at home; in fact, one or two of these artists made great local reputations for themselves and continued to be popular all their lives. Albert Bierstadt and Frederick E. Church, for instance, commanded prices that seem almost unbelievable today. Bierstadt received as much as $30,000 for a painting; and when Church exhibited his huge *Niagara Falls* in his studio, 10th Street was black with the crowds that flocked to see it and paid admission for the privilege. But these men were exceptions even in their day, and the disruption of national life brought about by the Civil War caused prosperity for the American artist to vanish almost completely.

It was not, however, until the Civil War had ended and peace was restored that American artists began to suffer actual competition from abroad. Up to then most of the art imported had consisted largely of indifferent copies of the old masters, but now contemporary foreign art poured into the country; and with the establishment of peace a new era set in. The country settled comfortably down to prosperous times and a new materialism that was at once more worldly, more sophisticated, and mercenary. Huge fortunes were made and spent. Americans began

to travel extensively abroad; while at home the wealthy built magnificent palaces for which they wanted art that would surround them with an aura of cosmopolitan taste. What they found were Bouguereaus, Gérômes, Cabanels, and the painting of Piloti and Hans Makart—the popular art of the day in Europe as well as over here. It was to this America, rich, materialistic, and not so much scorning its native art as ignoring it, that a whole group of young painters now returned.

What these young artists advocated was not any particular method of painting; they had the more ambitious aim of substituting the spirit for the letter and of opening their countrymen's eyes to the significance of art. Their revolt in the beginning was mild enough; it was directed more against entrenched privilege as personified by the Academy than against any single style. As we have seen, the Academy of 1875 had itself welcomed them with open arms; many of them—Bridgman, Brush, Wyatt Eaton, Saint-Gaudens, Thayer, and Weir among others—had won their spurs there. In 1876 their showing had not been so numerous, no doubt because the Centennial had absorbed their efforts; but by 1877, the spring before Weir's return to America, their numbers had become formidable. That famous year Weir, Flagg, Brandegee, Minor, Thayer, Chase, Low, Duveneck, Brush, to mention only some of the names of the younger exhibitors, all had pictures in the annual Academy Exhibition. Most of them showed more than one; Weir had five. The Hanging Committee was sympathetic to the new men, as were the critics. The *Art Journal* remarked on "the novelty and fresh character of the collection. A year ago there was a general complaint . . . of the great lack of invention and imagination evinced by our painters generally. This season it is as if some magician's wand had been waved over the scene, causing a sudden transformation . . . of conventional caution into audacious daring." But the old guard rose majestically in its wrath and promptly passed a resolution that henceforth each Academician would be entitled to seven feet of wall space per man. The new painters were to be quite literally cut off from the light.

As the *New York Times* put it in a biting editorial:

It will be generally understood that outsiders have no chance at the exhibitions of the Academy; interest in these exhibitions will cease; and people will simply stay away; . . . all this . . . because a body of worthy old painters are in a huff over the result of exertions on the part of a Hanging Committee of three elected by themselves, . . . because the paintings of young and comparatively unknown artists have been placed . . . on the line, while the can-

vases of older men have been "skied" . . . But the act of the Academicians at once acknowledges several things. One is that their work cannot stand the competition of outside painters even before a tribunal appointed by themselves; another that young painters must look elsewhere for encouragement and appreciation . . .

But there was nowhere else to look. There were no exhibitions outside of the Academy, and the few art dealers available seldom handled American work.

The seven-foot ruling was a battle gage thrown down by the Academicians and accepted as such by the new men. Their answer was the founding of the Society of American Artists in the summer of 1877. Weir was elected to the Society on his return from Paris that autumn and participated as a charter member in formulation of policy and in all subsequent exhibitions for some twenty years. The Society sought good work wherever it might be found and appointed committees to visit studios in New York, Boston, Philadelphia, and on the Continent, especially in Paris, where a five-member jury was established. All paintings, including members' work, faced jury rating to determine acceptance and precedence in hanging. The resulting shows introduced a new vitality into the American art world.

The Society's first exhibition, in March of 1878, was hailed by Clarence Cook, art critic for the *New York Tribune,* as a decisive departure. "This exhibition means revolution. Here in this modest room Art in America . . . shuts the door behind her and . . . sets out in earnest to climb the heights." Nearly all the finest American painters of the day were represented. Among the younger men—all future members of the Society—were William M. Chase, Frank Duveneck, Thomas Eakins, John Sargent, Abbott Thayer, John Twachtman, and J. M. Whistler, while the members made a strong showing with works by such men as George Inness, Walter Shirlaw, Homer Martin, John LaFarge, Albert Ryder, Winslow Homer, and one of the youngest, J. Alden Weir.

The critics were generally enthusiastic; and Clarence Cook, in an article devoted entirely to the work of Weir and Chase, pointed out the honesty and integrity in Weir's paintings and anticipated the difficulties which such truthfulness would encounter in the world of fashion.

By the artists themselves, no one of the exhibitors is reckoned higher in promise than he. Of course, Mr. Chase's work is far more taking. There is no difficulty at all in admiring that; but Mr. Weir's is not superficially attractive. One must have gone through with a good deal, have become tired of a good

deal, before he can take real pleasure in these low-toned, unkempt heads, and can recognize in their sureness of touch, singleness of aim, and absolute dependence on truthfulness, the spirit of a genuine artist. Apparently Mr. Weir cares very little as yet for beauty and less than nothing for what is known as "finish," but he does care for study, and he is bent on using his own eyes; and we may confidently wait for the results of his independence and his study . . . Since this exhibition opened, no work has attracted more serious attention than Mr. Weir's . . . But it will take a long while before the dilettante circle (especially those members of it who have invested largely in the art which we are now leaving behind us) will open their eyes to the growth that is going on about them.

Weir continued to exhibit regularly with the National Academy, but the Society of American Artists commanded his real loyalty. He was active on Society committees from the beginning, served as secretary during the crucial period of 1879 and 1880, and it was the Society which offered a focus and a stimulus to his artistic development during his journeyman years in New York.

In this respect Weir was fortunate, but prospects for a novice professional painter were uncertain at best. A man of slender means, he faced a long, slow pull very different from his student life on the Left Bank. In his small studio at 11 East 14th Street Weir began the portrait work that was generally regarded as essential for a career. To his brother John he confided some of the difficulties of this first winter.

It is a dogged battle I have been fighting, trying to get some things off and rent paid. So far things hang fire, which feelings you can appreciate . . . You would have heard from me, but the drubbing up and worrying has made the pleasure of letter writing disagreeable to me. Up to the present time I exist, and have some prospects of getting a portrait; but pictures can't be painted without models, which requires money. I hope to get two things in show windows this week and by next week to have two children's heads to place somewhere else . . . I had a letter from Wencker at Rome. It made me homesick.

The road was not easy, but among his fellow artists in particular Weir established himself early as one of the coming men. Young Howard Pyle in a letter of November 1878 wrote home excitedly about the new art movement and cited Weir in the forefront alongside Chase and Shirlaw. Weir he described as

gay, handsome, broad-built and burly, one such as you might picture to yourself as the beau ideal of a handsome, roaring, young English country squire of the early part of this century. He is a handsome man of about

twenty-six or seven, with regular features, a firm, rather heavy chin, short curly hair, a thick neck and broad shoulders. Yet, in spite of this seeming "fleshiness" there is a true vein of honest sentiment running through his nature that develops itself in a delicacy and impalpability of flesh color that has more real refinement about it than either the fiery Chase or the thoughtful Shirlaw can produce.

Slowly Weir's reputation grew and his portrait commissions increased, but the honesty and disregard for surface facility which Cook had remarked earlier prevented his work from becoming fashionable in a commercial sense. In order to supplement his earnings Weir taught painting, beginning at Cooper Union Women's Art School in the fall of 1878 and later on adding private classes and a portrait class at the new Art Students' League. He taught art for some twenty years, but teaching seldom came easily to him and he grudged the time it took from his own work. However, it did supply the funds to enable him to paint as he liked.

The portrait work of these early years represented Julian's best efforts and achieved considerable critical success. For the Metropolitan Museum's important first exhibit in its new Fifth Avenue Galleries in 1880, Julian sent his portrait of his friend Olin Warner (Fig. 4), the sculptor, a work declared by Clarence Cook to possess "so much veracity and force as to make almost an era in our portrait painting. . . . Manly qualities strike men everywhere, and Mr. Weir's portrait is distinctly a manly record of manly qualities." This same portrait Weir sent to the Paris Salon of 1881, followed the next year by *Portrait of Warren Delano*,[1] which won an honorable mention. At home in New York the critics concurred that portraits struck the strongest notes at the Society exhibition of 1883. Weir's *Portrait of a Gentleman* (Richard Grant White) was considered to be "a fine piece of straightforward, simple work, an excellent likeness without a trace of flattery," its dignity and repose contrasting sharply with the chic impudence of Sargent's flashing *El Jaleo*.

Despite the growing reputations of Weir and other talented young American portraitists, foreign work continued to dominate the market, a situation summed up by the *Art Amateur*'s loud complaint that "We have in New York and Boston a few men who paint portraits in a style that wins admiration, even in Paris where are painted the best portraits; yet these men are so stingily employed that it must be hard for them to live. In France such men as Duveneck, Alden Weir, W. M. Chase, Wyatt

[1] Warren Delano (1809–98), merchant, grandfather of Franklin Delano Roosevelt.

Eaton, Francis Lathrop, Thayer and Vinton would find themselves in full employment; but here, if our Museum of Art wants a portrait of its president, it gets it painted by Bonnat."

As a bachelor, however, Weir managed to live quite comfortably. His art classes were filled; his portrait commissions progressed, if slowly; and he moved into more convenient and spacious studios, leaving 14th Street in 1878 for the University Building, where Samuel F. B. Morse had established the first collegiate instruction in design forty years earlier. Then in 1880 Weir shifted to the Benedict Building, a new six-story red brick house on Washington Square East, where he had a studio with fireplace on the top floor and an adjoining room for private pupils. The quarters were thoroughly congenial, and among his good friends who took studios in the Benedict were Olin Warner, Wyatt Eaton, and Albert Ryder. There was always time for talk at the little French wine shops on the Square or up at a saloon on 14th Street and Fourth Avenue where the barrel beer and Swiss cheese were excellent. And Julian could be heard expounding on the great future of American art once the country realized what real art was like.

If there were times when Julian felt blue, the general outlook seemed to brighten steadily; and the summers were filled with delights. At Holly Farm in Cos Cob, Connecticut, he found country that he loved and a warm welcome which drew many artists and writers over the years to enjoy this spacious Victorian house.[2] And there were trips to Europe. On the heels of his first difficult winter Weir returned to Paris as Mrs. Alden's guest, touring England and France along the way and enjoying a summer of old friends and new painting. Again during the summers of 1880 and 1881 he returned to the Continent, combining the pleasures of a sketching trip with a highly successful round of purchases for a New York art collector.

Julian's letters to his parents from abroad are filled with European art, but his enthusiasms were rooted now in the American art world.

"Never was man more delighted than I was to again return to sunny France," Julian exclaimed happily in a letter from Paris (June 16, 1878).

I drove with Mrs. Alden to the Hotel de Bath . . . and took dinner, after which I came over here to the old quarter; and since I have been here, I have been feted like a king. Most of my friends are yet here and have been

[2] Among the regular visitors to Holly Farm, later Holly House, were the painters Alfred Q. Collins (1855–1903) and Henry Fitch Taylor (1853–1925), as well as Weir, Twachtman, Hassam, and Robinson, and the writers Willa Cather (1876–1947) and Lincoln Steffens (1866–1936).

doing wonders. Everyone talks of Bastien for the grande médaille d'honneur, his large picture goes ahead of all that I have seen in art. Dagnan, Courtois, Simi, Edelfelt also have strong pictures. I feel like getting right to work. The exposition is fine; I have only seen it twice and therefore cannot well judge. They have my picture on the line . . . My friends are so glad to see me and I them that it is to me like Paradise, and I have become a better American than ever. . .

I attended last night a meeting of the students to try and get up a student-ship . . . by competition to enable a student under twenty-five years to study over here for two years. Rome, Munich, Paris and New York were repre-sented in a good number . . . Our exposition is decidedly weak in landscapes, except LaFarge, who has made quite a success by one of his landscapes, and a few others. Huntington's work looks worse than ever, and so does Church's . . . I am not so overwhelmed by the Exposition in general. One thing I am glad of is that I am an American, and think more of my country than ever before . . .

[Cernay-la-ville,[3] August 21, 1878]

. . . On Saturday last Percy [Alden] came to town. . . We spent a whole day together both in the Salon and in the grand Exposition; we went through all the different schools. This was what I wanted to see the Exposition for, to know exactly where the French school stood, compared with the rest of Europe. I am quite satisfied; although there were very few that I would call chef d'oeuvres, yet there were more than in any other department. I was glad also to see the English school, where the celebrated Millais, Leighton, Alma-Tadema, etc. exhibit. Millais is an artistic artist, too much so for me; still there is a sense of refinement and character strictly personal, so mixed with candy colours and bad drawing . . . making one feel that he was confident that the putting in of a portrait was sufficient, hands horribly drawn and slovenly painted, yet in character.

I had a rare treat in the exhibition in the hotel Durand-Ruel, where were collected together the works of Rousseau, Corot, Daubigny, Millet, Courbet, Diaz and others of worth. To see these works one is really inspired to go to work immediately. The simplicity and truth of these men makes one love art and want to get to work. I am anxious over my work now, for fear that I will not be able to carry things on as I want to. I think I am doing work now that is far ahead of what I have yet done. You may not be so im-pressed; however, I will do my best, as I recognize that I must do something this year, to try and hold on to what little success I had last.

[Cernay-la-Ville, August 29, 1878]

. . . I am anxious, and often in wonder, as to how Father will look on my work of this summer. Some days I am much pleased with it and others it looks bad. Anyway I have made an effort to forget my school work, and work

[3] A village about 30 miles southwest of Paris. Weir had gone sketching there many times as a student.

as natural and naive as possible. I only wish I could have had the whole summer for work. I begin to think that an artist can be bred a good workman anywhere if he has some healthy men to work with who are not influenced by the old pictures except in sentiment. What has given me interest in the primitive Florentines is their sincerity and that their works must have been painted to a certain extent out of doors, everything is in a light key, and such pictures are certainly more sought after nowadays as the parlors are generally so dark that any other kind would not be seen, and people buy pictures, as they do furniture, to lighten up their rooms . . .

After a summer of painting outdoors Julian returned refreshed to New York, to his portraits and his art classes. He stayed in his studio through the following summer, sitting for a bust by Olin Warner. And his friends at the Beaux-Arts kept him posted on affairs in Paris. His comrade Albert Edelfelt reported that

Bastien has been decorated, and his success at the last Salon (the portrait of Sarah Bernhardt and his potato gatherer) has put him in the first rank of contemporary masters. All Europe talks of him, Paris resounds with his name. The Prince of the French goes to him to ask for his portrait, and the English artists receive him as a prince in London where he has gone two times this year. His studio is completely refurnished very fashionably. Dagnan is married. He has married the cousin of Courtois, a Miss Walter who they say is charming and in comfortable circumstances from the financial point of view. Baude is earning much money. He is a master and employs some ten workmen . . . Sargent, whose portrait of Carolus has a well merited success, is in Spain at present.

Weir was convinced that what America needed was the "real art" of men like these as well as examples of the work of the masters. When he was asked to return to Europe in the summer of 1880 on a picture-purchasing trip, he was delighted. His sponsor was Erwin Davis, a wealthy silver mine owner who was anxious to form an outstanding art collection, and who was wise enough to realize that he would need help from someone whose opinions he could rely on. Davis was a man of great force of character, inclined to be cynical and hard-boiled, who liked to consider himself an eclectic; but in matters of art he had great natural perspicacity and feeling. His collection became an unusual one, for his day, in that he shunned the smooth, slick pictures of facile workmanship which were then filling the private galleries of America. He wanted no Zamacois,[4] no Gérômes; instead he preferred the more solid work and rich tones of Rousseau, Corot, Daubigny.

[4] Eduardo Zamacois y Zabala (1842–71), Spanish genre and historical painter.

Weir found himself in general agreement with Davis,[5] and their joint venture proved eminently successful. Weir's major purchase for Davis that summer was Bastien-Lepage's *Joan of Arc* (for four thousand dollars), a painting which produced a sensation when exhibited the next winter at the Society's show. A critic in *Scribner's Monthly* observed that "its presence in America will doubtless not be without good effect upon the large and earnest body of youthful artists and art-students." And Edwin Abbey called it "the greatest modern picture I have ever seen . . . I never had anything so stir me up in my life."

The next summer Weir brought back to Davis a large collection of Rembrandt etchings and some thirty paintings which included three by Manet, a fine Velasquez, Courbet's *Violoncellist*, a portrait of a little girl by Sir Joshua Reynolds, and another girl by Gainsborough. The Manet purchases, in particular, showed Weir's independent and discriminating eye. As Guy Pène duBois commented later, the Manet acquisitions made clear "one of the reasons why American painting in the lifetime of J. Alden Weir and William M. Chase" went ahead "not through those who have copied foreign manners but through those who could see the intrinsic good in any man's work."

Weir's own account of his encounter with Manet recalls how he was prowling about Paris with Chase when

we came across the two pictures that now hang in the Metropolitan Museum, by Manet—*Boy With A Sword* and *Girl With A Parrot*—two splendid canvases which I purchased for a friend. I had never met Manet and was anxious to know so fine a painter—I think he lived just outside Paris in the direction of Bougival. He was at home when I called, painting from a very beautiful model in a Watteau costume. He insisted on my coming in and that he was about to stop work. I told him of the two fine canvases I had purchased. . . . He said: "I have a landscape that I think you would be interested in." It was a fight between the Alabama and the Kearsage off the French coast near Cherbourg; it gave me great pleasure and I asked him if he would be willing to part with it. His price was 2000 francs, which I decided to take. He went into the next room to get another canvas, when this charming model said to me: "Monsieur, you are a fool to pay so much, leave it to me, I could have bought that canvas for two hundred francs," which showed the keen appreciation of this charming creature. He invited me to dine with him the

[5] Weir had never considered Gérôme's paintings great art. His own efforts were moving him rapidly away from school work toward a "naive and natural" art. (See Weir's letters of August 29, 1878, from Cernay, and February 7, 1876, from Paris.)

next night.[6] He was very sore that his work had been acknowledged by so few. Invariably refused by the Salon, several times he had an exhibition of his work at the same time and near the Salon, but the critics were very severe and the class of painters to understand his work were very few. My impression was that he was a man whose disappointments had eaten into his very life.

For Weir what made this European summer of 1881 especially delightful was a leisurely stay in Holland at Dordrecht, painting and sketching with his brother John and his good friend Twachtman. John remembered it as the most ideal art summer that he ever spent. Each morning after breakfast Julian, John, and Twachtman would go their different ways, to meet again at the end of the day for a late dinner with the other artists staying there. This was always an enjoyable affair, with amusing results when art discussions grew warm and each man would burst forth vociferously in his native tongue. After dinner they would take long walks along the canals in the evening light, with the great Holland skies high over their heads. One day Julian hired a huge carriage drawn by six horses and took all the children from their street on a picnic to the next town; but most of their excursions were to the neighboring galleries or to visit artists or dealers on the hunt for pictures for Davis. They were a congenial trio, although John, being older, a college professor, and inclined to be more conservative in his views on art than the two younger men, was affectionately dubbed the "Old Master," while he in turn retaliated by accusing them of knowing only two men in art, Velasquez and Hals. For his part, Julian was "more than ever delighted with Holland"; and he wrote to his parents: "The Dutch are my ideal. They are a very sincere and conscientious people, it makes one feel the shallowness of the French."

Nonetheless, late August found Julian back in Paris, the center of the world of art, guiding John through the ateliers of the Beaux-Arts and completing his purchases for Davis before heading home. A week in London offered more galleries and friends, and another encounter with Whistler, a story Weir very much enjoyed telling.

It seems that Weir was working one afternoon in the National Gallery, copying Velasquez' *Philip IV*, when he became aware that someone had stopped behind him and was looking over his shoulder; after a few moments the observer murmured "Not bad." Weir, irritated at being

[6] This must have been the occasion when Manet presented Weir with a signed photograph of *Boy with a Sword*. Manet's *Battle of the Alabama and the Kearsage* is in the Pennsylvania Academy in Philadelphia. A newspaper reported that Manet introduced Weir to his friends as an American gentleman "who has bought a ship to go home on."

watched and at what seemed to him the rather patronizing comment, said witheringly without turning around: "To whom am I indebted for this compliment?" When the answer came: "My name's Whistler," Weir, who had long been an admirer of Whistler's work, was overcome with confusion. He turned quickly around, apologized profusely for his sarcasm, and introduced himself. When Whistler recognized the son of his old art teacher at West Point, he insisted on Weir's dining with him that night. Weir's remonstrance that he would not be presentable in his working clothes was brushed aside; and it naturally did not take much persuasion to induce him to lay aside his paints for the day. Getting into a hansom, they started off, Whistler occasionally prodding the horse—all unknown to the driver above them, with the thin wandlike cane he affected at the time—to hurry him along a little faster. They drove first to one of his clubs, where Whistler went in for a moment but soon emerged again to complain that that was not the place for them as he did not like what they were serving for dinner; they must try further. Accordingly they drove on to another of his clubs, but again he found it impossible, this time because some bore had ensconced himself. He decided they had better go home and try pot luck, and on they went to Whistler's house in Tite Street. Here Weir was again told to wait, while his host this time had a bath and dressed. This took a long, long time; and in the meanwhile Weir could hear people talking gaily in the next room. When Whistler finally reappeared, Weir discovered that the conversation from the next room had come from several guests, all of whom had been previously and properly invited to dinner. The party, however, proved too gay and festive for Weir to be in the least concerned with the fact that he was the only one not in full evening dress.

Back in New York working conditions were not as ideal as in Holland, but groups of congenial friends—artists, writers, and musicians—created a lively atmosphere. The Tile Club, in particular, offered its young members good talk and the companionship of men who spoke the same artistic language. The weekly gatherings of this small group from its beginnings in 1877 until its disappearance ten years later were mutually enriching. Among Julian's fellow members were the painters Abbey, Homer, Quartley, Chase, Vedder, F. D. Millet, Bunce, and Twachtman; the architects Stanford White and E. Wimbridge; the sculptor Augustus Saint-Gaudens; the illustrators Arthur B. Frost and C. S. Reinhart; the writers F. Hopkinson Smith and Earl Shinn; and such honorary musical members as Gustav Kobbé and Antonio Knauth. The club-

house, hidden in a courtyard at the end of a sunken tunnel entered from West 10th Street, provided an informal sanctum. And the club outings were marvelous, usually journeys "in search of the Picturesque," as Hopkinson Smith dubbed them. Edwin Abbey in a letter from England in 1880 gives a glimpse of how much the club meant to its members: "It seems to me that small, strong, earnest bodies of *live* men, working together and using each other's experience, as the Tile Club does, cannot help but become a strong power and influence for good. I never worked so easily and surely as I did when I was with the boys on Long Island [an 1878 outing] and I feel greatly the lack of the same congenial companionship here."

The Tile Club's Erie Canal outing gives a good picture of the lighter side of Weir's early years in New York. After a long search a suitable canal boat was found, the *John C. Earle*. It was hired for three weeks and fitted out like Cleopatra's barge. The cabin, forty feet by eighteen, was hung with old Flemish and Italian tapestries and on every side were bronzes, rare Japanese vases, Queen Anne furniture, spider-legged tables, clawfoot chairs, brass placques, antique hanging lamps, an open Japanese umbrella, and potted palms—nothing was lacking. Down the center ran the Club's long pine table, covered on departure with brilliant Eastern cloths and photographs of rare paintings. Along the walls were lounges, covered with draperies and tiger skins by day, which served as beds by night. There was even a chapel, so called, in a dim corner of the saloon, with a large Spanish crucifix flanked by the gilded figures of St. Roch and St. Joseph. Italian lamps were suspended from the ceiling, and in front of a Gothic Madonna hung a thurible for burning incense. The deck outside was covered at the stern with an awning for day, and at night a mammoth Chinese lantern was hung up as big as a Gothic saint's nimbus and surrounded by glimmering Japanese paper lanterns.

A tug pulled the *John C. Earle* down the river from Pier 39 on West 10th Street to the Battery, where they were lashed on to a line of some fifty tow boats for the haul up to Albany. At Troy they entered the canal, now drawn by their own mule team, which they promptly decked out with Spanish saddlecloths of scarlet and gold; for each long mule ear they provided a Japanese fan. The painters found endless compositions unfolding as they glided quietly along or as they slowed to anchor at sunset. And all along the way reports of their approach preceded them, the big Japanese gong being sounded whenever they drew near a town. Everywhere the inhabitants turned out with gifts of fruit and flowers,

curious to see the famous boat. At times the Club received their visitors with tea and music, occasionally in costume. And their guests were often invited to "dress up" themselves and join the mustachioed Japanese empresses, the brigand chiefs, the Veronese portraits, and the Mierevelt Lollards. If guests stayed too long they might hear rattling chains and groans from below decks, followed by a Tiler's deafening yell, always to good effect: "Run for your lives, the great hairy Twachtman is loose." Yet with all the fun went lots of work, and when they finally docked in New York at the foot of 22nd Street there were scores of paintings and sketches to show the crowd of reporters who met them.

It was during these first years in New York that John Twachtman became one of Weir's closest friends. From the beginning the two men shared a dedication to art and an attitude toward their own painting sufficiently critical to keep them searching for new and more effective styles. To Weir Twachtman could write of his dreams and his frustrations, of the images that flashed through his mind, "finer pictures than ever before. Ten thousand pictures come and go every day and those are the only complete pictures painted, pictures that shall never be polluted by paint and canvas . . ." After their summer together in Holland Twachtman wrote wistfully from his home in Cincinnati: "A good many people, all of them supposed to be up in art matters, have seen my paintings, but I am convinced they care little for them. This is a very old fogied place and only one kind of art is considered good. The old Duesseldorf school comes in for its full share of honor. There is no good art influence here and I shall be glad to leave. We will either go to N.Y. or abroad. The latter is probably the best thing to do and then I can study independent of everything. . . ."

But even in New York the road to artistic independence was hard to find. It would be a number of years before Weir and Twachtman would move confidently toward those personal styles of painting that would match their ideals; and in this winter of 1882 Weir's spirits were often low. A letter to his brother John in December shows him blue and discouraged. "I wish I could see your work, which I hear such glowing accounts of. My own has been, and is still, fearful. I still have some courage left, but my time is so woefully cut up with so many things that I tremble. 'Art is long and time is fleeting' . . . My ship is running near reefs now and shoal water on the other side." He little realized how soon his course was destined to steady.

During the previous winter Weir had started a class of his own in a

studio he took for that purpose on the ground floor in the Benedict Building, and he had also given private drawing lessons in the little room off his own studio to several pupils, among them Ernestine Fabbri and her brother Egist. One day in January Ernestine brought a new pupil to the studio, her dearest friend Anna Dwight Baker, a young girl of nineteen who had decided to take lessons not because of any particular artistic leanings but mainly from her desire to be with Ernestine.

Anna was a New Englander of English, Welsh, and French descent. Her forefathers seem to have been almost all early settlers in this country; and through her mother, Anna Bartlett Dwight, she traced her ancestry back to Governor Bradford, while the Rev. Nicholas Baker, on her father's side, settled in Massachusetts in 1631. Her grandfather, Rufus Lathrop Baker, was born in Brooklyn, Connecticut, in 1790 and entered the army as a young man. In 1818 he married Eliza Taintor, the daughter of Charles Taintor, a prosperous merchant in the little town of Windham, Connecticut; and here Anna's father, Charles Taintor Baker, was born in 1821. He, like his father, chose the army as a profession and was graduated from West Point in 1842. He saw service in Florida and "on the frontier," and from 1845 to 1851 was assistant instructor of tactics at the Military Academy at West Point. In December 1851 he married Anna Bartlett Dwight. That same month he resigned from the army for reasons of health; but when the Civil War broke out he nevertheless returned from Europe, offered his services to his country, and trained troops for the army. At this time, with their two daughters, Ella (born 1852) and Cora (born 1858), they settled in Madison, N.J.; and it was here that Anna, their youngest child, was born, May 18, 1862.

The old colonel, Rufus Baker, had added to the family's finances by wise investment, for he was a good businessman as well as an excellent army officer, so that Charles Baker was not obliged to earn his own living; he and his wife soon joined the ranks of those Americans to whom Europe became a second home. They made their first crossing in 1856 and after that went back and forth frequently, sometimes staying for a year or more at a time. As a family they all loved to be on the move; travel seemed to be in their blood, and Charles' uncertain health offered a good excuse for a trip to the Riviera or into Italy or to some German spa for the waters. Paris became most like home because Charles' only brother, Rufus, lived there.

When they were in America the Bakers spent their summers in the

old home in Windham, although the hot weather usually gave them another excuse to be on the move, and they would go to the seashore or the White Mountains or perhaps take a trip to Canada for a few weeks. In the winter they moved into New York, where they either rented a house or stayed in apartments at the Hotel Brunswick. Here in New York Anna received what actual schooling she got at Mme. Tardivel's. There were also music lessons, the conventional dancing classes at Dodworth's and, what she undoubtedly chose for herself, elocution lessons. The theater with her was a veritable passion, and her most cherished ambition—to her mother's horror—was to go on the stage. Even as a small child she had dressed up as Romeo and, with a young Juliet of her own age, would act to an invisible audience; and she loved reciting verses she had learned by heart.

The descriptions of Anna by those who knew her all blend to make a figure of haunting loveliness. What her friends recalled most clearly was a quality variously described as "exquisite," "ethereal," "like some beautiful dream woman," "there was always something of the other world about her." In appearance she was slender, of medium height, and "had to an extraordinary degree a suppleness which gave her an indescribable grace." Her eyes were dark blue, with heavy lids under eyebrows that slanted slightly upward, her features were clear cut, her mouth large and well defined; but her two most unusual characteristics were her clear, brilliant complexion and her thick, curly hair, sometimes described as "a reddish golden brown" and as "not bronze nor gold, not blonde, but a golden chestnut, very thick, full of wave and shiny." Her clothes were a part of herself and were always of an extreme simplicity even in those days of elaborate fussiness in line and trimming, and she refused to follow the prevailing fashion of a bustle.

When she came to Julian's studio that winter day she was wearing deep mourning for her father, who had died the previous February. As she took off her little black bonnet, with its long crepe veil, and settled down to her given task, Julian realized that he had at last met his fate. His criticism that morning lasted longer than usual. Ernestine Fabbri wrote: "It was for him 'a coup de foudre.' The evening after that first meeting he came to call on us and casually said 'what a pretty little thing Miss Baker is' and then he wanted to know everything about her. I remember we were amused, for he never made us any calls, day or evening, and we at once saw that he had been hard hit."

When her third lesson had ended and Anna was leaving, it started

to rain, so Julian (gallantly) volunteered to escort her home under his umbrella; and this, once done, became his regular custom. Their courtship went smoothly and auspiciously from the first, and no doubt things were further hastened by the fact that the two families had known each other—though not intimately—for years. Robert W. Weir had painted portraits of both Anna's father and her grandfather in the old days of West Point, and they had many mutual friends.

Julian soon noticed that Anna was particularly fond of flowers and had a habit of always wearing a few tucked into her belt; now a bunch of fresh double Parma violets began to arrive for her daily, a custom continued whenever she was in the city. By the end of three weeks they were engaged.

Toward the end of April the Bakers moved out to Windham for the summer, and the letters between Anna and Julian through the autumn reflect the course of their relationship.

[To Anna Baker]

NEW YORK, TUESDAY EVENING, APRIL 25, 1882

. . . I worked at my painting both morning and afternoon and when I left took a walk twice around the park and then home. . . . Mrs. Alden said to me when I went in the parlor this evening, that those beautiful flowers which she had on the table would remind me of you and that I was one of the few whom she cared for, whose choice was one that gave her pleasure . . .

To me the surrounding hills and trees near our old home were as welcome a sight to my eyes as friends, and if you go to West Point I shall hope to take you on various walks to see old rocks and hills which I associate with the earliest dreams and ambitions of my *earliest* youth. Pleasant souvenirs of the past . . .

[To Anna Baker]

FRIDAY, APRIL 28, 1882

. . . Being a professional man, I often am filled with fear lest I could not give you all the comforts and luxuries which you have been used to, and enable you to travel and do just as you would desire . . . but success must eventually come. I never seemed so small in my own eyes as when I compare my work with what it ought to be, before I knew you I was content to work quietly and steadily and abide by the verdict of my profession, but now I feel impatient . . . I find myself wishing you had never known luxury, until I could have by my own work, laid it at your feet. I would like to have gone off to some remote place, where quietly and modestly we could have worked until I might have shown my worth . . .

The vulgar newspaper criticism which before I was callous to, now cuts

deep; the one in the *Nation* . . . the man who wrote it I was once forced to order out of my studio, and his venomous pen is always ready. . .

[From Anna Baker]

WINDHAM, APRIL 30, 1882

. . . Why do you talk . . . about your fear of not being able to give me all the luxuries and comforts that you would like to? I can do without them *perfectly* well; besides, I know you agree with me in thinking that true happiness does not lie in those little outside things but in the heart and soul; and when these are at peace, all is well. As regards your not being able to gratify my fondness for traveling, that is all right too, for you know you have told me many a time that you preferred living quietly in one place to moving around; and as your happiness is mine, that settles the question . . .

It is no proof because your paintings do not satisfy you, that they are not fine works. I have often thought that you were far more critical in your estimation of them than anyone else, critics and all included; you know . . . in sober earnest that your . . . artistic talents are thought very highly of and that you hold a position in the opinions of artists and judges that most men would envy; not that all this would make the slightest difference in my affection for you. Were you simply Julian Weir, perfectly unknown and with none of the honors that are already linked to your name, my love and respect for you would be just as deep; so do not mind on my account what any of the old critics may say. Certainly the one you refer to is utterly beneath your or my notice, and I only hope you will follow my example and think no more about him . . .

[To Anna Baker]

NEW YORK, MAY 1, 1882

. . . While riding along the bridle path I thought of the time when you and I would be together in Devonshire, riding through those beautiful lanes and hedges, picking wild flowers and discussing the possibilities of a great future, of a long and happy life, learning from nature the wonderful and great beauty that is one's to enjoy and understanding how that charity is another field in which beautiful and spiritual flowers grow, if we will only learn to be kind—our life may be filled with beautiful thoughts for dark days, which will brighten those around us and make us good christians. . . .

[From Anna Baker]

WINDHAM, MAY 2, 1882

. . . I am reading such an exciting book at present, that Emerson's *Essays* have been almost forgotten. Perhaps you may know it, *Our Mutual Friend,* by Charles Dickens; by tomorrow I shall hope to finish it, and will then go back to deeper subjects . . .

I can imagine no place of its kind more fascinating than your studio of a

moonlight night. Sometime I shall ask you to take me there; and . . . we can hold converse sweet together . . .

[To Anna Baker]

NEW YORK, MAY 3, 1882

. . . I tore myself away early and made a visit to the Roosevelts, to explain in person how sorry I was not to have been at Miss Corinne's[7] wedding. There I met young Mr. Roosevelt, who with his mother had been to call on you, but you had left.

. . . I was very much surprised to hear that Mr. Davis was to build me a studio,[8] of which I know nothing, should he do so, I would not accept his politeness . . . whose special pleasure seems to be to talk of things he knows little about, and therefore uninteresting. I ought not to write such things on paper, but when I heard that someone had stated this as a fact, I could scarcely resist writing you at once, for such things do occasionally make me mad. This person has said this for two years, and knowing that he often says things that he does not mean to carry out, I have said nothing, but if I ever thought he intended such a step, I would take the first opportunity to acquaint him of the fact that life was too short, and decline such an offer. He is under obligations to me, which he pretends to appreciate.

I began today a portrait of a very pretty young lady, Miss Roderbush, she is a very lovely little girl, and I expect to enjoy painting it very much.

[From Anna Baker]

WINDHAM, MAY 3, 1882

. . . I went out on the piazza a moment ago to see the moon rise, it was beautiful! First there was only an indication of its approach by a slight flush in the east, and then it rose big and red from behind the low, dark hill, casting no light upon the country wrapped in dusky gray, but rising slowly and steadily, a single bit of color in the deep, mysterious twilight . . .

[To Anna Baker]

NEW YORK, MAY 4, 1882

. . . Last night at the [Tile] club I met Edwin Booth,[9] he asked me how you enjoyed the visit to the Theatre, and said that before it was changed it was quite a remarkable place, now, however, he says it is one of the ordinary order. . . .

The Benedict is becoming empty now, Bunce sailed yesterday, Maynard[1] left today and Mr. Ryder sails on Saturday. I shall be the monarch of the building and when you come here again we will do as you suggest, if there is still a moon. . . .

[7] Corinne Roosevelt, younger sister of Theodore Roosevelt, the future president.
[8] Anna had written him that she had been so informed by friends of her mother. The Davis in question was Erwin Davis, the art collector for whom Weir bought the Manet paintings.
[9] Weir began Booth's portrait in 1886–87.
[1] George W. Maynard (1843–1923), American painter.

[From Anna Baker]

WINDHAM, MAY 12, 1882

. . . When I came in I began to read *Gil Blas*, but somehow the book seemed to have lost its interest; so I put it down, set in my little chair by the wood fire . . . wondering what you were doing at that hour and wishing you were with me. Do you remember those lines of Proctor—"Neither time nor space keeps souls apart"—and really it almost seemed to me while sitting in the glow of the firelight, that you were thinking of me then, at that very moment; and I felt for that instant even though we were apart, yet we were still together . . .

[To Anna Baker]

NEW YORK, MAY 13, 1882

. . . I . . . have reread again your charming bright letter, the descriptions led me with you to the barnyard and those side hills and trees are dear to me as well; the pond with its placid waters and the friendly dog who swam out for the stick you threw in, bring back the brightest of bright days . . .

I have been at work most of the day excepting the hours when I was at the Cooper, which Institution closes next week, this will enable me to hurry on with the portraits, and so will hope to be free in the early part of June. . . .

I hope the eighteenth of May[2] will not come around before I am able to get the little present done . . . I look forward to painting with you this summer with the greatest pleasure in the world. I only wish that the knot was tied and all my agreements broken, that we might flee to some quiet place somewhere in Europe, where we could be surrounded by the glories of art and be alone . . .

[To Anna Baker]

NEW YORK, MAY 14, 1882

. . . I have been picturing this afternoon only a week ago, which seems ages since, when we went to church and afterwards walked down the main road and through the fields, passing by the hawthorne trees and so following the little brook until we came to the corner fence, when I helped dear Anna over, and as she stood upon those bars, with her lovely head against the sky, recall those eyes which did outshine the day, for now I but recall your face and form and all the landscape seems misty, then on the seat I see you by the pond in the niche of the two large trees and the last place where you sat down before we wended our way back to the house by the lane, this was near where the pond overflowed, so that your words recall the rippling water, as it washed over the pebbles. . . .

Last evening I dined with Mr. Lathrop to meet Julian Hawthorne[3] and several literary men. The dinner was one of the most delightful that I have

[2] Anna's birthday.
[3] George Parsons Lathrop (1851–98), poet, novelist, critic, married Rose Hawthorne, daughter of Nathaniel Hawthorne; Julian Hawthorne was her brother.

ever been to for a long while, the number was small, only eight, so that we all talked vive voce and the several poets and writers of the day were discussed. . . .

[From Anna Baker]

WINDHAM, MAY 16, 1882

. . . Last evening I went out to the oak just after the sun had gone down . . . After taking a little walk I came back to the rail fence and, leaning my arms upon it, watched the varying scene. The vivid crimson glow had vanished, leaving in its stead a deep soft orange, against which the line of hills looked dark and distinct. Far above, quivering in the sea of tender blue, shone the evening star, while below in the valley the plaintive cry of a whippoorwill sounded faintly upon the breeze. Far in the distance the tolling of bells was blown through the silence of the night, and the odor of the grasses filled the air with heavy perfume. I stayed there utterly oblivious of time . . .

When I see you again, I want you to tell me the difference between scientific and natural perspective. In the course of a few years I hope to be so up in everything that pertains to art, as not to be obliged to ask so many questions; but I am sorry to say that at present my ignorance is very great . . .

[To Anna Baker]

NEW YORK, MAY 19, 1882

. . . This evening I went out to another dinner, principally men who are going abroad. The author of *Uncle Remus and Other Stories* was there . . . among the guests of the Tile Club, as this dinner was really the last meeting of the Club. You know we have always met on Wednesday evenings through the winter; there are many honorary men, musicians and writers principally, so we always have plenty of good music and stories with our dinners, which are always pleasant. Tonight I left as the good times were approaching, they had already begun with stories and I had several good laughs before I left.

[To Anna Baker]

NEW YORK, MAY 24, 1882

. . . Here I am again tonight in my silent studio, lonely and feeling sad. . . . When I came within forty miles of the city I saw indications of clear weather and the apple trees and dogwood were in full blossom, the sun having dispersed the chill and all nature seemed to smile, while I alone felt sad. . . . How fortunate it is that even the disagreeable things fade away in our memories and only those pleasant remain. I begin to think myself more a boy now, than ever, for when I return from your lovely place I am homesick, and it is several days before I can reconcile myself to the fact that it must be, and I sit down and place your photographs in front of me, and often do more looking at the beautiful face than I do writing. . . .

[From Anna Baker]

WINDHAM, AUGUST 13, 1882

. . . Longfellow says that the setting of a great hope is like the setting of the sun. Certainly my dreams of fame have set, never to rise again, but it

may be that I shall find the quiet evening with its silvery moon and stars far more peaceful, far more perfect, than glittering sun, and that the dim shadowy future may contain far more happiness passed by your side than it would if my wish had been fulfilled. . . .

[To Anna Baker]

NEW YORK, SUNDAY NIGHT, OCTOBER 8, 1882

. . . This week my private class will begin and in fact all my machinery will be set into motion, so that I can no longer call time my own. . . .

Mr. Warner and Ryder returned on Friday, they are full of the great art treasures that they have seen, they walked over the Simplon pass in the Alps and had a grand time, yet they seem equally delighted to get back again, as do all, and I have no doubt after our sojourn on the other side we will be equally delighted to return after we have sipped the honey in the land of art and fable. I often find myself picturing our traveling in some remote place in an old cabriolet, with the servant strapped on behind with the luggage and a big pair of pistols buckled in his waist or riding horseback through southern England. Oh! there will be plenty to read and prepare ourselves for our trip and let us hope that society will not be allowed to get us under their thumb, and so for our real pleasure give us that which is unreal, for without a doubt the latter is the difference in the fable between the bone and the reflection. . . .

[From Anna Baker]

WINDHAM, OCTOBER 20, 1882

. . . I am improving my mind vigorously now, being deep in *Modern Painters, Lives of Italian Painters* by Mrs. Jameson, Plutarch, and a history of ancient India. I quite agree with you that Ruskin writes beautifully . . . It takes away half my pleasure in reading Ruskin though, knowing that he is not to be relied upon . . .

[From Anna Baker]

WINDHAM, OCTOBER 22, 1882

. . . So you think I am not quite as decided as I should be, wait until you see me again, and then you may find that there are depths of decision that you have not dreamed of in my character. I have had plenty of time for thought during the past three weeks, they have been many and varied though not always of the most pleasant nature, still can anyone undergo great adversity and depth of feeling without being in some degree changed? I think not. Looking back on what I was a year ago, in comparison to what I am now, it seems to me as though I was another person, as though that old self was dead, on the ruins of which are erected new thoughts, new feelings, new actions. Is the change for the better? I fear not. George Herbert says that all may have if they dare choose, a glorious life or grave. I shall try and prove the truth of those words in my life, and though my efforts may be poor and humble, though I may be often discouraged and hopeless, still if I play my part in life to the best I can, perhaps not as it should be played, but doing it

to the extent of my ability, I may in some little measure approach the meaning of those words. Sometimes I do long to do something great, to have fame and all that sort of thing, to stand by the right of genius above the throng of people who inhabit the world, to feel that it is your privilege to do more than is granted to most persons, to have your name spoken with admiration almost amounting to wonder, and to have it enrolled in the annals of your country and remembered from generation to generation. It may be wrong to wish all this, and I dare say it is; but I think you will believe me when I say that I am striving my very best to live down such feelings . . .

In November the Bakers moved into town for the winter. Julian worked harder than ever. Portrait commissions were rising slowly; his class of young ladies that winter brought in over $1,300; and prospects were bright for purchase commissions in Europe. With the spring his dream of a leisurely continental wedding trip seemed close at hand.

Julian and Anna were married at the Church of the Ascension on Tuesday, April 24. On the preceding Friday he gave a bachelor dinner to his ushers—Lindley Johnson of Philadelphia, the best man, and William Blodgett, Archibald Russell, Stanford White, Elliott Roosevelt, William M. Chase, Poultney Bigelow, Charles J. Nourse, and William Bingham;[4] and on Saturday he was the guest of honor at a large "complimentary dinner," given him at Martinelli's by thirty of his friends. Among them, in addition to most of the ushers, were R. Percy Alden, Carroll Beckwith, W. Gedney Bunce, Daniel Cottier, Erwin Davis, Dr. Richard H. Derby, Wyatt Eaton, Loyall Farragut, Richard Watson Gilder, James T. Inglis, W. H. Low, Charles F. McKim, George W. Maynard, J. H. Niemeyer, Charles Scribner, F. Hopkinson Smith, Augustus Saint-Gaudens, Olin L. Warner, and Richard Grant White.[5]

The dinner was gotten up in great style with an elaborate menu printed in gold and embellished with quotations, one of which gives a good idea of the young Weir as seen through the eyes of his friends:

"First Citizen—And who is that boy I saw you saying farewell to at the ship yestermorn?

"Second Citizen—Boy indeed, but no boy,—for he has years, knowledge, and a wife,—albeit a new one. Yet there is that in him will always

[4] Archibald Russell (1853–1919), realtor, partner of Elliott Roosevelt in 1883, son of Scots philanthropist Archibald Russell (1811–71); Elliott Roosevelt, younger brother of Theodore Roosevelt; Poultney Bigelow (1855–1954), author, traveler, son of John Bigelow (1817–1911).

[5] Daniel Cottier and James T. Inglis were art dealers in partnership; Dr. Richard H. Derby married Sarah Alden; Loyall Farragut, author, son of Adm. David G. Farragut; Richard Watson Gilder (1844–1909), poet, editor of *The Century;* Charles Follen McKim (1847–1909), architect; Charles Scribner (1854–1930), publisher; Richard Grant White (1822–85), author and critic.

keep him young, though he be as ancient as Methuselem: a generous disposition; a nature free, open and companionable; and a jocund gayety like a faun of the woods;—withal he is a painter that loves his art!"

After the wedding Anna and Julian went up to Connecticut to their new farm home in Branchville where Julian had acquired some hundred and fifty acres from Erwin Davis in exchange for a painting. The rocky pastures and woods were to become a center of family life and a source of inspiration for some of Weir's best work; but now their eyes were turned toward the Old World. After a few days of rest and seclusion they sailed for England with the intention of a three-year sojourn abroad.

In England Julian retraced with Anna some of his previous excursions, moving in leisurely fashion toward London, where he hoped to begin a search for fine paintings on behalf of Mr. Marquand[6] of New York. By a stroke of fortune he found a great picture, Rembrandt's *Portrait of a Man*, and bought it at once. In a postscript to Anna's letter to her mother he could scarcely contain his excitement: "We are now being launched into the wild and giddy life of London; we began the day by spending $25,000 for a rare picture and tonight we go to see Irving and tomorrow, if we are successful in getting places, we go to the Ascot and the Opera, next day a lunch and next week we are invited down in the country. Anna is a brave little traveller. We took dinner last night at the 'Mitre' after a lovely row on the Thames at Hampton Court."

In a letter to his own father and mother Weir enlarged on the

great achievement, I have bought today a remarkable Rembrandt, an old man very like the Bourgomaster Six, and which Boughton thinks is finer than any in the National Gallery, twenty five thousand dollars. Of all the pictures I have ever seen for sale, this is, I think, the finest. Now we will have one very remarkable picture of which the country will be proud, it is a gem of the first water. It comes from the Gallery of the Marquis of Lansdowne, who, owing to his estates in Ireland not paying, is forced to part with some of his pictures. Agnew, who is the great art authority, says that this is the finest Rembrandt he has ever sold and the last good Rembrandt he had, was sold in '48. Anna and I have been much excited and the Atlantic cable has been ticking to the tune of Rembrandt considerably. It was understood before I left that I was to receive five percent for my trouble, which will not come amiss, but did I not receive a sou I would be equally elated.

[6] Henry Gurdon Marquand (1819–1902), a founder of New York's Metropolitan Museum of Art and a trustee from 1871 until his death.

Mr. Marquand wrote to Weir approvingly from New York:

... You did well and I'm glad enough the Rembrandt is coming. I shall
be delighted without doubt. Boughton's letter is strong; he calls it a *smasher*.
... Now I hope Agnew gave you 200£., if not, write me and I'll send it
as I promised— My idea is generally 5 percent on 1200£. or under and 2½
on all big things; but your messages were so enthusiastic I wished to show
you my appreciation of your work in this purchase. ... For a few months
I must hold up as I had to borrow some money which I do not like to do—
No doubt next autumn there will turn up a choice Hobbema or something
prime....

After Marquand had seen the picture, he wrote again enthusiastic-
ally from Newport: "I went to New York a few days ago to see the won-
der and opened Rembrandt. What a gorgeous thing! You can't tell how
I feel and how proud I am to get it. If one fine thing in a year could be
had, what a gallery I could get in time. I have only a few minutes to
express my admiration and thank you heartily for this great scoop. ...
The pleasure of owning such a work is very great."

Writing to his wife's elder sister Ella, Julian described their fast
pace:

Anna has no doubt told you how we have been doing London, not ex-
actly as the "average American" but as wolves in search of what we could
devour in the way of poetical fiction, art and nearly all that comes under the
head of art. We have seen the best theatres naturally! Operas, galleries with-
out number (but few good pictures out of the National Gallery). ... We
have been in a regular whirl and Anna herself begins now to talk of settling
down in some quiet place....

But before they could settle anywhere they were off to Paris, where
Julian showed Anna his student haunts, inspected the Salon where
Julian's portraits of his father (Fig. 3) and of his sister Carrie (Fig. 6)
had stirred favorable comment, and finished by filling four trunks with
"fine things." Then they swept on to Stuttgart, Nuremberg, and Mu-
nich and finally through the Tyrol to stop in Venice for the month of
July.

"Here we are in this fairy Venice still," wrote Julian to his parents.

Ever since we have been here we have had the most wonderful moon-
light nights, and, as we have a gondola always at our command, we do little
walking. Often on a warm night we are floating about on the Grand Canal
until after midnight. ... Venice appeals very strongly to me, but I have
not yet been able to do any work that I consider good; it is so different from
the things I have painted, and so full of color that I am "knocked down"....

I have often thought while over here this year that Europe has lost most of its charms, or that I have become a better American, in fact Anna and I have both often wished to be at old Branchville, where we had plenty of room and comforts that one cannot have when one is wandering about. . . . Anna has made several purchases of beautiful stuffs, and some Venetian glass which is very beautiful. We will hope to have enough to make our little place, wherever it is, comfortable. . . . Duveneck has loaned me his studio and so I have begun a portrait of Anna, which I do not know yet how it will turn out. When this is finished we will likely push on to some other place.

In other letters home Julian confessed that although the art works were glorious, traveling was wearing. From Dordrecht in Holland, where they had gone from Venice, Julian wrote to Anna's mother of their plans to return home:

It seems but a very little time since we were saying goodbye, quietly revelling in the idea of having slipped off for a two or three years trip . . . [Now] we are not overcome by the fascination of a wandering life, but long for the quiet, plain little house among the rocks, where we can feel and know the nonsense of hotel life, and living in trunks, hurrying from one place to another, to be imaginary pleasure. . . .

We went up to the Hague yesterday and brought back some plunder, and last night I was very busy having a large case of brass and copper sent off . . . so we might free ourselves of trouble. I seriously feel we will both be ruined on our return, and believe we have done wisely in procuring now what may help to make our home and surroundings enjoyable. . . .

While Julian and Anna were traveling abroad, John and his family had gone up to Branchville for the summer holiday, and straightway the old place endeared itself to them. They too found it a second home and a peaceful retreat from the outside world. A letter from John on August 2 is headed "Here shall we rest and call *content* our home," an epigram which so expressed the place to Julian that later Stanford White painted it over the front door of the house. John reported that they found it

simply charming. In every way delightful, and we all enjoy it thoroughly. I tinker about the premises and hold the reins over the work which is needful. Your crops are doing finely. The barn is full of hay, and the potatoes and corn are in fine shape. My dear fellow, may your "corn and wine and oil increase." . . . We often speak of you as we sit on the pleasant porch in the evening twilight. I imagine you and *Anna*, seated in your two armchairs, sitting in these twilights in future summers. I advise you to hang on to this place, old boy; a "lonesome lodge" which is a pleasant place of retreat in

storm and drought—is no bad thing to have—for an artist—keep it trim and untrammelled and you will find it a haven of refuge. . . .

To John Julian wrote from Paris explaining his reason for returning sooner than expected: "A short three years, but from what I have seen and felt I rather made up my mind slowly that I was doing wrong as everyone was complaining here about not being able to sell, etc. and taking all things into consideration as a married man concluded it was best for me to return and hammer at portraits. I have left it just a little too long before returning here, and everything now seems so different and living being about what it is at home (that is respectable living and not Latin Quarter) that I concluded the main stay of life might be found better at home."

The Weirs returned to America in September of 1883, and after a short visit to Anna's family at Windham they settled at Branchville for the rest they had been looking forward to. During October farm affairs and domesticity occupied them completely and pleasantly, as the following letter (October 21) from Julian to Anna's mother shows.

I received your letter and the one of Mr. Baker enclosed, it is indeed a characteristic letter, and I could almost hear him chuckle, after the bit of sarcasm on the hunting. However some day we may be able to induce him over, and show him some sport. We have been living on game here lately, Saturday a hunter brought three partridges, a pair of quail and woodcock, so we have been revelling in what we call extras. I have had our cider made— six barrels and three quarters . . . sixty bushels of potatoes and barn full of grain, etc. so far so good. The art of painting however has not thrived in proportion, as I will bring back but one picture.

Early in November the Weirs moved into a tiny New York apartment at 31 West 10th Street and settled down for the winter. The American artist had come home again.

CHAPTER 6. PAINTING FOR A FAMILY, 1884-90

T his time on his return from Europe things were different, and Weir entered on a new and more difficult period in his life—that of a married man with a family to support. During his last two or three years as a bachelor he had been making a more comfortable income for his needs, and he was fairly confident that this would continue. He and Anna had been like two children that summer in Europe, spending money right and left for everything beautiful that caught their eyes. They must both have felt, if indeed they considered the subject at all, that Julian's income from his profession would expand as it was needed. But things do not always follow the way they should.

Julian had intended to "hammer at portraits," but owing in part to the increased popularity of "artistic" photographs commissions were hard to find, and throughout the eighties he struggled to make ends meet. His portraits were mainly of his friends and family, especially of Anna and of their first child, Caroline Alden Weir, who was born in March 1884, the spring after their return from Europe. For income Julian relied heavily on his art classes although he felt them a drain on his energies. In addition to his regular course at Cooper Union he took on a portrait class at the Art Students' League; he added another class there in 1886, and he continued to give private lessons from time to time. As was the case generally with paintings by American artists, Weir's work sold poorly during these years, although his flower pieces enjoyed a steady, modest market and paid for bread and butter again and again.

To make matters worse the Society of American Artists, which had been such a stimulus in the years before Weir's marriage, had lost much of its initial vitality, and its exhibitions of the middle eighties were scarcely distinguishable from those of the National Academy. The excitement of revolt was over. Julian was himself elected to the Academy as associate in 1885; he became full academician the following spring. On

the surface the New York art world was active. The American Art Association assembled a Prize Fund Exhibition in 1885 to highlight the season, but it, too, declined annually in quality and support and disappeared after four years. The Union League Club sponsored an exhibition occasionally to encourage American art; and Weir sent regularly to shows of the Water Color Society and the Club of Painters in Pastel. But what little market existed was dominated by Europeans—most of them dead. A letter to Weir from Twachtman in December reflected the tenor of the times.

> ... I was glad that you had my painting on your wall and that you liked it, and I was also pleased that you had sold the green thing for me. How did you ever stick anybody with that I should like to know, and as for the price you know how very refreshing it is to sell at all. It is the only thing I have sold since last spring when you sold that green landscape to Mr. Davis. I believe I shall have to appoint you my sole and everlasting agent; no one else cares a damn for my things. The old gentleman wrote from Cincinnati the other day that unless something turned up we should have to make that hog-sticking-city our home. You remember what Pinio said about every other man from Cin. and how can one help going into the hog-sticking business if you must make it your home.
>
> ... And the Society will have its ex. in the Academy this coming season. It seems to me that we are now driven to the wall and the only reason we take it is because there is nothing else to get. The U.S. is a country of fifty millions of people and in all the broad land there is not even one gallery to exhibit in. The annual county fairs, where hams are hung along side of Corots— (and how much they do talk of art)—can hardly be considered good art exhibitions. Why not acknowledge that society in N.Y. has no interest in the S.A.A. and not hold any more shows. They are never patronized in any way excepting possibly the art critic who has told us that some of these men promise good. They have been promising for a long time. ...

Promise was barely enough for the Weirs to live on, as Julian indicated in letters to his brother John that spring of 1884. In March he wrote:

> Well, the world jogs on here, a little the same and somewhat different. Not exactly a reformed man, but I shall send to the Academy. One reason is that they [the Society] propose to encamp this year inside the enemy's lines, holding our exhibition after the other has passed. Means that we are cornered and the possibility is that all who want to buy pictures have emptied their pockets before the "choice" gems are offered. The exhibition is to be held in the South room of the Academy. In my mind the idea of so doing takes from the S.A.A. the old snap of having the two exhibitions at the same time.

That May Julian was struggling with what he termed his customary "spring drought," and to John he confided:

You know me and you know me not. The reason of my not replying to your notes was the revival of the old disease of procrastination. . . . I had gotten on a reef, but my back bone is still intact. . . . I have not a commission nor have I sold anything, yet I am happy in thinking that accident might happen at some near time. . . . We want to spend the whole summer at Branchville if possible, but I would do anything to get you there. I have been having bad luck, but I cannot but feel that things must change soon. We want to go out (if our creditors will let us) on about the 20th of May. I have prospects at last of selling *The Muse,* which I hope will come to pass. Then we can spread our wings.

Soon afterward the sale was made, and Julian wrote jubilantly to John: "The clouds have indeed dropped their fatness. I sold my *Muse* $1500 but only $500 down the rest in the fall. Therefore be it known if it pleases providence, we leave the city on or about Monday next. . . . I have also succeeded in renting my studio from next week until Oct. or Nov. I hope you will manage some way to be near us. . . ."

The sale of *The Muse* smoothed out Julian's financial difficulties for the time being anyway; and there followed a long, delightful, un-eventful summer at Branchville. He painted some of the rooms himself soon after they got up there, and the farm became more and more of a reality. They lived quietly and Julian could work with few interruptions; their daily life was varied only by visits from their many friends, but guests were not allowed to interfere with his work. Their favorite diversion, if Julian's fishing be excluded, was driving; and they would harness up the old farm horse and jog for hours over the country roads and lanes, in the fall even penetrating as far as Danbury, ten miles distant, for the county fair. Sometimes if Julian was too much occupied with his painting to feel free to spare a working hour, or if the day had been unusually hot, they would drive at night, with a full moon or a starlit summer evening to tempt them out. It was a leisurely, peaceful existence. And the long, slow family summers at Branchville took the sting out of the discouragements of the winters.

But in November, or at the latest December, the Weirs reluctantly moved back into New York, Julian to work at portraits and prepare for the spring exhibitions. City friends were congenial; and family Christmases were always a special delight. But baby Caro's first Christmas was marred by news of the death of Bastien-Lepage, Julian's closest

friend from his student days in Paris. A break in Julian's close circle of family and friends had come five years earlier when his brother, William Bayard Weir, was killed in a skirmish with Ute Indians in Colorado; and his father had been seriously ill the winter before Julian's marriage. Robert Weir had recovered; but Bastien's death was a real blow to Julian, one of a series of personal tragedies that made the New York winters that much longer.

Bastien had been ill for months, but it was hard to believe that such a man could have been struck down at the height of his artistic powers. When Julian had left Bastien in France, their parting had been casual. Bastien had expected to join his friend in New York before long and to use his studio for portraits. Twachtman wrote from Paris of the funeral, echoing Julian's own thoughts.

Messengers of friendship should always make quick journeys as your letter did which I received today [January 2, 1885]. . . . You remember that project you had of buying a chateau in company with Bastien-Lepage. His illness was the talk amongst the painters and everybody but himself knew that it must prove fatal. But death is a thing with which we never become familiar and when he died it seemed as if he had not been ill at all—it was felt by the whole artist community. At his funeral everyone seemed to be present—there was such a large gathering. I stood opposite his house from which he was now taken forever and I thought of you and wished that I might cull a few flowers and send them to you. The hearse was covered with them. The procession moved slowly away and it was altogether a very sad scene. . . .

In his painting he seldom went beyond the modern realism which, to me consists too much in the representation of things. Sometimes he did get beyond that and in his *Joan of Arc* he was truly poetic, and in his *First Communion*, which I saw in 1878, he was more complete—there seemed in it something that he loved more than the mere doing. What tasks the man did set himself in the painting of a white apron with which he was as much in love as the face of the person. He was a wonderful force in art and will no doubt live as long as his canvas will last. Character in a blade of grass or a potato—the handle of a hoe or anything material was made true and looked like the real thing. In his technique, for which I cared but little, he has had many imitators. But you know all this and better than I do. . . .

If I must go home soon I hardly know what will take [the] place of my weekly visit to the Louvre. Perhaps patriotism, but my country shall always have that and the best possible painter I can make of myself. . . .

The following spring a memorial exhibition was held in an annex of the Beaux-Arts with over two hundred of Bastien's paintings. And Émile Lepage, Bastien's younger brother, undertook to raise funds for

a statue of Bastien by Rodin to ᴅᴇ placed in his native Damvillers. With the help of Saint-Gaudens and F. D. Millet, Julian raised what money he could and sent some twelve hundred francs to Émile.

Julian's ties with Paris had been weakening steadily with time and distance. Bastien had been the keystone which held the group of former comrades together. Now that he was gone those carefree fellowships of Weir's student days went with him, and the responsibilities of family and career loomed larger than ever. Writing to John the March after Bastien's death, Julian was clearly discouraged.

> . . . We jog on here and when the beginning of the week comes and we go to 18th Street [where his parents were living] to hear about the family news, no one seems to be able to draw forth the cheerful news. . . . If I could with conscience leave this city I would only too gladly take ticket to New Haven.
>
> Every day I awake full of hope and the possibility of a portrait to paint or the sale of an old picture, but such comes not. I sent a portrait of Lathrop and one of Anna's sister, Mrs. Davis, to the Academy. I shall send Anna's to the exhibition of American Artists to what will be known as the prize exhibition as a good place to exhibit, but whether they will accept portraits I know not, for this young world of art is queer.
>
> There is now on exhibition the Seney Collection,[1] with some few good specimens of Corot, Rousseau, Diaz and a few others, but on the whole I care little for it. . . . Nothing seems to be going on. Everyone has the blues and I learned yesterday that Mr. Sherwood has put down the rents of all the studios in his building. I wish Mr. T. would do the same with ours. . . .

No matter how bleak commercial prospects seemed, Weir never deserted the cause of general public art education. If inferior foreign paintings dominated the market, the answer was not higher import duties but better and more representative collections of the art of the world's masters so that an informed public might make its own decisions. In a letter to the editor of the *Critic* in 1885 he denounced the heavy duty on works of art as "unprecedented in the annals of any civilized community" and "most unwise and short sighted." It did not keep bad art out of the country; instead, it prevented "the collector of moderate means from possessing examples of good contemporaneous art." Furthermore, it raised obstacles to historical collections, for whose educational value the government should be grateful instead of demanding tribute.

Fortunately for those interested in the best contemporary work, the spring of 1888 saw New York's first exhibition of the work of the French Impressionists. Among some three hundred oils and pastels were ten by

[1] George I. Seney (1826–93) was a New York banker.

Manet (including Weir's purchases for Erwin Davis in 1881), a dozen by Monet, five by Degas, several by Renoir, and representative works by Morisot, Latour, Seurat, Signac, Besnard, and Mary Cassatt, the Philadelphian expatriate whom Julian had proposed for membership in the original Society of American Artists ten years earlier.[2] The critics were alternately indignant and cautiously appreciative. Julian wrote John not to miss it. He found "some very remarkable work and some dufferish" but considered it on the whole "the most interesting exhibition for an artist to see that we have yet had."

New York, with its exhibitions, clubs, journals, and art schools offered Julian and his family many advantages, and their winters became somewhat more agreeable after the autumn of 1886 when they borrowed enough money from Anna's mother to settle into their own house at 11 East 12th Street, where they were to remain for twenty-two years. As usual Weir at once set his own stamp upon the house, which was like many others in that neighborhood, two and a half stories high, of red brick, with a high Dutch stoop. The ground floor consisted of a parlor, a dining room, and a studio at the back. The parlor was separated from the dining room only by tall Corinthian columns, but they were made into two distinct rooms by a huge piece of old Flemish tapestry which hung between them. Its two windows reached to the floor and were leaded and hung with old red brocade that had come from some Venetian palace. The high ceilings, so different from those of today, made rooms perfect for hanging pictures; and Weir hung the walls with his own works and those of his friends, such as Twachtman, Robinson, Swan, and Duveneck. The dining room was dark, as was to be expected in a central room, and at mealtime it was always necessary to have the gas chandelier lit. In fact both rooms were inclined to deep rich tones, for the parlor was painted a Venetian red and the dining room a dull blue. They were both, needless to say, the perfect foil for Weir's possessions; but in spite of the quantity of beautiful things in them, Weir's surroundings never took on the faintest tinge of a museum aspect. Even though the pieces themselves might be of museum quality, the sum total that he sought and achieved was a home; and nothing was ever too precious not to be used as it was intended. One of his first convictions was that good things would always harmonize with each other, no matter where they had originated; and his taste was far too catholic to stick

[2] Mary Cassatt (1845–1926) met Weir in Paris in the seventies. She exhibited two paintings with the Society of American Artists in 1879 and was elected to membership the following year.

to any one period or country. The result was a happy blending of old Dutch, English, Spanish, Italian, or American furniture, with pewter or brass gleaming from sideboards and mantelpieces. Over the mantelpiece in the dining room hung his collection of old Dutch pottery mugs with their pewter covers and bases, and even the horns of an elk that was placed in their center did not seem out of place. Nothing obtruded or jumped out at one. It was his theory of painting carried over into another field. He disliked having everything taken in at a glance, preferring instead that things should disclose themselves gradually, when one was least expecting it.

Once settled in his own house, Julian gave up his studio in the Benedict Building and took over the big room at the back of the 12th Street house as his working quarters. This room was separated from the dining room by large mahogany folding doors whose glass panels were engraved with a marvelous flourish of scrolls and flowers. The room extended across the whole width of the house (twenty-five feet) and was in the early days heated by a tall iron stove that stood in one corner. The light came through three long French windows to the north: two of these were partially blocked by the old mahogany bookcases that had belonged to Robert Weir, but the third led onto a narrow balcony that looked out over a large backyard shared with the house next door, boasting trees, flowers, and a central fountain. The main trouble with the room as a studio was that it was too much the center of the house; the dining room and pantry were both adjoining, and all the sounds of a house full of children would crowd in where peace was imperative. By my childhood in the nineties the studio, although it still kept its name, had long since ceased to serve as such. Instead, it was used as a gathering place through the daylight hours, beginning when breakfast was served there at 7:30. But all through the eighties it was the artistic center of the house.

In February of 1888 a new baby, Julian Alden Weir, Jr., added his voice to the household; and at about the same time John Twachtman, Julian's good friend, became a frequent visitor, having decided he would "never go back west to live." The two men could now work more closely together, and that summer Twachtman rented a house nearby in Branchville. He proved the best of companions, and Weir worked at his painting harder than ever, with time out for fishing and long walks in the country. Caro was four years old and baby Julian a delight. It was a good summer for the family, the last happy one for a time.

The Weirs returned to New York refreshed. But in March the baby

died of diphtheria, a terrible blow for Anna, from which she never entirely recovered. The death of Julian's father, Robert W. Weir, followed soon after. He had been failing and his death was not unexpected; but to Julian he had been a pillar of strength, a prod alike to work and excellence.

Through these sad days Julian's brother John gave assurance from the depths of religious conviction that "little Alden" was waiting for them in a happier country and that Julian, for his part, remained blessed by a closeness to nature that promised a renewal of divine love. ". . . Your nature draws about you a world of unseen affection," wrote John.

. . . I always feel when I am with you a wonderful sense of the nearness of higher influences, for your whole nature is intuitional, or inspirational, and there is no hard repellent shell to be broken through when they would approach you. . . . You have touched nature at many points, for you were born a child of nature, and nature's instincts flowed in and through you easily. . . . You are the same wonderful boy to me in all circumstances: in joy and sorrow there is such lucid clearness in your nature that often makes me wonder: I am so different, with more to overcome. . . . I hope you will have the portrait to paint that you may lose yourself in work. . . . I would like someday to go with you to your rookery at Branchville: just to stroll over the place and then sit before a fire in the big fireplace and talk. I always feel happy when I am with you. . . .

Julian and Anna decided that some sort of a change was imperative; they must get away if they were ever to get back again to normal life. So early in June they sailed for England, leaving Caro behind with Anna's mother. They landed in Liverpool and almost at once crossed over to the Isle of Man for three weeks spent on water colors, pastels, and etchings. July found them settled in the tiny village of Rowsley, in Derbyshire, close to Haddon Hall and within fishing distance of the Wye River. They had considered visiting the Sargents in Fladbury on the Avon and the Millets at Broadway, but they decided on a month's quiet. Anna seemed to recover well, and they went on to Paris in August to see the Universal Exposition, where despite the hold of expatriates on the American section Weir won a silver medal with his full-length portrait of Caro and a bronze medal for water colors and drawings.

It was also at this time that Weir managed to persuade Puvis de Chavannes to undertake the murals in the new Boston Public Library. Stanford White, a good friend of Weir and a partner of Charles McKim, the library's architect, was in Paris seeking a muralist when he met Weir. Weir recommended Puvis as a man whose work he admired greatly, and

on White's request Weir met with the elusive Frenchman and talked as one painter to another. Puvis had seen Weir's work, and he accepted the commission, to the great good fortune of Boston and the United States.

Toward the end of September the Weirs went back to England and in October returned to Branchville, staying on late into December with the air fresh and fine and the leaves stripped by the frost.

The winter of 1889–90 in town was outwardly rather uneventful, but pleasant enough in its round of quiet activity. "I wish I had more to tell you about," wrote Anna to her sister Ella, "but each day is exactly the same; painting, reading, walking, and people coming in to see us, is the usual program . . ."

Weir sent pictures as usual to the exhibitions that winter, including *The Absent One*, an especially lovely water color of Anna sitting by a table in a pink dress with Caro on the floor beside her. However, his major work was done the next summer in Branchville. In a burst of productivity he seemed to have found the road toward a personal style which would match his vision of nature. He remained always dissatisfied with his work, but at last he broke free to paint the landscapes that he loved, and his palette rapidly lightened. His work of the eighties, so much of it in the dark tones made fashionable by Munich, shows a slow progression toward the quiet radiance of artistic maturity.

Weir's paintings of the seventies had been uniformly dark; his father's white hair in the portrait of 1879 had stood out dramatically. His best work in the middle eighties, *Against the Window* (Fig. 7), *Lady in a Black Lace Dress* (Fig. 8), and *Reverie*—all of them striking portraits of Anna—were phrased in what one critic referred to as Weir's "customary sad harmony of black and gray." But in *Against the Window* (1884) Anna was framed against the lightening New York skyline seen from the Benedict; and the flesh tones of *Lady in a Black Lace Dress* (1885) illumine the traceries of dress and tapestry. *Reverie* (1886), on the other hand, is painted in nearly unrelieved shadow, the light striking only the tip of Anna's nose. It seems as if with this picture Weir was striving—perhaps unconsciously—to set forth for a last time his interpretation of darkness made visible, to try out, for his own satisfaction, his love for dark, rich tones to their limit before deciding definitely that other paths would lead him further.

Among the various elements contributing to the pattern of growth which Weir's lightening palette represented none was more important than his feeling for landscape. For the first time since boyhood Julian

was now in the country for long months on end, and he was finally able to satisfy his own inclinations and work and experiment to his heart's content. Landscape in America, with its clear atmosphere, can best be served by a luminous palette, and Weir moved steadily toward this conclusion, beginning with such canvases as *A Connecticut Farm* of 1886 (Fig. 26). Although his Academy pictures as late as 1888 were uniformly moonlit, the great majority of the paintings which Weir sold in his joint auction with Twachtman in February of 1889 were landscapes noticeably lighter than his studio work.[3] By this time Clarence Cook, the critic, had pointed out the shift in Weir's style, and in the landscapes it became increasingly evident.

The integrity of Weir's painting remained through all his styles and gave to his portraits a solid quality evident as early as his *Robert Walter Weir* of 1879, in the self-portrait painted for the Academy in 1886, and notably in portraits of his friends Olin Warner (Fig. 4) and John Twachtman (Fig. 16). Technique as we have seen did not come easily to Weir because it was not what primarily interested him. What he was seeking to do was to put on canvas the beautiful material world he saw around him, transmuted through his inward vision into something entirely his own; and to succeed in this he was willing to cast to the four winds those things that he considered merely secondary. In consequence, his technique was sometimes heavy and clumsy, something that he had to bend to his will. But it was always a means and never, as some critics maintained, an end in itself. Another criticism, so often made of Weir, that he sacrificed the good looks of his models to his interest in the picture as a whole, I think was often true. He would have been the first to acknowledge these deficiencies; he would have liked to have a smooth, easy technique at his finger tips and to add just that little something that would give a flattering rather than a plain, unadorned likeness to his sitters. Those small details count so much with the world. But it was character he was seeking, not prettiness; his interest was in the picture as a picture, not in the way it was painted, and he consistently refused to lower even slightly the standard of what he considered his artistic integrity.

The Weirs were later than usual in moving to the country the summer of 1890. Not that New York was more enticing, although Sargent and Abbey had helped make it a gay winter. It was rather because I was

[3] At auction some forty paintings grossed Weir $3,826; Twachtman received $3,585 for the same number. Sales were helped substantially by Alfred Corning Clark, a champion of American art.

born that June 18. But once in Branchville Weir worked with energy and industry on through the summer into the bitter cold, shifting from the yellow greens of summer to the sparse browns and grays and whites of winter. With the help of Paul Remy, an Alsatian farmer who for many years was to be the trusted steward of the farm, Weir concocted a house built on runners with windows on its four sides, where with the aid of an oil stove he could work in the coldest weather; the sledges made it possible for the oxen to drag it to whatever spot Weir wished to paint. Paul promptly christened it "The Palace Car," and as such it became a household byword—even when, years later, the children turned it into a playhouse.

Weir was now deeply immersed in his search for a new means of expressing what he wanted to say, and what *is* apparent from that summer's work is that he now found two paths opening before him. One of these I think he ceased to explore after a few months. The paintings in this vein show a tendency toward a very light key indeed; the color is delicate, almost tenuous, and the paint is laid on thinly, with the accents drawn in with a fine-pointed brush. *The Road to the Farm* is a typical example. I do not think he continued this method even into the next year. The other line along which he was working was also with delicate —but not quite such delicate—tones. The brushwork is more broken, more vigorous, more vibrant. *Nasturtiums* and *Drilling Rock* are examples of this style. The former is a portrait of Anna. She wears a light blue summer dress, her left hand is raised to the white ruching at her throat, and the background is light behind her. A tiny bunch of nasturtiums in the lower left corner gives the picture its name. *Drilling Rock* shows an old man, seated, drilling a hole in which to blast the rock at his feet. The later pictures added to this a richer color scheme and a more solid substance—but their beginning was now. By 1891 the paler, mistier phase had completely disappeared, and Weir's art was developing vigorously in new directions.

CHAPTER 7. TOWARD A PERSONAL STYLE, 1891-97

The opening of Weir's first one-man show at the Blakeslee Galleries in January of 1891 signaled a new phase in his artistic development. The nineties were years of experiment and search in which Weir forged a personal style, years filled with work and family and friends. His Blakeslee show at Fifth Avenue and 26th Street was notable for the work of the previous summer; of the twenty-three paintings exhibited seventeen were landscapes, many of them filled with light. The unusual tonal qualities of an even more recent painting, *The Christmas Tree* (Fig. 11), drew special attention. Caro stands this time with a doll in her arms, her face and white dress glowing warmly in the light of the Christmas tree's burning candles. The lighting and color scheme baffled many of the critics and one of them took refuge in noting that the painting was "less refined in quality than Mr. Weir knows how to make it."

In spite of mixed critical reaction the wide notice the exhibition received was encouraging. Clarence Cook, always perceptive, took a long view and concluded that the apparent shift in Weir's style was no more than

the legitimate outcome of his artistic tendencies. In a general way, perhaps, these pictures belong to the Impressionistic school, but we have no doubt whatever that they would have been what they are if the Impressionists had never appeared on the scene. They show the same way of looking at nature that we associate with his painting from the beginning, the only difference being in the key in which they are written. The unity in Weir's work would be more easily demonstrable if a room could be hung with a selection of his pictures painted during the last ten years. The earlier ones are much darker in tone; but we do not know of any artist among our men of first importance—and no one will dispute Weir's claim to a high place in the catalogue—whose work shows a more . . . consistent progress. What he loved in the beginning he loves today.

Weir's new manner of painting shocked his conservative brother John, and Julian wrote quickly to explain.

I hasten to reply to your kind note, in which I see that you are worried

on my account— I have exhibited these things because I recognize in them a truth which I never before felt, and [to] which there has been much opposition shown by not only the press but the artists, still with all that and the fact that there have been very few sales, I feel encouraged and firmly believe that I am in a way to progress as I never have been before— My eyes, I feel have been opened to a big truth and whether or not I can develop in that direction I know not, but one thing I do know is that painting has a greater charm to me than ever before and I feel that I can enjoy studying any phase of nature which before I had restricted to preconceived notions of what it ought to be. I do not say that I am right but I do say that if nature and art have greater charms to me owing to my "hypnotism," as one of the papers calls it, then I cannot be far wrong, my art is my life and who ever said a truth that was believed at first? Traditions are good things and interesting, but are not these things so much instilled in me that instead of the character and aspect interesting me most, I was trying to see through the eyes of greater men so that I was hampered by trying to render the things I did not see and unable to get at the things that really existed. I do not think that what little art I ever promised will be dissipated by serious study, if so it was worth little or nothing—The mistake we all make is that we should ever arrive at a period when we did not feel the importance of study! All kinds of study and research are of value and when one feels as strongly as I did the false position I was in, it is probable he may fly to an extreme.

Your note I most sincerely appreciate and that bond which has existed between us is strengthened by the fears you express as I feel that it is sincere— I was dining last night and William E. Dodge was speaking of you. I said I thought you the most interesting man I ever met—we stand on a firm basis, that should you have felt these things of mine good you would have been delighted, instead I know your letter must have given you pain to write, yet I know that when you read this and appreciate how in earnest I am, you will be cheered to think that it is not a fad or a wild fancy— I wish you could see these things again, for the first impression would in all probability be rather antagonistic. I am delighted to have had my exhibition open at the same time as the Seney Collection, which although it had much good art, has a false flavor to me.[1]

The roots of Julian's new-found delight in every phase of nature lay deep in his experiences and beliefs. And they are nowhere more explicit than in a note to his namesake, young Alden Twachtman, the son of his good friend.

JANUARY 3, 1892

DEAR ALDEN:

I received your poem on "the Brook" which I like very much. It brings to my mind very vividly the running water; but what charms me most is that

[1] The Seney collection included works by Gérôme, Meissonier, Fortuny, and Corot.

you are looking at these beautiful things which God has given us to enjoy, with your own eyes, and beginning early to love this little stream that runs by your home.

There is another, a greater stream which this little one will teach you much about—the stream of life—home is the starting place and love the guide to your actions. Great men who loved their homes and were kind and generous to their playmates in their youth, learned many truths which were of much value to them all through their lives—

The flowers, rocks and trees which one learns to know in their childhood always seem more beautiful—

When I come out to your father's, which I hope will be before long, we will take a walk by the brook and enjoy these beautiful things together.

Give my love to your mother and father, Elsie and Marjorie, and with a "happy New Year" believe me always your friend,

J. Alden Weir

It was fortunate that Weir stood firm in his convictions, for the critics jumped on the paintings he sent to the Society exhibition in the spring of 1892. The *Times* granted the charm of his landscapes but considered his "New-Impressionistic handiwork" decidedly "out of place" in a portrait. The *Herald* commented on the "spinach-like texture" of his figures; and the *Sun* pointed to a "mist of green that suggests miasma" in his *Ode to Spring*, a semiclassical study of a nude woman and Cupid.

Julian expected John to join the critics, but John had evidently come to terms with his younger brother's aims, and he now wrote in a more sympathetic vein:

You have thrown up reputation, success, all that *professionally* most people strive for, for a conviction within your own breast, the immediate effect of which brings down upon you ridicule and harsh criticism. I myself cannot understand it, for I think and see differently. But seeing you have shown such insight in your art in the past, I cannot but credit you with that same intelligence in following your present conviction. But he that buildeth a city must count the cost; or one who stems the current of conventional ways must be content with a crust, eschewing soft raiment. One thing *he* has as a substitute—the joy of *sincerity of belief*, of living up to one's convictions, of being identified with at least the honest search for truth. I am no prophet to tell what is in store for you; but this I can say, these are the signs of the rising up out of the past, of a new heaven and a new earth for you.

However, everyone was not as understanding as John; and it must have been galling for Julian to have Percy Alden lecturing him and fearing he would "not stick at it, unless pushed on by a sharp stick in the

hands of a friend—but will go to painting your peculiar (present style) pictures, which though, no doubt, most excellent and artistic, people will not buy. I am not a fool, and I tell you this as my firm conviction, based on what I have heard in various circles, artistic and Philistine. Now, I take it that you want to sell—nay, *must*, for you are a skilled workman and should always command your own price, if, *bien entendu*, you do work that your *customers* (excuse the word) like and want."

The customers remained cool to impressionist work on through the mid-nineties, although the critics and even the Academy showed signs of acceptance. In May of 1893 the American Art Galleries arranged a joint showing of the works of the Frenchmen Monet and Besnard and the Americans Weir and Twachtman. It was the first show to put the four on an equal footing, and the lively reception among artists and critics pointed up the elements which distinguished the American work from the canvases of their French contemporaries. In the heat of controversy the *World* waxed magniloquent, calling Monet "the King of the Impressionists," "the first real painter of landscape who has ever lived," a view tempered in other circles by the opinion that he was more an authority in "realistic truth" than in "artistic truth." Another critic found Monet's works "often lacking in the decorative sense, and in this very respect they form something of a contrast to the work of the two American painters . . . It is this we often miss in Monet, and almost always find in Twachtman and Weir." Nor were the palettes of the Americans as bright; they looked on nature with soberer eyes and had "none of the splendid barbaric color that distinguishes the work of the Frenchmen. They tend to silvery grays modified by greens and blues quite as silvery."

Despite the comparatively subdued key of this American Impressionism, the work of Weir and Twachtman continued to shock the public, especially in Boston, where they held a joint exhibition at the St. Botolph Club in December 1893. The best that the Boston critics would grant was that since there was no way "to avoid seeing the paint" the show was "more adapted to interest than delight the average beholder." They found the two men's styles so much alike as to be indistinguishable, and concluded brusquely that "if this is how nature really looks to some people, there must be something wrong with their eyes."

Impressionist work highlighted both the Society and Academy exhibitions in the spring of 1895, Weir's paintings being prominent on both occasions. As the *Tribune* put it, Weir, representing "the extremist

phase of our Impressionistic cult," lent to the Academy show in parti-
cular "a sense of vitality and progress." But the price of progress re-
mained high, as indicated in a letter from Harrison Morris, director of
the Pennsylvania Academy, in reply to Weir's urging purchase of paint-
ings from Twachtman, whose little daughter had died that winter. Mor-
ris was sympathetic, but the art market shunned experiment. "I heard
from Theodore Robinson of Twachtman's loss," wrote Morris. "As to
selling his pictures, that may of course happen and I'll do all in my
power, you may depend; but the public is still apathetic in buying at all,
and 'Impressionism' as they name whatever is too sincere for them to
understand, has few votaries among the non-elect. Alack-a-day, it takes
a generation or two for the public to grow up to a big idea."

The big idea, or as Weir termed it, the "big truth," to which his eyes
had been opened and which now enabled him to "enjoy any phase of na-
ture," was part of a broad pattern of experiment attesting to the artistic
vitality of this period in Weir's development. His impressionist depar-
tures in oil paintings were accompanied by forays into other mediums,
into etching, engraving, and lithography, as well as continued work with
drawings, pastels, and water colors. He painted a large set of murals for
the Chicago "White City" Exposition. And an interest in Far Eastern
art led him to explore the delicate disciplines of Japanese paper and
Japanese inks. Despite the personal sorrows of the nineties, in which he
was sustained, as always, by his family and friends, his work was never so
varied and ambitious, and in its quiet power it marked the approach of
maturity.

Weir's progress in etching was especially notable. He had begun to
etch in the summer of 1887. The following year he and Twachtman
delighted in a new press at Branchville. By the winter of 1890 Weir
was pulling prints of his Isle of Man series from a new press in his New
York studio; and two years later he was elected to the New York Etching
Club, where he exhibited regularly. The next spring at the joint show
with Monet and Besnard, Weir's etchings drew unanimous acclaim as
the work of "a master in the art." The etchings he sent to the Chicago
Exposition were medaled along with Whistler's and the entries of four
other Americans. In all he prepared over one hundred twenty plates
ranging from the merest drypoint sketch through every stage of rework-
ing. Along with some fifty landscapes (and two still lifes) there were
seventy or more etchings of figures, the majority studies of Anna. Christ-
mas Greens was one of the best.

Weir's own recollections of his etching period were recorded, fortunately, by Walter Pach in a 1911 essay in the *Gazette des Beaux-Arts*.

I have always declined to interpret myself and my work and do not know how to go about it. I etched and drew on copper for the sole reason that it had the mystery of a new path . . . For a period of about eight years I was deeply interested in etching and especially drypoint as it was so easy to carry about in one's pocket a half dozen plates which would fill up odd moments.— I gradually got so interested in a certain charm that etching only possesses, had my own press and would often pull prints to the early hours of the morning. A number of my best plates were ruined by the dropping of a shelf which contained some twenty odd pounds of copper plates, breaking a large bottle of nitric acid Dutch mordant which my foolish man had stood under this shelf. My ardor was somewhat cooled only later to go on again. *The Lamp*, an etching and dry point of a figure reading by night, injured my eyes. At that time I worked at night as painting took a new interest and I gradually dropped etching, hoping and desiring ever since to take it up again.

He was working harder than ever at his etching in the winter of 1891–92 when his world fell suddenly apart. A letter from Anna to her sister, Ella Baker, on January 5 indicated that things were going well in the tranquil round of the Weirs' New York life. A new baby was expected very soon, and "Julian has just finished an etching which he is very much pleased with, and says to tell you he is keeping one of the best impressions for you, as he thought you were too far away to send it to." On January 29 their fourth child, Cora, was born; and a week later, February 8, Anna was dead from puerperal fever.

To Julian it was a blow so complete and devastating that to expatiate on it seems an intrusion. The letters written to Anna's mother and sister, who were on a trip around the world at the time of her death, show his very life broken in two. Anna had been so close—they had been separated only two nights during their whole married life—that even work without her seemed impossible. Anna had made herself a fundamental part of his artistic as well as his personal life; and her moral support had been a bulwark to him during these last years when he had been fighting so hard for his convictions, for as he wrote to Mrs. Baker: "When we were first married my income was much larger than it is now, having of late striven for other things in which Anna gave me strength and encouragement, and we were both ambitious, we often talked of the time when we would look back on these hard times and smile at them. Man proposes and God disposes . . ."

Life, however, had to go on; and in work he found distraction. That

winter there were portraits and classes of students and preparations for the spring exhibitions. In the early summer he conducted a sketching class at Cos Cob with Twachtman, and in August he started a project which challenged all his energies—a mural decoration for Chicago's Columbian Exposition.

The mural project, which set a milestone in American art, appears to have been largely fortuitous. Money for exterior and interior painting at the World's Fair had been already appropriated when suddenly the situation changed. A man named Turner invented the squirt gun; and the question arose as to what should be done with all the money saved in wages by this invention. It was Millet who made the novel suggestion that it be used to employ American artists to decorate the buildings. Mural painting was still a very new art in this country, although Hunt and LaFarge had already blazed a distinguished path. This experiment in Chicago was the first time that anything had been attempted on such a scale, and the men chosen were all novices at the job, their only qualification being their artistic ability.

Julian left the children with Ella and Mrs. Baker at Windham and took the Limited to Chicago along with Elihu Vedder, writing back to Ella some of his first impressions of the Exposition.

CHICAGO, AUGUST 11, 1892

Yesterday we arrived after a very disagreeable journey, it being intensely hot and dirty, but after ablutions of a most luxurious kind we were met by one of the Commissioners of the Exposition and taken out to the World's Fair. I have never been so impressed in my life, and it is no exaggeration to say that it far surpasses the last Paris show both in the beauty of the situation and in the charm of the great buildings. With a few exceptions the architecture is a dream . . . In the lagoons and winding ways are fascinating little islands covered with palms; and trees, lilies and bull rushes seem as if they had always been there, wild flowers grow on the banks and little boats run with electricity skim about like birds.

I have a very comfortable room, out near the grounds, and thankful I am too that I do not have to live in that horrible city, which gave me the blues.

We arrived here in time to have the selection of the eight domes and you may be sure I did not choose the least desirable one. It is not quite completed yet and is covered with scaffolding. I have had a studio portioned off in the large Horticultural Building which will be ready by the beginning of the week. The model of the dome is not yet begun, so I have had them make me one on a much larger scale, which will be easier to get at. Everything suggests great possibilities, except time which is too short I fear.

There were eight painters—Cox, Beckwith, Shirlaw, Reinhart, Weir, Simmons, Vedder, and Blashfield—as well as several sculptors. Each artist was to decorate a dome and the pendentives rising from the four supporting piers, the actual painting to be done in six weeks, scarcely time for the sketches. Edwin Blashfield recalled later

how green we were, how very, very verdant, and earnest and enthusiastic! . . . We were to use tons of pigment . . . In reality, we used very little color. Its cost was a small item; floods of turpentine were needed instead. But if we were unsophisticated, we were serious . . . Scale and foreshortening were re-doubtable to us as problems. To foreshortening in the long run we wisely paid little attention; but to scale, still more wisely, we paid a great deal. Co-lossal paper dolls, with plenty of thumb tacks, helped us out, and though our scales varied, none was noticeably unsuited. . . .

We were to paint the domes *in situ*, on plaster that fairly broke your heart and skinned your knuckles and was like a relief map of Switzerland for bumpiness. But for our sketches and studies studios had been prepared; pens, Millet called them and they were; but good big pens, eight of them in a row, in the Horticultural Building . . . Today I still remember the fragrant smell of those nice new wooden walls to our studios. Weir's pen came first, then mine, and so on. Each morning Vedder knocked on Weir's abode, and they chatted; next he came to me for half an hour, then went on down the line visiting. At noon . . . Vedder's model . . . rose patiently from the stair-head . . . and went lunchward.

Our two pessimists were Beckwith and Vedder—Beckwith a joyous pessi-mist, Vedder a melancholy one but seasoning his melancholy with unfailing charm. The common subject of their pessimism was Chicago. Meantime the Fair grew and grew, and we all worked hard through the long summer days, and the evenings began to grow chill and inauguration to loom near and ap-prehension to come to us "how was all this to be completed in so short a time," and very earnestly we wondered as to what the public would say to our "prentice work." In the evening we naturally discussed each other's theories about mural painting as a novelty, and . . . we were inclined to pick Simmons as our winner . . .

It was not all beer and skittles either; the work was laborious, for we hadn't learned to do it; it was most of it in the open air; ladders were new to most of us, and working upon curved surfaces overhead . . .

The dome chosen by Weir was over the south entrance. In it he placed four seated goddesses in the pendentives, between which stood four boys, each holding a tablet marked, respectively, Pottery, Gold-work, Decoration, and Printing, the insignia of his symbolical figures; from these tablets floated banderoles which, with the flying drapery that arose behind each goddess, helped bring the decoration together as a

whole. He achieved the big simple effect he wanted by laying in his fig-
ures with flat tones, while his general color scheme came from his sky,
which was done in blue hatchings with the white plaster showing
through.

It was hard work, and in letters to Ella recounting his progress on the
murals Julian spoke wistfully of returning to home and the children.

[September 7, 1892] . . . The sky of my dome was begun today, up to this
time I have been working on models, first the sketch, then drawings of nude
models in action and movement of the figures, then the studies of drapery. I
feel as if a work of this kind ought to be on hand a year to complete and do
justice. There are so many experiments, both of color, foreshortening and
tone, that although I have done more of this than any other man, they all
have benefited by my experience and so made their work much easier. I hope
by the latter part of the week to begin on the figures, enlarging the drawings
and having them traced on, then, and only then, the pleasure of my work
will begin . . .

[Two days later] . . . It must be hard for you to write every day, but hon-
estly that is the only solace I have out here, hearing about the children, and
where they are is the only place on earth where I long to be . . . After work
this afternoon Millet took us all on a little trip in a steam launch through the
canals and we wound in and around all the buildings. The afternoon was
beautiful with the setting sun, these large piles of apparently white marble
buildings reflected in the water producing most beautiful effects . . . I dined
alone tonight and have spent the evening in my room. I am feeling all right
again, working for all I know how . . . I think I have done the best day's work
since I have been here, but oh my, it is long from the end yet and already the
first week of September has gone. . . . I do hope the mild weather will con-
tinue until we get well underway . . . the scaffoldings have not the awful fore-
bodings to me now they once had. . . .

[September 12] . . . Yesterday I had a whole budget of letters which made
me feel very happy, but when I am ready to leave, I shall consider myself a
favored man . . . I think this affair here has been the hardest task of my life . . .

Weir left Chicago during the last week in October with a difficult
job well done. Stanford White wrote him that both McKim and Saint-
Gaudens were "completely delighted" with his decorations and "were
constantly speaking of them."

On his return to New York Weir resumed his regular painting and
turned experimentally in still another direction, trying his hand at en-
graving. Engraving differs from drypoint or etching in that the tool, a
burin, is pushed away from the artist instead of being drawn toward him;
and the metal is removed instead of being bitten with acid as in etching
or displaced as in drypoint, so that it entails a slower and more careful

manner of work. The result of his new departure was, in its way, a small masterpiece.

"The only engraving I ever made," he recalled later, "was *Arcturus*. Having had an order for a drawing for a magazine, *Scribner's*, I chose this means as I knew it would make me more careful; and this plate I spent a month on from the model, and a delightful month it was." It seems strange that this plate should have been both a beginning and an end; it was to all intents and purposes Weir's swan song in the graphic arts. Although he did make an etching or two after this, they were not much more than sketches; and his lithographs were very few. There are several reasons for this. He had undoubtedly said what he wanted to say in graphic arts; also he realized that the delicate work bothered his eyes, particularly work on plates at night. Possibly, too, the complete lack of encouragement, except from a very few connoisseurs, may have helped to tip the scales; but what was undoubtedly most responsible was the fact that at last his new phase of painting was coming entirely under his control and there was no longer the need for a change of medium as a relaxation.

Arcturus made a striking impression on John, and he wrote enthusiastically to Julian in January 1893:

Your "Hunter" [*Arcturus*, Fig. 14] has been in my mind ever since I saw it. It expresses the sincerity and beauty of simple truth; the form is very fine—the torso and lower limbs and the action, the modeling of the chest, the truth of the single line that bounds the lighted side, and the same of the leg, are admirable. The modeling of the knee and the foot are fine. The arm is less good—not really fine, or equal to the leg. The drapery about the feet is fine. The head is good, and boylike, and the idea of the whole is good. The bad parts are the ribbon and the raised arm. Were it not for these, it would be thoroughly masterly. But what a delight to come so near a perfect thing at the first go with the burin—perfect, I mean, as things go, even with the best. I want to say that seeing your work has made a sensation within me, and a desire to do some one little thing well—a piece of drapery or anything. It is wonderful what a true line will express—flesh, structure, anatomy, modeling, grace and above all, nature—it doesn't matter what is the subject. I am all the while thinking of your little figure.

When I first caught a glimpse of you at the Century, talking with some one, you looked like one who had done *something* and could stand on your feet. As to myself, I seem to have lost all confidence and my work has become detestable; I seem even to have lost *faith* in myself, and that is a bad state to be in. So I think I must try and redeem myself by doing some little thing with absolute sincerity and love of truth—for I do love these things . . .

Now again I see your little boy, the hunter, standing on his globe before

my eye—that fine leg and foot, the pose, the fine full chest—really it is a work of art . . .

Such praise from John was doubly welcome, and Julian hoped his brother would soon begin to see what he was driving at in his encounters with sunlight and nature. For the countryside would always demand its due from a discerning eye, no less during the following summer, which found him again in Branchville, with Mrs. Baker and Ella running the household for him and looking after the children. While they were all there, he began a large picture (80" x 47") of Ella, seated out of doors on a stone bench, with baby Cora on her lap. Dorothy, on the lower right, has her arms around a lamb who reaches out for a bunch of grass that Ella holds out to him. Caro, standing on a rock behind them, rises high above the group, looking down on the scene, an arrangement that makes a handsome and unusual composition; her right hand rests on one of the slender branches of the forked oak tree under which the group is placed and around whose trunk winds a garland of laurel which swings across behind the seated figures in front. In the background are seen two white turkeys, a picket fence with a clump of green trees beyond it; but most important of all is a sun-flecked sward back of the group so full of color that at first one does not realize how delicate in tone it is. It makes a perfect setting for the white dresses of the children and the pale lavender gown that Ella is wearing. It is one of the loveliest canvases that Weir ever painted, the only thing to regret being that it never received its final stroke—although it is fortunately complete in all its essential parts. Undoubtedly the posing of three small unruly children was what brought it to a standstill, but that is the more to be deplored because this picture has its own place in Weir's development. What makes it of particular interest is the fact that it so obviously stems from his work of the previous summer at the Fair. It is in effect a decoration, not an easel painting; it could easily have been painted directly on a wall as a mural. It makes one regret that Weir never went further as a mural painter.

In the late summer the Bakers moved up to Windham, taking the children with them; and Julian went back and forth from there to the class he shared with Twachtman in Cos Cob, while John and his family moved into the Branchville house.

Writing from Branchville on September 8, John wondered if anything could

exceed the loveliness of this place, the freshness of the air, the calm, the quiet and repose? . . . Your summer's work is like coming from a cellar into the

glorious sunlight. But the motive of light and color and decoration should be subordinated to a *human* charm—the theme lies in the figures, in expression of the hands and human life. I feel as if I wanted to see the eyes of at least one opened and looking out at the observer, taking *him into the scheme,* as part of the presence, though unseen. How would it do to have Miss Ella looking out at the one who sees the group? The figures are all charming with this exception—the group is asleep. This is my only criticism (apart from the wreath) for the whole charms me more and more as I study it, and so it does Edith. Don't make the mistake we all are always making, of exhibiting them before they are ready to be seen . . . being out of sight for a while, you will come to them freshly after an interval, and then you will see at once the little that is needed to make them complete. And that little can be quickly done if clearly seen, giving the whole animation and life.

I wish we could be more together, occasionally, though I believe in *solitude* for the best production. I sit in your studio, smoking my pipe and looking at your canvases and feeling the atmosphere of your aspirations and your work. Sometimes I think we *fumble* too much. The masters thought out their work and then produced with directness and facility which has its charm. But why talk of art when the sunlight without is so glorious as it is this morning—so I will desist . . .

Through all these long months since Anna's death Ella had been a tower of strength and a refuge for Julian. Hers was an unselfish and generous nature, and she gave herself unstintingly to make a home for the children, until the house that had at first been a dreary, desolate place to enter, with no lamps lit as the evening drew on and everything left at sixes and sevens, became, under her charge, once more a home and a happy place to live in. She loved the children, and they were devoted to her; and to Julian she gave the intimate companionship that he needed so badly. She had, besides, excellent taste and a real knowledge of art, for she was herself an amateur painter of distinction. Their marriage in Boston on October 29, 1893, seemed a fitting culmination for them both. Twachtman, Julian's closest friend, was his best man.

That winter saw the Weir household settled into a welcome routine. As well as painting a portrait of Twachtman and a large (70" x 40") oil of *Baby Cora* (Fig. 15) held up in Ella's arms, Weir continued to experiment, this time under the stimulus of Far Eastern materials and techniques. He had started collecting Japanese prints in the eighties when their vogue was just beginning in the United States, and he had long admired Korean pottery and Chinese blue and white porcelain. Two Japanese art dealers, Heromichi Shugio (a Tile Club member) and Mr. Hayashi, guided his natural connoisseurship and became his good friends.

From Japan Hayashi sent paper made from the inner bark of the mulberry, long-grained and delicate, as well as brushes and inks. One bar of ink proved to be an antique so beautifully carved that Julian could never make up his mind to use it but would every now and then take it carefully out of its box, unfold the piece of silk in which it was wrapped, and turn it over in his hands, enjoying it as a work of art in itself.

Weir was challenged by the discipline required for working on Japanese paper, where error was without remedy; and he enjoyed many hours working in both black-and-white and color. He had been drawn to Japanese prints by their simplicity of design, their clear color patterns and rich blacks. Now in his own water colors he transformed this stimulus into a personal idiom. Two of these, *Japanese Screen* and *La Cigale*, Weir sent to the Water Color Exhibition of 1894, drawing down the bewildered wrath of the critics, one of whom cited them as evidence of "the uncertainty that has surrounded Mr. Weir for some time now, as to where he is at." Unfortunately these water colors have disappeared, and the record of Weir's Far Eastern experiments came to a close the following year in his one-man show at Wunderlich's gallery. Among a group of some thirty-four drawings, pastels, and water colors and fourteen etchings there was—"last but much the least," as one critic pronounced—a small wash drawing in Japanese ink of a feather. On the back of this sketch Weir wrote its epitaph: "One of 70 drawings made of a feather to try and render it in the simple manner as the Chinese do."

Through the summer of 1895 Weir worked on landscapes with considerable success, notably in *The Red Bridge,* now in the Metropolitan Museum. When the family went up to Windham for their annual visit, Julian was dismayed to find that one of the picturesque old covered bridges that spanned the Shetucket River had been taken down and a stark iron bridge erected in its place. He missed the old landmark and regretted the necessary march of progress until one day he suddenly saw in the ugly modern bridge a picture that I am sure no one but he had ever seen. Perhaps he went by just after the fresh coat of paint had been applied, and the vibrant red color caught his eye. The severe iron bridge with its preparatory undercoating of red lead, gay against the green landscape, the river, the sky, and the luxuriant river banks all form a harmonious whole, redolent of summer.

The Red Bridge received scant notice when exhibited at the Academy the next spring; "a stiff iron bridge" was evidently not considered a proper subject for art. Nor has there yet been any recognition of Weir

as a painter of what is considered today the "American scene." This picture of a prosaic iron bridge; the series, five or six of them, that he made of the Willimantic factories; *The Sand Pit, Ploughing for Buckwheat, The Building of the Dam,* the two city "Nocturnes"—to mention only some of his themes—all testify that it was not alone in idyllic fields, woods, and pastures that he could find pictures. His discerning eye saw a "picture" wherever he chose to look, no matter how commonplace the setting.

The pictures Weir's eye caught began to catch the public eye as well in the late nineties. Somewhat to his surprise, *The Old Rock,* a landscape he had barely finished, won the first prize of twenty-five hundred dollars at the Boston Art Club in 1896. It was a clear triumph for the "New School," as the second and third prizes went to Childe Hassam and Frank Benson for two gaily "Impressionistic" paintings. The *Boston Transcript* greeted Weir's "dramatic and conspicuous" reappearance on the Boston stage by pronouncing his picture "unlike anything that he ever painted before . . . It is, let us say, Impressionism minus its violence, an original."

Needless to say Weir was delighted with the award. Now he could do what he had long wanted to—build a pond, for fishing of course, at Branchville. It was known as "The Boston Art Club Pond" and gave him as much pleasure as any money he ever spent. For as time went on, his life centered around Branchville, and his closest friends were men who understood his work and shared his delight in the woods and streams, men like Twachtman, Warner, Robinson, and Hassam. Of all the friends of these years only Ryder seems never to have relished the vigors of country life.

Albert Pinkham Ryder had been Weir's friend since their earliest student days in New York, and, like Weir, Ryder had chosen to pursue a personal artistic vision. Ryder and Olin Warner had toured Europe together and had been frequent visitors at Weir's 12th Street house, although Ryder kept more to himself as he grew older, pleading weak health. After one long illness in the spring of 1897 Ryder was persuaded to convalesce on the farm in Branchville; and a letter to Julian reflected the wonder that Ryder felt in the presence of life.

BRANCHVILLE, MAY 5, 1897

MY DEAR JULIAN:

I feel it my duty to drop you a line to let you know what good your kind interest and brotherly friendship have done for me. I sleep nights, Mr. and

Mrs. Remy are as kind as possible; I like the domestic noise and bustle of their dwelling, and the busy planning of the garden which comes on apace.

I have never seen the beauty of spring before; which is something to have lived and suffered for. The landscape and the air are full of promise. That eloquent little fruit tree that we looked at together, like a spirit among the more earthy colors, is already losing its fairy blossoms, showing the lesson of life; how alert we must be if we would have its gifts and values.

My little guide Carl Remy waits in the morning to see what I would do; and is altogether a sweet and aimable little lad and his brother also.

If when I get cured I could only learn to have language so as not to be continually misunderstood, except by you and those who have known me so many years.

I wish you could have been here and enjoyed the beauty of your own place.

I am still quite weak in the head, so with kind remembrances and best wishes for Mrs. Weir and the children I am yours in all friendship and appreciation,

<div align="right">Albert P. Ryder</div>

Returned to New York in June, Ryder wrote that he imagined the farm was "flourishing like a green bay horse with the rains"; and before long Julian had Ryder back in Branchville to "bask in the sun and indulge in the luxury of feeling very tired," as Julian put it. But Ryder was reluctant to stay more than a few days, and that September he confessed to Weir that a walk in Bronx Park appealed more than fishing. "Catching mice is more in my line," he wrote, "and they are shivery looking enough for me. Still I realize it [fishing] is a grand sport and requires a patience equal to doing a picture."

For Twachtman, on the other hand, the country became ever more satisfying; and a letter to Weir from nearby Greenwich indicated the shared excitements that drew their painting out into every phase of nature. With characteristic generosity Twachtman added a note of encouragement for Theodore Robinson, who had begun to work along similar lines.

<div align="right">[Postmarked Greenwich, December 16, 1891]</div>

DEAR WEIR:

That was a splendid talk we had this evening and I become more convinced each time I see you. I want to tell you how confident I feel. Tomorrow will be a fine day and I wish for lots of canvas and paint to go to work with.

Tonight is full moon, a cloudy sky to make it mysterious and a fog to increase mystery. Just imagine how suggestive things are. I feel more and more contented with the isolation of country life. To be isolated is a fine

thing and we are then nearer to nature. I can see how necessary it is to live always in the country—at all seasons of the year.

We must have snow and lots of it. Never is nature more lovely than when it is snowing. Everything is so quiet and the whole earth seems wrapped in a mantle. . . . All nature is hushed to silence. . . .

After thinking it all over, it appears to me that it would be best to let Robinson have all the space at the Architectural Show. It seems that it was so intended by the management in the beginning. He will have a better chance for success as the space is rather small. As for my things, they have all been seen only last spring. Go and see him and tell him what I think and it will save me the trouble of writing another letter.

My wife joins me in kindest regards to Mrs. Weir and yourself.

<div style="text-align:center">As ever,</div>

<div style="text-align:center">Twachtman</div>

Theodore Robinson had known Julian since their student days in New York and Paris, but their intimacy began in the nineties as Robinson, under the direct influence of Monet, joined Weir and Twachtman in their artistic searches. Robinson had come back from France in 1878 and had worked with John LaFarge on decorations before returning to the Continent in 1884. In Giverny he became a friend of Claude Monet, and Impressionism gave a new impetus to his work. In May 1891 he wrote Weir that he was "feeling well, and immensely interested in work, and am getting a kind of clear head, a definite idea of what I want, that I hadn't a short time ago." After a winter in New York Robinson wrote again from Giverny (May 1892):

I saw Monet Monday and a dozen or so canvases he did at Rouen last winter. They are the Cathedral, mostly the *façade*, filling up all the canvas, and they are simply colossal. Never, I believe has architecture been painted so before, the most astonishing impression of the thing, a feeling of size, grandeur and decay, an avoidance of the banal side of the subject. They are at all times of day, one fog, and the tower gradually becomes less visible as the eye ascends, a large grey day (*façade*), several of sunlight. One beauty— early morning—a light rosy sky behind the front all blue and purple. He is not satisfied himself, will return next winter—said he tried to paint them as he would paint anything, "all together" and not a "line" anywhere—yet there is a wonderful sense of construction and solidity. Isn't it curious, a man taking such material and making such magnificent use of it . . . Monet was cordiality itself— It's very pleasant to think I have a place in his affection.

Again in July Robinson wrote Weir:

I am pegging away, so far not too much satisfaction, but I hope to make the latter part of the summer tell. Just now I think a good deal of a word of

yours Twachtman told me once. Your asking T. on his coming in from work, "Did you paint?" I am too much inclined to dawdle, "stain" as Thayer says, and scratch around—getting ready, instead of pitching in, man-fashion. Twachtman wrote me a few days ago—he spoke of seeing you—what a fine nature is his—a friend that one is glad to have . . . For six weeks I worked mornings on two landscapes—sort of panoramic affairs—the valley and Vernon seen from the hill-side, they are not great successes, I fear—I tried to paint floating cloud-shadows—I am interested just now in skies—which I have always shirked too much, there is an inexhaustible field for beautiful variety and color . . . Your friendship would be something to attract me back to America, even if there were no others. It was a great stimulus to me last winter.

In the fall of 1892 Robinson returned to America to live, determined to express the flavor of his native countryside in his new style of painting. He worked hard, battling ill health and unfriendly critics to win recognition finally only a short while before death stopped his brush.

Robinson died in April 1896, and that July Weir's loss was aggravated by the sudden death of Olin Warner, struck by a horse and carriage while riding his bicycle in Central Park. Warner's accident cut off a vigorous sculptural talent in mid-career. As an additional blow came the death in September of Mrs. Alden, Julian's patroness and a kind and loving friend.

Although Weir and Twachtman lost a kindred spirit when Robinson died, their artistic aims appealed to a number of painters in the nineties; and Childe Hassam, one of the most talented of the group, became one of Weir's good friends. Hassam had settled in New York in 1889, and he recalled later: "The first dinner I went to in a New York painter's home was at Weir's charming 12th. Street house with its fine old furniture and pewter. . . I remember a Thanksgiving dinner there with Weir and a turkey at one end of the oak table (which was without a white cloth, most unusual in New York at this time), and then there was Twachtman and another turkey at the other end."

It seems quite fitting that Hassam's first recollections of their friendship should be of a festive occasion, for no one ever enjoyed life with more gusto. He was a virile, vital, definite personality, as alive as a breath of fresh air, and a complete antithesis of the lay idea that artists are effeminate creatures. There was nothing of the Boston brahmin or puritan about him; his roots went into a soil much more earthy. Hassam was born in Dorchester, Massachusetts, in 1859, and was a New Englander through and through. His New England was not that of a faded,

romantic past, but still boasted vigorous beauty. The New England that he saw and translated so clearly and brilliantly was a region of whaling towns, of busy wharfs and streets, of colorful rocks swept by wide Atlantic waves, and white churches seen with a pagan's eye. He himself asserted that "New England churches have the same kind of beauty as Greek temples." No one ever saw more graphically or recorded more lovingly the simple beauty of New England's old houses, both inside and out; and his creed he stated simply: "My business is to sit in front of a beautiful church or a beautiful woman and paint them."

Hassam's laugh was as hearty as himself. On one occasion unexplained shouts and roars of laughter were heard coming up from the lane that runs by the house at Branchville; the cheerful sound continued for a long time before its authors put in an appearance. Finally a three-seated buckboard drove up to the door with several dogs running out from underneath, while from the wagon itself emerged Poultney Bigelow, Hassam, and Frederic Remington, himself a six foot giant. The first two were on a visit to Remington in nearby Ridgefield. Their appearance these days might cause no particular comment, but for that time their getup was unusual: blue jeans, pirate bandannas tied around their heads, and Poultney Bigelow in carpet slippers with the toes cut out. They were all in high good spirits, like boys out of school, and how they all enjoyed just being alive.[2]

Hassam and his wife soon became frequent and much loved visitors at Branchville, where Hassam and Weir would spend long days painting out in the fields and long nights playing interminable games of dominoes. Hassam made a number of oils, pastels, and water colors and at least one etching of the Branchville scene.

For four years, beginning with the summer of 1897, Weir held an art class at Branchville during the months of June and July. Mary Cassatt once wrote him that his pupils "always are more open to advice than any others I see"; and his classes were characteristically free of doctrinaire pronouncements. At Branchville he was at his best. One of his students, Joseph Pearson, who became a devoted friend, has written me a vivid picture of Weir in this informal setting. Pearson had been stirred by seeing Weir's work on exhibition in Philadelphia and had

[2] It was Remington who nicknamed Hassam "Muley," after Muley Hassan in Irving's *Alhambra*; his intimate friends were quick to seize upon it, and from then on he was always known as "Muley" to them all.

eagerly joined the students who gathered for criticisms near the rambling farm in Branchville:

Your father seemed to have an innate appreciation of good things. His tastes were catholic. He assembled unrelated objects and people in perfect accord. He escaped colleges, was not stilted, thought simply, lived simply but by no means commonly, so that any worthy object or person rested comfortably near him. What a curious aggregation were those objects and people, but they were at peace as in the sight of the lord. All, from the beastly bull dog Jags to the divine lady, from the fork in the manure pit to the Whistler etching over the mantelpiece, rested side by side seemingly unaware of their differences and in blissful incongruity. I am made glad by the thought of it. Could anything be more heavenly . . .

You may recall in what deliciously boyish fashion your father referred to men no older than he; as old Carlsen, old Paul etc. How he loved them and enjoyed telling anecdotes about them. They were fit stories, not extraordinary, and were oft repeated but never lost their charm . . .

Few artists of character I have known have escaped the diverting effect of the purchase and development of run down property. Your father was no exception. He had much property. It was lovely. It charmed him. He gave much thought, time and energy to its improvement. How he enjoyed clearing vistas, trimming trees well up from the ground revealing beautiful notes and things unseen before. The making of level places for tennis, working with his men who used great red oxen to haul the boulders to one side; the building of the pond with prize money, some of which was generously shared with employees; piling brush here and there and making a bon-fire now and then when the boy in him suggested it. That all of this was not diverting only may be readily understood when one recalls the pictures *Building the Pond, Noonday Rest* and *The Coon Hunt*. The things made by the faithful Paul found a place in his pictures: split sapling fences, rustic arbors and bridges as well as hen runs, and informal gardens.

I regret that I never had the opportunity to show your father what I have been doing while he suffered silently the apparent extinction of his protege and bright luminary. How kind was he, how dear to me. One of my sons bears his name and that is some comfort to me and must have been to Lathrop and Twachtman who also named sons after him. Has ever an artist of any time been loved so much by his fellow men? . . . a rare soul, this man, a priceless person. Strong, simple, tender, generous, large, a fit man . . .

While your father was a director of the Metropolitan Museum, he came over to Philadelphia to see the memorial exhibition of that very great man Eakins. We saw the pictures together, and as we passed along the line we came upon a small and until that moment very little known picture. Your father was immediately delighted with it, with the result that through his good offices it is now in the Metropolitan.[3] It is a panorama of what old

[3] Thomas Eakins, *Pushing for Rail Birds* (1870).

Philadelphians call "The Neck," the marshy country below the city between the Delaware and the Schuylkill. Ducks and reed birds were hunted there, and the picture represents men poling themselves about in flat-bottomed boats among the reeds and grasses. One who knew your father may readily understand the appeal that picture would have for him. It has the interest of a Currier and Ives print; the detail and finish of a great Dutch picture; an integrity and unaffected charm seldom equalled. So easily might its worth be unsuspected that even today it may have remained unknown had it not been for your father's ready realization of its charm.

Like Sargent, your father had for Eakins the very highest regard . . . As I rode through the city with your father, who by the way loved to call it *old Philly ma Klink*, the only question he asked was "Where does Eakins live?" and I, like a true Philadelphian replied "I do not know". . . . I cannot imagine Eakins making a speech but I can recall your father's enthusiastic expression of appreciation of a speech that Eakins delivered in French . . .

I was a guest at your home near Branchville, your uncle John was there! T'was Sunday. After dinner we strolled about accompanied by you and Cora. Presently as we sat upon some boulders in the shade and conversation had about ceased, your father suggested that one of you children fetch the bible from the house and that Uncle John read to us. Could anything be better bred, could anything be better read?

Your father revealed, through passages read to me from various sources, a sure instinct for that which is simple, direct and unaffected. The written word had for him as great charm as painting or music. He did not discourse nor orate nor did he try to . . . Your father did not take himself seriously but was rather like a boy with boys. What others did entertained him; what others said delighted him. An incident that might be overlooked by others was recalled so delightfully by him that one never forgot it . . .

Weir's summers at Branchville during the nineties helped him come to terms with himself and his art. In the peace of warm, lazy evenings and the exhilaration of tramps through the hills his zest for living revived completely after the sorrow of his wife's death. In 1897 Weir was forty-five years old; his experiments and struggles had broken the trail that he would follow in the years ahead. That summer his painting progressed smoothly. His work seemed at once easier and more confident; and such major canvases as *Noonday Rest* (Fig. 28), *The Factory Village* (Fig. 27), and *The Sand Pit* reflected a mood of acceptance.

Soon after Anna's death Julian had determined to erect a stained glass window in memory of his wife and their little son. Slowly and carefully he worked out a design, making countless sketches in color before painting the whole on canvas the actual size of the window. He showed

the finished cartoon at the Architectural League Exhibition in 1897; the lead line drawing for the window was readied the next year; and before long the window was set in place in the Church of the Ascension in New York, the canvas original going eventually to hang in St. Paul's Church in Windham.

The subject he had chosen was a moment of rest during the flight into Egypt. In the left lancet Mary kneels in adoration of the Child, who lies in a cloth at her feet. In the right lancet Joseph kneels in the foreground, while behind him an angel stands watching and a donkey's head appears across a rustic fence. In the upper part, floating on clouds that cross a blue sky, are five angels; two of them are playing musical instruments, two adoring, while in the pendentive at the top the fifth angel, arms raised, holds a chalice aloft.

The color scheme is unusual for stained glass, which is generally associated with rich, deep tones; here everything is subtle in color, the landscape delicate in its blues and greens. Even the robes the figures wear are all white or pale pastel shades, sometimes of opalescent glass. There is none of the brilliant glass that his contemporary, John LaFarge, was producing. It was Weir's own palette, transferred to another medium; but the whole is such a unit that one does not feel the lack of more brilliant tones. The effect is beautiful and serene, and a sense of the ethereal shines through it.

Weir's window was unique. He never designed another, and his memorial stands significantly alone, marking a stage in his personal and artistic history. Arthur Hoeber, the art critic, pointed out the novelty of the window as it finally evolved, noting especially its effect of "great tranquillity." Even more perceptive were the comments of Weir's old friend Dr. Winchester Donald,[4] who had married Julian and Ella a few years earlier. "Yes! I not only liked the window," he wrote. "I saw in it the history of your soul quite as much as the evidence of your art."

[4] E. Winchester Donald was rector of the Church of the Ascension in New York from 1882 until 1893, when he moved to Boston's Trinity Church.

CHAPTER 8. "TEN AMERICAN PAINTERS," 1898-1911

Throughout his career Weir remained committed to American art and the organizations which provided support and encouragement for professional artists. He played a leading role in a variety of these organizations, not because he was an administrator or a politician—he was neither—but because he believed in encouraging work of high quality, whether by new artists or established men, whether experimental or traditional. If a new association of artists promised a fresh direction or a productive grouping, he was all for it, not in a spirit of revolt but on the grounds that variety was essential if American art were to avoid the mediocrity of institutional tastes compelled too often to compromise.

In the spring of 1898 Weir once again joined in the formation of a new group of artists. "Ten American Painters," or "The Ten," as they were soon called, exhibited regularly for the next twenty years, and the uniformly high level of their shows contrasted sharply with the profusion of works in the older exhibitions, those of the National Academy and the Society of American Artists. Weir had been associated with the Society of American Artists from its beginnings in 1877; and the Society had provided an important focus for his activities during his early years in New York. But it had lost its distinctive character, and now, after twenty years, its exhibitions no longer challenged the Academy with any force. The good work was often lost in a general mediocrity. In the winter of 1895-96 Weir withdrew from the Society's jury activities; he sent no pictures to the exhibition of 1897; and that December he submitted his resignation, joined by the new group's prime mover, Childe Hassam, along with John Twachtman and seven other sympathetic painters.

Hassam recalled that Weir fell for the idea "like an artist," as did Twachtman. Then

Thayer was asked and the three Boston men, Tarbell, Benson, and De Camp, but Thayer did not come in. Then the other men, Metcalf, Dewing, Simmons

and Reid, whom we met often at The Players Club, made up The Ten. The plan was to have an Exhibition at the Durand-Ruel Galleries, then at 36th. Street and Fifth Avenue. It was one of the large, old New York Mansions with a gallery that had a top-light—a real picture gallery of moderate size. There were to be no officers, and meetings only to arrange for Exhibitions . . . [paintings to be] hung by dividing the wall space into ten centres, one wall cut by a door not being so good. Weir was always enthusiastic about this method of hanging. He was always well represented in every Exhibition which The Ten held, and never missed one—which was a much better record than some of us made. In fact, Weir and Twachtman may be said to have contributed most to its artistic success.

Weir wrote to persuade Winslow Homer to join them, and Homer's reply underlined the significance of their step toward independence.

SCARBORO, MAINE, JANUARY 20, 1898
. . . On receiving your letter I am reminded of the time lost in my life in not having an opportunity like this that you offer—

The chance that each member will have of showing their work in a group —the larger the better, and under their own direction will be a great spur in tempting them to great effort and enterprise. I know on my own part that I have been kept from the Academy exhibitions by the fear of the corridor and the impropriety of my trying to make terms as to placing my work.

You do not realize it, but I am too old for this work and I have already decided to retire from business at the end of the season.

So you see that I cannot join you at even this most cordial invitation— and admiring as I do all of you.—

You see it would oblige me to work—at this late day—when I wish to make the most of the few years I have left. . . .

The resignations of The Ten raised a considerable stir. The departure of so many first-rate painters from the Society brought forth charges of ingratitude and lack of cooperation. There were interviews and counterinterviews, but Weir was reported as saying that "there was no ill feeling in the Secessionists." They had merely grown "dissatisfied with their membership in a large body which is governed by form and tradition, and having sympathetic tastes in a certain direction in art, they had withdrawn from the Society . . . to work together in accordance with those tastes. Mr. Weir said that one object of his friends and himself, following the Japanese view, is to get rid of the barbaric idea of a large exhibition of paintings. And so they propose to give each year a small exhibition limited to the best three or four paintings of the men interested in the new movement."

Tarbell pointed to the lack of distinguished artists on the Society's Committee of Awards. DeCamp attacked the rising tide of commercialism. And one of The Ten was quoted as declaring: "We resigned because we felt that the Society no longer represented what was intended in the beginning . . . Genuine artists would not seek primarily to exhibit what they thought would sell, but what they thought was really good. But as the Society is now organized with its large leaven of business and society painters, art in the best sense is getting to be more a vanishing quantity and the shop element is coming more and more and more into the foreground . . . it could be called the Society of Mediocrity."

To John Weir these published interviews seemed part of "the gentle art of making enemies"; but the first show of "Ten American Painters" in the spring of 1898 won enough friends to become a permanent feature of the season. It opened at Durand-Ruel's gallery on March 31 for two weeks, overlapping exhibitions of the Society and the Academy. Following the original plan there were no officers and no jury in the new society, and the gallery walls were divided into ten equal lots, each man drawing for his section and exhibiting his work as a whole. The press was generally favorable in comparing The Ten with the larger group exhibitions, and according to *Brush and Pencil* it was a real "treat" to walk through a little gallery "containing nothing but good pictures." What the critics found difficult to understand were the reasons behind the formation of the new group. They had expected another revolt of 1877, and they had looked forward to seeing "the most advanced form of painting," but they found few "new views," no "new battle cry," no "particular school of ideas." And they were forced to conclude that if The Ten were to be "taken seriously it is not because they are seceders but because of the intrinsic quality of their work."

Weir exhibited eight paintings, more than any other member of The Ten, all of them pictures painted that winter or the previous summer. His landscapes included *Noonday Rest* and *A Factory Village*, works that stand with his best. But even more striking were his figure pieces, notably *The Grey Bodice* (Fig. 17) and *The Green Bodice*. These were both painted from the same model, the sister of Henry Dixey the actor, a girl of unusual refinement and intelligence, as is apparent in the air of quiet distinction which Weir succeeded in portraying so clearly. His paintings were coming along more easily now; no longer did he paint over fifteen out of twenty-five canvases, as he had admitted to John in 1891. The figure paintings of these years reflected

the confidence of a mature artist. Again in *The Black Hat* and *The Green Dress,* painted in the winter of 1898, Weir carried through beautifully poised works.

The years from the first exhibit of The Ten in 1898 to the coming of the "moderns" in the Armory Show of 1913 were ones in which Weir reached the crest of his art. Not only was he painting at the peak of his powers, but his work was beginning to command larger public attention. And among his fellow artists, where his reputation had always been firm, he gained new eminence. In January of 1899 he was able to give up his teaching permanently and devote all his energies to his art, sending fresh work regularly to the annual exhibitions of The Ten and to the Academy. Weir and Twachtman were the mainstays of The Ten until Twachtman's death in 1902, when Hassam joined Weir as the central figure in their group shows. Weir never approached the facility of a painter like Hassam, and he continued to chafe at the resistance of his medium; but he never missed an exhibition, and each year's work was impressive. In 1907 there was a retrospective show, the next year another one-man show of fresh work. To call the roll of the major pictures of these years is to call up Weir at his best, whether in country scenes of Branchville and Windham or in the figure work and city scenes from his New York studio.

The quiet beauty of Connecticut shone from such canvases as *Ploughing for Buckwheat* (1899), *The Border of the Farm* (1902–04), and *The Upland Pasture* (1905, Fig. 31). Cloud shadows shift across the hazy slopes of *Obweebetuck* (1908), a mountain scene from the garden at Windham; while the *Danbury Hills* (1908) sparkle in the sunlight with an occasional white note of a house showing through the trees to remind us of a different and more peaceful kind of America. The sun blazes down on *The Building of the Dam* (1908); and *Hunter's Moon* (1909) catches the shadows of night as delicately as *Pan and the Wolf* (1908) captures the half-light of dawn. Peaceful family summers cast their spell over *The Donkey Ride* (1899–1900, Frontispiece), *Visiting Neighbors* (1903, Fig. 29), and *The Return of the Fishing Party* (1906). Vivid memories of the hunting tramps Weir loved return again and again: in the gallery of his dogs—Bush, Jags, Prince, Pedro; in the crisp autumn woods of *The Haunt of the Woodcock* (1905); in the jumping firelight of *Hunting the Coon* (1905).

This last picture was exhibited at the 1906 exhibition of The Ten and provoked an amusing letter from Frederic Remington. "Your coon hunt made a hit with me. How you were ever going to keep a fire in the

night confined to its place like a dog on a chain I minded not, but you certainly did it. The whole thing is rich and distinguished but you must be careful—it is perilously near a story. Art must rise superior to human interest—not to speak of coons."

Not long after he gave up teaching Weir moved back into a studio at 51 West 10th Street, into the same building where he had lived in 1869 in the days of the old Academy school. He worked for the rest of his winters in this historic Studio Building, the first structure designed especially for artists to be built in New York.[1] From here he sent out a steady flow of portraits, mostly of his friends, and studies of quietly beautiful "gentlewomen." There were notable portraits: *Colonel C. E. S. Wood* (1901, Fig. 21), *Albert Pinkham Ryder* (1902, Fig. 22), and *Childe Hassam* (1902). And *The Rose Pink Bodice* (1904) seemed to Edmund Tarbell "the most lovely piece of color" Weir had ever made. *The Fur Pelisse* (1906, Fig. 20), which Weir sent to the final exhibition of the Society of American Artists (merged with the Academy in 1906), was a sensitive and subtly toned oil which proved to be one of the few successes of the show. The refined grace of his model was captured in both *A Gentlewoman* (1906) and *The Pet Bird* (1910) with a rare delicacy.

Even the city skyline was transformed by Weir's imagination. He had done a few paintings of snowy streets in the eighties, but now he turned to the play of city lights at night. Two handsome "nocturnes," *Queensboro Bridge* (1910) and *The Plaza* (1911), added their weight to the mounting evidence that Weir was seeing new pictures everywhere and that he felt sure of control over his means of expression.

He was thoroughly absorbed in the American art world during these years, busy with exhibitions and jury work, and sustained by summers with family and friends, summers that stretched from May to December now that he had stopped teaching. Europe had long since ceased to attract him strongly, but he did make one trip abroad in the summer of 1901. The purpose of the trip was to verify the authenticity of a Luini painting which Percy Alden wished to sell. The high spots of the journey were visits with Sargent, Whistler, and his old master Gérôme. It was always stimulating to return to the Old World, but Weir came away strengthened in his commitment to American art.

He arrived in London in July with Ella and his three daughters,

[1] The Studio Building was erected in 1857 by James Boorman Johnston; its architect was Richard Morris Hunt, the first of an influential generation of Beaux-Arts graduates. Its tenants included many painters of the Hudson River School as well as John LaFarge, Winslow Homer, Homer Martin, Thomas Dewing, and William M. Chase.

and after starting the Luini on its rounds among the experts got in touch with some of his old friends, among them John Sargent. Sargent was busy, as always, but his note from his Chelsea studio proffered a cordial welcome.

<div style="text-align: right">

31 TITE STREET, CHELSEA, S.W.
WEDNESDAY, [JULY, 1901]

</div>

MY DEAR WEIR:

I am delighted at the prospect of seeing you— Will you and Mrs. Weir, and the children all, come to lunch here on Sunday at 1:15—

I will ask my mother and sister to whom I know it would be a great pleasure to meet you again after so many years— I am so full up with two sittings a day and several appointments every afternoon after working hours that I cannot propose an earlier meeting—and my evenings of this week are taken up too.

In case you meant to go out of town on Sunday like everybody else, don't change your plans, but give me Monday or Tuesday— However I should feel much less harassed on Sunday, and could take you to my other studio where my Boston work is— I am glad you like my Crucifix.

My mother and sister live at 10 Carlyle Mansions, Cheyne Walk, Chelsea and are in after 5:30. They leave for Contrexeville on Wednesday and I leave on the same day for Norway.

If you can't come on Sunday I think Friday at lunch at the Hans Crescent Hotel, Hans Crescent S.E. would suit me best at 1:15, but it will be a rush.

With kind regards to Mrs. Weir,

<div style="text-align: right">

Yours Sincerely
John S. Sargent.

</div>

Let me know quickly when I may expect you—

That luncheon at Sargent's stands out in my memory. I remember in particular Mrs. Sargent, his mother, seated on the sofa in the Tite Street studio and her remark that she had kept every single drawing that Sargent had made as a child—and my wonder that anyone should think another child's work worthy of such treatment. I remember too how gracious and charming she was, how delighted my father was to see her again, and how he put himself out to pay her every attention. It was while we were in this studio, I think, that we saw the big triple portrait of the Hunter sisters which was on Sargent's easel at the time, where it completely dominated everything else. The sisters, all in dresses of dark hue, are seated on a round divan; and the tone of the painting is dark and rich, as contrasted with that of the three Windham sisters where everything is light and white. I remember being much impressed with

it—all but the small dog lying on the floor at their feet, for since Sargent painted it while standing looking down at it the dog has a curious appearance of falling on its head.

After lunch came a drive in a hansom—it must have taken several of them to transport us all—to Sargent's other spacious studio at 12–14 The Avenue, Fulham Road, where he was able to work undisturbed on the big decorations for the Boston Public Library. Here in a huge room towered the colored bas-relief in plaster of the Trinity—God the Father stretching out His arms over Christ on the Cross below Him, with the red folds of His garment enfolding the whole, while over His head floated the Dove.

In August the Weir family crossed the Channel and, after stopping at Mont-Saint-Michel, proceeded to Chartres and on to Paris to continue the investigation of the Luini. From Paris Julian wrote to his old friend C. E. S. Wood:[2]

> This is a lovely place to loaf in and see fine things. . . . We expect to return to the best country in the world on Sept. 29th., D.V. I did not get a chance to do my cathedral as I had planned. We have all been well however and wasted lots of time. I believe I loaf naturally. I had a week at Chartres where is the finest cathedral I have ever seen, but I did not paint, but ran about the country seeing chateaux and having a good time generally. . . .
>
> We live very well here at the Hotel de l'Empire, Rue Daneau for two dollars and a half apiece a day, with a chef that would make you feel good and an excellent wine. To be sure, we have to mount up three flights of stairs, but what is that for we-uns.
>
> I dined with Whistler in London and we lunched on Sunday with Sargent and saw all their work and had a very good time. But I hate the English and was glad to leave. Sargent has done a Crucifixion in plaster that is the finest thing I have seen here. It belongs to his decoration for Boston joining the upper part and lower part of his picture. . . .
>
> America is the place. I feel as if I had lost a whole summer. . . .

While in Paris Weir called on his former teacher, Gérôme, whom he found now an old man, crushed by the death of his only son, his one solace his work. He had turned entirely from painting to sculpture, and Weir was pleased to find that he could more honestly admire Gérôme's new field than his painting; but he came away saddened from this meet-

² Charles Erskine Scott Wood (1852–1944), was soldier, lawyer, poet. He was graduated from West Point in 1874, campaigned against the Nez Percé and the Piute, resigned to study law at Columbia University, was admitted to the bar in 1884, and practiced on the West Coast, settling in Portland, Oregon. His published writings include *A Masque of Love* (1904), *The Poet in the Desert* (1915), *Maia* (1916), *Circe* (1919), *Heavenly Discourse* (1927), *Too Much Government* (1931).

ing with his old master and with his touching words "work is all I have left me" ringing in his ears.

In order to conclude his mission Weir made a flying trip to Berlin to consult the leading authority on Luini, Dr. Bode.[3] He loved the French and disliked the Germans; and he wrote Ella that Berlin was a big, ordinary town without "any style or charm." Dr. Bode declared the Luini genuine and Weir was able to return to England with his mission accomplished and Bode's written testimony to place beside the painting, which he left with a London dealer.

Weir had dined with Whistler in London in July, and saw him again several times before sailing back to the United States. Whistler was still excited over a letter he had received recounting an alleged attack on him by William M. Chase. He had sent Weir a copy of the letter through their mutual friend Francis Lathrop, and Weir had written to Whistler in defense of Chase.

MANDEVILLE HOTEL, MANDEVILLE PLACE,
JULY 30, [1901]

MY DEAR WHISTLER:

You must read between the lines of the letter which Lathrop sent me. This man who wrote it is undoubtedly a blaggard and was probably turned down by Chase. Nothing would give him more pleasure than to have you take it up, it would not surprise me if he supervised the article in order that he might use it to the destruction of Chase—who may at times over step himself but he has a sincere admiration for you and your art— You might chide him if you like, but wipe the floor with this dirty blaggard, probably on some Yellow Journal. I will do what I can to find out about him and will write you on my return, but Chase I know to be a Loyal admirer of yours— Chase and I would have succeeded in having your *Woman in White* bought for the Metropolitan Museum had it not been for (your friend?) Avery. Believe me Whistler you can afford to over look that which is displeasing to you (or any one) in that article, which I doubt not was inserted for a purpose.

Sincerely yours,

J. Alden Weir

Whistler was never one to overlook this sort of thing, however, and he was anxious to see Weir, not only as an old friend, but as a man at the center of the American art scene. On September 27 Whistler sent Weir a telegram: "Unwell do come Garland's arrange with Lavery." This was followed by a note from Garland's Hotel, Suffolk Street: "What can pos-

[3] Wilhelm Bode (1845–1929), German art critic and art historian associated with the Berlin Museum from 1872 on and instrumental in its development as an art research center.

sibly have occurred. I *waited* for you! Don't you think you had better hop into a cab at once—and tell me all about many things—before you really leave—without seeing me?—! Present my best compliments to the ladies and beg them to spare you to me for half an hour—if it be possible. J. McNeill Whistler."

Later Whistler went further and invited Weir to bring his whole family, which by now included two of Julian's sisters, Anne and Carrie, to take tea with him in his studio. When the day came Weir set out with his six ladies in train. To reach the studio we crossed a dismal courtyard, ascended a flight of stairs, and then walked the length of a long passageway which had glass windows along one side and a glass roof overhead, all of which were as thick with dust and dirt as might be expected in a city of smoke and fog like London. Whistler's studio was a large, light room, as I remember it; but unfortunately the only painting that I can recollect is a small one that stood on an easel and may have been *Little Lady Sophie of Soho*; at any rate, it was a portrait of a girl with her hair loose over her shoulders.

Here in the huge studio tea was served, with Whistler's sister-in-law, Miss Birnie Philip, acting as hostess. I remember her as tall and slender in a dress of heavy black material with a long dramatic train that swept the floor. We children were quite aware that we were having an unusual privilege in being entertained by one of the world's great artists—we knew the reverence our father felt for Whistler; but perhaps the strongest impression we carried away was the picture of Whistler reciting to father the wrongs that had been done him, so he thought, by some American art jury. Just what it was all about is not very clear; but very clear is the remembrance of Whistler, small, dapper, and slender, standing in front of my father, who was his complete contrast in size and build, holding him by the lapels of his coat and shaking them back and forth to emphasize his points, as he grew more and more violent in his conversation. Once more there must have been an argument about Chase, Weir again standing up for him, because my last recollection was of our walking down the long passage, with its unwashed, gray windows and Whistler standing at the far end behind us, calling out as a last fling: "Weir, Weir, you tell Chase that what I have to say to him cannot be said before ladies."

By October Weir was back in Branchville and he confessed to an old friend that "no one was more happy to return to a place than I was to America. Europe palls on me. For some there is no place like home." He

celebrated his fiftieth birthday the next summer, and he became more and more reluctant to leave his own woods and streams and the leisurely pace of work amidst family and friends.

Especially pleasant during these long summers were visits from his friends, most of them painters who shared the joys of good food and drink after a day of sport or sketching. Twachtman and Hassam were regular visitors, and Edmund Tarbell was delighted with a visit to the country of Weir's paintings. William Gedney Bunce, a close friend of Weir's student days, returned from Europe to settle not far away, and Frederic Remington and Frank Millet often found time to join Weir on his tramps.

When Sargent returned to America in the spring of 1903, he went up with Weir to Branchville for a few days of camping out, joined by Millet and a talented young English artist, Wilfred Von Glehn. Von Glehn proved so congenial that he returned for a real visit that summer, to everyone's delight and especially the children's, who watched him sliding off the "wicked" donkey's back. After he left, Von Glehn wrote appreciatively from the Adirondacks (August 3, 1903):

I write you—as from a different country, so great is the change here after the quiet, peaceful and pastoral Branchville—that will always represent for me, when I return to England—the peace loving "intime" America and very dear to think of— I'm glad to come back to you and am looking forward to it . . .

I can't tell you how I enjoyed those good days with you all—the fields—the woods—the fishing—silent hours, the peaceful times at night looking up into the stars . . .

The next winter Weir had several bronze casts made of the bust that Olin Warner had made of him, and one of these he sent over to England to Sargent as a present. Characteristically, he did not accompany it with a letter and so called forth the following from Sargent:

31 Tite Street, Chelsea, S.W.
February 16, [1904]

My dear Weir:

There was a surprise today when, on unpacking a case that I thought contained something quite different I saw your features appear—your bronze bust by Warner— I haven't had any notice of it so I am puzzled for I don't dare to expect it is for me—much as I should like to take possession of it . . . meanwhile it looks very much at home in my studio and I very much like having your mug to look at and will be sorry if it is on its way somewhere else—let me know.

I often think of that last day and night of mine when you carried us out

of the heat of New York to your dear country house—Frank Millet, Von Glehn, and me . . .

Kindest remembrances to Mrs. Weir and the children.

Yours ever,

John S. Sargent

Another close and dear friend of these years was the painter J. Appleton Brown, one of the kindest, most big-hearted men that ever lived. A dyed-in-the-wool Yankee from Newburyport, he suggested Lincoln in his long, rangy American build—a gentle Lincoln, with something touching in his genial smile and quiet ways. Childless himself, he was blessed with a childlike heart that drew all children toward him. We sensed his character on his very first visit and were quick to adopt him as our own particular guest, monopolizing him accordingly; but his adult friends, too, were legion. He was truly one of the pure in heart, with a warm humanity that made all men love him, and with a wit and a way of telling a story that were inimitable.

In Weir, Brown found a deeply understanding friend. The two men shared an almost pantheistic feeling for the world of nature, and Brown's letters glow with warmth. "You are the only one I somehow can pour out my soul to," he wrote. "Is there anything in this wide world that is comparable to a sympathetic friend . . . We seem to like the same things and without that sympathetic feeling, it's of no use going on." After a Branchville fishing trip Brown wrote that he wished "sometimes I could be like Thoreau, caring so little for the world that I could be content alone for days in the woods. I have that wish about two seconds and I come back to my poor self and forthwith congratulate myself that I demand a congenial companion that's true happiness. The sort of days I have had with you in your wood down that stream . . ."

Brown admired Weir's paintings tremendously, paying them the ultimate compliment: "nature looks so like your pictures." Weir, in turn, gave Brown the encouragement he needed. "I really think I am painting better," wrote Brown, "and I hope to accomplish something; if I do it will be largely due to you, for I cannot forget how I was set up by what you said to me. I say to myself I wonder if Weir will like that."

In one of his letters one catches a glimpse of a humility truly touching. He was feeling discouraged over his own painting, from the very human reaction to having thought things were going too well: "I don't quite understand how I should have been so elated over them—I do see how when I stop to think; it was the incomparable loveliness of those

spring days—everything was beautiful and hope unquenchable, now I am sobered off."

During the summer of 1899 Brown and John Weir were both in Branchville at the same time, and the three men, with their many mutual interests and their common profession to draw them still closer, enjoyed one of those short, golden interludes that occur all too seldom in life. Brown's death soon after was to sharpen the memory of it unforgettably. Writing to Julian, Brown recalled in particular one talk with John that, he asserted, would "live long in my mind and to my own good—it was when you were fishing in your boat and we sat on the bank— What a helpful thing it is to be such a man—one with so high a purpose, so natural, so simple and who rings so true, and with all what a keen sense of humor . . . I like to think over those evenings on your piazza . . . Oh, but it is all fine and everything is wonderful— The days aren't long enough and the nights are as beautiful as the days—if a man isn't made better by it all he is a hopeless thing . . ."

Appleton Brown died suddenly in the winter of 1902. Weir arranged a memorial exhibition of Brown's pictures at the Century Club and in Boston; he raised a substantial fund to help Brown's widow. But a rare and kindred spirit was gone. John Weir must have come close to Julian's feelings when he wrote from Italy to add his own sad reflections on Brown's death:

He is one of the few whom I looked forward to seeing more of on our return, and always with happy thoughts. That last meeting, when we were at Branchville together, and we sat out on your porch talking and laughing at his humorous tales—it all comes to my mind, and with his delightful manner and open heart . . . Somehow my thoughts have been with you a great deal since hearing of his death—knowing how you loved him . . . Dear Brown, what a sunny nature was his . . . what a loss he must be to you—as with my comparatively slight acquaintance he is to me. To think we shall not hear that voice or see that smile; those yarns and witty sayings, and his admiration of you . . . I imagine you as now looking toward Branchville, with the spring blossoms and their joy. Dear old Brown, *his* blossoms will now ripen into golden fruit— "Apple-Blossom Brown" they called him in Boston. It must have been a happy task for you to arrange his things at the Century, and no doubt he was beside you while you did this, and with his dear old smile . . .

That same year, in August, John Twachtman died. He was one of Weir's oldest and closest friends, a real source of strength through the early experimental years and on into the mature work of The Ten.

Twachtman had felt keenly the lack of appreciation of his own painting, and he died without the reassurance that the next years would surely have brought. Weir set about arranging an exhibition and sale of his friend's work, and there was some consolation in the enthusiasm shown in the galleries and at the auction, where ninety-eight of Twachtman's canvases brought in a total of $16,610.

Through all these years John Weir remained close to his younger brother. A common love for Branchville and for art kept them happily together. John could never stop exhorting Julian, as he always had, but his encouragement stemmed from a firm admiration. John traveled through Europe in the summer of 1902, viewing the galleries from a historical point of view that the Weirs never lost. Florence, after thirty years, was still "the same old fascinating dream that I remember, but some things speak louder now and mean more." The contemporary art of Paris, on the other hand, meant less. And on May 6 he wrote Julian of the "general scream" of the Salon:

I have been all the morning at the Salon. It makes one shiver after the winnowed wheat we saw in Italy. I was there also last Sunday afternoon till my legs almost sank from under me. Here and there a fine thing—mostly in landscape. The portraits pretty bad—good old master Gérôme has one arena picture—a ghost of his former work. No great light, no master *par excellence*, a few quiet modest things in a wilderness of debaucheries. The old group of real masters have gone by. Still there are some fine landscapes and of course all kinds of technical masteries, and, I may add, *mysteries*. I am something of an old fogy, and relish things not too fresh perhaps. As a whole the exhibition produces a melancholy effect—perhaps this must always be the case with such an immense affair containing only the year's work. Quiet things are lost in the general scream. I am reminded, per contrast, of those evenings when you were "pulling a proof" of a newly etched plate in the corner of your back room—that seemed to me the genuine inspiration of art, and not this banner-flying, crowd-chattering crush of an opening Salon. Still I mean to get in as close as I can and be openminded."

What John Weir missed were the calm joys of Connecticut. "I look forward to hearing of your going to Branchville and all that that implies," he wrote to Julian. "Don't get too much involved in *affairs*—keep the paints and make that business the conspicuous first. I fancy you coming along the road with a six foot canvas over your back and the old fresh glow of enthusiasm over a good day's work. . . . No glories here equal—or quite equal the glory of a fine day at Branchville when we

have come in for a fine dinner after a good day's work: that marks the high watermark of joy and happiness. Goodbye, old boy—I again look out of the window to waft a zephyr toward you. . . ."

Next to John and his comrade Twachtman, Weir's closest friend as the years went on was C. E. S. Wood, a West Pointer who had turned up in New York in the winter of 1897 to renew their close ties of fifteen years earlier as easily as if they had never been parted. From this time on, even though separated for years at a time by the whole breadth of the American continent—for Wood had left the army and settled as a lawyer in Portland, Oregon—there was never another lapse in their friendship. They kept in touch through correspondence, and by a lucky chance most of the letters on both sides were saved; these give abundant side lights on both their lives. The two men were perhaps drawn closer together because of a similarity in their unusually warm and generous natures; each was forever trying to think of different ways in which he could help his friends. With Wood, this took the form of trying to kindle an enthusiasm for art in his friends and acquaintances out on the Pacific slope. The four Eastern artists who became his particular friends were Weir, Ryder, Warner, and Hassam—the three latter quite likely met through Weir—and he was always trying to find ways of selling their works for them, on the novel theory that the buyers of the pictures would benefit even more than the artists. He almost always returned from the East with pictures, hoping to find purchasers for them; and as often as not he ended by buying one himself. In return, Weir would insist that he take some other one as a present; and so it went, each one trying unselfishly to outdo the other. Wood's keen interest in art makes their correspondence unusually valuable, for Weir was apt to send him a report of all his successes—and failures; and news, as well, of their mutual friend Albert Pinkham Ryder.

A letter from Wood in July 1898 shows him already well embarked on his role of understanding art patron. He had taken with him, when he returned to Portland the previous spring, a group of Weir's pictures, hoping to dispose of them for him; and now he enclosed a check for $50,

the price of your smallest pastel, a little square of sunny slope with tree stems in foreground. I hope to find purchasers for all you have out here, rather than send them back. . . . I have grown very fond of your pictures. You remember I . . . ed you for your new departure, and I do think you were not so sane as now,—in the rabbit trap snow landscape and the other little snow scene the feeling and technique are marvellous. I let Mrs. Corbett have the

small snow scene for just the amount of my loan to you—which is I hope, satisfactory—it was the best I could do. Times have been very hard in the West, and of course, chromos and cheap literalisms appeal to the most of western folk who naturally are very primitive. I myself am very fond of the old barn and green hillside, and hope if any of us prosper this summer to keep all the pictures here. I am so fond of your flower piece that I have, that I would like to see your treatment of flowers today. Do you ever do it? I'd like to buy a small oil if you have one you approve of some time. . . .

On January 4, 1899, Weir wrote to Wood:

. . . I am much interested in some pictures which I have under way and having given up teaching I am a ten times more enthusiastic painter. The old sensation of the delight of painting makes me feel as if I have been born anew.

I met last week at the Century Club François Millet, the son of Jean François Millet, the peasant painter and if not the greatest painter of the century is so in my mind. He said that his father before he died said to him to paint landscape as all great painters had been landscape men at one time or another. It seems to me that a great lover of one truth cannot but feel that wonderful something that the landscape in nature suggests, somewhat like the soul of a human being. . . .

In May Wood wrote that he would like "ere the season be too late, to suggest a still life; embracing as one part of the composition—apple blossoms. I believe I could dispose of it for you. There is no such certainty as amounts to a commission, but I believe I could." And he tried in vain to persuade Weir to come out to Portland, telling him how cheaply he could manage the trip and adding: "I should hope, with you on the spot to get you one or two portrait commissions . . . I may be able to get the commissions in advance."

As for "Pinky" Ryder, he was going to write him. "Awfully sorry for the poor old fellow. He ought to have been a monk in a fifteenth century monastery— To live fat and unwashed and paint to his heart's content."

Apparently a casual mention of Weir's to Wood that it had not been financially a very good winter was all that Wood needed, when he came East that June, to start him off trying to improve matters. He had been charmed with *The Green Bodice,* so much so that Weir had offered it to him at a nominal sum; but Wood refused to accept any such sacrifice, and characteristically wrote that he would "take much greater pleasure in seeing it go to another at an adequate price but which I cannot pay, rather than to steal from you a valuable thing for an inadequate price."

He then proceeded to try to sell the picture for Weir, and the numerous letters that cover the negotiations show how little Wood counted the time and energy he threw into this labor of love.

He eventually did succeed in selling the picture to E. F. Milliken who, as he wrote, was "very amenable to intelligent explanations (and I pride myself on my intelligence). Milliken's principal objection had been that the model wore a feather boa about her neck: "feather boas were out of style now nearly three years, and the costume would soon be antiquated."

When the sale was consummated, the whole proceeding was complicated by the fact that Inglis[4] considered that Milliken was his client and was not satisfied with the transaction. Wood did not agree at all with this, as he told Weir frankly that he had "no doubt in the world that the girl would never have been sold but for me." But he assured him that Inglis "has only three living Americans he recommends, and he does intelligently and forcibly speak of them—Weir, Ryder and Bunce . . . Inglis with all his selfishness is sincerely your friend in art. He says he would like to be in person but never can get near you." The matter was finally closed by Inglis receiving a commission, and everyone was satisfied.

Weir was greatly touched by Wood's labors on his behalf; as he told him, he could never forget or repay such kindness. When in return he sent a picture that Wood had once chosen himself, *The Rainy Day*, Wood, delighted, wrote that he "was enjoying it here in my office, where I shall keep it, I think. Why shouldn't a man have some joyousness around him in his office? I shall hang opposite to it that other of yours which I have and which I now recognize—the old barn. Maybe its public exhibition in my office will help sell it, but it is very hard to sell such unconventional and imaginative work here; most of the people want the photographic and pretty. . . ."

On the portrait of his son Erskine, Wood reported:

I do not believe I would have recognized that you had altered Erskine's background if you had not said so. I think it a fine portrait—good likeness, good character, good drawing and color. Mrs. Wood is *delighted* with it. Her criticism is that it is Erskine two years younger . . . —but the fact is, in this period of his life he has changed more in the last six months than he did in the last two years. . . . Curious, your remark about his knightly

[4] An art dealer and friend of Weir. See p. 158, n. 5.

qualities, and you had taken the sweater as modern armor. Everyone sooner or later drops the remark: "He is like a young knight." . . .

Erskine is tickled to death over the *Dogs*,[5]—brags to everyone they are his . . . Darn it, it makes me ashamed to receive so much from you that is of *great* market value as I see it. I wish you'd seriously consider this portrait trip. . . . You would stay with us as to bed and board of course. . . . Wish I could see the donkey picture. Don't let the faces get *flat* even if they are out of doors—I notice that is the effect of so much of the out door portraiture to *my* eyes—a flat disk with holes in it. . . .

And a few days later he wrote again:

I cannot tell you how happy I feel in the thought that in even a partial way I have helped to throw off that incubus of debt and money worry. Isn't it *Hell?* I don't see how a man can do free unrestrained work with that on him. . . . I am sure old Pinky is working hard, people don't understand that it means days and days of incubation, and struggle, and brain rest, with him, to a small visible result. I think it is too bad he is badgered about his loafing, and yet I am afraid in a jocular way I join the rest in teasing him. Those sort of things are catching. . . .

In September 1900 Julian's mother died. Her family were not unprepared for the blow, for she had been in failing health for a number of years. Death could only be reckoned a release for her. But in the end death always comes as a sad surprise; another link has been broken with the past—and with the death of a parent there comes the added realization that the children themselves have stepped into the vanguard.

In November, on Thanksgiving Day, Wood wrote that he too had been having a difficult time:

to make a long story short, I have been going through "liquidation," which seems a more polite word than bankruptcy. . . . You'll be glad to know that in this shipwreck the planks I cling to last are my Weirs and Ryders —whether it is friendship biases me or not, I don't know, but I get more comfort and sweetness out of these pictures than those few I have, by— shall I say more famous men? Courbet, Monticelli, etc. Your flower picture I seem to cling to passionately, to the last. If it goes, you certainly must do me another when I get on my feet again, as I shall, if I live. . . . We often say we'd like to have you out here and hear you say "By Jove, these little oysters are *fine*."

Wood was east again that winter; and while he was in New York Weir painted two portraits of him. In the smaller one, only 13¼" x 10¾" in size, Wood is seated, facing front, with his hands clasped over

[5] Another picture Weir had sent as a present.

the back of a red velvet chair. He wears a light gray suit, a white waist-
coat with coral buttons and a coral-colored tie. The picture is dated
1901. It is a lovely, alive portrait. After he had returned home, Wood
wrote Weir that they were "all delighted with the little sketch portrait.
I am particular to mention Inglis because of other adverse criticism,
and his remarks showed he knew what he was talking about. He thinks
the *'living'* quality of the whole thing fine, flesh—pose—style and ex-
ecution *'masterly.'* I wish you could have seen the *frame,* beautiful . . .
ebony—broad in beautiful curves and lines, but very simple—and a tiny
hand-carved inner edge in dull gold. It made the picture *hum.* . . ."

From Washington, D.C., Wood wrote on May 2, 1902:

. . . You are such a super-sensitive cuss that I never know where you are
at. I hope you don't think I'm not pleased with Nan's portrait.[6] I love it and
it is she—and you know it. I only suggested this other because I saw her in
this costume, black ostrich hat and red cloak, and it seemed such a stunning
effect. I wish you weren't so darned imaginative, you keep a fellow guessing
whether you are hurt. . . .

Did I tell you I gave Jongers[7] a couple of sittings to change and correct.
He is a nice sort of fellow, frank and modest and simple, but I'll tell you
honestly, you ought to feel very thankful instead of timid about yourself,
for the Lord gave you a delicate insight, and a power of refined expression
denied *all* those other men. As for myself, I'd rather *be* the man you have
painted a thousand times more than the other . . .

Again in May he wrote that passing through Baltimore he

ran into Will Councilman, an old schoolmate—now professor of pathology
at Harvard, and he said: "Well—well—Erskine, I walked into the St. Botolph
Club the other day and ran right square into you standing there as big as life
and twice as natural. That's a magnificent portrait—Who did it?" I told him
and he said: "Well, it's the best portrait I ever saw, for it has some character to
it, and is a perfect likeness." So you see how fresh eyes view it, and he has
known me since we were boys together. . . . Well, old man, have a good
time. Loaf and fish and lay up grey matter to turn into works of art. I've
come to the conclusion, after mature deliberation, that you are the boss—
and don't forget if I sell the grant, I'll invest in some Weirs . . .

After Wood had returned to Portland he wrote:

Poor Jonger's picture of me has come and I simply *cannot* let it exist.
I was foolish to sit. I surely am not that weak theatrical creature, and if I
am, then I will not perpetuate it. I want to be known hereafter by your

[6] Wood's daughter, Mrs. David Honeyman.
[7] Alphonse Jongers, portrait painter. Born in France in 1872 of Dutch parents and trained at the
Beaux-Arts in Paris, he came to America in 1897.

portrait, and am determined to destroy this. It is not fair of course, in one way, and yet in another it is, because, after all it is my right to decide. He is a clever little fellow, but all on the surface. I do not flatter, Weir, but speak from the heart. In spite of your own laments over likeness, you are the only man for whose portraits I really care. . . .

In September Weir wrote Wood that he had been to the city and had seen "old Ryder, just exactly the same and so were all his pictures. Yet he could not come up and see us as he was just going to finish [the picture] and so I wish he could, poor old fellow." By the end of October, however, Ryder finally managed to find time for a visit; and with his old friend once under his own roof, Weir embarked on a portrait (Fig. 22) that must have been a source of great satisfaction to them both. It is a small bust portrait—24″ x 20″—painted full face, with the left hand hooked through the armhole of the vest. The likeness was speaking, and the whole picture gives Ryder's character in essence, with his tawny beard and hair, slightly thinning now over his high forehead, and his mild expression of gentle kindliness shining through his face. It is one of Weir's great portraits. It is now owned by the National Academy of Design.

On November 7, after his return to town, Ryder wrote enclosing a letter from Wood as well as four of his own visiting cards, each separately inscribed to a member of Weir's family. Wood's letter is characteristic of his endeavors to help his old friend out of the difficulties of everyday existence and leave him free to paint in peace.

MY DEAR PINKHAM:
 You deserve a scolding, the wise have long ago known man is a machine. He can do so much work no more—when his limit is reached he must rest. He can use that strength and time in painting, digging, washing, cooking but he can't do all. Mrs. Corbett would gladly save you from cooking or washing to get the *Lorelei*—I would to get the *Tempest* and the *Moonlight,* there are others. Why don't you be sensible and frank and apply to your debtors for cook money and wash money as you need it and go on painting. You are foolish and unkind. We want our pictures and we want you to live long in the land. I hope you will see things rightly and sin no more. I enclose $50. and am too cross with you to write more . . . Weir is an old neer do weel—I haven't had but one letter from him in a year. What's he painting? Give him my love tho' he don't deserve it. Try and Reform. . . .
 Wood

The enclosed visiting cards had each a special message:
"A merry first of November to Mrs. Weir from Mr. Albert P. Ryder."
"Hope you had a merry Halloween, Miss Caro."

"I hope Branchville will have a snow storm whenever you wish so Miss Dorothy."

"I hope you did not get wet last Thursday going home very kind of you to go to train. I hope the apple lovers were all bobbing for them last night Miss Cora."

Another letter from Ryder followed the next day.

308 W. 15TH ST., NOVEMBER 8, 1902

MY DEAR JULIAN:

A brief note to show my appreciation of my pleasant visit to your farm, and to thank Mrs. Weir and yourself for your kind efforts to make my stay agreeable and the pleasure it was to see and the beauty in thinking of, the lovely affection of your children to yourselves and to each other.

I hope your impulse is still strong; for your work so near a happy completion: it pained me to think you must stop and be bothered about getting me to the train: as it was not necessary.

Have written Mr. Wood of your summer's work, quite a catalogue, and your masterly portrait; and the wonderful truth, and last but not least, the rapid execution of it.

Please find P.O. order for ten dollars your kind and timely loan. If agreeable to you to fee the maids of your household for me will reimburse you almost had N.P.[8] over it. . . .

Was up to the haberdashers to find what you paid for sundries, but could not find out. Do let me know . . .

Let me be a stimulus to you with my good wishes: it often goes a long way in making stimulus: and the fine weather now, a sort of combination: propitious skies, and good wishes.

Please do not think of your health, my bane, you are in splendid trim.

With a doff of the hat to Mrs. Weir, Caro, Dorothy and Cora, and a ranch of affection for yourself and all that good wishing can imply for you all.

Affec. Ryder.

Wood wrote to Weir November 10, 1902:

From a correspondent who is as notoriously unreliable as yourself I suppose one must feel gratified to receive a letter semi-annually. Jack and Lou Pitcher[9] were at dinner at my house the other night . . . The boys, (greyheaded) admired your paintings on my walls, and Lou said, "I tell you that fellow is a genius—Why his pictures sell for the most enormous prices, and he is kept busy all the time." I wish the last were as true as the first, but when did ever a genius reap in its own day?

I still insist you are the most fortunate man I know. Enough to keep the

[8] Nervous Prostration.
[9] Friends of both men from West Point days.

wolf from the door, a clear conscience to keep ghosts from the window. Loving and lovely children, a sympathetic wife and an occupation which is always coaxing you, not driving you. Could millions give you much more— A few Rembrandts and old chests and rugs, perhaps, but after all they are not essential. You see how glibly I can moralize away from the bric-a-brac shops. A letter from that sweet minded philosopher Bishop Ryder came today, telling of things which make my mouth water. A portrait of himself—"A lovely bit of painting," two "fine large" landscapes—etc. etc. I'd like to be there to see.

Once again Wood was trying to make a sale for Weir; but it was difficult, for the prospective recipient was an elderly lady who "is somewhat conventional in her feeling for art, and looks at the subject as of great importance; or rather as I should put it, masterly painting of a common or disagreeable subject would not attract her. . . . Mrs. Corbett also wants to know at what price you'll sell her *The Open Book* (Fig. 13), she to pay you in installments. . . . I shall write Mrs. Weir to put pen in your hand and sit you before paper, so we may have a prompt reply. . . ."

Weir *did* for once take his pen in hand, only a little belatedly, delayed perhaps by the portrait or by the hunting season, and on November 30 he wrote from Branchville:

I am indebted for two letters to you when it ought to be the reverse. I am at present struggling with a portrait which is coming on finely. . . . Oh, how I wished for you again this fall to enjoy birds. We have had partridges or quail for supper every night since Nov. 1st and still there hang seasoning eight partridges and one quail. Today is the last of the shooting for this year. I have a good dog and have had plenty of fun after the day's work generally stopping at 3:30 P.M. and taking the dog and gun till dark. . . .

In regard to your letter about a picture I hardly know what to say. I have two canvases in the city 20 by 24 one of an oak in sunlight and the other a lane with old fences and a fine sky, but I fear this would be hardly enough of a subject as you suggest. If Mrs. Corbett wants *The Open Book*, she can have it for two thousand. I have asked three for it and think it worth it. However, that's me. . . .

I have not produced as much as you have been led to believe, but I think that the canvases I have have a more consistent truth. I have not changed in any way not even in the subjects chosen but it is my hope and desire to get close to Nature, to know her character more intimately, but I will be old, old, old before I can do even the little I do without her assistance. I hope to accomplish much this winter. I am in good shape after all my walks and climbing stone walls, and how many beautiful things I have seen in these tramps. . . . I wish I could use a fairy wand and make you a neighbor when we could be together in the fine hunts when I try to bag nature even more than game. . . .

Wood telegraphed Mrs. Corbett's purchase of *The Open Book* at two thousand dollars and wrote:

I wish you'd do something of yourself for me. You don't understand living alone, as I practically do out here—what a comfort it is to see good portraits of men who have been my lifelong friends. Photographs give you *nothing* as art does. Erskine's portrait every day of my life is the greatest consolation to me. You cannot understand it, living among your own as you do—and it's a fine portrait, Weir. People who abused it when it first came, now see what a *real* portrait it is. So it will be with Mrs. Corbett's. Jonger's portrait of me, they say, looks like me. That is a *popular* portrait. It makes me *sick,* and I have sent it into the attic; and after a while if no accident happens, I'll destroy it. I won't be handed down so—while I have yours—or I wouldn't anyway. I like to think and I do think I am what you have seen, not this. I see now, how wise it is not to be too easy going in sitting for your portrait to anyone who asks. It is a *crime* you don't do yourself large, for your family and for the history of American Art; but you can practice on a little one for me....

The next summer Weir lost another good friend, a fine painter, Alfred Q. Collins. Childe Hassam wrote Weir from the Isles of Shoals, August 12, 1903:

Your letter found me up here. I had only heard of Collins' death a few days before—on my way up in fact. I was very much surprised and sorry to hear it. I saw him for a moment just before I left town. He was a sincere worker and a fine fellow ...

The summer is moving on apace—with long leaps in fact. I am working and swimming every day in the clean ocean and thereby acquiring some merit—by swimming any way.

I felt pretty blue here for the first few days, the place is filled with ghosts (the first time I met Collins was right here) and a good many of the people I know can just hobble about. I was very young when I came here first.

I am reading Emerson, Carlyle and Maeterlinck. If you haven't read *The Life of the Bee* by Maeterlinck get it and read it. It is astonishing. I also have read again with the greatest pleasure Whistler's *Ten O'Clock.* I had not read it for ten years. How true it is! and it is reassuring too! ...

Weir sent word to Wood on August 15:

I received your welcome letter and also the salmon which arrived in fine shape. I immediately wrote to Ryder to come up and help enjoy it, but alas said that I was going away on the 20th. which balked him and he replied that he was just recovering from the fatigue of last winter and must apply himself to the picture belonging to the electrical doctor, who would return next month from Europe and would expect to find it finished. He spoke

of nightly walks to Hackensack,—incorrigible. He will certainly some day join the tramp brigade. . . .

My dear old friend Collins died this summer of Bright's disease. He was only sick two weeks. I went to the funeral in Cambridge some three weeks ago. I had a great respect for his attitude towards art and a great love for him; in fact I saw more of him and Ryder than any other artists and learned much from him. He is a great loss to me. His body was incinerated which seems to me harsh and cruel, but it was his wish. So it goes, we part but I have a strong faith we shall all meet again.

Last week while we were at dinner it got suddenly dark and I remarked that the heavens looked as if they did not know whether to laugh or cry when bang, a flash and a crash and rushing out found our house had been struck by lightning. It tore out one of the pillars of the porch and ripped the plaster off the wall of Caro's room and the servants' bedroom, tore up the pavement and split the big maple tree. We think there must have been two bolts. Fortunately no one was hurt and the house was not set on fire. Paul[1] says: "it is a good thing that it was a cold bolt" or else our house would have been burned.

Ryder's visit to Weir that summer was undertaken with habitual hesitation.

308 W. 15TH ST., AUGUST 8, 1903

MY DEAR JULIAN:

It is very gentle and kind of Mrs. Weir and yourself to remember me with an invitation to Branchville.

You mustn't think I am indifferent to it; but I hardly feel as if I could leave now.

I lost most of June through reaction from the winter and July from my eyes and now I must press on with the work, and hardest yet, fight myself into a working condition; Dr. Sanden has already made his appearance, and is off for Paris Tuesday, and I must do all I can in his month's absence: his work is all paid for; and it is up to me as they say to do the work. Fortunately I am fairly vigorous and when I really pull myself together, I should be able to do quite a lot. . . .

If you let me know the day you are coming in, I will meet you at the train, and yet do not think you must as I can realize how hard it is to write; perhaps I will see you often in the winter as the 10th. St. Bld. is near . . .

An affectionate Adieu,

Ryder—

Cool weather; good for walk to Hackensack, Albany and Troy, Syracuse and Athens . . .

Weir renewed his invitation—to Windham this time—but it was

[1] Paul Remy was Weir's caretaker at Branchville.

difficult for Ryder to pull himself together to make the necessary plans; and he replied (September 23):

I will just acknowledge your letter now and write Friday again; as I am a bit bewildered as to say just the day I could leave now.

My laundry is out; but it is doubtful if I can get it before Saturday night.

I tried to write you last night, but my eyes became inflamed and I had to stop.

Perhaps it is fairer to let you name another day or perhaps as I cannot leave Saturday you would have arrangements at Windham wherein it would be inconvenient to have me. You mustn't think I would have any feeling if you should have to change your mind.

I will take this up to G. C. Station in hopes it may find a train to Windham and you would get it in the morning.

I am very pleased to hear your good news of the Woods; and equally sorry to know that you have been miserable; I hope you are yourself again.

Many thanks for your enclosed remembrance, I hope it will be only for a little while. There must be something doing at 308 W. 15th St. before a great while; meanwhile I shall not allow myself to worry too much.

Perhaps it is just as well to philosophize together;—I think I do not indulge myself sufficiently in work more suited to my moods. I know I sometimes lose a whole day trying to get to work on a picture that I think I should be doing; when I might have struck out another canvas or carried some other one along; I think I shall have to do that.

Kindest regards to Mrs. Weir and Caro and Dorothy and Cora and yourself.

Of course your kind care is very comforting; and melts the hard spots of the heart; I regret our relations are so one sided; and that I haven't even brightness as a palliating virtue.

As I am, I am

Yours affect.

Albert P. Ryder

SEPTEMBER 24, 1903

MY DEAR JULIAN:

. . . If I do not hear from you to the contrary I will leave Tuesday morning; the train you mentioned. That will give you time to answer if it interferes with your plans in any way. Do not hesitate to say if for any reason it is not convenient to have me. I know it is hard to plan for a certain person on a certain day and that a change makes a change all around.

Meantime I can give my moths a little fresh cloroform; and hunt up my things I can't find et-cet-era.

Meantime God keep you and yours.

And with an "Au-Revoir" I am yours as ever

Albert P. Ryder.

The train Weir had mentioned was a through train that left New York at 8:15 A.M., a painfully early hour for a night owl like Ryder. To make sure of catching it he decided to sit up all the previous night. The effort was too much for him: an hour or two before he was to leave he fell asleep, of course missed the train, and had to come the following day.

Ryder was completely done in by this harrowing experience. I remember our childish amazement and amusement when we noticed that he did not help himself to some dish that was passed him, and discovered that he had fallen asleep sitting upright at the table.

Wood's letters of that summer and fall are full of the subject of pictures. In August he wrote that he wished that "I had written as I intended, on the first burst of enthusiasm on opening the pictures." He wanted to know why Weir didn't paint more ideal pictures. "I want to say that now, my dear Weir, emphatically. I appreciate, I hope, as much as anyone, the beauty of nature and, in one sense, all representations of nature are ideal—all art is ideal, but the very inmost soul keeps coming back to a picture like *The Open Book* (Fig. 13) with that same delight the old Greeks must have felt in their tales of dryads, nymphs and the whole attendant train of the god Pan. It is something higher and sweeter and better than we ever do actually see in this world."

In October Wood urged a visit. "I wish to goodness you were not such an old homebody—a regular *tree,* you're so hard to move. I want you to come out here—I can't go East this winter, I *dare* not. It always lands me too far in the hole. I can get passes and commissions if only you will come out. But talk of Pinkey, he is a *Nomad* compared to you . . . I go to Mrs. Corbett's and sit before *The Open Book* like a worshipper—Why don't you do another ideal. You *surely* ought."

In February of 1904 Weir wrote back that he had read Wood's letters to Ryder,

who by the way is feeling in good health again. He attributes it all to wearing no stockings and sleeping on the floor rolled up in rags. He could not work last week as he had so much mending to do. They ought to be grabbed and burnt, but he has tender affection for holey and torn garments which he thinks ventilate his body better. . . . I went on to Boston to see the Whistler exhibition and was very much impressed. I think him a master of the first rank. I was talking to Pinkey about him who seemed very much inclined to patronize him. I think it is simply that he does not know his work. One eccentric man never likes another. . . . I have given orders to have the studio built at Windham and hope to accomplish a lot of work this summer. . . .

Old Hassam has been off on a bat for three weeks but is all right again. The decoration for you is going on fine.

Wood, writing of Hassam on May 23, inquired if Weir had ever seen such a cuss? Whirled in and painted me a whole wall for my studio, and they tell me it is beautiful. I am anxious to see it. It grew out of a remark of mine that I was tired of my bric-a-brac house, like a dealer's shop, and wanted to get back to Greek simplicity,—the whole room done as an intentional whole by one man—and I suggested him for my study, you for my dining room, and Pinkey for the hall, as the largest of all— Dear old Pinkey, I am hit as with a stone over your news. I shall not shake it off. I do not like signs of decay in so lovable a nature. Dear, dear old Pinkey. . . .

Decay, however, was too strong a word to describe Ryder's physical condition; it was rather merely the natural growth of his unconventional habits, which had intensified themselves with the years. His innate serenity remained despite occasional rheumatism, and his letters to Julian that summer had a pleasant georgic note.

<div style="text-align: right;">308 W. 15TH ST., AUGUST 14, 1904</div>

MY DEAR JULIAN:

I scratch you a few lines to cover the letter of your request,[2] and now answer your kind letter, or give you a line of remembrance.

I was just thinking of writing you when your letter came; I had not realized it was so long since you were here. . . .

I think you will get, have or enjoy some good weather now, and Windham must be looking like the green pastures of the Psalms; so the rain leaves a fresh color and charms the eye and the senses and we rejoice that it has been.

I was on the roof for an hour today: I can't tell yet whether like the tin I will have rust in my joints from it tomorrow, half feel as I might.

Have you all tried to call Mr. Dooley[3] to your side; try that when the weather tends to the vapors and persist till you are glad to give up.

Thank Lou for his sympathy; and I hope he may never have the poor man's gout.

Tell Carlsen I shall expect something up to his landscape in the Society exhibition, made in Windham, next spring.

You will be doing something right along now.

My best wishes and regards to Mrs. Weir, Caro, Dorothy, Cora and yourself.

<div style="text-align: right;">Affec. Yours,
A. P. Ryder</div>

[2] Here Ryder makes a lot of scratches.
[3] Pseudonym of Finley Peter Dunne (1867–1936), humorist and journalist.

308 W. 15TH ST., SEPTEMBER 22, 1904

MY DEAR JULIAN:

Received your kind letter and note, and get out my "Royal Coach" to answer.

There is a question apparently at the end of the note that I can't make out although I have just reread it again, probably means why didn't you tell me when you could come?—as an Irishman would say you can guess eggs if you see shells. Tell that to Paul.

Dr. Sanden is due the first, and I shall have to be here till he arrives anyway.

I think you had better give up my visit this year; although I am very grateful to you for your kind interest. I am getting stronger gradually; but my legs are quite weak yet: who would think one's limbs had so much to do with painting? . . .

Wood says "I have been wanting to write to you and to Weir for a long time, but have found it simply impossible to get the time. Hassam has been here for about six weeks and is still with us. He has been to the sea coast and painted really some very beautiful pictures, some of which I think he will sell here. I don't suppose you will see old Weir, you are such a town mouse and he is such a country mouse, but if you do, give him my love and tell him I am going to write."

With kindest regards to Mrs. Weir, Caro, Dorothy and Cora, and with an affectionate greeting to yourself.

That the fish will thrive, and there will be no more 25 lb. turtles. Almost a sea monster, wasn't it.

That your work will answer.

And your farms too, and haystacks grow, and rocks disappear, and everything be as you wish.

Ryder's condition was becoming a source of worry to his old friends. When Wood made another flying visit to the East in October, he made time to drop in on Ryder, although he again missed seeing Weir. From Buffalo Wood wrote Weir (October 10, 1904):

Here again and off again without seeing you. I had a surprise party at Branchville laid away as my particular pleasure—but it could not be done. I did not see my brother or sister even—was in N.Y. but two days and then going night and day. I went straight from the train, you might say, in the early morning to old Pinkey's because I was and am worried about him. He seems to me clearly breaking, but as hopeful and cheery as ever—and ever thoughtful of others. . . . His disciple, Mrs. Fitzpatrick,[4] who lives below him, says she could not care for him through another illness, as it has broken her health. Dear old fellow, I tried to get him into new quarters—out of that junk

[4] On Mrs. Fitzpatrick, see p. 252, n. 5.

and filth—but you might as well try to get a snail out of his shell. I suppose he knows best. He spoke most affectionately of you and Mrs. Weir, and your efforts to get him up there. . . .

I have lots of funny things to tell of Hassam—will only say now that I enjoyed his visit immensely, and he is a gentle, kind fellow, I think—and surely an artist. I told him he was falling heir to all the things I had been planning for you and he says he is going to sit by your fireside as a veritable Marco Polo, and fire you up to like adventures. I hope he does. . . .

Several years earlier Percy Alden had suffered a stroke and had become more or less of a recluse in consequence, but he was one of those people who refuse to be downed; as Weir wrote Wood, "his mind is active and he amuses himself in getting together a library. He has classical and literary tastes so is able to pass much time away." Weir was one whom Percy was always glad to see, as is very evident from his letters. "If you come, as I *trust* you may, tho' I will not urge it, you will not tire me in the least; in fact it will do me good to have your friendly and cheerful companionship." And on another occasion he hoped "it will not be long till you are in town for the winter and I can hear your familiar and cheerful voice again in these rooms, from time to time." In May 1906 Julian wrote Wood that he was going to take Percy down to his country place in Cornwall, Pennsylvania. "I have gone with him every year since he has been paralyzed and I must not disappoint the poor fellow." This was a duty that Julian took on himself from his affection for Percy; each spring and fall he would take the long train trip with him to Cornwall, never allowing any of his own plans—even for fishing—to interfere with the journey.

The summer was filled with painting, but Weir seems to have been rather blue as winter set in, to judge from a letter to Wood (December 16, 1906):

It is a long time since I have had a chat with you and I half expected to see you walk in at any moment with that nonchalant air of just popped in. You are always with us looking down on our morning gathering[5] and if I had only written to you half as often as I had intended, you would have been surfeited with pen scratches. We have been back from the country just one week yesterday, and it was with regret that we had to pick up our tents.

Weir had met a friend of his

looking scornfully at a gigantic building that has just been erected in front of us so that now not a ray of sunshine comes in the house and we will have to think of leaving this spot where for twenty years we have been undisturbed.

[5] A reference to the bust of Wood by Olin Warner.

He remarked that Brooklyn was full of sunshine which I do not doubt but somehow I would much prefer the country plain and simple to a place where such know-alls come from. There are days when it is not conducive to peace to have a man talk to you with an insinuating smile, not but what he may be the best of good fellows. I always feel blue and down about this time of year instead of having that fine spirit that I know is yours and living up to peace and good-will to all. This is the Christmastide when cheerfulness should reign over all Christendom. We realize our blessings when they are in the past but the difficult thing is to live up to the present.

Old Pinky seems to be as near content with his enjoyment of his vapors and new dishes à la Diogenes as any man I know. He does not allow his work to trouble him and always rises superior to his surroundings.

Wood wrote back that he knew of a man who wanted a Weir, and he suggested that his friend send two or three paintings for inspection:

His taste runs to landscapes. I tried to persuade him that all really great painters painted landscape, figures and still life—and he ought to have one of each by you and by Hassam—but that struck him as too much of a wholesale order. To tell you the truth, while he has a certain amount of real appreciation, I think his ambition is to own *a* Monticelli,—*a* Michel,—*a* Weir,—*a* Hassam—and so on—and he'll not buy two of a name till he has filled out his list of names. Funny, isn't it? If you care to send, I suggest two landscapes and one figure. If you can add a still life, so much the better . . .

I cannot leave you without expressing as usual my belief that you are a pig. Years and years have passed and you have not sent me my book-plate nor portrait sketch of yourself. I have reconciled myself to the fact that you've lost that bookplate design . . . Why don't you open the New Year with an honest reform, take an hour off and *do it*.

Writing to Wood the end of May, Weir seemed to be still discouraged:

We have all been in the woebegone state, nothing doing but things piling up. One hardly knows which way to look or what to do. However the sun may still be shining but things look blue black.

Our mutual friend Hassam has been in the greatest of luck and merited success. He sold his apartment studio and has sold more pictures this winter, I think, than ever before and is really on the crest of the wave. So he goes around with a crisp, cheerful air.

Ryder was in last evening. He has had a very appreciative article written on his work in the *Burlington Magazine* and although he is not a great producer, he has the philosophical air of content and I think his health is better than it has been in years and hope he may complete some of his many canvases. . . .

Weir's own work proceeded steadily. His one-man shows of 1907 and 1908 won him increasing reputation and honors. But any recognition

amazed him afresh. It was not that he was overmodest, for he was always quite humanly delighted by praise, but rather that his own standards were high; and unless he felt that inner self-approval that every artist recognizes, the rest was dust and ashes. In the fall of 1909 he wrote to John:

... I wish I could feel tranquil of mind with my work, but I can not seem to satisfy myself and days and nights seem nightmares, so you can see others besides yourself have anything but peaceful daydreams, which I used to think was the life of an artist. However, I keep hoping things may look better later on.

Today the weather has been like spring and I was in all day. I had my dog brought down [from Windham] thinking I would go off for a few miles hunt after the day's work as I used to, but legs and mind seem to differ. . . .

The Weirs had moved into a large duplex apartment at 471 Park Avenue in 1908 and expenses were heavy. With difficulties on the Branchville farm as well, Weir was continually worried over finances. As always Wood worked energetically to help him and wrote encouragement.

SUNDAY-AT-HOME
PORTLAND, OREGON, [AUGUST 3, 1910]

DEAR OLD MR. WEIR:

My delay in answering your Out-of-the-Depths letter has been due to an effort to bring you relief and I have been drumming my acquaintances to "buy a Weir."

I am awfully sorry that your shipment to Ike Fleischner was so bungled, but must say you were neglectful in not notifying me of the fact, or having Montross do so. I had no idea the pictures had been shipped. I spoke to Hassam and told him if you wanted to sell a picture, to send one out; I thought I could sell it, but that I had written and spoken to you several times, and nothing ever came of it, so I supposed you didn't care to send so far on such a hazard. He said "Of course he wants to sell and I'll see that he sends something out." That was my last advice on the subject until your letter; then I rang up Ike Fleischner on the 'phone and to my surprise and disgust found the pictures had been here and returned to Montross. I was mad as the devil and asked the little ass why he hadn't let me know. He said he understood I was not in town. Maybe I was away for a few days, I often am, but he certainly never tried to let me know. I have an office and a house where a message could have been phoned. He said he didn't like to take the risk of keeping the pictures. I pointed out that while the pictures were primarily for his inspection, I wanted to present them to others in case he did not buy. He said "Well, I would have taken the landscape at $1,000. but it was priced

$1,800. and was too high for me." "Well," I replied, "Weir might have fixed that for *me* as a friend. You know pictures are like attorneys' fees, there is no fixed standard. It depends on circumstances. Now" said I, "if you want me to offer Weir $1,000. for the picture, let me know." "Well," said he, "I am going to the beach now in a rush, I'll talk it over with Mrs. F. and let you know." That's the last I've heard from him. But it seems he and his wife are the only ones that saw the pictures and I intended to hang them in the Art Museum. I have been waiting to hear from Ike and have been asking one or two plutocrats to let me have you send out some pictures; but they all decline, saying times look hard ahead and they don't feel like spending money on foolish unnecessary things like pictures. It beats hell, Weir, how *really* poor millionaires can feel . . .

Now what do you think about this. Send me about three pictures—I can hang them in the Art Museum, also in our new Club House—a fine building—and could give 4 or 5 fine and dignified publicity, and almost certain of selling one or two.

Wood's next letter, August 26, is full of his own business affairs, though in it he exclaims sympathetically, "I know, like myself, you have always been hard up," and ends by begging Weir not to be "downhearted. I'll buy a picture . . . unless there is a cataclysm or kittyclasm."

Weir replied gratefully on September 12:

I am too astonished to find your letter unanswered, the reply which I sat down to write on its receipt was never sent. You must think me an ingrat, as the French would say. I received and reluctantly took the check and that night it was all paid out to them who did the most clamoring.

I intended to go to N.Y. and send a picture to you, but the canvases I am working on seemed to me more important and now I wish I had done that the first.

I am simply tied hand and foot and still hope something will happen with the canvases I have out. . . . I wish the farms were deep down in the sea. I can't get a good man and you know what happens when it is all guess. . . .

Again on November 13 Weir wrote Wood from Windham:

We are still in the country as you see. Last week I took four pictures to the city to see how they looked. Dorothy took a Kodak of them which I will enclose. *The Spreading Oak,* the largest canvas, is 40 x 50. I had great times lugging it by wagon some four miles in the dust and heat, but I think it has turned out much to my liking. I showed it to Pinky when I was down and he was much delighted. The poor fellow seems to lack energy but still takes long walks and seems to me better in health. But I should think the fact that he cannot seem to produce would drive me crazy, but with him he has the philosophic spirit and the well-spring of hope.

Hassam I suppose is back by this time although I have not heard from

him. He produces more canvases than any man I know, thirty or forty in a season seem nothing to him. I wish I had that power. I count on six or eight and think I am doing well.

We had a light fall of snow two days ago and last night with the moonlight it was very lovely. I have one moonlight mostly completed, but it is more than difficult to get a suggestion of that most subtle note. My large moonlight of last year goes to the Corcoran Gallery and after that to the Ex. at Rome next year.

We will probably stay here until after Thanksgiving for one reason or another before returning to the city. I have just finished a portrait of the farmer's two boys which I seem to like but have not done any fall work. Am worked out and am trying to get the expenses on the farm reduced and something accomplished. I bounced the head man and have been running the farm myself up to the present, making a check system so as to stop unnecessary expense. Our apartment I fear will swamp us, so much more expensive than I had any idea of. So that we stagger from one end of the year to the other. I have fortunately rented 11 East 12th. . . .

A Christmas letter to Wood sounded a pleasanter note:

This is Xmas Eve. To you and your whole family greetings. What a fast sliding year this has been. How at our age time skids by with so little results. But with you this year the boys all getting married, you must feel a certain satisfaction, for it is certainly the right and normal state. So may they all have full quiver. Children are certainly the joy of this world and the only thing to keep us young.

I hunted up Pinkey yesterday with a substantial Xmas present. You remember the little picture I had of his. He gave it me some twenty years ago and I have had all that enjoyment out of it. So I hied me and found a purchaser for it for the sum of one thousand. I stipulated with him that it was to be used at the rate of twenty-five dollars a month. This will give him three years as he said he spent but fifteen cents a day for food. So this will enable him to do some better and I trust it will keep some of the worry away and he may get back to painting. He swears he will never take another order. Landon he said told him he would be willing to take his picture as it is and I tried to persuade him to let him have it and get interested in some other canvas. I should think it would be a great relief to him knowing how he can so easily lose what he has got. However, he is looking thin but very well, still takes his walks in Hoboken.

We are all going up to New Haven to take Xmas dinner with my brother, John, as this is his last year at Yale having reached the age limit. . . .

Weir was himself approaching sixty, and the series of comprehensive exhibitions which he arranged in 1911 was in a sense the culmination of his career as an artist. The achievement of these shows was all the more striking when seen against a background of failing health. The first of

them was held in January, at the St. Botolph Club in Boston, and from there was sent on to the Century Association in New York, while the largest and most important of the shows was held at the Carnegie Institute in Pittsburgh from April 27 through June. In September a group of the paintings was shown in Buffalo, and the following spring—March 16 to April 15—nineteen of his works were on exhibition in Cincinnati.

Perhaps the most interesting and rather surprising fact in regard to these exhibitions is that they were seldom retrospective. With the exception of *The Christmas Tree* (Fig. 11) and *Wild Lilies*, both dating from the early nineties, and a possible half dozen that date from the end of the nineties, they were, like his exhibition of 1908, composed of pictures of quite recent date.

A letter to Wood written on New Year's Day speaks of

Again another shipment from Windham of a case of apples which you sent me there and the poem of goodwill which came to us here. How in the world with all your multitudinous friends and demands on your time can your brain stand what your heart demands?

I get a fit of the blues and everything stands still. When you have pictures staring you in the face and but a little more time which evades you and an Ex. coming off in a few days, as Muley would say, "it is to laugh." However, I shall only send those I am thoroughly satisfied with which will be in number nineteen and trust Boston may sit up and take notice.

For two days the thermometer has been about zero and today it has started to rain. It is with its sudden changes a very mean climate. Hot or cold I can stand, but to change 40 degrees in one day makes one lose one's grip and catch the real article. I feel like one out of tune and cross. . . .

To this Wood retorted on January 7 that he was

dead tired, but if I were to wait till I wasn't, I'd never write at all I fear.—I have been in court trying a case before a jury all week, and not till you do that, and then try to attend to your general business in the meal hours and at night, can you have any right to talk about being *"tired."* Why man, painting pictures is *fun.* I paint bum pictures as a recreation. Suppose you try being a bum lawyer to refresh yourself. You are getting to be a damned old troglodyte. Why didn't you come out here when I asked you, and fish and get a new side light on life, instead of playing tiddledewinks at the Century Club.

You talk of feeling blue with *19* pictures to exhibit. What's the matter with you anyway—Here's $2500. for you. I wish for your sake and mine it was all new business, but we'll both have to be philosophical[6] . . . I want the other

[6] Wood, unable to collect $1500 from a client to whom he had sold a Weir, supplied it from his own funds.

$1,000. to go on something of yours for myself. You may be the judge yourself, whether it shall be a complete payment on something of that value, or a partial payment on something of greater value. . . . If you are willing to take your chances on delay, I'd like something of greater value, treating it as part payment, because I find a growing inclination toward large and important canvases as wall decorations, one or two to a wall, rather than so many small ones—though of course I understand that quality counts and is not measured by inches. Nor do I wish to deprive you of a saleable canvas on which you could realize cash, but I trust you to be frank with me and just to yourself. I have thought from your description of it, I would love the big moonlight. I am fond of moonlight in art and nature. Also I liked the big canvas of the building of the dam or reservoir. I am only indicating, and leave all to you, with the hope and belief that I can pay the difference in full. . . . I covet a fine important "Weir" and regard it as a good investment. But the application of the $1000. to any particular picture, I leave wholly to you. It is not important that any special selection be made now, what is important is that you "getta de mon." And don't sell out all your best things, for if I ever do get rich, (and things begin to look a little boomy out here) I want a room of Weirs.

What will you take to come out and decorate the salon of my palace? Now don't say as "Artemus Ward" did in response to a telegram—"What will you take for 30 days on the Pacific Coast?" "Brandy and water."

My best love to the family and my dear old chap, may we have many happy New Years yet—

This letter for once brought forth a prompt reply from Weir, for on January 13, the day after receiving it, he wrote:

Your letter reached me last night and the contents of it filled me both with joy and sadness for I appreciate the predicament. Alas, things bitter and sweet do not affiliate. . . .

The Moonlight or *Hunter's Moon* goes to Rome to the International Ex. there, the price I ask is $5,000., it being a large 40 x 50 canvas. I think one of my most important canvases. *The Building of a Dam* I think and Ryder thinks is one of my best, a canvas of about 30 x 40. I want $3,500. It is very decorative and seems to me to have an equal charm of color. I wish you could see the Ex. at Pittsburg and trust it may be well received. I will have a catalogue sent you if I get out there. I will not overcrowd the wall, try to leave a space of about a foot between each picture. The Century Club has asked me to make the Ex. here after the things come back from Boston, which I shall do and make an experiment on the color of the wall, with reference to repeating it at Pittsburgh if successful. I did a canvas last spring of a nocturne out of our window looking over the city which seems to me to have much of the mystery of night about it. Of course, none of it could be painted direct having had to make studies and memorandum to use the following day. The

thing itself was so beautiful I had to get the big notes which, as you know, are terribly subtle. . . .

The Boston exhibit proved a great success, and even Weir was delighted with his showing at the Century Club. In March he wrote Wood:

I am feeling in pretty good shape as far as my work is concerned, but the Dr. likens me to an auto that has run thirty or forty thousand miles and he says with care and prudence, I may continue but must go slow and all sorts of precautions that at first scared me badly. I suppose at my age with a bad valve, the heart has to do twice the work. I ride down to my studio and stand up working all day leaving there about 5 P.M. when I go to the Club and play billiards until six. This is my means of getting gentle exercise. I have grown to be very fond of a game that I never before could understand people wasting time over. . . .

To the spring exhibition of The Ten Weir sent *Nocturne—Queensboro Bridge*; *Near Norwich*, a fresh, vibrant landscape; and two figure pieces, *Lizzie Lynch* and *Pussy Willows*. As a critic commented in the Cincinnati *Times Star*,

Weir is the only one of the "Ten" to suggest the existence of untamed nature somewhere in the world. The gentlest of artists, with the simplest and tenderest technique, his art at first glance seems to call for any adjective other than wild or untamed; nevertheless there is something in its simplicity of vision and spirit . . . that makes it possible to conceive of it having sprung up in country fastnesses away from cliques and critics. Mr. Weir does not belong to the "Ten" or with any group.

After much prodding from Wood, Weir sent a group of pictures to Portland for exhibit. Wood was delighted and reported in a July letter:

I have hung the entire breakfast-room with nothing but your pastels and it is so simple, quiet and beautiful that there have been innumerable wishes expressed that the club might buy them all and keep the room just as it is. The room itself is rather a pale French renaissance room. The club is really a lot of philistines and I consider the impression this room has made quite a compliment to you. . . .

To this Weir replied (August 5):

I would be delighted to have you make a figure for all the pastelles "en block" if the club cared for them. In fact, I leave the whole matter in your hands. I had a sensation this spring and sold my picture exhibited at the Ten to an artist, $2500. No kick this was a great encouragement to me I assure you. At Pittsburg I had many complimentary notices etc. but I do not think my

work was loud and bold enough, but to my mind the exhibition was a very swell one and I was glad to see many old canvases that seemed to have lost nothing. With the exception of the borrowed pictures, the rest are at Buffalo where I have a separate gallery.

Ryder sent Weir compliments in a letter headed by a cryptic formula for remembering his new address.

<div align="right">308 W. 16 St., [August 11, 1911]</div>

16 × 2 = 32 theres your 3 • 2 + 6 = 8 theres your 8 • o for the middle number gives you 308

My dear Julian:

 . . . I was very happy over your notices kindly mailed to me by the Carnegie Institute.

Mr. Kenneth Miller[7] was remarking to me about the notices you are having these days, referring generally to them as being in the vein of genuine appreciation and understanding of your art.

He is a strong admirer of your work. . . .

You will not be very exhilarated by what I have done; but "Alls well that ends well."

Don't ask me to write any more today, like Sterne's starling in the cage, I want to get out, and need to, although a great deal better, have had a close call, with the gout or one of the Fifty kinds of Rheumatism. In my shoulder today and "Weehawken" will cure it.

Kindest regards to all the family,

<div align="center">Affec.</div>

<div align="center">Albert Ryder</div>

Weir's one-man show moved on to Buffalo in August with continuing success. *Early Morning* was bought by the Albright Gallery, and *The Return of the Fishing Party* went to a private collector.

On the West Coast Wood was still performing miracles for his friends and for Weir in particular, as is evident in his letter of November 15, 1911.

Enclosed find $1,000. for sale of the . . . *Summer Day*. I sold it last summer . . . but have only just been able to deliver it from the exhibition and receive the money . . . I have also sold your pastels to the Club for the decoration of the breakfast-room—just as I had them originally hung—for $1000. nett . . . to you . . . I hope this will all be satisfactory. I made a cut to the Club in consideration of the lump sale, but hope the sum total of two sales will be satisfactory. If not, please be frank with me—because while it is too late to remedy it now, it will give me an idea as to any possible future transactions. It is so

[7] Kenneth Hayes Miller (1876–1952), New York painter, student of W. M. Chase at the Art Students' League.

hard to know how to value a work of art when you try to sell it. Now I think your marks on the pastels were ridiculously low—yet I cut them because I thought you'd rather have the money, considering too, they go into a sort of permanent public exhibition collection. A sort of Weir room in the club. I'll get this club money early in December—when the dues are collected from members—so you can count on another $1000. long before Xmas.

I am sorry I haven't been able to do a thing for Hassam. One reason is his things are not his best—and his prices are high—though for the matter of that, some of the little things—water colors and drawings are not high at all.

Now I'd like a commission out of this in the shape of a charcoal or crayon or pencil or any old kind of a drawing of J. Alden Weir—you darned old reprobate; I've been asking for that for ten years and I think you ought to be ashamed of yourself. . . . I think I have sold that *Breezy Day* cloud picture of yours for $500. In fact, I am sure I have—but it is not closed yet.

Weir replied promptly (November 23, 1911):

It will be impossible to tell you the extent of the surprise you have given me. On the verge of desperation you have stiffened up my backbone and braced me up. . . . Your letter revived the spirits of the whole family and thank goodness. I have a fine start for the winter.

I have been greatly troubled with my leg and it has gotten so that my nights are broken up innumerable times with sharp pains which wake me up. I will now go and see your old Dr. Whitman and see if it is possible to do anything for me. I suppose I really ought to have attended to this years ago, but alas. I trust it is not too late. When one has something of this kind, you are always anxious and it prevents concerted efforts. Still (it may be what I need?) I am so much obliged to you in all you have done for me. I must in some way try to make the boomerang hit your grizzled old pate. . . .

December 15 Wood wrote again, wishing Weir

Merry Xmas—here is your mon. . . . You did not say whether you approved my sale of the pastels at $1,000.—but I have assumed you did. If not, it's too late as here is the money. In fact you never directly and distinctly answer any question I ask you. I am enclosing a note for *Mrs.* Weir. Please give it to her. . . .

471 PARK AVE., DECEMBER 20, 1911

MY DEAR OLD WOOD:

You have been indeed a Santa Claus. I most heartily approve of the sale of the pastelles and if you can get five hundred for *The Breezy Day*, get it P.D.Q. I will be delighted to send *The Hunter's Moon*, *The Spreading Oak* and *Building a Dam*, three good canvases I think. The price is big on two of these canvases $5000, but if you want either or any of the three you will have a special price. I have a feeling you will like all three, or rather I hope so.

I think if Lisa[8] saw anything in any of the pictures not sold, one that she

[8] Wood's daughter; she was about to be married.

may choose would help decorate the walls of her new abode, I should feel honored. With the rest of them you may do as you think fit. If you can get any bid, otherwise later they can be returned. . . .

I forgot to acknowledge the check you enclosed which has a fine fat look, especially at this season. Bless your good heart.

Ryder I have not seen lately, but when I last saw him he looked better than he has in years. He says it is all due to the fact that he does not live by his own cooking. Always cheerful and under the circumstances he must be considered a great philosopher as I have never heard a word of complaint. An ordinary person would be crazy under similar circumstances. . . .

Although Ryder's circumstances were largely of his own making, the difficulties which confronted many American painters arose from a public indifference which Weir was always quick to attack. Even in sophisticated art circles there were signs of what Hassam called "provincial snobbism," a condescension toward native American art. Weir had been highly indignant in 1898 at the Metropolitan Museum's refusal to accept a gift of a landscape by Theodore Robinson even when this painting had been selected carefully by a group of artists. In an interview with the *New York Times* he had declared that the reason back of the refusal

was that the picture was a small one by an American artist, instead of by some French or German one. A foreign artist has great vogue over here, and the museum seems willing to accept any third or fourth rate painting so long as it comes from a European painter. This painting is far better than a great quantity of foreign pictures in the museum. Many of these are absolutely worthless, big canvases, without any artistic value whatever. The Museum, of which I am a patron . . . has accepted a great deal of worthless rubbish in the past; and I suppose they thought that now they ought to call a halt, but they chose the wrong picture. They selected for refusal a picture which was the choice of professional artists and representatives of American art . . . The Museum Trustees have not always shown a great desire to foster American art. Some time ago they had an opportunity to secure a fine Whistler and they let it slip. But any foreign painting which takes up a lot of room seems to be just the thing to have.

Ten years later American painting enjoyed a somewhat higher regard, but Hassam could still ask, "What will finally be thought of a country that does not support its own art?" Weir remained a militant champion of American artists, and as his one-man show toured the East in 1911 he took occasion to reiterate his stand. In an interview published

in the *Pittsburgh Dispatch* he spoke out to a new generation of art students and advised them to stay at home and keep trying.

Asked if he considered this country a good place in which to study art, he replied:

"There is no better instruction given in the world than in America. My advice to the art student would be, 'Go to Europe if you will for enthusiasm, atmosphere, study in the galleries; but if you are in earnest, this country will serve your purpose quite as well.' I do not know of better instruction than that given in New York."

"Would you advise a painter to take up many branches of art or specialize?" Weir was asked.

"It is an age of specialization," he said reflectively. "The public is educated up to that sort of thing. For the man whose principal object is a market for his pictures, specialization is the quickest way. An unaccustomed medium or change in style only delays its attainment. After all, the individuality of a man must determine his particular course."

"Do you know how it feels to be rejected?"

"Bless you, yes," Weir exclaimed. "No man has attained any degree of success without passing through that phase. Don't you suppose we often hate to reject a picture when we think that a man may have put his last dollar in a frame? But it has to be done. No man should regard it as any more than a valuable criticism. A real painter will only try to discover his mistake. It is really only a 'try again' written across his work."

Weir was seldom satisfied with his own work and he was continually trying again. This restless dissatisfaction gave him a rare flexibility and an openness of mind. Even as he spoke, a new wave of experimental art was sweeping toward the United States to pose a final test for his discriminating eye. It remained to be seen how the dramatic and often strident innovations of the "moderns" would affect Weir's own gentle creations.

CHAPTER 9. AMONG THE MODERNS, 1912-19

Weir had by now been affiliated with so wide a variety of artists' societies that his name had come to be associated in the mind of the art public with new enterprises of genuine artistic merit. It was natural, therefore, that the organizers of a new group, the Association of American Painters and Sculptors, looked to Weir for support. And it was this new association which sponsored the International Exhibition of Modern Art, better known as the Armory Show, and introduced the American public to the violent novelties of the European avant-garde.

Weir's connection with the Association went back to its inception in 1911. At that time three painters, Elmer MacRae, Jerome Myers, and Walt Kuhn, feeling that the time was ripe once again for a new organization made up of the younger, more progressive artists, had called a meeting for this purpose at Henry Fitch Taylor's. Among the artists present were Arthur Davies, Gutson Borglum, William Glackens, Robert Henri, Ernest Lawson, and George Luks. At this meeting, although not present, Weir had been elected president without a dissenting voice, Borglum vice-president, Kuhn secretary, and MacRae treasurer.

As is already clear, holding office of any kind was never one of the things that Weir coveted; neither was it one of the things for which he was best suited, for no one could have been less political than he, and executive affairs bored him. However, his very aloofness from diplomacy and absence of self-seeking gave him a singleness of purpose and an integrity that made his name a symbol, particularly to some of the younger men.

On January 3, a few days after his election as president, Weir was considerably incensed to read a letter, written by Gutson Borglum to the *New York Times,* which implied that the new society had been organized with opposition to the National Academy of Design as its main

objective. This he felt placed him in a most unfair position; he was at the time serving on the Council of the Academy, and he did not consider it honest to serve also as president of a society that was represented as "formed as a protest against the methods and proposals of the Academy." He therefore tendered his resignation to the Association and sent the following letter to the *New York Times*.

471 Park Ave., January 3, 1912

To the Editor of the *New York Times*:

I was greatly surprised to find in your columns of this morning the statement that I am the President of a new society "openly at war with the Academy of Design." I have been a loyal member of the Academy for more than twenty-five years, and am now a member of its council. I believe (under the able leadership of its President, Mr. Alexander) it to be doing everything in its power for the promotion of art in this country, and it would be impossible for me to take such a position as that which the new society is said to occupy.

I have attended no meetings of this society, and was told only that it was formed to provide further facilities for the exhibition of such worthy work, particularly by younger artists, as is, unfortunately, sometimes crowded out of the Academy exhibition by lack of adequate gallery space, and that it had no intention of antagonizing the older institution. As I am always interested in any movement for the betterment of artistic conditions, I reluctantly accepted the office.

The account of the aims of the new society given to your representative has convinced me that I have no business *dans cette galère* and I have formally declined the presidency and the membership tendered me.

Trusting that you will give this statement the same publicity as that which you have already printed, I remain

Yours truly,

J. Alden Weir.

Weir's resignation distressed the younger men who had been instrumental in electing him, and Arthur Hoeber voiced their feelings when he wrote in the *Globe:* ". . . Without Mr. Weir the society loses considerable of its prestige, since he is one of the most distinguished of his craft by general consent, and his name alone would have carried much weight. His retirement is a distinct blow to the organization."

Borglum, on his side, was quoted in the press as being "amazed." The fact that the society was out of sympathy with the plans of the National Academy of Design he thought was known to everybody asked to join. But Weir, also interviewed, firmly repeated: ". . . I am in

sympathy and will support any society of artists that is formed, but am not going to oppose the Academy." He added that, in his opinion, the complaint that men were not permitted to exhibit under good conditions unless they were members of the Academy was "not well grounded. For some time I have heard casually of this movement. As Gutson Borglum is the Vice-President, he is undoubtedly at the head of it. He has revolted before, and this action is characteristic of the man. There has been no discrimination against anyone in the Academy of Design. Furthermore I want to say that it is not controlled by any one set of artists . . ."

Weir's was the first resignation, but it may be remarked that Borglum's was the second. Arthur B. Davies was elected to take Weir's place, a happy choice, for he showed outstanding abilities as an organizer and administrator and made an excellent president.

The exhibition of "modern" art that was organized by the Association of American Painters and Sculptors as their first show was an altogether extraordinary affair. It opened its doors on February 17, 1913, and started off rather slowly at first, but gradually gathered momentum from all the publicity it received, until it ended by boasting the largest attendance attained to date at an art exhibition in New York, over 100,000 people passing through its gates.

As its name indicates, it was an "international" show; and its enthusiastic founders took endless time and trouble to have it justify that name. Europe was scoured for exhibitors, and the show when it opened was as varied as it was huge. The three hundred exhibitors ran the gamut from Europeans of an earlier day such as Goya, Ingres, and Delacroix, through the American "elder statesmen" like Whistler, Ryder, Twachtman, Hassam, and Weir, on through the younger Americans, Bellows, DuBois, Kroll, Sloan, and Mahonri Young, to mention only a few. However it was not any of these men who caused the show's notoriety; that was due to newcomers. Here for the first time the New York laity had their attention called to Cézanne, Matisse, and Picasso, to Brancusi and Rouault, and to the Americans Maurice Prendergast and John Marin. The most radical work created the greatest sensation, led by a Marcel Duchamp painting, *Femme Nue Descendant l'Escalier*. Perhaps, after all, it is not so strange that it was the extreme that caught the public's fancy; there has always been a peculiar attraction—particularly with those who delight in setting a fashion—for the *dernier cri*.

Weir's reaction to the welter of new styles was mixed. Several years

earlier he had replied to an interviewer's query as to his opinion of Matisse and his followers that although much of their work was interesting, it lacked "stability" and slighted "the principles of constructive art as established in all schools." But in 1915 he saluted the "interesting" work of the new American experimenters and their break with "traditions that are dead." And in a letter to Wood he commented in an open way on an exhibition of the Futurists, finding "three or four of them interesting and the rest as wild as one can imagine, but with all an effort to throw off the commonplace."

Weir walked quietly among the "moderns" during these years, painting in his own way, unperturbed by the shouts of novelty and the pressures of fashion. The picture that he sent to the Armory Show, *The Orchid* (1899, Fig. 18), represented an ideal of the American gentlewoman which recurred in some of the loveliest work of his last years, notably in *An American Girl* (1912), *The Palm Leaf Fan* (1914), *The Letter* (1915–16), *A Follower of Grolier* (1916), *Improvising* (1917), and *Knitting for Soldiers* (c. 1918, Fig. 24). Out of the long summers in Connecticut came landscapes and hunting scenes which conveyed his love of nature and his sensitivity to its changing moods, expressed now with a confident brush in a truly individual style. The fullness and serenity of summer shone from *On the Shore* (1910–12, Fig. 30) and *The Fishing Party* (c. 1915). *A Bit of New England* (1916) and *Windham Village* (1913–14) had the special charm of fragmentary, local moments; while *Hunter and Dogs* (1912, Fig. 33) and *The Hunter* (1914–15) fairly danced with woodland colors and lights. Canvases brought back from trips to Nassau were alive with Caribbean sunshine; and a trip to England in 1913 resulted in a series of water colors of scenes along the Itchen River executed with the facility of a mature eye and hand.

Along with this steady flow of painting went added duties and honors in the art world, in which Weir had long played a distinguished role. He was elected president of the National Academy of Design in 1915, an election hailed in the press as signaling a movement toward higher artistic standards and an increased role for "genuine artists" as well as a better reception for experimental work. He served two productive years as president and as trustee of the Metropolitan Museum of Art, climaxed by honorary degrees from Princeton in 1916 and from Yale the following year. He was elected to the American Academy of Arts and Letters in 1915; and the next year he served as "Painter Member" of the National Commission on Fine Arts. All these honors called for

services which Weir never stinted and which underscored the loyalty to American art that shaped his entire professional career.

Beneath the surface of these busy and successful years Weir continued to struggle to measure up to the highest standards of excellence. To Wood he confided many of his doubts and resolutions, and their correspondence offers the best picture of the pattern of Weir's last years.

Writing in mid-January 1912 Weir reported from New York that he had

just returned from Windham where I have been on a January loaf. . . . I find here a fine box of apples from your famous state. Kindness and gifts overflowing from your big heart. I feel ashamed that I have not been awake. I fear my soul needs grafting and rebudding, but you are continually in my thoughts and I am so much in a sort of lethargic state. Maybe you think or you do not that our work exudes in a sort of lazy way, but all that ever amounts to anything is through a sweating struggle mentally. Discouragement often sits gaping at one, but so it is with all who do anything I suppose. . . .

The Chicago Institute has just bought *The Grey Bodice* for their collection. I am glad it will be in good society as I understand they have a very good collection. . . .

The simple life I suppose is a thing of the past. I often feel as if I would like to leave this town and live in the country with its simple worries. Yet, I suppose, the ills and worries are the same. Enough of this. You see I am a bit blue, but still I have the recuperative bug within me yet. . . .

Two weeks later (January 25) Weir wrote again that he

had to go to a specialist about my old heart which, it appears, is not in good shape. I suppose everyone has something the matter with them, either hard up or disabled in some way. . . .

How strange it must seem that although in the same town, I see very little of old friends. Pinky never comes to see me. I go when I can to see the old chap, but I suppose his night marauds put him out of commission. He looks better than he has looked in years but does not seem to get to work. Every time I go he washes out his canvases with kerosene and they are as black as your hat. I think if he would take a new canvas he would probably do something, but I don't think he worries much.

In March Weir's outlook was brightening and he wrote:

. . . I have sold a picture to Chicago Institute, to Carnegie Institute and one in the Ex. of the Ten to Worcester Art Institute; so I am not feeling low down. I think the *Hunter's Moon* and *The Oak* I might take five hundred off if it meant a sale. *The Building of the Dam* I would like you to have as an expression of how I feel toward you and the many encouragements

you have given me. So without saying anything more accept it with my love.
When I wrote you first, I was hard up.

We all expect to go abroad for two months this summer, July 13th and
come back in September. This pleases the girls and Mrs. Weir, but honestly
I would prefer to stay here. Yesterday I went up to Branchville for the day.
It was balmy and the birds were singing and the odor of the earth was a most
exhilarating perfume. The men were burning brush and everything looked
lovely. . . . This is about my time to get loose on the streams and I assure
you fishing is not all in catching fish. A day in the open on a dancing stream
is most exhilarating and if I do say it, it is ideal.

In June Weir inquired of Wood:

Well, what do you think of the irascible Teddy? I shall vote for him.
Enough of lawyer presidents for the present. I want to see the tariff reduced
to a speck. But what a political fight, like two school boys. Write me your
ideas. I want enlightening, as you may judge. I like a man of convictions,
but he seems almost too radical and revolutionary and a trifle too much of a
politician. . . . Price of *Moonlight* and *Oak* $5,000. with 10 percent off.

Wood on receipt of this letter, acting once again with his habitual
liberality, wrote that he ought

to have my money May 1, 1913—I as you also know must apply much of it
on debts—but I regard your pictures as not only pleasure to myself but a good
investment. I suggest tentatively that I take both *Oak* and *Moon* at $10,000.
10% off—$9000. net. $1000. down which I enclose—and $1000. on your re-
turn—and then I'm afraid to make positive *obligations* till next May, but as
and if I get in earlier money will pay installments and all to be paid up
May 1, 1913—This is not very nice for you and is only tentative as I say—and
if I can sell the pictures for a cash sum I will—meanwhile you take and use
the $1000.— And good luck to you all.

Such open-hearted liberality quite took Weir's breath away. "You
darned old cuss," he wrote,

I have just received your magnificent offer and also a binding check. If
you want those two canvases you get 20 percent off instead of 10 percent.
This check will fix me up in good shape with what I have and now I suppose
I will probably be for the time being a loafer with sketching pads and cop-
per plates to try and record some of the many interesting things that I will
see. I want to go to Ireland which is not so much over run with the terrible
tourist.

Hassam spent last Sunday here. Like the birds, he was early in the cherry
tree, but although they were fine he kept saying you ought to see the cherries
that Wood has, as large as hickory nuts, the greatest in the world. We talked
you and your family over and wished you were here with us. I told him
about the whiskey punches we had when you were here, how that never be-

fore or after did they taste like anything . . . He goes now to the Isles of
Shoals where it seems to fascinate him and where there is no well to fall into.
He is a great lover of swimming and although the weather is as cold as the
Arctic he revels in it. I have not heard or seen anything of our old friend
Pinky. I hear of his inviting ladies to his studio so I take it he is in good
health. I think he looked better last winter than I ever remember him look-
ing. He attributes it a great deal to the fact that he no longer wears socks.
The leather probably enters into his heels.

When he was abroad with his family that summer one of the pil-
grimages Weir made was to Glasgow to see Whistler's *Portrait of Carlyle;*
and while he was in that neighborhood, Ella persuaded him more or
less against his will that he should go out to Paisley, to see the town from
which the Weirs had originally come to America. Weir never quite lived
down this trip. It was a Saturday afternoon. Paisley, a manufacturing
town, was closed up for the weekend, its streets dreary and empty. The
day itself was grey and cheerless. Weir became so impatient with the
whole place that after a glance or two around he flatly refused to look
up records or churchyards, and the family returned to Glasgow with
relief and laughter.

By October the Weirs were back again at Branchville, whence Julian
wrote Wood (October 9) to tell him he was sending him a Stilton cheese
he had brought back for him from England.

. . . We had a very delightful trip and the west of Scotland is as wild and
weird as anything one can imagine. The lochs were very fine, rain and sun-
shine almost every half hour. We visited all the old abbeys which suggested
most wonderful architecture, always so beautifully situated. Henry VIII,
the greatest of all vandals, destroyed most of them, and robbed them of what
could be carried off.

I visited and fished in the Dove, Isaak Walton's favorite stream. It was
as clear as crystal and the fish were very scarce but the delight of those we got,
very gamey and beautiful in color. . . . Our return trip was all that could be
desired. Need I say that I did little work, I don't seem to be able to do things
on the jump.

I had to go to town on Monday but could get no tidings of Muley. I
suppose he is still at some of his haunts.

The trees about here are very brilliant, but they do not tempt me as the
more sober kind do. Still I will try and tackle some of the gorgeous va-
riety. . . .

Wood kept urging a visit to Oregon, and Weir wrote in December
from Branchville:

I would awfully like to see your grand country, but you treat your guests
too princely and then probably would expect them to work. Old Hassam is

a wonder. How he can settle down anywhere and do fine things is beyond me. . . .

I am going to try to do as you have asked and do a drawing of my phiz. I have a sneaking idea that I remember where that old book plate might be and if it turns up, I will try to go on with it. How is that for promises, almost as good as some lawyers. . . .

Wilson is a good man and I hope he will bust the tariff, but none of them dare monkey with it. His wife was a pupil of mine. I had hoped to have done his portrait, but someone has got ahead of me. I have some Madeira that belonged to my father bottled in 1837 by Woodrow and Wilson. Do you suppose it was his father? It is bad anyway and I think I will send him a bottle when he settles down. . . .

Back in the city again, he reported to Wood on December 23:

I saw old Pinky last week in his den and had forgotten to take the last three hundred with me, but I fortunately had it two days after when there came a knock at my studio and there he was. Poor old fellow, he looked dirty and certain odors of age were upon him and although I am very fond of him, I was glad when he went. So I cheered him up with what was his own. He thinks he has discovered a new road to health, that is to eat five times a day instead of three. He wanted to prove to me that it was the Indian habit, but I guess not says I. How about days when there was no game etc. then a great debauch. Well, Well. I am glad if he can convince himself of anything that will give him pleasure. But he has grown old this year and is still surrounded with that great raft of old clothes, old furniture and all sorts of other old and dusty things. He said he had a person who he thought would buy his *Death on the White Horse* for which he wanted seven thousand. I do not think it is a very representative picture of his, but I hope he will sell it. There is some friend who helps him for whom he is painting *Macbeth*. But it grows darker all the time. At one time it was very fine.

I probably wrote you that I got a medal and five hundred dollar prize at Chicago and since then I sold one to the Corcoran Gallery [*Autumn*]. I had a gentleman inquire about *The Spreading Oak* which I was glad to tell him was sold. So at last I hope my turn has come to earn my salt. I am teaching at the Philadelphia Academy during Jan. and Feb. and in March Mrs. Weir's sister has invited us all down to Nassau where she has a fine old fashioned house with a grove of cocoanuts in the front and grapefruit in the back as well as many varieties of tropical fruit. I want to try and get at that wonderful color, but I have "me doubts," a little good fishing thrown in.

I am not forgetting my promise and trust that time will show the result. A little like some of us, full of great promises for the future. . . .

Early that winter of 1913 Wood wrote that he was sending Weir the galley proofs of "a little book of sonnets and lyrics" that he had written

and was having privately printed—only one hundred copies were to be issued—and he wanted Weir to illustrate it for him.

. . . Most of it will appeal to you—the feeling for nature will, and the art quality, possibly a certain modern pantheism not inconsistent with your own religious beliefs, but there is a certain anarchistic note especially relative to free love (Do you know any other kind?) and opposition to the iron bond of marriage. (You have only seen the happiness, I am consulted every week on the hell of it—usually a woman appealing from the legal *ownership* of her by the man).

Well, what I want you to do for me is to read it over, and of the Greek in it, the pastoral and ideal—the Nature beauty which the super-woman or Earth goddess, Maia, represents—I want you to make me, if you will, two poetic idyllic illustrations which I leave to your imagination—but suggest one in which the figure is the thing, the nymph or goddess (to *me* ideal woman) Maia—the other a beautiful landscape with two figures in it, small of course. I turn to you in spite of your wail to me of overwork—and lack of go; because aside from friendship, I personally know no one equal to you in the true poetic quality, and secondly, I would as a matter of sentiment like to have you and me identified in this poetic tale.

I thought too, it might amuse you to do this as lithography or charcoal drawing—reproduced. . . . And lastly, I want to pay you for your work—otherwise *no,* the thing is ended. . . . You make your living by your brush and I like to feel I have been able to commission you for this slight work. You may make very great art of the little illustrations—I feel you will. Take your own time . . . Only don't wait *forever*. Make it a play if you can. Understand when it is all done I pay a *proper* price—otherwise I call it all off. By proper I mean a good liberal price.

I write this hastily to arrive with the proofs—I am dead tired. . . . Love to all.
<div align="center">Wood.</div>
Don't get disgusted at some of the strong stuff in my sonnets. Measure it all by *Nature*. She after all is the best moralist, the holder of Truth.

But this time Weir could not see eye to eye with his old friend. The book was beyond his understanding. He acknowledged that it was "full of fine thought and the social sentiment is fine, but for me I draw the line at free love. Old Muley I think has a strong belief in that faith, but he is losing his teeth and why not the rest. That sentiment belongs to youth and the spirit of the three musketeers. Hurrah for the Anarchy. No, this is all beyond my depth." And he returned the book to Wood, who had it printed without Weir's illustrations.

In March Weir wrote Wood from Nassau:

Here we are at the Tropics. Thermometer about 80 with a wonderful

sense of light. I have a half dozen canvases begun but the overwhelming sense of light all but paralyzes me. All this light is evidence of more color. I never worked with more interest to try and realize the problem. Many of the men whose work I have not been keen about have undoubtedly found that the great power in the tropical country is color and that was the theme that interested them. The color of the water here which has a bed of coral has more splendid and brilliant color than I have ever dreamed of, but to harness it in its just relation is indeed an interesting problem. I started two canvases yesterday and worked on a third in the P.M. and last night I was played out. . . .

Suddenly in July word came to Windham that young Cora, who was traveling in England with friends, had come down with typhoid fever. Ella and Julian left for New York on forty minutes notice and sailed for England the following morning. Cora was out of danger when they arrived. And the trip turned into a pleasant excursion as they settled near Winchester in a house within a stone's throw of the Itchen River, a gentle, clear English stream edged with rushes and bordered by meadows. Weir spent day after day wandering along the banks, painting several dozen water colors with an ease and a delight he did not often find in his oil work.

Returned to Windham with Ella, Weir wrote Wood in October:

The wood fire is flickering on the hearth and we have letters from Cora and Dorothy to say that they will sail on Nov. 1st. We will stay here in the country as long as all are contented. I am trying to do some work with a most fitful weather which seems to change each day. But when those girls get back to fill the house with laughter or even without laughter, we will be again supremely happy. . . .

I had to go to N.Y. for a day and I met Muley with a one eye glass and a rough English tweed, truly more foreign than he ought to be. He shot out the glass with a haw haw, when he caught my eye. He is now beginning his decoration for the San Francisco Ex. None of that for me, not cut out for it. The Chicago Ex. was enough, interesting but not adapted to your humble. . . .

What do you think of the Altman legacy of some fifteen millions worth of pictures to the Metropolitan Museum?[1] I will be very anxious to see them as I think he may have had a different stand point from Mr. Morgan.[2] Certainly with these two collections the Museum must be well represented with old masters.

I heard that Ryder (whom I did not see) was enjoying good health but had no time this summer to do any work. Poor old fellow, I wish I could get

[1] The art collection of the New York merchant and philanthropist Benjamin Altman (1840–1913) included thirteen Rembrandts.
[2] John Pierpont Morgan (1837–1913), financier and collector in bulk.

him in the country, but I fear he is one of those who prefer the city under any conditions to the wild country. . . .

Good night. Ella sends her warmest remembrances and wishes too you were here and I believe we would all have a toddy although none have we had since you were at Branchville.

By a curious coincidence this letter of Weir's to Wood in which he speaks of not wishing for a decoration to do crossed with one of Wood's offering him just such a job. After describing how busy he had been Wood went on to say:

I do not know that I would be writing you even now, were it not for the fact that Sam Jackson, owner of the *Portland Journal,* asked me whom I would suggest to decorate the walls of the new Journal Building. (Interior of main office) I told him you, but that he couldn't afford to bring you out. "Wouldn't fifteen thousand tempt him?" he replied to my surprise—and added, "I expect to spend ten or fifteen thousand on it." Now, I suggest that I get him to pay your way out and back for you to come here, look at the building, hear his ideas and state approximately what you will do it for. You can then do it and come out and put it up before you go to San Francisco on the 1915 Fair Jury. Jackson is a garrulous erratic fellow, and is liable to speak to some one who will land a cheap worthless artist. (Jackson doesn't know a Corot from a chromo)—and the deal will be closed. This is not our time of year, (rainy) but there ought to be a good thing for you in it at fifteen thousand—besides the permanent and important decoration. Let me know *at once* how it strikes you. . . .

However, Weir refused; he was not to be tempted away from his own convictions—unfortunately.

Now, old veteran in art, what are you getting me into? I know my limitations and I know damned well that I am not a decorator. I will angle with the gentleman and hold myself so high that a fog will be between us. I am grasping but could not undertake a thing of that kind. Why? For the reason it does not interest me as nature pure and simple. However, I can lead him to some bright light in the decoration way. . . .

I fear I am getting old as the Salmagundi Club proper gives a dinner and your humble as guest of honor. I tried to get out of it and maybe I have, but I fear not. These things scare me.

Really I know not what I am best at. I believe I am a fisherman, dreamer and lover of nature and like Hokusai if I lived to 120 I might become an artist. Yet I fight and struggle to do things and sometimes I get quite close, but the restlessness of discontent leaves me little enjoyment.

The Salmagundi dinner of 1913 was a great success; more than one hundred artists gathered to do Weir honor. He was not only tremen-

dously pleased but also quite touched and, more certainly still, surprised to find in what love and esteem he was held. The next day there were several newspaper accounts of Weir's being "hailed as the foremost of living American landscape painters." Speaking at the dinner Royal Cortissoz declared that "Mr. Weir had done much to keep alive interest in things new," and he must have gotten a good laugh from Weir himself when he claimed that "Weir's paintings of Connecticut pastures . . . were lovelier than anyone ever saw them in Connecticut." The speeches ended with a toast to "the painter who has always kept at the top."

Not long after this dinner Weir was interviewed in connection with the National Academy exhibition. His interviewer found Weir "an academician with no official poison in his blood," a man whose sincerity had won the respect of "even the young radicals of art." The dinner given Weir, the writer declared, "was not so much due to his honorable record as to the fact that he is alive and growing."

When the interviewer turned to questioning him about his own painting, Weir's replies were characteristically frank:

"What interests you most in a painting?" Weir was asked. "It can't be put in a word," he replied, hesitating a moment. "Yes it can! Character— that's the word. If you get that, it doesn't matter about your brushwork. Men are beginning to see the truth again. Some of the strange things exhibited nowadays come out of that impulse. Those French fellows had been doing clever work for years—painting their pretty models over and over, smoothly. Finally they realized how little there was in it all and they went to the other extreme. After I had read Van Gogh's book,[3] I saw more in his work than I had seen before. He means it. You can feel that in everything he wrote.

"These young fellows are getting at the real thing," Weir continued. "They are the ones to watch. Our work is a thing done. They are going to nature and the public is responding to it. Once in a while a man fails to get attention for work that is good; but usually the fault is in himself. A young fellow came to me once and said he couldn't sell anything. He took me around to his studio. He admitted that he was trying to fix 'em up so that they would sell—smooth, pretty things. I told him to throw away his brushes, go out in the country and paint with a stick—look at nature and get the paint on anyhow. He was disgusted—thought that was fool talk. But the next I heard of him, he had done it—actually gone out and tried to get the character of the scene and then daub it on the canvas, and he got the real thing.

"Of course young artists ought to study. They need to work at their

[3] Probably *Lettres de Vincent van Gogh à Émile Bernard*, Ambroise Villard, Paris, 1911; or possibly *Personal Recollections of Vincent van Gogh* by Elizabeth duQuesne van Gogh, tr. by Catherine S. Dreier, with a Foreword by Arthur B. Davies, Houghton Mifflin, Boston and New York, 1913.

drawing. They are usually in too much of a hurry to paint. Things are better than they used to be. When my father came back from Europe about 1828 there was one painter in the Academy and the rest were bankers! So the artists got together and started a new Academy. In time that fell into the same old conservative ways, and the Society of American Artists was formed. Now they have joined with us in one big body . . ."

The character of Weir's own work was nowhere more evident than in his show of thirty-one water colors, primarily the Itchen River series, which opened at the Montross Gallery on February 5, 1914. The other rooms of the gallery were hung with paintings of the Cubists, and the *New York Sun* observed: "Mr. Weir's paintings bear up bravely with the new things . . . The Cubists no doubt would have been delighted to call him their own. The Cubists have a really remarkable habit of calling all the undeniably good ones 'Cubists'." The *Times* spoke of Weir's water colors as "records of impressions upon a quiet mind by quiet landscapes," while the *Post* pointed to "a tranquil spirit of enjoyment of quiet gracious scenes; they are less striking than persuasive, and their delicacy of feeling invades the mind like the wholesome fragrance of the fields."

Jury work and regular exhibitions rounded out the season, followed by a relaxing country summer. But in August war broke out with the attack on Weir's beloved France by her ancient foe. To a sale on behalf of French widows and orphans Weir sent a handsome still life, *Pheasants;* and in December he wrote Wood:

I have no reason to feel blue except for this terrible war and the suffering it must entail. I got a $2000 prize the other day[4] and sent some to the families of the French painters in Paris who must be not only hard up but demoralized. I hoped it might arrive about January 1st, the time they always celebrate and make happy. Down with the Kaiser. What a senseless war this seems to us all here. The girls and Mrs. Weir are all working on stockings, scarfs, etc. made of heavy wool in hopes it may do some poor fellow good and help keep him warm.

The 1915 exhibition season found Weir's sales challenged by the rising vogue of modern work; he pointed to the new fashion in a letter to Wood (January 30):

Many things are happening these days in the way of art exhibitions. Matisse's, the erotic French artist, which seem to me abominable, in fact rotten. Other shows and the collection of Mr. Ichabod Williams, who has

[4] The Corcoran Gold Medal Award for *Portrait of Miss de L——*

two Bunces, three Ryders and my *Muse of Music,* the first collection of
pictures that has come to the hammer in a long time and I do hope they will
be appreciated. There are so many strange aspects in the field of art now
that I wonder if the public is not weaned from the good for the sake of
fashion and the much talked of degenerate's reaction. Reaction constantly
taking place. . . .

Wood replied (February 5) that he was

holding myself back in any judgment of Matisse and his confederates by
mentally insisting to myself all the time, that the past has never compre-
hended the future. Corot, Courbet, Monet were all derided outcasts. The
movement of the world is against authority, and form is a species of au-
thority. . . . It is only occasionally I see that vital spark of all art—Beauty—
in the Futurist work. I hesitate to condem—was the trouble with Corot or his
critics—Is the trouble with the Futurists or with me—I don't know—so decline
to dogmatically condemn. Some futurist work struck me as beautiful; some
as having the simple sincerity of the Primitives, but strangely enough, even
in these very portraits and compositions I liked as simply sincere, I felt in-
definably but surely, this was not the sincerity of the early workers—which
was a part of their unconcious being—their simple crudities the best they
could do—but this was a sort of affectation of simplicity and crudity—There
is mighty little of it I care for, but sometimes, as I say, I find beauty in it.
 I wish to God I had the money to buy *The Muse of Music.* It's a beautiful
picture. What do you suppose it will sell for? But there's no use my fooling
with the idea—I'm awfully hard up—I do hope for better times, and do hope
to have some money next year—so I wish you'd paint a nude for me, a large
one. If I can't buy it you'll have it, and the world will be the richer. I want
a still life of yours also. There you are, consider yourself commissioned by
hot air—and while I'm asking—suppose you take some morning at Nassau—
look in the glass and make me that sketch of yourself. It seems to me for an
artist, you are making a whole lot of trouble about giving me that drawing.
A real artist would have dashed it off several years ago. . . .

 Once again Wood tried to tempt Weir to come West for the Fair,
offering him every inducement he could think of, fishing, fine fruits,
scenery, commissions—"Or I'll sit for you in the fishing camp in scanty
attire as Abraham in the Desert."
 That spring Weir was appointed a member of the international
jury for the San Francisco Exposition, and he hastened to write Wood
(May 4):

Look out "the mountain is coming to Mahomed." I have been appointed
one of the International Jury and due in San Francisco May 24th. I will
have to be there probably three or four weeks. On our way back by the
Canadian Pacific we are going to look you up. Mrs. Weir and Cora are going

with me and I only regret that I could not persuade the other girls to go with us. I got back from Nassau on the 5th of April and on the 13th went out in Pennsylvania to try the trout. So you can see I am off my base as far as painting is concerned. Yesterday I received your princely letter, but I am not a Muley who can paint on the wing. I shall loaf and fish if I have any time to spare.

I am enclosing you some clippings by which you will see I have risen to some distinction, having been honored by the presidency of the N.A.D. Now I fear my trouble will begin. However, if I can be of any service to the Academy and our art [I] am willing to sacrifice myself. . . .

The jury work in San Francisco was filled with committee meetings, but before long Weir was deep in the Oregon woods on the fishing trip that Wood had been promising for many years. He reported in a letter to me that he had

fished in the famous Mackenzie River which I will have great fun in telling you all about, shooting rapids and all sorts of hair breadth episodes. After the first day I was inspired by the knowledge of the men in charge [so] that all fear fled and I enjoyed the wild sport . . . the whole trip has been one of wonder . . . No writing nor pictures could give you an idea of its wonders—fertility and vastness. The people are as big hearted as the country they live in, and I feel that aside from their many charms a good share of common sense predominates. . . .

Back in Branchville Weir resumed his summer painting, and in October wrote Wood to ask if he could borrow Wood's portrait for an exhibition, adding that he had "been hard at work and it is only within the last two weeks things have begun to move ahead. . . . It is needless to say how we enjoyed our visit to you and since my return I have found it hard to shake off the loafing habit. You dear old man, I wish I had a bit of your many virtues. . . ."

In reply Wood exclaimed: "May you exhibit my portrait? Who has a better right? Suppose I said no—what kind of a duffer do you think I'd be? Well, I'm not that kind of a man. You need never write such superfluous questions. . . . I was back [in San Francisco] and found an admiring throng one afternoon around your wall with nocturnes on it. We certainly are a Philistine country, though, money and a real hunger for art seem never to go together."

Wood went on to describe his difficulties in trying to get some commission from among his rich friends for a young sculptor he thought deserving. He told them he was

"sick and tired of you rich men—You have money for autos—for strings

of pearls—for anything you *truly* want—but you don't want art. You don't do your duty by your generation or your children. Where are the bankers and the business men of Greece, and Rome, of Florence or Venice? but their art lives and you can only hope to live hereafter as you become a patron of the arts." They laughed and said "Hear, Hear! We'll have to do something if only to please the Colonel." "Not much" I said, "I don't give a damn—but if I had your money, I'd have fountains in my grounds, not cast iron ones bought at Wanamakers, but works of art. I'd have great fine canvases, by men like Weir, or mural decorations by men like Hassam." "Gee!" they said, "you must think we're rich." Then they went on to tell of the fearful demands on them on account of the unemployed and the war, etc. which is true—but nevertheless their wives do wear ropes of pearls costing fifty to a hundred thousand dollars. . . .

Early in January of 1916 Weir located Ryder and reported to Wood that he had

found Pinky at last in quite a spacious two room apartment. One room as heretofore filled with family furniture and the poor old fellow shuffles about as he has not the entire use of his legs. However, he is well taken care of by Mrs. Fitzpatrick,[5] who is very thoughtful and kind. She told me of the Santa Claus from Portland. God bless him. Ryder has some grudge against some, who evidently are too officious. He has sold two pictures at good round figures, one to my friend Morten and one to someone else. Mrs. Fitzpatrick said he had some money still from the one I sold. So the old fellow is comfortably off for several years. The Dr. gives him encouragement but I fear he will not do any more painting. He has the chuckle as of old and his long beard gives him a Rip Van Winkle look. . . .

All sorts of Exhibitions are now going on, all sorts of Art Mania. . . . It is after midnight and as I have a model tomorrow, I will have to turn in. . . .

On April 8 Weir wrote to put Wood au courant.

It begins to look now as if Teddy was going to stand a good chance for the next presidency.

I had great luck in the Exhibition of the Ten. Knoedler bought my three pictures and he a dealer. That may be a good sign.

I am getting a little more used to the official position and it is not quite so irksome. Yet I cannot work very regularly which seems to be necessary with me to accomplish anything.

We expect Caro's wedding to take place on the 7th of June.[6] I wish you were here to take part and hope Mrs. Wood can. She has promised to come

[5] Charles Fitzpatrick, a carpenter and former sailor, and his wife, herself an amateur painter, had lived for many years on the floor below Ryder at West 15th Street. In 1915, after a serious illness, Ryder was nursed by Mrs. Fitzpatrick in Elmhurst, Long Island, until he died in 1917.
[6] Caro Weir married G. Page Ely.

back after her Baltimore trip. I was too miserable when she was here to do anything, but I know that I can do better work now.

Poor Blakelock[7] who has been in the Asylum for the past ten years or more has achieved a success in that one of his pictures sold at auction for $20,000. This matter of price has suddenly developed a great interest in him. Everyone is crazy for his work of which there are many spurious works suddenly in the market. Such is fame.

During that winter a utopian plan was put on foot to make some arrangement to finance certain artists regularly by the year, the idea being that such a scheme would enable them to work without the worry of the necessity of making sales. This was the occasion of more interviews with the press, and Weir's impatient comment in reply to a reporter's inquiry as to how he felt on the subject is typical of him.

". . . Painting with a mind at peace," exclaimed Mr. J. Alden Weir, while the model waited. "Why we've got to starve first. It's only when we've got more than we can do that we really begin to work as we should. Mind at peace," he cried with an amiable grin. "I believe in war."

The European war affected Weir more and more strongly as the months went by. His old love for France burned ardently, and he felt from the very start that his country should hasten to her aid. It was therefore quite in keeping with his loyalty to what he considered a sacred duty that, in spite of his health, which was now definitely a cause for worry, in spite of the pain that his hip now was giving him on the slightest exertion, and in spite of the fact that warm weather always bothered him particularly, there was never any hesitation in his mind about walking in the preparedness parade that was held on May 13. As he wrote to me, "I am down to be one of the paradees. I do not know if I can march all the distance but will do my best." As a matter of fact I think that the exertion was in a way a relief to him as a way of giving expression to his intense feelings on the subject.

And in September he wrote militantly to Wood: "Well, I suppose you are trying to solve the problems of your state, but do for gracious sake leave that stuffed saw-dust secretary of State[8] or hit him a dig for me. A peace wind bag. I only wish Roosevelt would have run. I believe he would have been elected by a large majority, a man with a backbone."

The topic of the war proved to be one subject that Weir and Wood

[7] Albert Blakelock (1847–1919), painter of landscapes at sunset and by moonlight. Neither Blakelock nor his impoverished wife and children were able to benefit from this delayed fame.
[8] William Jennings Bryan.

did not look at with the same eyes. Weir's family association with West Point strengthened a sense of military duty. He had done his best to join up in 1898; and now that France was attacked he championed the war. To Wood it was not so simple. He was inclined to see power politics at work in the struggle. On November 25, 1916, Weir wrote to take issue with his friend: ". . . You do not believe in National honor. What about Belgium? She stood up and did her duty, but not we of the tender hearted kind who do not raise children to go to war. Who does, but is there not a time when it may be necessary? I hate to see you so flopped over. . . ."

Weir went on to inveigh against the Interstate Commerce Act and all the strikes that were taking place: "What we want is to get back to the earth. . . . Legislate on such things that are necessary to the people at large and stop speaking opinions. Too much hot air is what it seems to me . . . Enough of this now . . . We all moved in from Windham last week. I have been quite miserable. I have done no work at all this summer, the first summer I can remember when such a thing occurred. . . ."

Wood replied (December 27, 1916) by urging Weir to refuse more committee work:

I do wish you'd give up these meaningless horrors, which are only a means of getting work out of you, while your vitality should be saved for art. *That's* why you have, as you say, done so little lately. You are *tired.* The creative faculty requires leisure to brood in and fresh strength to execute. My own life has been a sacrifice to debt and law. I hate to see a greater genius used up in temporal things. . . .

Two days later Wood renewed his plea:

. . . I find a book I subscribed for long ago, for you—at the Yale Press . . . do you want it? and will you read it? or give *all* your time to the National Academy, the Metropolitan Museum, the Corcoran Art Gallery, the National Gallery, The District of Columbia Commission on the Beautiful, the Matinée for Struggling Artists, the Soirée for French Widows of Artists— You know, the way I nag you reminds me of the dear devoted spouse of Albrecht Dürer, with the open trap door in her room above his studio, watching his every idle or flirtatious hour. Fancy an artist being able to work under such circumstances. But if I hadn't nagged Hassam, he would not have brought half that he did out of the Desert. That *Golden Afternoon* in the Metropolitan Museum, the most poetical thing of his—would never have existed if— (myself attracted by the brooding beauty of the day) I hadn't gone to the carpenter shop, made the stretcher, stretched the canvas and galvanized old Muley. I have a letter here from his etching agent asking me to promote an exhibition of etchings of which he has already done "over a hundred."

He is certainly a Kodak. But he pays the penalty of skill and fertility. He stops at externals. It is inevitable. The facile man, psychologically sees and does the superficial, I may say, though it is hardly fair to apply that word. Beautiful, of course—It is the beauty that impels. The brooding and introspective man is bound to be slow. Haste is incompatible with brooding. And wanting so much more than the surface, he finds it difficult to achieve his desires. . . .

Weir answered (January 26, 1917):

Your last welcome letter contains advice I propose to carry out and try to get rid of the honors that seem to me to demand too much of my time. At present it is at Washington on the National Art Commission which necessitates going on there every month for a day or so. . . .

At present here in this great bee hive there is a Spaniard who is trying to repeat the Sorolla success.[9] They have pulled all wires to get the Metropolitan Museum to get one, $25000. To my mind a man of talent who thinks the American public can be satisfied with anything. The Museum turned it down and now someone interested in having it talks of purchasing it and presenting it to the Museum. I hope this also will have a quietus given it.

I have just sold two pictures in Washington and one in Chicago, so I have no kick, as they say. . . .

February 16 he wrote again to Wood:

It seems a long time since I wrote to you or heard from you. I do not seem to get right after the Grippe and the neuritis is worse than ever. I have begun heroic treatment. . . . Last night there was a large collection of pictures by American artists, that sold very well, although the first night there was little doing. I suppose the accounts of such sales get in your papers, as the country at large is interested in American pictures as never before.

I had an Ex. of ten pictures in Chicago and have disposed of four and a possible fifth, which I feel is a fair appreciation.

On March 14 another letter went to Wood, and curiously enough this one is the first addressed to "My dear Erskine," a new cognomen to the shy Weir who, with the rest of his generation, was always chary about addressing people, even intimate friends, by their first names. The letter continues:

I have so much respect and admiration for you that I feel I may be too familiar in thus addressing you and yet our early acquaintance was about the year 1868. You have certainly given me a stimulus in my work for which I am and always will be, most appreciative. . . . Tomorrow is the Academy dinner at which I have to make an address, a difficult task for me. However, one can do no more than his best however insignificant that may be.

[9] Joaquin Sorolla y Bastida (1863–1923), Spanish genre and marine painter, had fetched high prices in New York. In his path now followed Ignacio Zuloaga y Zabaleta (1870–1945).

About two weeks ago Ryder sold a picture for $2500 and I was called up yesterday by Mrs. Fitzpatrick who inquired about it. Ryder, she says, wants it deposited in his bank. Naturally, in which she says he has in the neighborhood of one thousand. So he can afford to have the comforts of life in a simple way. He is down on Long Island and, she says, is feeling pretty well for him. She promised to send the canvas that belongs to you to me for your keeping, but I have not yet received it. . . .

On March 28, 1917, Ryder died. Although for the last few years illness had prevented the two friends from meeting as frequently as they had in the past, their deep affection for each other had never dimmed; and Julian, when he came back from the funeral, sat down and wrote the following moving account to Ryder's other close friend, Wood.

MARCH 30, 1917

MY DEAR ERSKINE:

The day has been beautiful. The sun was warm and at Elmhurst the maple trees were red with buds. There at the little house of Mrs. Fitzpatrick, dear old Ryder lay in the mystery of death! There seemed nothing sad. The dear old fellow had a peaceful look and the struggle was over. A good number of his old friends were there to take their last farewell. The little clergyman read the service in a kindly way and made a few remarks. Poor Mrs. Fitzpatrick, who has been such a good friend to Pinky seemed bewildered with the sense of sorrow. Ryder's niece has agreed to see that she is recompensed for all that they have done (the Fitzpatricks) in the years that they have looked after him and we all are feeling very grateful that the thought has been met so kindly.

Your two pictures [by Ryder] I had brought up last week to prevent any misunderstanding, and they are now at my studio. I took a beautiful box of lilies for you and one for myself.

Peggy Williams[1] kindly took Dewey, Gellatly and myself down in her car. We left there with the understanding that we, all his friends, would go to the Grand Central and escort the body to the train, as the burial is to take place at the old burying plot in New Bedford where his father and mother lie. Davies, Hassam, Dewey, Shilling, Gellatly and myself [went to the station], where we took our final farewell. A profusion of flowers was sent. Now he is free and his great and simple soul will enjoy that rest and peace that passeth understanding.

With love to you all,

Affectionately,
Julian

The war in all its manifestations continued to be very much on Weir's mind. In March he was one of the signers, along with such men

[1] The art dealer Daniel Cottier's daughter.

as Taft, Root, Stimson, and Choate, of an advertisement that appeared in the New York papers calling upon all patriotic Americans "to assure the President that he will receive the united support of the American people in taking effective action to uphold American rights and defend the national honor." In April, with other artists, he was one of the founders of the American Camouflage; while in May he enjoyed very much being one of the committee that received the French and British committees sent over under Joffre and Balfour by their respective governments to further the war. Anything he could do to help the effort he did; and as he wrote Wood, "I only wish I were young enough to join the colors."

Writing to Wood in February 1918, Weir confessed that he had "become such an irascible person that I cannot discuss the war but in one way. These dastardly and Hunnish enormities, which the Germans have perpetrated can never be effaced." He went on to remonstrate on the pacifists and on Wood's "getting mixed up with the I.W.W., a bunch of murderers and scoundrels (them's my sentiments)."[2]

Weir's health had been poor for the past several years, but in the autumn he reported to Wood that he was much improved. Wood, who had himself been injured in a severe automobile accident a few weeks earlier, wrote Weir on November 20:

. . . I cannot express to you the joy I feel in your recovery and restoration to youthful feeling. I am glad to my heart for it and we all rejoice in it. Erskine is greatly relieved to know of it. He was rejected from the Army on account of old Tuberculosis scars, but Peace has come,—thank God, but now begins a war between the old order and the new—but this will be bloodless.

Contrary to you, my feeling is suddenly of great age. I feel like a man one hundred years old—only fit to sit about, but the doctor says this is natural as shock—in one as old as I—and will pass in time— (So will I)—Just this short letter makes me wobbly . . .

I am sorry you sell the apartment if you don't want to, but I think *nothing* compensates at our age for worry, and I would love to hide in some place like Branchville for the rest of my days. Can I be of any help?

Weir replied (December 2):

. . . We are here at Branchville still, Ther. 20 degrees above, quite cold enough for me. Our fire wood is all out and green wood is no good. . . . We are getting used to the fact that we must all economize now apparently more than ever. . . . We will probably get away from here on Wednesday but where we will be is a conundrum. As you know, I had to give up my apartment as

[2] Wood had been defending several I.W.W. leaders in the California courts.

the proprietary rent was beyond me. Things are stored and we will probably migrate to the South.

I have done little work this summer as most of the time I have not had any ambition or pep as the boys say.

The last time I was in Washington I dined with Mr. Henry White whom the President has made one of the envoys to the peace table, a charming man but too gentle for such an undertaking. . . .

The Ten held their final exhibition that winter. This was not one of the regular shows held for the last twenty years, but rather an invited show held at the Corcoran Gallery in Washington; and the reviews treated it as a retrospective event. The *Washington Star* (February 9, 1919) credited The Ten with having "exerted a strong and beneficent influence upon the devlopment of American art"; and Weir it asserted was "looked upon by many as one of the biggest men in the art world today, one of the most sincere and significant of living painters . . . His work . . . stands the test of time and familiarity."

The exhibitions of The Ten had demonstrated the vitality of a sympathetic group showing and had set high standards of independent work at a time when the weight of numbers threatened to hold the established societies down to a level of mediocrity. However, by 1918 the challenge of The Ten was muted; its initial momentum had been lost, and it quite properly vanished. But within the Academy a new generation of painters was restless, and in May of 1919 a group of broad-minded academicians joined with thirteen rejected young painters to form the American Painters, Sculptors and Gravers, which came to be known as "The New Society." Its credo focused on mutual respect among members and exhibitors, and Weir's support was eagerly sought.

He joined the new group, as he had always joined whatever movement promised encouragement for talented American painters. The first exhibition of the New Society, held in November, was Weir's last. Again the paintings he sent, *Nocturne—Queensboro Bridge* and *Portrait of a Lady in Black*, stood with the best.

Weir spent the summer in Windham; but he lamented to Wood that "not a line have I wet this summer, excepting the last day of the season, when I took a brace of trout two and a quarter and three quarters of a pound. I only had an hour an a half; so I feel as if I had my share."

Toward the end of the summer Weir became seriously ill. But he recovered; and on October 1 he was strong enough to pen a note to his

sisters Carrie and Anne: "That by the Grace of God I am feeling pretty well and my strength seems to be improving so that I feel as if I am improving in strength if not in health, yet I have no complaint to make—I feel I have more blessings than I have deserved; I am enjoying the joy of the children. I thank God for these great blessings! ! !"

On the fourteenth he wrote Wood that his sickness had left him "in a rather wobbly condition," and he reported sadly that he had "done no work in the past six months although the conditions are better than they have been in several years and there seems to be a great interest stirring in the art world."

The one bright spot of that autumn was a weekend visit to Windham from John Sargent and his sister Emily. They arrived the very end of October. It was a propitious time when Weir was almost feeling like himself again; and the two men would be driven up to Weir's studio in the fields back of the village—it was too much of a walk for him to take by now—and spend happy hours there looking at Weir's pictures, talking art, and reminiscing over the days of their youth. One afternoon we all motored over to Nathan Hale's birthplace, in nearby South Coventry, to call on its owner, George Dudley Seymour. Mr. Seymour met us, costumed in a sweeping double cape and high beaver hat, ushering us through a room toward a door on the far side of the fireplace—but he stopped and unfastened what appeared to be a narrow closet door on the near side. "This is reported to have been made as an escape from the Indians," he explained. The back was a solid board and you edged through the left side. Everyone squeezed through but Sargent, who preferred to go through the usual door. After seeing the rest of the house from top to bottom, we arrived at the dining room. In front of a large open fireplace was an old table set with a silver urn surrounded by silver beakers and flanked by a huge brown jug of cider—altogether making a very distinguished and hospitable atmosphere. Sargent was missing. As we were about to partake, he suddenly appeared and announced, "I did it!" with a great laugh, in which everybody joined delightedly. He had sneaked back and squeezed through the passage. I remember the visit as being one of those infrequent carefree hours made to bloom once more through the medium of an old friendship. Sargent, when he left, wrote that "for my part I feel the younger for this excursion into the old days of half a cen—no, not half a century, but thirty years ago."

For Weir this was the last flare-up of good health; he grew more and

more miserable. On November 18 the family moved back to New York for the winter, to a new apartment they had rented at 116 East 63rd St. Here Weir grew slowly, almost imperceptibly, worse, and he died at nine o'clock on the morning of December 8.

During those last sad months there are a few days that I still love to recall. It was after his severe illness at the end of September and the beginning of October, when finally he was considered strong enough, not to walk, but to be carefully carried downstairs by the two men who worked on the farm and laid in a swing that had been set up on the lawn back of the house. Here he would lie contentedly by the hour. The weather was that perfection of early autumn with clear blue skies, the air fresh, not cold, the trees just beginning to put on brilliant colors, and the grapes on the vine that ran along a trellis near where he lay giving off their delicious perfume. It was the time of the year that is as full of the hint of warmth left behind as of the chill of days to come. Here Weir lay, weak but happy to be at peace. And how many times I heard him say, always with renewed wonder in his voice, "What a beautiful world it is." He had found the world around him beautiful, and he had spent his life showing others the visions he had seen.

Appendix: Note on Dates of Paintings

A list of paintings may be found in *Julian Alden Weir: An Appreciation of His Life and Works,* New York, The Century Club, 1921, with supplementary information in two major exhibition catalogs: *Memorial Exhibition of the Works of Julian Alden Weir,* New York, Metropolitan Museum of Art, 1924; and *J. Alden Weir 1852–1919 Centennial Exhibition,* New York, American Academy of Arts and Letters, 1952.

Dorothy Weir Young's researches have made it possible to date certain paintings more accurately. These are listed below (in each case the last owner known has been given to aid identification):

Mrs. Anna Weir on the Balcony of Duveneck's Studio, Venice. 1883. 77½ x 47½. Mahonri Young.

The Road to the Farm. 1890. 22½ x 16. Charles L. Baldwin.

The Red Bridge. 1895. 24¼ x 33¾. Metropolitan Museum of Art.

The Green Bodice. 1898. 33¾ x 24⅛. Metropolitan Museum of Art.

The Orchid. 1899. 24 x 20. Mrs. Ian MacDonald.

Plowing for Buckwheat. 1899. 47 x 32½. Carnegie Institute, Pittsburgh.

Portrait of Mrs. David T. Honeyman. 1900. 25 x 27. Col. C. E. S. Wood.

Going to School. 1902. 24 x 20. George Barr McCutcheon.

The Border of the Farm. 1902–4. 50 x 39¼. Mrs. Robert C. Vose.

Portrait of Maxwell Wood. 1903. 24 x 20. Col. C. E. S. Wood.

Autumn. 1906. 36 x 29. Corcoran Gallery.

Black Birch Rock. 1906. 23 x 27. Charles Lansing Baldwin.

Danbury Hills. 1908. Denver Art Club.

Driving the Cows to Pasture. 1908. 34 x 25. Burton Mansfield.

Obweebetuck. c. 1908. 24 x 34. George M. Oyster.

Peacock Feathers. 1909. 25 x 30. William Macbeth.

On the Shore. 1910–12. 25 x 30. Horatio S. Rubens.

Queensboro Bridge—Nocturne. 1910. 29 x 39. Milch Galleries.

The Spreading Oak. 1910. 39 x 50. Col. C. E. S. Wood.

Lizzie Lynch. c. 1910. 29 x 24. Mrs. H. M. Adams.

The Plaza—Nocturne. 1911. 29 x 39. Milch Galleries.

The Lute Player. c. 1911. 30 x 25. Paul Schulze.

An American Girl. 1912. 35 x 27. Worcester Art Museum.

Windham Village. c. 1914. 25 x 30. City Art Museum, St. Louis.

A White Oak. c. 1915. 25 x 30. Edwin C. Shaw.

The Lace Maker. 1915. 30 x 25. Paul Schulze.
The Fishing Party. c. 1916. 28 x 23. Phillips Gallery.
Portrait of Colonel H. C. Weir. 1917. 30 x 25. Col. H. C. Weir.

A list of prints may be found in Agnes Zimmerman, *An Essay Towards a Catalogue Raisonné of the Etchings, Dry-Points, and Lithographs of Julian Alden Weir,* Metropolitan Museum Of Art Papers: Volume I, Part II, New York, 1923.

INDEX

ILLUSTRATIONS

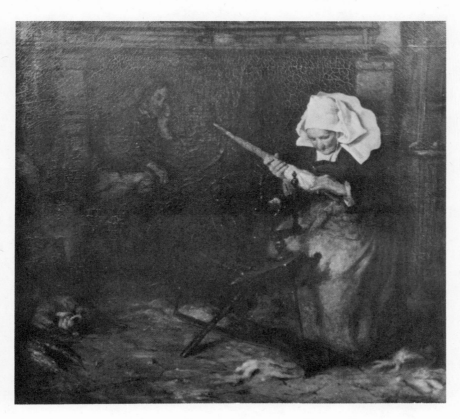

FIG. 1. A BRITTANY INTERIOR. 1875

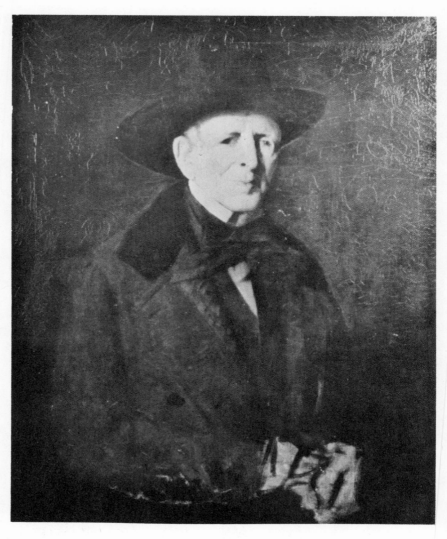

FIG. 2. PORTRAIT OF AN OLD GENTLEMAN. 1870—9

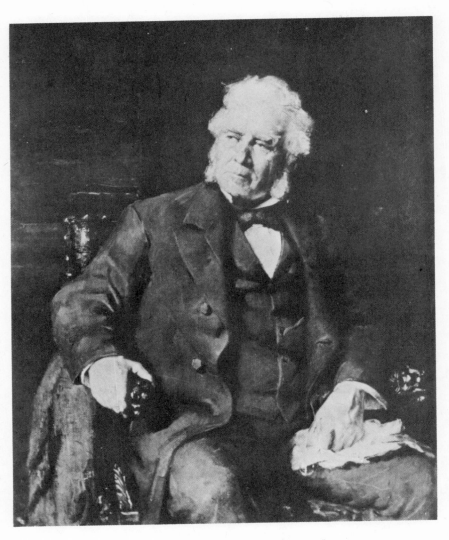

FIG. 3. PORTRAIT OF ROBERT W. WEIR. 1879

FIG. 4. PORTRAIT OF OLIN WARNER. C. 1880

FIG. 5. PORTRAIT OF ARTHUR QUARTLEY. C. 1880

FIG. 6. PORTRAIT OF MISS C. M. WEIR. 1882

FIG. 7. AGAINST THE WINDOW. 1884

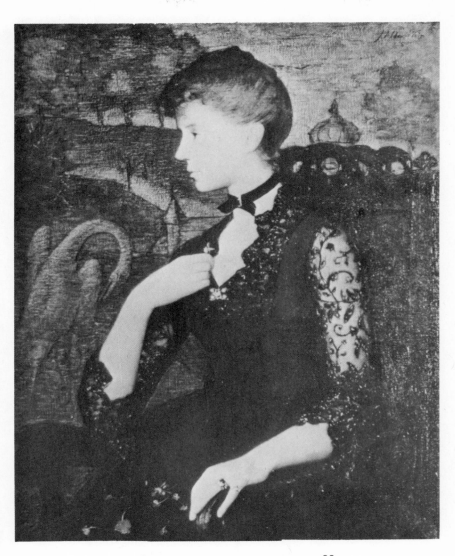

FIG. 8. LADY IN A BLACK LACE DRESS. 1885

FIG. 9. THE DELFT PLATE. 1888

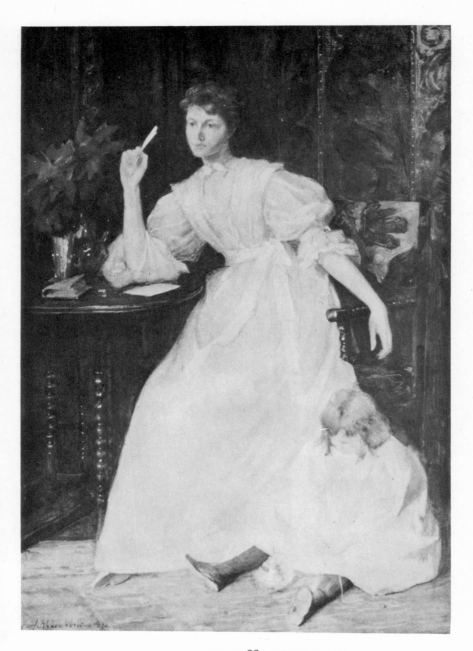

FIG. 10. THE LETTER. 1889. WATER COLOR

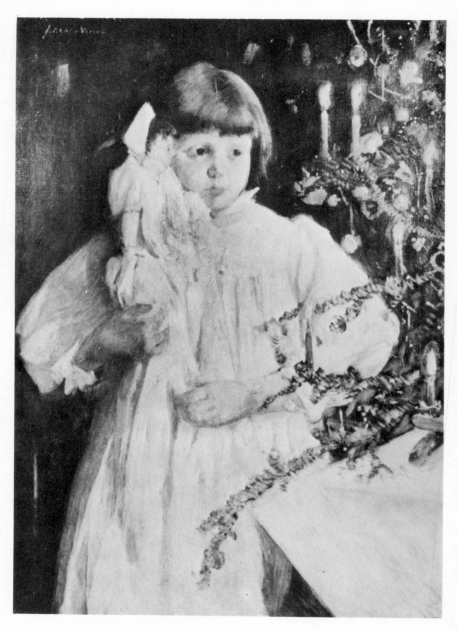

FIG. 11. THE CHRISTMAS TREE. 1890

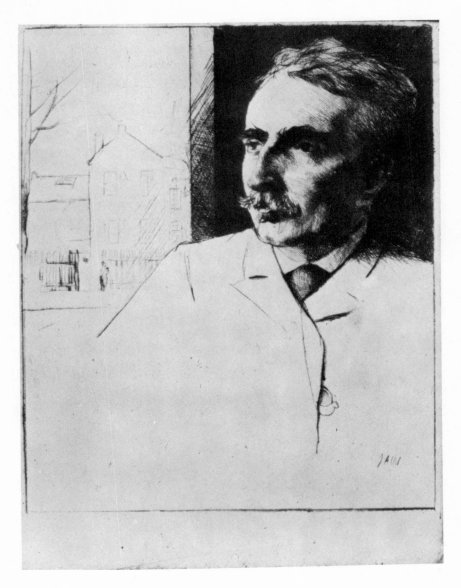

FIG. 12. PORTRAIT OF JOHN F. WEIR. 1890. DRYPOINT

FIG. 13. THE OPEN BOOK. 1891

FIG. 14. ARCTURUS. 1892. ENGRAVING

FIG. 15. BABY CORA. 1894.

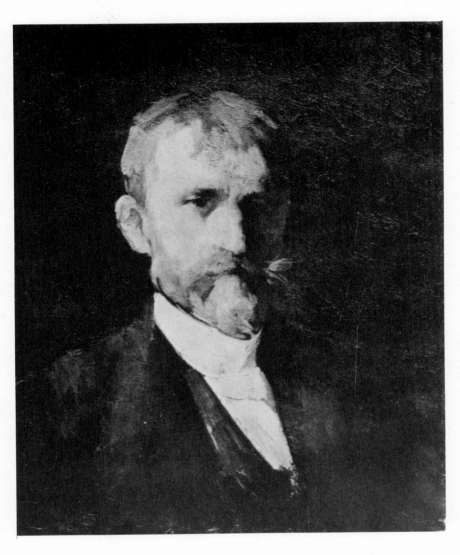

FIG. 16. PORTRAIT OF JOHN H. TWACHTMAN. 1894

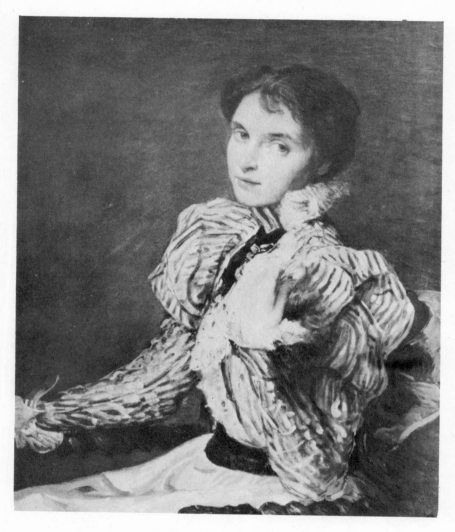

FIG. 17. THE GREY BODICE. 1898

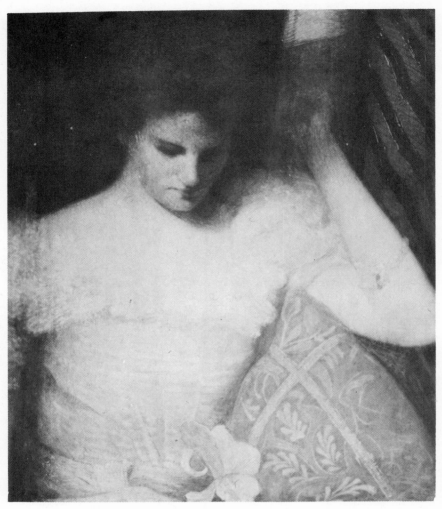

FIG. 18. THE ORCHID. 1899

FIG. 19. AN ALSATIAN GIRL. 1890—9

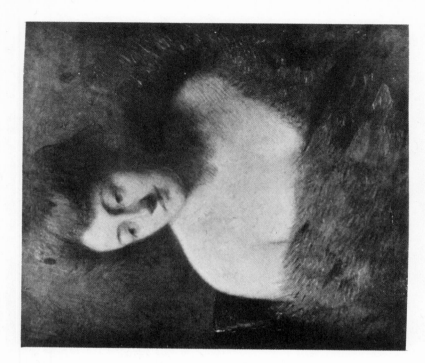

FIG. 20. THE FUR PELISSE. 1906

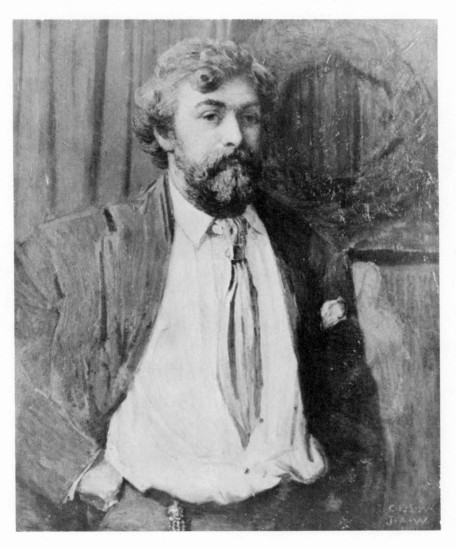

FIG. 21. PORTRAIT OF COLONEL C. E. S. WOOD. 1901

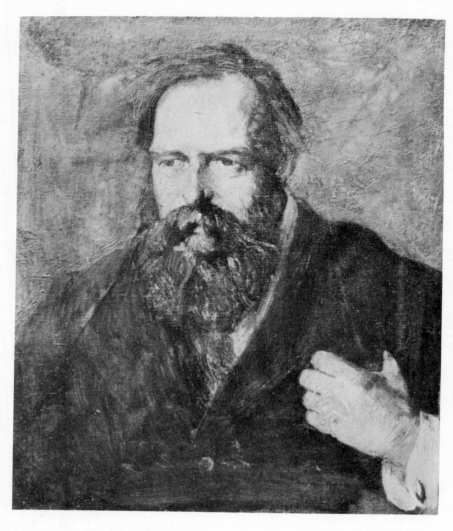

FIG. 22. PORTRAIT OF ALBERT PINKHAM RYDER. 1902

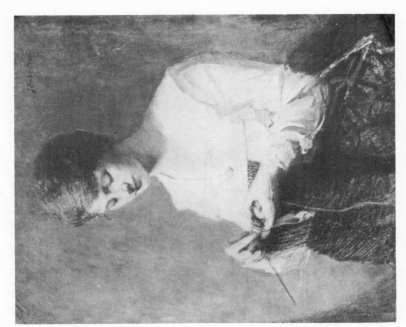

FIG. 24. KNITTING FOR SOLDIERS. 1918

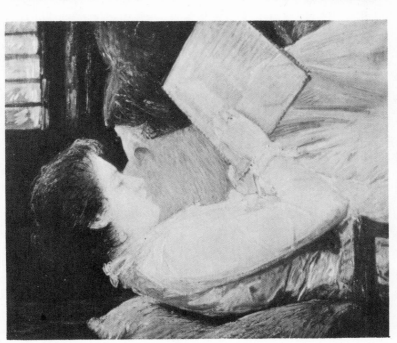

FIG. 23. THE LACE MAKER. 1915

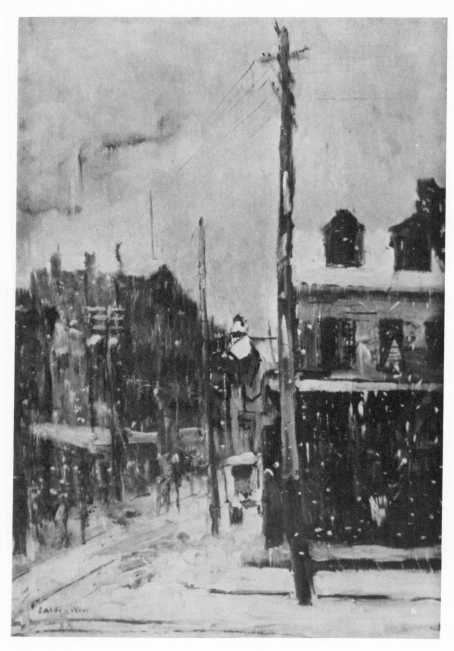

FIG. 25. SNOW IN MERCER STREET. 1881

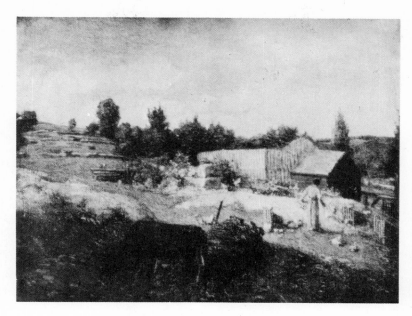

FIG. 26. A CONNECTICUT FARM. 1886

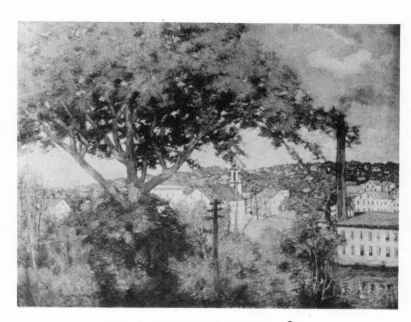

FIG. 27. THE FACTORY VILLAGE. 1897

FIG. 28. NOONDAY REST. 1897

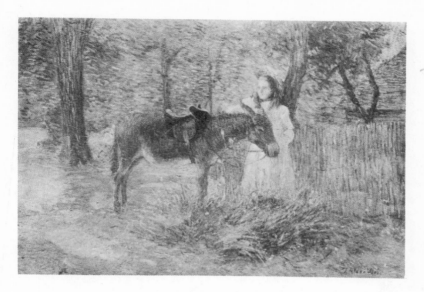

FIG. 29. VISITING NEIGHBORS. 1903

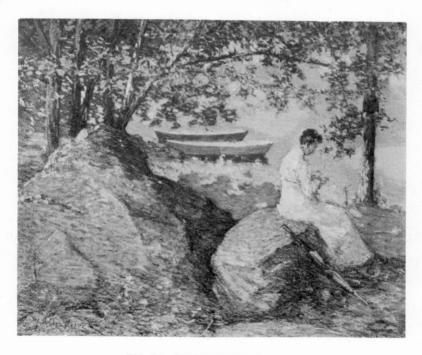

FIG. 30. ON THE SHORE. 1910–12

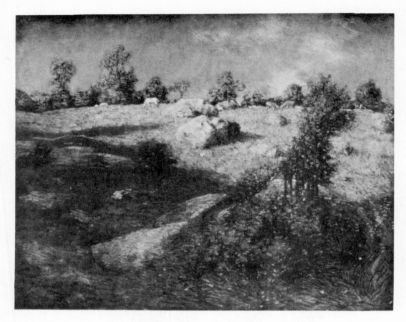

FIG. 31. THE UPLAND PASTURE. 1905

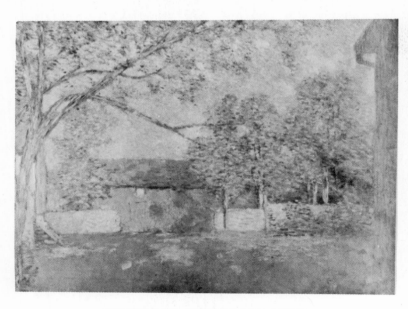

FIG. 32. BARNS AT WINDHAM. C. 1915

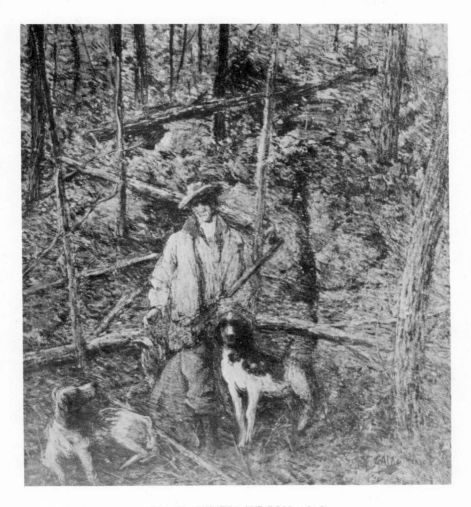

FIG. 33. HUNTER AND DOGS. 1912

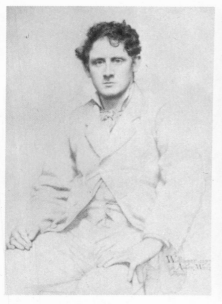

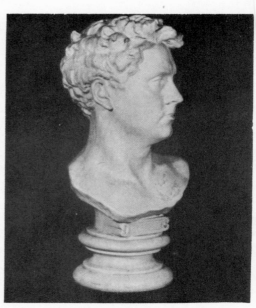

FIG. 34. PORTRAIT OF J. ALDEN WEIR
BY WOLFINGER. 1877. PENCIL

FIG. 35. BUST OF J. ALDEN WEIR
BY OLIN WARNER. 1879

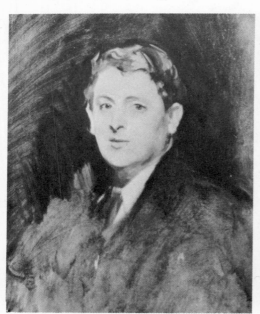

FIG. 36. PORTRAIT OF J. ALDEN WEIR
BY JOHN SINGER SARGENT

FIG. 37. PHOTOGRAPH OF J. ALDEN WEIR
AT 63